THE STONE AND THE THREAD

THE
STONE
AND THE
THREAD

ANDEAN ROOTS
OF ABSTRACT ART

BY CÉSAR PATERNOSTO

TRANSLATED BY ESTHER ALLEN

University of Texas Press, Austin

Translation of *Piedra abstracta.*
La escultura Inca:
una visión contemporánea
by César Paternosto
© 1989 Fondo de Cultura Económica

Translation © 1996
by the University of Texas Press
All rights reserved
Printed in the United States of America
First Edition, 1996

Publication of this book was made
possible in part by support from
The Pachita Tennant Pike Fund for
Latin American Studies.

Designed by Ellen McKie

Requests for permission to reproduce material from this work should be sent to
Permissions, University of Texas Press, Box 7819, Austin, TX 78713-7819.

∞ The paper used in this publication meets the minimum requirements of
American National Standard for Information Sciences—Permanence of Paper for
Printed Library Materials, ANSI Z39.48-1984.

LIBRARY OF CONGRESS CATALOGING-IN-PUBLICATION DATA

Paternosto, César, 1931–
 [Piedra abstracta. English]
 The stone and the thread : Andean roots of abstract art / by César Paternosto ;
translated by Esther Allen.
 p. cm.
 Includes bibliographical references and index.
 ISBN 0-292-76565-7 (alk. paper)
 1. Inca sculpture. 2. Inca architecture. 3. Inca textiles. 4. Symbolism in art.
5. Art, Abstract. 6. Andes Region—Antiquities. I. Title.
F3429.3.S39P3813 1996
709'.85—dc20 95-22899

To the memory of my parents.

To Cecilia Vicuña.

CONTENTS

ILLUSTRATIONS

Maps

Figures

Plates

PREFACE TO THE ENGLISH EDITION

Since 1989, when this book was published in Spanish under the title *Piedra abstracta,* issues that were implicit in it, or insinuated but not fully developed, gradually have begun to emerge in more defined terms. First of all, I realized that I had not followed through with a central point of my argument: Though I repeatedly pointed out the uniqueness of the in situ sculpture of cuboid or faceted cuts—in the whole spectrum of the Amerindian arts, nothing else is comparable to it—I never fully addressed this singularity.

It began to dawn on me only some time after *Piedra abstracta* had reached the bookstores: The Incas were great synthesizers of the thousands of years of cultural and material development that underlie the other Andean arts (textiles and ceramics). The uniqueness of their abstract sculpture of tectonic forms must therefore be due to something that, given the total lack of ethnographic references, can only be called a "tribal idiosyncrasy"—some peculiar cultural trait of the peoples who originally settled in the Cuzco valley. Tantalizing as speculations on the symbolism of Inca abstract sculpture will always be (as I state in this book, the stone seems *to represent only itself*), the most important point to be made in regard to this sculpture is that, in the end, it is the only original contribution of the "sun people" to the Amerindian arts.

Reflecting on my post-publication realization, I became aware that, rather than thinking solely in terms of the sculpture's symbolism, I had been concerned primarily with emphasizing the fundamental geometric vocabulary that emerges from both two-dimensional (textiles or ceramic painting) and volumetric (sculptural) Inca symbolic forms. As I wrote in *Piedra Abstracta,* this shared origin is implicit in the etymology of the

word "tectonic": the word's Indo-European root, *teks*, conveys the primary sense of art, in which construction and weaving are virtually one and the same thing. "Tectonic" is a risky term; it is rarely used outside of German art theory, and its most common usage is geological, as in "plate tectonics." In English-language writing about art it is, at best, employed as an adjective conveying architectonic or constructive connotations. Yet because of its far-reaching semantic implications, I found it irreplaceable, the *mot juste*.

As I worked on *Piedra abstracta,* I was confronted time and again with inescapable evidence that pre-Columbian tectonic forms appear to be an overlooked source, or anticipation, of much of the art of the twentieth century. I did not fail to point this out in the book, but, then, wasn't I writing about the origins of an abstract sculpture in the Americas? How is it possible that, at the end of the twentieth century, "art" in the Americas is still regarded as having begun with the colonial transplant of metropolitan styles? During that transference, native artists were coerced into adopting the rudiments of sixteenth-century European art, a tradition that ran entirely counter to aboriginal symbolic practices. These native practices were concerned only occasionally with the human figure—even less with the fidelity of its rendering—and their planar iconography often resulted, particularly in the Andes, in thoroughly geometric designs. But wasn't this geometric structuring fervently adopted by Western culture four centuries later, thereby virtually defining "modern art"? Why, then, the thinly veiled irritation with which art historians adamantly refused even to consider the possibility of an abstract art originating elsewhere than in modern Europe? In the end, was not this transference of European styles the beginning, at least in Latin America, of an ongoing importation of aesthetics disengaged from the cultural and socioeconomic conditioning that spawned them?

Ruminating about all these issues, and a myriad of related ones, I realized that a whole new piece of writing was needed. Normally, the English translation would have provided the chance to make minor changes, improving and refining the original Spanish text. I found, however, that two new chapters were needed, as well as a restructuring of the original text. Thus the book is now divided into two parts. The first, which deals with the "stone and the thread," a metaphor for sculpture and weaving, reproduces most of the original Spanish text.

The second part of the book addresses the reception of ancient tectonics in the twentieth-century art of the Americas. Its first chapter (Chapter 9) deals with the issues delineated above, rereading the artifacts of non-Western cultures as *arts* that are central to cultures of unified and non-hierarchical symbolic practices, such as Amerindian cultures. Obviously, the subject is inseparable from a revision of the history of art in the Americas: if the artifacts are, in actuality, the *arts* of ancient America, why do they remain largely unrecognized in mainstream art history, segregated as scientific specimens?

Chapter 9 operates, to a degree, as an introduction to the second part of the book. It is followed by the former Chapter 8 of *Piedra abstracta,* which deals with the "constructivist aspect" of Inca sculptures (that is, their symbiotic relationship to Inca building techniques), as well as with

the repercussions of ancient tectonics in the twentieth century, especially in the work of Josef Albers and Joaquín Torres García.

Chapter 11, which is new, is an attempt to cut across the art historical divide that has, during the last forty years, separated the arts of the Americas into "American" (United States) art on the one hand, and "Latin American" art on the other. Based on documentation that became available only recently, I emphasize the intense relationship that some members of the New York School, particularly Barnett Newman and Adolph Gottlieb, had during the 1940s with the aboriginal arts of the American hemisphere and thus the affinities between their work and the work of the older Torres García in Montevideo, at the other end of the continent. The linkage of these elements along the North/South axis alters the established art historical discourse and provides the conceptual basis for the emergence of an abstraction rooted in the tectonic arts of the Western Hemisphere.

"Nature as the Grand Scale," the third chapter of *Piedra abstracta,* dealt with the Inca practice of sculpting whole rock formations, as well as the similarities and differences between these sculptures and the lines and mega-drawings in the Nasca desert plains. In the last section of that chapter, I dealt with the resonances those ancient modes have had on contemporary art, basically in reference to "earth projects" or other, more conceptual works such as trekking and its documentation. In the Spanish version, this account, though sketchy, filled an information gap, but in the context of the English version it would be redundant, given the ample literature on the subject and its main practitioners—Robert Smithson, Michael Heizer, Walter De Maria, Richard Long, Nancy Holt, and others. So I decided to omit this chapter, preserving some parts that are now interpolated into the main line of discourse, insofar as they provide contemporary points of reference that aid in reading the ancient works. This procedure is in keeping with the methodology of mutually enlightening cyclical references that informs this book. If contemporary "earth works"—or geometric abstraction, for that matter—teach us to read the forms of ancient art, we should not forget the latter's long lineage, as well as its character as an examplar for the art of today, insofar as it was totally integrated into the life of the sociey that produced it.

What follows is my reading of the ancient American arts; as such, it is far from unbiased. In fact, it could be read as a long, protracted manifesto stemming from my art practice: As a lifelong abstractionist, I totally identified with the abstract or plainly geometric forms of the Andean arts, of which the stone sculpture of the Incas was the first revelation, my entrance to that incantatory world of ancient symbols.

To a large extent, these forms were defined within the textile grid; that is to say, they were the creation of the minds and hands of women. Therefore, as my discourse was virtually centered around a women's art—declassed as "craft," or considered, at best, as a subspecies "fiber art"—almost by definition, it established itself away from mainstream historical constructions. Not only was the planarity of the Andean textile paradigm essentially at odds with the centuries-old Western system of pictorial representation, but it also allowed for a redefinition of the Modernist grid. Furthermore, as emerging from the ancient American traditions, abstrac-

tion appeared as a language charged with symbolic and cultural meanings, indeed a far cry from the formalist abstraction, largely typified by the Greenbergian discourse—an emblematic target in the postmodernist dispute that I had so blissfully ignored while I was working on *Piedra abstracta*.

But, just as significant for me, as the writing gradually honed a hemispheric narrative, it finally appeared as a mirror reflection of the existential geographic/aesthetic South/North axis along which my life evolved: From South America to North America; back to the Andes, and forth again.

NEW YORK, 1995
C. P.

ACKNOWLEDGMENTS

Despite this book's "esoteric" nature, as it was once described by someone in the New York publishing industry, the list of names of "initiates" who stimulated my work in one way or another is not short. Professor Nicolás Sánchez Albornoz heads that list as the project's first intellectual mentor; his prologue will testify to the extent of his participation in this enterprise. The comments and advice of Graciela Sánchez Albornoz, Lucy R. Lippard, and Anne Twitty were also extremely valuable in the initial stages of the project.

I've already expressed my gratitude for all the information Professor José González Corrales furnished me with during my stay in Cuzco in 1979, and I would like to reiterate that gratitude here. He was the first scholar to write about this subject, and in such situations, the kind of prodigality he showed me is not at all frequent. I also very much appreciated the time that Dr. Chávez Ballón spent with me during my stay in Cuzco.

Since 1980 I have shared my life, studies, discoveries, and intuitions with Cecilia Vicuña, who was born at the foot of the Chilean Andes. This book is marked by her specific contributions and by her deep ties to the ancient cultures of the continent; but, more than anything, it reflects her implacable demand for ever-greater clarity of exposition. If in its final form this book has communicative efficacy, it owes that to her. All this is in addition to her constant support and faith in my ideas.

Christopher Mitchell, director of New York University's Center for Latin American and Caribbean Studies, invited me to be a visiting scholar at the center in 1981, which enabled me to continue my research. Around the same time, I received an encouraging letter from Professor Alberto Rex González, who had read the first version of the manuscript. Professor

González is not only the foremost scholar of Amerindian cultures in what is now Argentinian territory, but was also the first to exhibit pre-Columbian art in an avant-garde context more than thirty years ago. Needless to say, his unconditional support has been a solid foundation for the book's completion.

The final motivation to complete the manuscript gained force in 1986, during a delightful stay in Mexico—a long postponed trip that finally materialized thanks to the insistence of Tomás Parra. Adolfo Castañón, managing editor of the Fondo de Cultura Económica, which published this book in Spanish, and his colleague Alejandro Katz showed a receptivity to the project that was decisive. First in Mexico and then in Buenos Aires, Alejandro dedicated many long hours to the crystallization of this project; for that, and for his perceptive observations, I am deeply grateful.

Other friends who have shown me their support at various times (either sharing information or comments with me, or inviting me to publish or give lectures) have also been very important. They are: Dore Ashton, Barbara Braun, Benjamin H. D. Buchloh, Luis Camnitzer, Stanton L. Catlin, Gonzalo Fonseca, David Guss, Horacio and Julia Herzberg, Herbert Klein, Miguel Ocampo, and Eliot Weinberger in New York; in Buenos Aires, Silvia de Ambrosini, Ruth Benzacar, Guillermo Gasió, Daniel Martínez, Alejandro Puente, and especially, Mario Gradowczyk, who was constantly making valuable suggestions; Professor Néstor García Canclini in Mexico; and, during my last trip to Peru in 1988, Augusto Mosqueira in Cuzco and Robert Randall in Ollantaytambo. The architect Graziano Gasparini in Venezuela also deserves my special gratitude.

Shortly after the Spanish edition of the book appeared, Professor George Kubler honored me by asking my opinion of a lecture he gave at the Institute of Fine Arts on "Esthetics since Amerindian Art before Columbus" (September 1989). In responding to his work, I clarified my ideas regarding aesthetic decisions in ancient symbol-shaping, as a condition of cultural variety. This clarification, which made its way into the English edition, could not have happened without Kubler's challenge to my intellect, for which I am most grateful.

Professor Stanton L. Catlin became even more enthusiastic about the book after its Spanish publication and asked me to collaborate with him on a proposal for a show that would feature the development of geometric abstraction in Latin America, as well as its connection with the ancient arts. Though the show never materialized, our conversations and exchange of ideas as we put together the proposal helped me a great deal to focus on the distinct "abstraction of the Americas" discussed in Chapter 11. Francesco Pellizzi, on his part, read an article that was an early version of this chapter and made valuable suggestions. I am also grateful to Cecilia de Torres, who, always supportive of my ideas, made possible my unrestricted perusal of Torres García's archives. My gratitude also goes to Mari Carmen Ramírez, who invited me to read a paper at the "Inverted Map" symposium, held in connection with the exhibit *The School of the South* at the Archer M. Huntington Art Gallery of the University of Texas at Austin. This gave me the opportunity to do more research and reading of Torres García's theoretical output, which, in turn, deepened my knowledge of his approach to pre-Columbian art, a perspective now reflected in the English version of this book.

I owe profound gratitude to Professor Terence Grieder, who has given decisive support to my ideas since he first read an article of mine in 1986 on Inca sculptural works; he has also generously allowed me to publish one of his photographs. I am also particularly grateful to Theresa J. May, the Assistant Director and Executive Editor of University of Texas Press, who has devoted a contagious enthusiasm and energy to bringing this English version of *Piedra abstracta* to full fruition. I also would like to express my gratitude to other members of the University of Texas Press staff, Ellen McKie, the designer of the book, and Lois Rankin, manuscript editor, and to Victoria Moreland, copy editor. Andrés and Vanessa Moraga have also contributed with timely advice and information. I would like to thank, as well, the distinguished photographer Edward Ranney for allowing me to reproduce two of his beautiful photographs of Inca sites that I was unable to reach, and author John Hemming, who gave me generous permission to reproduce a map that he had personally compiled for *Monuments of the Incas*. Others who generously provided photographic material include: Glenda Hydler and Jene Highstein, executors of the estate of sculptor Suzanne Harris; the Argentine artist Líbero Badii; the Josef Albers Foundation; the Fundación Torres García, in Montevideo; Mr. Francis Cincotta; Ms. Rachel E. Adler; Mr. Bernard Chappard; and Ms. Linda Schildkraut of the Merrin Gallery in New York.

The rhetorical twists of my "Spanish voice" in *Piedra abstracta* could not have found a better translator than Esther Allen: her respect for and identification with the material at hand has resulted not only in an effective transposition of my thought into English that a non-native speaker like myself instinctively finds readable and graceful, but also has made our working relationship a most pleasant one. For all of that, my deep gratitude. And when it came to the point of presenting a workable project for the cover of this book, my daughter María José selflessly put her designing skills to my service. I am especially thankful to her.

I would like to pay homage to the late sculptor Isamu Noguchi's artistic achievements; in the early stages of this project, he graciously shared with me his views on the Inca stoneworks—our mutual love—and lent photographic material for reproduction in *Piedra abstracta*. This homage must also be extended to another influential and fecund artist, Anni Albers, whose pioneering activity in the noble and ancient practice of textile art has been sadly slighted by the dominant system of "high art," which relegates textiles to the category of "fiber art." I would like also to pay tribute to the memory of Robert Randall, though we met only briefly in Ollantaytambo in 1988. His tragic and much-lamented death has ended his creative and uncompromising scholarship in the field of Andean studies, as well as the fruitful correspondence between us. The recent passing of Alfredo Hlito and Marcelo Bonevardi, two appreciated colleagues and friends, adds to the heartfelt losses that are connected, in various ways, to the artistic developments I address in this book.

And finally I want to mention the patient labor of the technicians at G&W and Soho Black & White laboratories in New York and the dedication and experience of José Cristelli and Ernesto Regales in Buenos Aires, who have enabled my attempts at photography to attain the best results possible.

C. P.

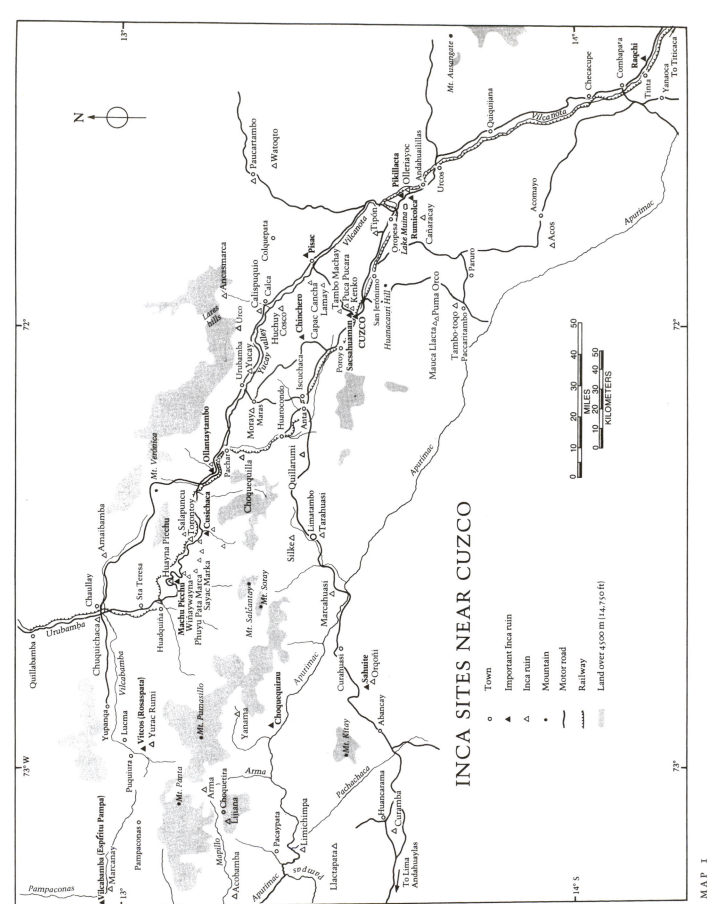

INCA SITES NEAR CUZCO

Town ○
Important Inca ruin ▲
Inca ruin △
Mountain ●
Motor road ——
Railway ┈┈┈
Land over 4500 m (14,750 ft)

MILES
0 10 20 30 40 50

KILOMETERS
0 10 20 30 40 50

MAP I

Inca Sites near Cuzco. Compiled by John Hemming. Reprinted by permission of the author from Hemming and Ranney 1982, 66.

THE STONE AND THE THREAD

PROLOGUE

*pero dadme
una piedra en que sentarme*

CÉSAR VALLEJO

The word is the thread.

CECILIA VICUÑA

The existence in Cuzco, and its zone of influence, of carved stones without figurative forms has long been known. The first chroniclers of the Spanish Conquest noted their presence, but their meaning has persistently defied explanation. The lack of knowledge about this point of Andean art and thought has caused increasing dissatisfaction, and recent speculations have begun to approach certain aspects of the mystery. In this book, César Paternosto proposes a global, simple, and convincing explanation. His is the first work that does not deal with this subject in passing but focuses on it exclusively. For Paternosto, these cut stones are simply sculptures. This idea is like the famous Count Lucanor daring to call things by their name, after which everyone else followed suit; the same thing is sure to happen here. From now on, the Andean carvings will be accepted as abstract sculptures, and with this definition Paternosto has added a new dimension to Andean art.

I cannot promise that Paternosto's reading of every piece will emerge unscathed from the scrutiny his text will undergo. Such a thing would be exceptional, and would carry César straight to the Pantheon. But I would like to point out two problems, quite alien to his argument, which do worry me. First, why has it taken centuries to recognize the nature of these carvings? Second, why has an artist like Paternosto, and not an accredited expert in Inca culture, found the solution?

The step Paternosto has taken reminds me of the recognition Western aesthetics accorded to African art at the beginning of the twentieth century. The barriers separating "primitivism" from modernity were broken down, and painting, especially, was enriched. But this recognition did not go beyond Africa, and did not reach American art. Only Henry Moore and

Josef Albers reworked Mexican inspirations in their sculptures, and, as Paternosto points out, they did so years later. Inca art continued to be ignored by contemporary aesthetics, or, at most, it contributed to the literal images of a nativist art.

Paternosto's perplexity over this incongruity led him in two directions. First, he borrowed Andean forms and used them in his abstract painting, repeating what Picasso and others had done with African forms. But the easel would take Paternosto further than that: His brush cast light on their meaning. Only study, however, would reveal it.

Paternosto's abstract painting—which I have followed from his Paris exhibit, which we celebrated with a glorious dinner at La Coupole, to my almost monthly visits to his studio in New York—is vibrant but eminently intellectual. The intellectual aspect of his personality helped him take a step that is difficult and unexpected for an artist. Without ceasing to paint, he also plunged into libraries. There he immersed himself in everything written on Andean culture, from the early chroniclers to contemporary anthropologists and linguists. Meanwhile, his continuing reflection on contemporary and modern art kept him abreast of what was being done and thought. Paternosto has thus been able to merge diverse perspectives with his artistic sensibility.

This book combines historical research with contemporary aesthetics, and it is one more proof of how rewarding it can be to break out of intellectual and academic pigeonholes. Try as they may to demonstrate the autonomy of Andean culture, anthropologists and archaeologists have been operating with borrowed categories and have failed to hit upon the right path. It seems to be easier for an artist than for a scholar to delve into the details of prehistory and come up with a link to present-day culture. Paternosto has created such a bridge for communication. In the field of history, which is my profession, cross-fertilization among different disciplines has become more frequent in the past several years. These odd couplings now seem familiar to me, and it is time they reached Andean nonfigurative art. Both historical knowledge and the practice of art have arrived at a point where an encounter between them can be warmly welcomed. In this book, I see the same force of conviction that its author has often revealed to me in conversation over a friendly glass.

NICOLÁS SÁNCHEZ ALBORNOZ
New York, December 1988

INTRODUCTION

Unlike the Persians, Egyptians, and Babylonians, the civilizations of America were no older than European civilization; they were different. Their difference was radical; a true otherness.

OCTAVIO PAZ
"Mexican Art: Sense and Matter"

The colossal statue of Coatlicue—"she with the skirt of serpents"—was exhumed in 1790 during a municipal construction project in Mexico City's Plaza Mayor, only to be reburied a few months later as an expression of the devil, "an affront to the idea of beauty itself" (Paz 1979, 51). After Mexico won its independence from Spain, Coatlicue was unearthed once more, for the last time. First the statue was stuck in a corner in a university hallway and ignored; then it was hidden behind a screen as an object of curiosity or discomfiture. Much later, it came to occupy a central place in the section of the Mexican National Museum of Anthropology dedicated to Aztec culture.

As Octavio Paz wrote, the vicissitudes of Coatlicue, "from goddess to demon, from demon to monster, and from monster to masterpiece" (1979, 52), illustrate the changes of sensibility we have undergone throughout the centuries. Moreover, the initial confrontation with Coatlicue "repeats on a smaller scale what European consciousness must have experienced during its discovery of America. The new lands seemed to be an unknown dimension of reality" (1979, 53), as did their civilizations—so completely *other*.

The monumental sculpture of the Incas constituted, until recently, a special case of this American otherness. Strikingly geometric reliefs and rocks sculpted in situ, most of them abstract—like the innumerable and useless stairways or facetings that modify entire geological formations— were not exactly the kind of artistic expression to captivate the gaze of the first Spanish chroniclers. The ever-perspicacious Cieza de León observed that some examples of Inca stonework had a certain autonomy: he referred to the "*bultos* (shapes) and other, larger things" ([1553]n.d., 477)— sculpture "in the round" we would say today. In any event, it would have

been impossible for Cieza and the other chroniclers (or, indeed, for any European of the sixteenth through the twentieth centuries) to appreciate the sculptural nature of these works in which no representation of natural forms was involved. Thus the fate of the Inca monuments was sealed: no inquiries were made regarding their symbolism or their function within the society. Their final meaning was hidden from us forever.

Disconcerted by the absence of representations of natural forms, either explicit or geometrized, Geoffrey Bushnell suggests that Inca sculpture "on a large scale does not survive, and indeed there may not have been any" (1967, 127). Noting that "the Inca characteristically lacked interest in decorative stone sculpture and relief modelling," John Howland Rowe believed that their "technical ability" is reflected in the manufacture of cups "decorated" with the shapes of animals "which will bear comparison with any Aztec work." But Rowe also observed very acutely that "the Inca had a functionalist's love of simple structural surfaces" (1963, 288).

George Kubler thought that the miniatures in stone and metal representing human beings or animals "may reflect a vanished monumental sculpture."[1] Nevertheless, at the beginning of his discussion of sculpture, he points out:

The urban impulse to commemorate important experiences by monumental sculpture was satisfied in Inca society by intricate nonfigural carvings on the surfaces of caves and boulders. Such work was common throughout the southern highlands under the Inca regime. It consists mainly of terraced seats, stepped incisions, angular or undulant channels, and, in general, of laborious modifications of the striking geological features of the landscape. They mark the presence of man without representing him in images or statues. (1975, 334)

Kubler happened to have read an earlier work, *On the Royal Highway of the Inca,* by Heinrich Ubbelohde-Doering, in which the first discussion of this subject (though it is not specifically described as "Inca sculpture") is found. Ubbelohde-Doering explored, excavated, and photographically documented sites scattered over vast areas of Peru, going as far as Saywite. Reading his book decisively stimulated my interest in the subject. His ideas about the sculpted stones still have great validity, and I will refer to them frequently.

François Hébert-Stevens, in *L'art ancien de l'Amérique du Sud* (1972), also takes up the subject, but from a more ambitious perspective that includes all aspects of the pre-Columbian art of South America. Nevertheless, his publication—which is the first—of the Pierre Solaire or Third Stone of Saywite is an extremely important contribution, as are many of his appraisals of the *"retenue"* or circumspect religious symbolism of Inca sculpture.

In *Everyday Life of the Incas* (1973), Ann Kendall observed: "The most expressive form of stone-carving is found on the surfaces of caves and boulders, where terraced seats, steps, angular hollowing, channelling and other emphatic shapes were hewn out of solid rock, including—though only occasionally—a puma or a snake. In these carvings, man appears to have been identifying himself with nature and creating his own shapes among those of the landscape" (161).[2] Though Kendall does consider

these works the "most expressive" form of Inca stone-carving, the conceptual inhibition that keeps her from calling them "sculptures" is apparent.

In *Inca Architecture* (1980), Graziano Gasparini and Louise Margolies recognized that the great variety of rocks sculpted in situ into stairways, "chairs," altars, thrones, and niches represent an area of investigation that is different from architecture. They clearly perceived the Inca worship of stone, "whether . . . natural or modified in multiple ways by the stone carver" (266–267)—a decisive criterion for understanding these works. But reticence about calling these works "sculptures," and their creator a "sculptor," persists.

Only in *Monuments of the Incas* (1982), with photography and text by Edward Ranney and John Hemming respectively, was this idiosyncratic chapter of ancient American art at last fully recognized. This is the first exhaustive photographic compilation of the monumental sculpture of the Inca empire, and the superb quality of the images fulfills the aesthetic goal Ranney announces in his preface: to reestablish the intimate relationship of the monuments with their natural surroundings, which were also the object of worship—an integration that archaeology had repeatedly ignored. Hemming and Ranney document the profusion of works sculpted in situ with a breadth that far surpasses my photographic work in 1979 and 1988. But any expectation of a theoretical elucidation of the subject is, for the most part, postponed by the text; perceptive reflections on the religious significance of the sculpted works are weakened by the inclusion of some of the clichés that plague studies of the Inca world. The text practically begins with the inevitable comparison, "The Incas were the Romans of the ancient world" (1982, 13).

In his 1971 doctoral dissertation, Professor José González Corrales of the University of Cuzco was the first to grasp with clarity the sculptural character of the abstract works, as well as the symbolic nature of a discreet but nevertheless significant aspect of those works: the protuberances in the walls.

For the traditional scholar, Inca tectonic sculpture was elusive and unclassifiable, but for the artist or theoretician of contemporary art, the absence of representation of natural forms confers on it the status of instant "modernity." From our ethnocentric perspective, we tend to see the nonfigurative art of ancient or non-European societies (Islamic art, for example) as a kind of tentative stammering, the mere beginning of an evolution that would reach its apotheosis in the geometric abstraction of the twentieth century. This arrogant stance is the result of vaguely formalist considerations, which, in general, are unconcerned with the value systems that inform such geometric art. Such a perspective, is, however, of great usefulness in appreciating the aesthetic qualities of Inca sculpture, though it leaves us with nothing more than some beautiful artifacts that are devoid of meaning when torn out of the cultural fabric that generated and nurtured them.

This appears to be the inevitable consequence of our evolution toward aesthetics as a differentiated, specific experience. As Arnold Hauser describes it:

The Greeks were the first people to complete this transition from the instrumental to the "autonomous" form of activity, whether in science, art

*or morality. Before them there was . . . no art as we understand art—as an
activity whose creations may always be considered and enjoyed as pure
forms. . . . In the seventh and sixth centuries B.C. the Greeks in Ionia . . .
created the first works of a pure purposeless art, the first suggestion of l'art
pour l'art. (1951, vol. 1, 78)*

This evolution culminated as recently as the end of the Middle Ages, when
sculpture and painting separated from architecture and defined themselves,
during the Renaissance, as autonomous categories. The development of
easel painting, an artistic form that has no counterpart in other cultures, is
the most significant aspect of this evolution (see Greenberg 1965, 154).

Marble, bronze casts, canvas stretched over a frame thus became
neutral media, receptacles of "pure" artistic activity giving rise to the
"artistic object," the painting or sculpture. All the rest became "applied
art"—decoration embellishing functional, useful objects. But this process
can be observed with greatest clarity in easel painting: the stretched canvas
was conceived as the material support of an activity that was "artistic"
from the very beginning, while no such rupture with the pre-Renaissance
past exists in the methods and materials of sculpture.

These categories, these qualitative differences, cease to apply outside
Western culture. As Kubler points out, the post-Kantian concept of pure
experience is opposed to the "relative unity of the functions of the soul
elsewhere than in modern Occident and previous to it: a whole in which
religious, ethical, aesthetic, and social functions were all experienced as a
seamless entity and conveyed in a single system of metaphors" (1975, 17).
But this "single system of metaphors" itself is nothing but the universe of
meanings that informs the value system of a given social group: even in
our societies, art cannot exist outside of a system of values. The unity of
functions, which outside the West is experienced as a "seamless entity,"
includes the aesthetic, which thus is inseparable from symbolic or utilitar-
ian necessity. To put it more concretely: In the context of pre–Columbian
America, the pure aesthetic experience was unknown.

When Amerindian objects first reached Europe in the sixteenth century,
their configuration bespoke an alien intentionality. The objects were all
"useful," ranging from enigmatic ritual implements to simple yet beautiful
tools. Though some were figural, the human form was not central, and the
newly discovered European system of one-point linear perspective was
entirely foreign to them. Thus, the question arose of finding "the art in the
artifact" (Greenhalgh 1978, 1101; cited by Kubler 1991, 17). "[N]o
artifact is conceivable without art, no work of art can be divested of its
function as a tool," writes Kubler. "The interval between art and artifact is
a graded series: there literally is art in every *arti*fact and, vice versa, in
every work of art there lies the shadow of an arti*fact* or tool."

This "shadow of a tool," however, and indeed the whole gradation
between the art/artifact polarities, vanishes if we think in terms of a
unifying, all-inclusive *art-as-symbol-making*. In other words, in a non-
Western context, the aesthetic cannot be separated from the symbolic
function, and therefore it has to be seen only as *commensurate with the
symbolic intensity*, a dimension that supersedes the private emotional
responses of pleasure/displeasure. The aesthetic as a choice in, or undiffer-
entiated from, the shaping of a symbol is a principle as valid for the Aztec

THE STONE AND THE THREAD

Coatlicue or the Maya-Toltec Chac-Mool as it is for a Wari-Tiwanaku tapestry or the Intiwatana stone in Machu Picchu.

Writing on the Mesoamerican civilizations, Octavio Paz perceptively noted that "aesthetic pleasure was not experienced in isolation, but in union with other experiences (1979, 62)." This thought was prefigured in an earlier observation: "Utensil, talisman, symbol: beauty was the object's aura, the consequence—almost always involuntary—of the secret relation between its making and its meaning" (1979, 8).

All pre-Columbian artistic production, Kubler states, "consists of objects for use"; thus, "all crafts can be treated as parts of sculpture or painting. Textiles are paintings on flexible supports. Most pottery vessels are sculptural forms, and some are paintings on curved surfaces" (1975, 14). We could also include stone artifacts, which Kubler does not mention, in this line of thinking. In contrast to Western culture, pre-Columbian America *never developed the media for "pure" artistic activity;* purely aesthetic experience was foreign to its inhabitants. In consequence, our hierarchical distinction between "art" and "craft" could not have existed either, since our conceptual dichotomy "pure art/applied art" has no meaning in that context. The interpretative criterion of the "purely decorative"—the "ornamental"—must therefore be jettisoned, since it is manifestly alien to the nature of pre-Columbian artistic activity.[3] The ancient American languages had no word to express what we have come to call—through a specifically Western historical process—"art," *arte, Kunst.*

By thus eliminating the category of "decoration" from the study of pre-Columbian art, we arrive at a more appropriate methodology: every inch of visual evidence acquires significative intensity as part of a single metaphorical system. If we cannot yet reveal the meaning of the geometric designs of the textiles or ceramics—and there lies the interpretative problem—this does not imply that they lack meaning, only that we have lost our connection with the cultural codes that informed them. As Valcárcel saw it, "the figures imprinted on our archeological objects, [which] we see as simple adornments, are perhaps signs that one day will be deciphered" (1964, 165). Though unfortunately I do not share the optimism of this eminent Peruvian ethnohistorian, it is important to consider his thoughts, which go far beyond the theoretical narrowness of his time.

In its original sense, "ornament" was one of the meanings of *kosmos* (the Greek word for "universe" and "order"). It signified the intuition of a cosmic order: equilibrium, proportion, rhythm, symmetrical recurrences. Gradually emptied of these rich connotations, the term "cosmetic," which obviously derives from the same root, has today become the epitome of a superficially applied beauty. This semantic avatar does no more than reflect the trajectory that begins "when the arts sundered," to use William Morris's phrase (quoted by Gombrich 1979, 33).[4]

Ancient Peruvian painting is one of the least-known aspects of Andean art.[5] We know so little about it because its correct elucidation was long delayed by the persistent interpretative confusion of this artistic form with "the decorative." For that reason, a brief discussion of it would be very illustrative.

If we accept Kubler's affirmation that a textile is a *painting,* describing it

as "decorated with motifs" would be the same as saying, for example, that a Renaissance canvas has been "decorated with colors." Nevertheless, Luis G. Lumbreras tells us, "Archeologists have contributed enormously to the obscurity in which Peruvian pre-Hispanic painting has languished, especially because we have seen it only from the point of view of the textile material on which it is done, so that it has always been classified as a category of textiles: 'textiles with *painted decoration*'" (1979, 12). This candid mea culpa attributes the interpretative error to the fact that, unlike European paintings, these paintings were not done on primed fabrics, and they were not conceived to be presented as art in the European sense. In the West, art is presented to us in a particular context, to be "received with a particular mental set" (Gombrich 1979, 62); this could be called the "fine art syndrome," a self-referential, or rather, self-contextualized and fragmentary experience, divorced from the rest of social experience. This cultural conditioning inhibits the spontaneous perception of a pre-Hispanic textile as a *painting* because it was a tunic or had a ceremonial use.

Here we confront a conceptual error committed by archaeology, which uses inadequate, ethnocentric models to interpret pre-Columbian culture. For that reason, a number of interesting facts have gone unrecognized. First, that the ancient Peruvians used cloth as a pictorial support long before the artists of the West did so. The painted fabrics of Karwa, with Chavín iconography (Plate 1), date from at least the first millennium before Christ, while in Europe canvas was first used only toward the end of the fifteenth century. Second, not only do these flat, geometric paintings anticipate the modern evolution of art, the technique by which they were painted also establishes a clear precedence: in the West, until the discovery of acrylic emulsion paints, it was impossible to paint on untreated canvas. Art critics in the United States considered the techniques of Jackson Pollock and Helen Frankenthaler just short of revolutionary because they allowed the color to soak into the canvas, to stain it, rather than being deposited on top of a coat of primer, as in oil painting technique. This was something ancient Peruvian painters were doing almost two thousand years before.[6]

In proposing the elimination of the words "decoration" and "ornament" from discussion of pre-Columbian art, since their inevitable connotation of "superficial embellishment" distorts the meaning of that art, I suggest that they be replaced with terminology I believe to be more appropriate: drawing, painting, sculpture, and, where absolutely necessary, design. Though the definition of "design" is "drawing, sketch, schema," a more modern sense is imposed on the word by the concept of industrial design, involving design as bi- or tridimensional color and form; in this sense, the word "design" is perfectly applicable within the theoretical context of pre-Columbian art.

The categories of "decoration" and "ornament" are only pertinent within the context of modern Western culture. The best way of approaching the meaning of the hermetic forms of Inca sculpture—and of all the Amerindian arts, for that matter—will, necessarily, be a holistic evaluation of these works in light of the cultural values of Inca society. As Ortega y Gasset advises, we should "expand our sagacity until we understand the meaning of that which for us has no meaning" (quoted by Rostworowski de Díez Canseco 1953, 39). Instead of subjecting Inca sculpture to our

cultural parameters, which are so inclined toward pure aestheticism, we should arrive at an interpretation in terms that the works themselves propose to us. Aloïs Riegl realized some time ago that "it is an error to measure the work of art of earlier times with a criterion that has no share in the intentions that governed its creation" (cited by Westheim 1985, 80).

In order to "expand our sagacity until we understand the meaning of that which for us has no meaning," it is important to take into account certain facts of the Inca cultural system.

We could say, paraphrasing Louis Baudin, that Inca civilization was a rational, geometric empire (see Baudin 1972, 425). Many years after it was formulated, this seductive view acquired a vaster meaning and other resonances: rational, but not in an Aristotelian sense, and geometric, but decidedly non-Euclidian. Cuzco, the sacred capital of the Incas, was of mythical origin, and its every position and direction was endowed with "a particular accent," as Ernst Cassirer puts it, a return "to the fundamental mythical accent, the division between the sacred and the profane" (1975, 85). This geometry manifestly differs from Euclidian space, in which a homogeneity without any inflection whatsoever prevails.

The system of the *ceq'e* (lines) is the most notable example of accentuated directions and geometric partitions. According to the original information gathered by Polo de Ondegardo (c. 1561), all the *wak'a,* or shrines, of Cuzco were grouped along ideal lines—the *ceq'e*—which radiated out toward the four cardinal points from the Qoricancha, the principal temple of the cult of the sun. Polo's document, *Relación de los adoratorios de los Indios de los cuatro caminos (ceques) que salían del Cuzco,* was lost, but Molina "El Cusqueño" rescued from it a list of *wak'a,* which, in turn, was used by Bernabé Cobo. The system's vast implications were partially "discovered" by R. T. Zuidema in his *The Ceque System of Cuzco* (1964), but the complexity of the system's details must of necessity remain beyond the limits of this work.

Perhaps a drastic—and not terribly rigorous—simplification will help us glimpse the idiosyncrasy of the Andean mind, since the *ceq'e* system was one of its most characteristic expressions. The *ceq'e* lines are, above all else, abstract, polyvalent notations. Zuidema writes: "The *ceque* system has been compared to a giant *quipu,* laid out over the Cuzco valley and the surrounding hills that served in the local representation of the Inca cosmological system, in its spatial, hierarchical, and temporal aspects. The *ceque* system was used at different times of the year for different purposes and by different classes of people for recording superimposed cycles of ritual events" (1979, 231).

The system was based on the quadripartite division of the territory (to which we will return): the *ceq'e* were organized in three groups of three lines each within each sector or "quarter" (with the exception of the western quarter, which had two additional *ceq'e*). The three groups were called *collana* (principal), *payan* (second), and *cayao* (original), concepts that had a hierarchical meaning; in turn, each of the three *ceq'e* would receive one of these names. There were forty-one lines in all, and a total of 328 *wak'a* were located along them, with an average of 8 per *ceq'e*. Each of the *wak'a* represented a day in the agricultural calendar, while certain of the *ceq'e* functioned as astronomical observatories from which the rising and setting of the sun, the stars, and the moon could be viewed. Other

ceq'e marked springs of water. The care and maintenance of the *wak'a* was entrusted to the various social groups, the *panaqa,* formed by the descendents of the rulers of the Cuzco dynasties. It was this aspect of the system that allowed Zuidema (1964; see also 1990) to study the city's complex social structure during the apogee of Inca civilization.

The name "Cuzco" had, as well, the meaning of "omphalos," navel or center of the world, and many chroniclers translated the name in this cosmological sense, but Sarmiento de Gamboa writes that it always means "to occupy a space in a magical way," another definition full of similar connotations (cited by Rostworowski 1988, 33). In any case, the quarters or *suyo* into which the city was divided extended to the farthest dominions of the state, called the Tawantinsuyo, "the four quarters of the world"— or, according to Rostworowski, "the four regions united among themselves" (1988, 16). To the north was the Chinchaysuyo, to the east the Antisuyo, to the south the Qollasuyo, and to the west the Kontisuyo. This quartering of the territory included, in the area of Cuzco, a partition into halves or *moeities,* which may have been more ancient: the northern or "upper" sector was Hanan Cuzco, and the southern, "lower" sector was Hurin Cuzco. (I will discuss this division in greater detail in Chapter 3.)

The Incas recognized only two orientations: the east, *anti,* the rising sun; and the west, *konti,* the setting sun, which was the principal deity of the state pantheon and was, moreover, considered the ancestor of the Cuzco dynasties. The Incas lacked any word for "north" or "south," which were designated by known geographical directions: "north," for example, was "the road to Quito."

This principle is generally valid, but Gary Urton (1981) and Robert Randall (1987), in pointing out the cosmological importance of the southeast-northwest intercardinal axis, made decisive contributions to a reinterpretation of the great constructive enterprise the Incas undertook in the valley of Urubamba. The importance of this axis originally emerges from the mythical discourse: it was the rectilinear route followed by the god Wiracocha from his appearance in Lake Titicaca, to the *southeast* of Cuzco, passing through the city and going to the *northwest* to disappear into the sea at a point located in the city of Puerto Viejo in Mantas, Ecuador.

Though, in a primordial sense, the settlements in the Urubamba valley—which is also oriented along the southeast-northwest axis, as is Cuzco itself—introduced their incorporation into the Inca cosmos, the orientation of the most important symbolic structures of Machu Picchu and Ollantaytambo reafirms the importance of this cosmological axis. The repeated alignment of these monuments along the southeast-northwest axis clearly indicates a will to virtually unify the sacred space of Cuzco and the edifices of the valley in a symbolic continuum. In the analysis of individual sculptural works, we will see, particularly in Chapter 3, how the principle of accentuated directions functioned, since the importance of the southeast-northwest cosmological axis did not preclude the validity of other equally significant orientations.

For many decades, scholars focused almost exclusively on the material advances of Inca society—the distribution of economic resources, the sophisticated agriculture, the mega-program of public works and infrastructure. From this socioeconomic framework emerges the image of an

efficient society—certainly the most advanced of its time in America—whose efficiency was the result, in large measure, of the power of an oppressive state apparatus.

The Tawantinsuyo was far from being a paradisiacal society. Nevertheless, the socioeconomic system organized by the Incas had seemed at times utopian, before its devaluation by scholars, which is based on dubiously applied principles in the context of ancient America. The system's idiosyncrasy has given rise to diverse interpretations, whose tone has changed with the times: it has been viewed as a "socialist empire" and a "welfare society," a view that stressed the state's redistribution of goods; and as a "feudal" or "enslaving" society, or "Asiatic-style monarchy," a view that took into account the existence of the *yanakona* (a kind of semi-slaves, though they were scarce in number) and the *mit'a,* the laborers forced to work on public projects and often relocated, along with entire populations, to distant places.

In an exemplary study proposing a revision of pre-Hispanic historiography from the "point of view of the vanquished," Wachtel warns of the inappropriateness of "projecting onto a civilization so distant in time and in space categories taken from our industrial societies" (1976, 95). For my part, rather than apologizing for imperialist aspects of the Tawantinsuyo, and for certain of its methods that we would repudiate today as totalitarian, I think another reading is possible from our contemporary Western perspective.

The absence of a mercantile economy—money did not exist—allowed for a vertical integration of the ecological levels; the campesinos of the high mountains traded their products with those who lived in the lower valleys, and this enabled both populations to achieve a balanced diet. Tribute was another way in which goods circulated, but it consisted solely in the lending of work. Labor in the lands belonging to the state—to the Inca or to the *curacas,* the local governmental leaders—served to enlarge the reserves in the state granaries. And, as Wachtel points out: "The Inca's generosity assures the upkeep of the old and sick campesinos who are unable to work. In times of hunger he redistributes the reserves of his granaries to the communities. The campesinos thus feel that they are participating in the consumption of the products which they gave as tribute" (1976, 110).

The contrast between this "exotic" system and the model created by the "advanced industrial societies" of our century is unsettling. While famines persist in vast regions of the world as an insult to our supposedly civilized condition, the production of material goods for consumption reaches unprecedented levels—goods destined for a minority that possesses the economic means to acquire them. Meanwhile, the industrial production of those goods has left us with lethal chemical residues that seriously threaten life on our planet, while our "reasoning mind" appears to give priority to the protection of invested capital. Perhaps something else that "for us has no meaning" should be recalled here: the whole cycle of agricultural production, which was undoubtedly the vital center of Andean economy, was punctuated by ceremonial acts of worship to the soil, water, and sun—all the givers of life. This harmony with the environment should be a lesson to Western civilization, though perhaps, again, with merely utopian implications.

Though it is not easy to detach ourselves from the stereotype of the efficient, pragmatic, and totalitarian empire, the studies of Zuidema, Urton, Rostworowski, Duviols, and others present a new perspective that allows us to overcome sterile clichés and draw closer to the more subtle and complex traits of the Andean mind, of which the Incas are the latest avatar.

The majority of these studies, which are based on analysis of mythical discourse and ritual cycles, underscore the complexity of the symbolic elaboration within the all-comprehensive religious universe of the Andes, the central importance of which escaped or was undervalued by the earlier socioeconomic perspective. Religion was the primordial factor of social cohesion, or, in today's secular terminology, religion was the binding "ideology" of pre-Hispanic societies and, as such, was the greatest determining factor of artistic content. In that sense, this study has welcomed, and greatly benefited from, the corrective orientation of the Andean studies mentioned above; all the more so since, in the absence of a written language, the visual metaphors of the Andean arts are pregnant with meaning in a manner that is foreign to our literate civilization. In other words, the arts are figural condensations of cultural codes, functioning as efficient substitutes for writing.

This already has been pointed out by Kubler, who observed that the Maya pictorial traditions surviving in murals, vases, and manuscripts "share a common fund of figural conventions"; he also discerned the "Andean traditions of conventional signs ordered more by semantic needs than by mimetic relationships" (1975, 175, 323). For his part, Richard F. Townsend (1985, 118) stated, in a more comprehensive way, that the arts of ancient America "fulfilled a basic role in communicating essential cultural information, along with ceremonial dance and orally transmitted poetry and song." Hébert-Stevens, too, emphasized the role of the arts as the privileged expression of a "pensée symbolique" developed in the absence of writing. In this sense, we can say that the history of pre-Columbian cultures is a story told by the arts. Yet, since this vast construct is the result of archaeological or anthropological inquiry into the iconography of the artistic remains, the limitations of such historic schema are self-evident. In other words, we are far from achieving coherent interpretative principles because the stark geometric designs of pottery, sculpture, and textiles have, as in the case of the Andes, been virtually ignored by scientific inquiry.

The following reflections sketch out an area of study that is still in a state of the utmost orphanhood: the interpretation of abstract, geometric forms with no iconographic reference whatsoever, of which Inca sculpture is only one aspect. As I will emphasize during the course of my exposition, it was weaving—the manipulation of thread—that became the structural matrix not only of the geometric designs but of the predominant orthogonal iconography of Andean arts. I said it before: the purely geometric forms, inseparable from a "single system of metaphors," were also significant, with a prevailing symbolic content. The deciphering and consequent verbalization of that content seem practically impossible today because everything indicates that, in this particular area, we have irrevocably lost all connection with the cultural codes that prevailed before the Spanish conquest. This is perhaps one of the most critical aspects of the encounter

between two such diverse cultures—an encounter with the *other:* the inability to perceive that the geometric designs were also "legible."

A prominent aspect of the new methodology is the importance it gives to ethnological, and especially to ethnographic, studies as a means of drawing closer to the pre-European past. Along those lines, valuable research has been done on the semiology of the minimalist geometric forms of the highland textiles, perhaps the only artistic form in which the ancient culture has survived with great fidelity (see Cereceda 1986).

I believe now is the time to introduce interpretative models that take into account the evolution of the art of the twentieth century toward what is generically known as "abstract art," or, in the modality that most concerns us here, "geometric abstraction." But rather than being ethnocentric or isomorphic—rather than attempting to specify pre-Columbian forms which are "similar to" European forms—the use of such models will be oriented not toward a dubious verbal definition but toward an approximation of the *sense* the abstract forms had in the past.

I also hope to demonstrate how the working of the stone—in all its abstract stoniness—and the thread—unfolding its implicit geometric models—has created structural paradigms that still resonate in the art of the Americas.

WORKING THE STONE
AND THE THREAD

MONUMENTAL STONE SCULPTURE IN THE ANDES

Beginning with rudimentary carvings on rocks in the surroundings of Cuzco, the peculiar and idiomatic monumental sculpture of the Incas reached its apogee during the Inca Pachakuti's program of construction coeval with the territorial expansion.

This vast mobilization of resources was made possible primarily by massive agricultural surpluses—resulting from more sophisticated farming techniques—which permitted the Incas to maintain not only an army but also a large contingent of builders, masons, and sculptors. A similar combination of circumstances must have preceded the building of the ceremonial centers of Chavín de Huantar and Tiwanaku, both the material symbols of cultures which, like the Inca, reached indisputable preeminence in the Andes.

Archaeological evidence has demonstrated that in the history of Andean societies periods occurred in which a high degree of cultural homogenization radiated out over wide areas from what seem to have been unifying centers. These moments have been called "pan-Andean periods," or, more commonly, "cultural horizons." Unlike "pre-classical," "classical," and "post-classical," the labels from Greco-Roman antiquity that are applied to Mesoamerican periods and almost inevitably connote a judgment as to quality, "cultural horizon" is a neutral denomination that allows a temporal segment to be individualized, though, in any case, it will be determined on the basis of diffusion of iconographic patterns that are characteristic of a dominant culture. The series of horizons, in turn, is preceded by and interspersed with periods of regional cultural development. According to John Howland Rowe's hypothesis (1962), which is generally accepted

today, the complete sequence should be: Initial Period (itself preceded by the Pre-Ceramic Period), Early Horizon, Early Intermediate Period, Middle Horizon, Late Intermediate Period, and Late Horizon. The Early Horizon and Middle Horizon were defined basically by the dissemination of the iconographic characteristics of the sculpture associated with the ceremonial centers of Chavín de Huantar and Tiwanaku, respectively. The expansion of the Inca state—the largest unified area in ancient America—determined the patterns of the Late Horizon; in it, tectonic sculptural forms are only a partial aspect of a cultural imprint defined by an overwhelming insistence on aniconic signifiers, which marked a sharp stylistic difference from the preceding periods.

Given the absence of writing, it seems inarguable that in the context of pre-Hispanic art "iconography" and "style" are the graphic condensation—the visual signifiers—of basic cultural codes. The diffusion of the Chavín style seems to have been in the ascendance of a primarily religious visual semantics: a "catechization" apparently achieved by peaceful means. On the other hand, after a minimal reformulation in the center of Wari in the southern highlands of Peru, the diffusion of Tiwanaku iconographic traits appears to have been the result of a bellicose imperial expansion; on the basis of archaeological evidence, this period has been identified as the "Wari-Tiwanaku empire."

The power centers of the three "pan-Andean" periods were all in the highlands of the Andes, where the mountains create an impressive natural frame. In this environment, the need to create a material symbol, to make the abundant stone expressive, must have been what motivated the appearance of sculptural techniques, though in their forgotten beginnings such ambitions were realized in a modest way. The existence of a monumental sculpture presupposes technical development on a larger scale.

I am not trying to suggest that lithic sculpture can exist only in a mountainous region like the Andes, since examples proving the opposite are abundant. But the powerful, intrinsic meaning stone possessed in the Andean cultures had a particularly decisive influence on the formation of the Inca sculptural vocabulary, so different from the stonework of Chavín or Tiwanaku. Despite the formal differences, the iconography of those cultures is much more analogous to that of ancient Mexican sculpture. In Chavín, a tracery of intricate reliefs prevails (Figs. 2, 3, and 4); the stone is a flat surface on which complex visual metaphors are spelled out. This tradition continues in Tiwanaku, in forms which are perhaps less elliptical, but which reaffirm their *plectogenic* nature—that is to say, their nature as images first developed in textiles, something peculiar to the Andean world and without parallels in Mesoamerica.

Though the archaeological evidence is incomplete, especially in the case of Chavín, the capital importance textiles had, and still have, in the Andes suggests that the flat, synthetic, lithic iconography of these cultures first evolved in the reductive, geometrizing matrix of the textile medium (see Chapter 7). It is thought provoking to note that, despite the undeniable technical capacity of the sculptors of Chavín and Tiwanaku, they only very rarely shaped their sculptures "in the round." The monoliths of Tiwanaku (Plate 3), despite their prismatic, "columnar" configuration (so reminiscent of the Toltec "Atlantes" of Tula, in Mexico) are entirely covered by filigreed reliefs that reproduce textile designs.

In contrast, the vigorous *stoniness* of Aztec sculpture—the adjective was used by Henry Moore, whose work was decisively influenced by the sculpture of ancient Mexico (see Braun, 1989, 1993)—took the form of an intimidating iconography that is markedly volumetric: the fascination it still exerts today, an enchantment in which admiration and repulsion, perplexity and horror, are mingled, is the best evidence of its communicative potency. In Inca sculpture, which is contemporary to Aztec sculpture, something happens that differs radically from all other sculpture of ancient America: the stone appears to represent itself. This is a very different concept. It could be said, paraphrasing Octavio Paz, that the stone, divested of all iconographic aims, extracts its own essential juices.

My interest here is in monumental works that had a ceremonial function and were frequently associated with the architecture of temples and sanctuaries as manifestations of dominant and highly institutionalized religions. This interest must define the limits of my examination of the antecedents of Andean lithic sculpture. The symbiotic relationship of the monumental stoneworks to Inca architecture confers on them a transcendence that largely surpasses the votive significance of the figurative miniatures in stone or metal that until now have routinely been considered the only form of "Inca sculpture."

Cerro Sechín

The incised slabs in the ceremonial center of Cerro Sechín can be considered the oldest evidence of monumental sculpture in the central Andes. Nevertheless, the age of the Cerro Sechín Temple was long debated because its relation to Chavín culture, with which it has a certain stylistic kinship, remained unclarified. Kubler considered Cerro Sechín to be earlier than Chavín (1975, 250), but other authors, among them Lathrap, considered the carved slabs to be the receptors—"a rustic version," Lathrap writes (1968, 74)—of Chavín influence.

Recent excavations have dated Cerro Sechín toward the end of the Initial Period, making it the only known exception to the general absence of monumental stone sculpture prior to the form's proliferation in the center of Chavín de Huantar (see Samaniego, Vergara, and Bischof, 1985). The archaeological site of Cerro Sechín was discovered by Julio C. Tello in 1937, after his exploration of the impressive ruins of the ceremonial center of Chavín de Huantar. This fact (along with the discovery of other sites later established as originating much earlier than the Chavín culture) long influenced the interpretation of the entire early era; at Tello's suggestion, Chavín was perceived as a cultural matrix.

Cerro Sechín is a granite hill that rises in the lower valley of Casma at the meeting point of the Sechín and Moxeque Rivers. Apparently, the peoples who built the ceremonial center also lived on the barren slopes of the hills in order to preserve the arable soil of the alluvial flatlands. The temple consists of platforms and the remains of conical adobe walls, which indicate a construction process carried out in various phases. The walls were plastered, and traces of a painting representing a jaguar still exist.

The carved slabs, in rude polygonal forms or elongated rectangles, and varying in height between thirteen and one-half and four and one-half feet, are vertically included in the frontal wall, constructed in stone, using the

FIGURE I
Incised slab, ceremonial center, Cerro Sechín. (Ink drawing by the author.)

post-and-infill system. The images are depicted by carved lines, a concept reminiscent of the "Danzantes" of Monte Albán, though the stylistic differences are obvious: while the Olmecoid figures of Monte Alban are clearly related to natural forms, the figures of Cerro Sechín are schematic and subangular, having no well-defined right or acute angles. Their manifestly ideogrammatic meaning alludes directly to feats of war, or perhaps more precisely, to ritual sacrifices that may have been the consequences of a military victory. Most of these representations are legible: warriors, priests, mutilated bodies (Fig. 1), entrails, and heads separated from bodies. One of the slabs represents a pile of "trophy heads," which looks like an abridged version of the Tzompantli ("place of the skulls") in the Maya-Toltec ruins of Chichén Itzá. On others, the design becomes ciphered, ambiguous (does it represent vertebrae? a string of eyeballs?), and, at times, frankly abstract. These last examples are scarce, and in this very literal and descriptive context, they seem to be disconcerting intrusions.

In fact, very few Chavinoid stylistic traits can be found in the lithic iconography of Cerro Sechín: only the eye with an eccentric (off-center) pupil (which, in fact, is common in several forms of pre-Hispanic art) and the distended mouth with lips depicted in a continuous band. The terrifying fang, the ornithomorphic configurations, the hand-claws of the bird of prey, the serpent capillaries—the whole alphabet of the metaphoric language that has enabled archaeologists to trace the Chavín influence through the vast territories into which it expanded—are absent. This language is decidedly foreign to the prevailing literality of the Cerro Sechín slabs.

Chavín de Huantar

The golden age of the society that built the ceremonial center of Chavín de Huantar probably took place between 800 and 200 B.C. The ruins of this center are located on the eastern flanks of Peru's highest mountains, on the left bank of the river Mosna, a tributary of the Marañón in the Amazon basin. The fundamental characteristics of the fascinating and complex imagery of the lithic sculpture associated with this center—friezes, stelae, and columns carved with bas-reliefs—can be found in textiles and painted fabrics, ceramics, and small carvings made of stone, bone, or conch found in various parts of Peru. A vast geographic dispersion—from the valley of Jequetepeque on the northern coast, across the central sierra, to the valley of Ica, on the southern coast—is the determinative characteristic of the first pan-Andean cultural era, which we know as the Early Horizon.

The site was visited in the 1860s by the Italian scientist Antonio Raimondi, who brought to Lima the sculptural piece known today by his name. In 1919, the eminent Peruvian archaeologist Julio C. Tello initiated intense excavations and studies that, in his view, would determine the influence of Chavín on the early cultures of ancient Peru. As already mentioned, for many decades Chavín was considered the "mother culture" of ancient Peru. The chronological order of its discovery, as well as its undoubted importance—indicated by the magnitude of the remains of the temple and the monumental sculpture found in the center at Huantar— obscured the assessment of other archaeological sites that were thought at

first to have derived from or been associated with Chavín. However, today it is known that on the central coast, at sites such as Río Seco or El Aspero, pyramidal constructions were already being undertaken between 3000 and 2500 B.C. —before the arrival of ceramics. The antiquity of this ceremonial architecture, which in fact is contemporary with the first Egyptian pyramids, indicates that the appearance of a complex social structure on the South American continent is much more ancient than was previously established by the scientific community. The evolutionary process accelerated during the Initial Period, which is marked by the reception of ceramic technique, new developments in irrigation systems, and a consequent increase in food production and thus an increase in population. The ceremonial constructions proliferated, extending into the highlands, while certain patterns common to all this architecture began to take shape: the pyramidal volumes are organized in a U-shaped plan, to which are added sunken pits or plazas. These data seem to indicate regional religious beliefs that were common to all of these societies.

A more elaborate form of stonemasonry appears in La Galgada, a site in the highlands whose initial settlement has been dated in the late Pre-Ceramic Period (2400 B.C.) and whose construction occurred in phases extending over five centuries until the early Initial Period. The patterns in which the blocks are arranged in some of the exterior walls have a striking similarity to those in the walls of the Chavín de Huantar temples (see Grieder and Mendoza 1985, 93–109). Dating from a somewhat later period, the remains of the architectonic complex on the site of Sechín Alto (perhaps a distant antecedent of the Temple of Cerro Sechín in the valley of the Casma) indicate that the complex extended over three hundred to four hundred hectares, which makes it the largest pre-Columbian monument in South America. In some sites, such as Huaca de los Reyes or Garagay, the remains of plastered and painted clay friezes in high relief are associated with this type of ceremonial architecture and exhibit an iconography that clearly foreshadows the appearance of Chavín art. This hypothesis is further supported by a frieze displaying three-foot fangs that was discovered at the site of Cardal, in the same area as Sechín Alto.

Our improved understanding of the initial stages of ancient Peruvian cultures—schematically delineated here—has meant that today Chavín culture is viewed more as a process of consolidation and synthesis of all the regional developments that preceded it than as a progenitor culture. In other words, though the Early Horizon does appear to be marked by the pan-Andean diffusion of a Chavín cult, many elements of this cult, such as forms of ceremonial architecture and certain symbols and ritual artifacts, were already present long before the construction of the temple of Chavín de Huantar.

In his exhaustive 1962 study, John Howland Rowe stated that in Chavín de Huantar the construction of the temples and of the lithic monuments belongs to different historical phases, but this fact did not affect the vigorous stylistic cohesion of the center. To delineate the evolutionary sequence—though not the precise age—of the sculpture, Rowe studied the Chavín influence on an external series: the diverse phases of a long ceramic sequence of the Paracas culture, found in a section of the valley of Ica called Ocucaje (see Menzel, Rowe, and Dawson 1964). Moreover, at Chavín de Huantar itself, Rowe found evidence relating the

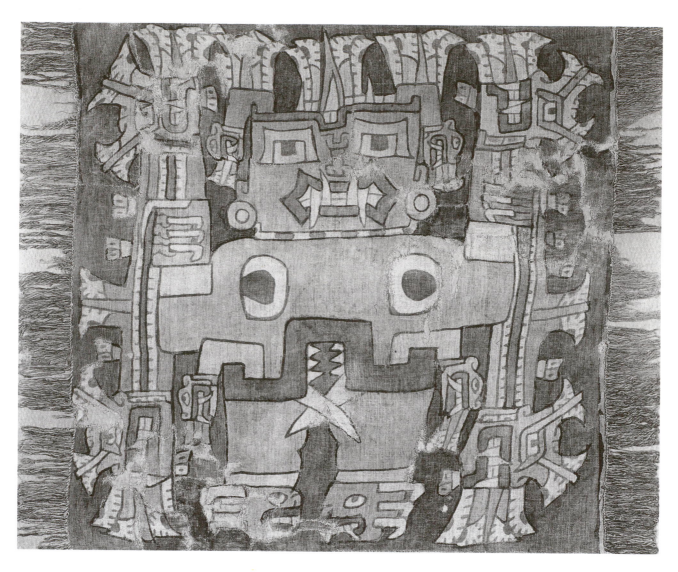

PLATE I
Female deity with staves, painting on cloth, Chavín culture, Karwa, South Coast, Peru. (Photo by Ken Cohen; courtesy of Merrin Gallery, New York.)

sculptures to the various phases of the temple—a difficult task indeed, since looting and vandalism had left few of the monuments in their original places.

The architectonic remains of the temple are organized in rectangular structures built of compact masonry. They are elevated on pyramidal platforms apparently destined to be the bases of the shrines located in the upper part. The interior is traversed by a network of corridors faced with stone slabs, a concept "unique among the groups of temples in ancient America," according to Kubler (1975, 254). The remains of plaster with traces of red and yellow paint, as well as the painted plaster relief Tello and Rowe observed in these galleries, appear to be tenuous remnants of a vanished mural art. Tello assumed its existence without further evidence. But the more revealing evidence of fabrics found on the southern coast, which were painted with an unmistakable Chavin iconography (Plate 1), corroborates the notion that a pictorial art, whether mural or on cloth, may have reached a far higher level of development in Chavín de Huantar than the paltry mural remains would lead us to believe. Even if the fabrics were painted in Karwa, where they were found, they must have followed models taken from the ceremonial center in the mountains.[1]

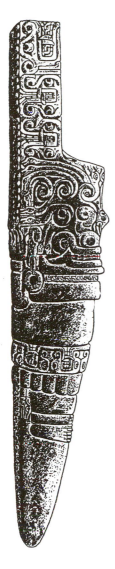

Lanzón, Chavín culture.
(Ink drawing by the author.)

The labyrinthine network of interior passageways appears to culminate in a cruciform gallery, at the center of which appears the so-called Lanzón (Fig. 2), a prism almost fifteen feet high in the form of a spearhead or, more accurately, an enormous fang. Carved in bas-relief, this sculpture alludes to an anthropomorphic deity with a wide feline mouth, large fangs, and a head that culminates in capillary-like "serpent scrolls."

The omnipresent feline mouth with all-powerful fangs, one of the defining traits of the iconography of the Chavín pantheon, is unmistakably "numinous." This term, according to Mircea Eliade (1959), defines the experience of *primordial* consciousness when confronted with the revelation of divine power: it is a feeling of terror before the sacred, before the overwhelming mysteries of the majesty of an oppressively superior power. The numinous—I will return to this expression more than once—is central in the formation of the religious patterns of ancient America. In this case, it indicates that the feline cult, whose tradition was widely diffused, was a fundamental factor in the evolution and expansive development of Chavín culture. It is odd, then, that no authors have noticed that the Lanzón has the form of a gigantic fang, a fang that would appear to accentuate its metaphorical meaning by sinking its sharp point into the ground as if into meat.

The Lanzón is one of the few objects of ancient devotion that remains in its original location. Rowe notes that "the scale of this great image," as he prefers to call it, "and its placement in a dark passageway, can still inspire a reverential fear in the incredulous visitor of our time" (1967, 75).

This large fang is considered, from a stylistic point of view, to be an early work, and its characteristics are seen as fundamental to the "Chavín style." Practically unmovable, immune from looting, its placement in the galleries of the original sector of the temple has determined this typification, since works of earlier periods were reused in successive expansions. Thus, for example, the tenon heads, whose characteristics situate them in the Lanzón period, appear embedded in walls that were built much later.

The original temple was U-shaped, open to the east, and embraced a circular sunken plaza; this, as we have seen, corresponds to the patterns of ceremonial architecture already developed during the Initial Period. The additions built onto the south wing in successive phases eventually were given a portal, the upper part of which features a cornice of carved slabs. The columns flanking the portal are also covered with bas-reliefs. The northern half of the portal was built in calcareous black stone, whereas the southern part was built in white granite. This Black and White Portal, as it is known, offers a definite context for determining that the figures associated with it belong to a late period. The constructions of the late phase are also complemented by a sunken plaza, quadrangular in shape, which is located to the east in front of the sector of the Black and White Portal. The plaza is surrounded by platforms and stairways that connect it with the temple.

The consistent orientation of all phases of the temple suggests the possibility that some form of sun worship was practiced in Chavín de Huantar. Associated with the religious beliefs of agricultural societies, the adoration of the sun was widespread in Egyptian, European, and American antiquity, as well as in parts of the Asiatic continent. After observing the appearance of mirrors made from jet in pre-Chavín periods, Chiaki

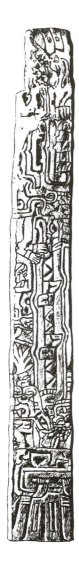

Kano (1979) notes that mirrors were linked to the worship of the sun in ancient China and Japan. In turn, Westheim points out that in the myth of the four worlds, or four suns (represented in the Aztec "Sun Stone"), the successive destruction of the worlds is the result of the struggle for absolute power between two divinities, Quetzalcóatl and Texcatlipoca. "Texcatlipoca created the first of the worlds and made himself Sun," writes Westheim (1985, 19). "He is also the god of the setting Sun" (1985, 105), roving and ubiquitous; "as he walked his smoking mirror revealed the thoughts and sins of men to him" (1986, 196). Westheim adds: "The concept of the jaguar god—which becomes Texcatlipoca in the central meseta—was born in the tropical jungle of the Gulf region. It is a favorite theme of the Olmecs: no other phenomena appealed as much to their religious and artistic fantasy" (1986, 254). This close relationship between the sun cult, the feline cult, and mirrors—a pattern that manifests itself in the formation of Chavín culture—reinforces the belief that the orientation of the buildings of Chavín de Huantar toward the east had a sacred character. Moreover, the alignment of temples in *accentuated* directions is too frequent an occurrence in ancient America to leave room for doubt.

Both the Tello Obelisk (Fig. 3) and the Raimondi Stela (Fig. 4)—perhaps the most famous artifacts of Chavín culture—are now in the National Museum of Anthropology and Archaeology in Lima. The obelisk already had been displaced from its original location when Tello found it. By analyzing its stylistic traits, Rowe attributes it to an early phase, though later than the great fang or Lanzón. The obelisk is a prism with four carved faces, which, like the Lanzón, demands to be seen from all sides and may have been destined for one of the open areas of the temple. The complex interweavings of the bas-reliefs allude to a caiman deity whose shape can only be perceived with some difficulty, given the additions and florescences that alter its natural organicism. As we will see, this method of recombining natural data is central to Chavín art. Nevertheless, the baroque exuberance of the Tello Obelisk makes it an odd work, almost atypical within the sequence attributable to the Chavín de Huantar center.

The so-called Raimondi Stela also comes from the ruins of the temple, but no indication of its original location remains; its eponymous discoverer located it in a house near Chavín in 1867. It is a slab seventy-eight inches in height and twenty-nine inches wide, carved in bas-relief on one side only, which indicates that it must have been embedded in a wall. Much more legible than the Tello Obelisk, the Raimondi Stela describes a human figure, viewed from the front, with a feline mouth, pronounced fangs, and hands with bird-of-prey claws that are holding staffs. It is known as the "Staff God," a concept whose essential traits will reappear in the theogony of the Middle Horizon.

The human form occupies only the lower third of the stela. From the head rises a succession of scrolls, snakes, eyes with eccentric pupils, and fang-daggers, which some authors think is a headdress or an emblematic cap. Kauffman Doig (1976, 107) suggests that the sculptor wanted this headdress, which normally would have been invisible from the front, to be projected conspicuously upward—a decidedly Cubist conception of space, I would add, since I am inclined to accept this interpretation.

The Raimondi Stela is paradigmatic: worked in planar carvings, the natural forms are reduced to geometrical notations, straight lines, curves,

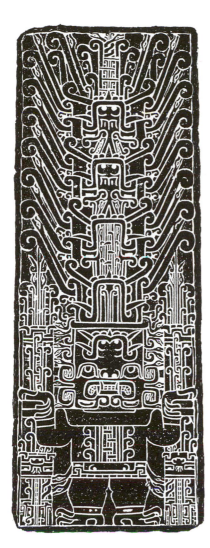

FIGURE 4
Raimondi Stela, Chavín culture.
Museo Nacional de Antropología y
Arqueología, Lima. (Ink drawing
by the author in the manner of a
rubbing.)

and scrolls. It is a summation of late Chavín sculpture and represents the culmination of the series of works originating from Chavín de Huantar.

We have already observed that the recombination of natural data is central to Chavín art and therefore to formulation of the visual signs of its theology. The definitive traits of a human figure or of a bird of prey (an eagle) generally provide the basic form of the icons we know; but added to this basic form are the organic attributes of jaguars—the formidable fang—and of serpents, which results in complex and indissoluble visual metaphors for deities or mythical beings.

In "Form and Meaning in Chavín Art," Rowe expends a great deal of effort taking apart the Chavín visual syntax in order to identify the natural forms represented in it. He firmly believes that Chavín art is representational and that its details are obscured by its metaphorical figurations. According to Rowe, these metaphors are more understandable in a literary context: what we have is the practice of "comparison by substitution" (1967, 78), in which, for example, "nest of serpents" would imply "hair." This artifice, called "kenning," was typical of Old Norse court poetry and required a previously shared code in order for the listener to understand the allusions. Here we find one basic, plausible suggestion: that the configurations of deities and important mythical beings are those that require the most elaborate "kennings."

But to participate in deconstruction of the metaphors in order to identify a jaguar mouth, a harpy eagle, an anaconda snake, or a caiman, discarding all abstract artifices as mere decorations—in other words, to affirm that the ultimate meaning of Chavín art is to represent natural forms—is to accept the immediate impoverishment of its fabulous imagery.[2] Obviously, Rowe's perception is that of the classical West, in which it is imperative to recognize the represented form because, from the time of Greek statuary to its dissolution of form in the Impressionist color mist, the translation of a natural, recognizable fact constituted the very definition of art.

The interpretation proposed by Rowe thus suffers from a hermeneutic error: it evades the cultural presuppositions of Chavín art in order to introduce Western parameters, forgetting that in the art of ancient America the notion of the "decorative" did not exist, and therefore we cannot fail to take the "abstract artifices" of Chavín iconography into consideration. In fact, if *any* of the parts of the intricate metaphorical assemblage is left out, the icon ceases to "function" expressively. Like an organism, it requires the proper functioning of all its components. What matters is the whole, the totality: a man with a jaguar mouth, the obsessive repetition of fangs, hands-feet-claws of birds of prey, hair that is either geometrical scrolls or serpents, and so on.

We no longer have access to the cultural codes that would make a reading of these ancient metaphors possible. We can, nevertheless, affirm that the raison d'etre of this laborious iconography was, in some cases, to inspire a devout response, in others to condense mythical stories into a visual form.

The art of Chavín was, above all else, a religious art. In this sense, it corresponds to Romanesque painting, for example, in which the religious reverberation animating the figures is more important than the correct representation of natural appearances. In African tribal sculpture—another

FIGURE 5
Bowl with variation of the head of the Ofrendas monster. Drawing by Félix Caycho Q., from "Towards a Re-evaluation of Chavín" by Luis G. Lumbreras, in Conference on Chavín, *Dumbarton Oaks, 1971, Fig. 20, p. 20. Reprinted by permission of the publisher.*

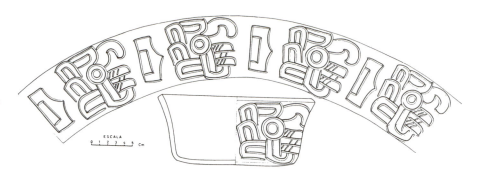

FIGURE 6
Bowl with Ofrendas monster. Drawing by Félix Caycho Q., from "Towards a Re-evaluation of Chavín" by Luis G. Lumbreras, in Conference on Chavín, *Dumbarton Oaks, 1971, Fig. 21, p. 20. Reprinted by permission of the publisher.*

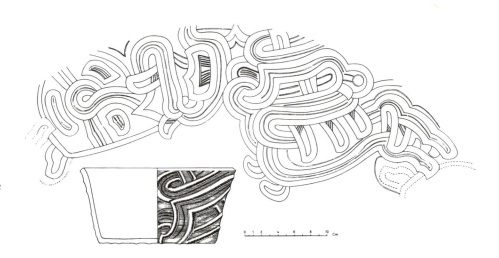

art that is permeated with religiosity—the dominant need to configure a spiritual tension leaves the faithful translation of natural forms aside. This art, as is well known, had a notable influence on the gestation of Picasso and Braque's Cubism, which, in turn, is the point of departure toward geometric abstraction in the twentieth century.

The development of an artistic language of reductive geometric forms has enriched contemporary perception in such a way that, though the literal meaning of Chavín art continues to elude us, it is now possible to appreciate this art—and, indeed, all pre-Hispanic art—in a new way. By accepting the indissoluble reality of these metaphorical images, we can discern that the permutations and recombinations of natural forms, like the geometrical reductions to which they were subjected, served the purpose of *distilling and intensifying* religious or mythical symbolic meanings.

This process of intensification by exclusion can be observed with greater clarity in ceramics. For many years it was believed that Rafael Larco Hoyle had discovered Chavín ceramics, which he called "Cupisnique," in the valley of Chicama, on the northern coast. But the excavations of Luis G. Lumbreras and Hernán Amat at Chavín de Huantar itself have determined that Cupisnique is a regional variation of the ceramics they found in the sanctuary there (see Lumbreras 1971). The constitutive traits of these ceramics define what today is considered the "Chavín ceramic style."

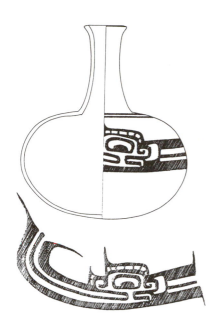

FIGURE 7
Mosna bichrome bottle. Drawing by Félix Caycho Q., from "Towards a Re-evaluation of Chavín" by Luis G. Lumbreras, in Conference on Chavín, *Dumbarton Oaks, 1971, Fig. 26, p. 25. Reprinted by permission of the publisher.*

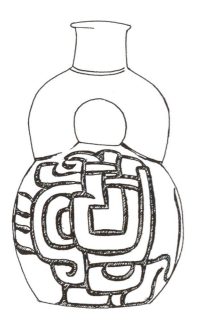

FIGURE 8
Stirrup bottle, Tembladera, Jequetequepe valley, Chavín culture. (Ink drawing by the author.)

These fundamental characteristics have, in general, a close relationship to the sculptural iconography, in the sense that, despite their metaphorical complexity, the generic forms of the icons are recognizable (anthropomorphic or ornithomorphic beings, and so on).

Nevertheless, in certain of the examples called "Offerings" (because they were found in the temple's Gallery of the Offerings), more abstract designs can be seen (Figs. 5, 6, and the bichrome bottle of Mosna in Fig. 7). The designs are the result of an abstraction and synthesis of the natural data, which must have been considered to have *greater symbolic power*. We don't know exactly how the diffusion of the Chavín religious symbols was carried out, but it is certain that in the regions affected by this diffusion, many of the ceramic artifacts appear to register reception of these religious principles in ciphered, abstract form, as if in code. I refer to examples of Tembladera, in the valley of Jequetepeque, or Congoyape, but especially to Cupisnique (Fig. 8). Certain vases with designs that are incised or in high relief appear to be the supreme version of these abstractive processes that recover the essential forms. In many cases, these designs appear to have a decided glyphic function, brief notations that refer to a greater textuality (see plates in Lavalle and Lang 1981, on pp. 61–63, 67, 68, 73, 89, 94, 122 left, 123, 125).[3]

However, in the final analysis, this reductive method originates, as I mentioned earlier, in the textile coordinates of warp and weft. Conklin observed that "during the successive phases of Chavín, textiles become increasingly important. The gradual change in sculptural styles towards bidimensional surfaces may well reflect the growing importance of textile design" (1972, 18). But beyond the tendency toward this reductivist bidimensionality, the other iconographic conventions—symmetrical dualities, repetitions, composition in horizontal modular registers—are structural procedures easily recognizable as having been derived from textiles. These characteristics are observable even in the early phases of Chavín, but they were probably accentuated as the textile media grew in technological sophistication as a result of the inventions of the Chavín artists. Thus textiles assumed an ascendancy over other artistic media that would last, to a greater or lesser degree, throughout Andean history (see Conklin 1978).

Geometrizing abstraction is more apparent in certain aspects, as, for example, in the headdress of the Raimondi Stela's Staff God. Fangs, eyes with eccentric pupils, the S-shaped motif, scrolls, snakes, all intricately related among themselves, did not configure any recognizable entity. Vertically structured, they are, one might say, a stela within a stela. But there is something more: if the figure is inverted, the possibility of reading it from above emerges, meaning that it is an anamorphic image. This further indicates a textile influence, since textiles are a medium in which images with multidirectional readings are frequently generated. Moreover, this characteristic accentuates the enigma of the meaning and nature of the original placement of the stela—was it meant, literally or metaphorically, to be seen from above?

In the final analysis, all of the diverse iconic formulations are dominated by rigid conventions. This has been noticed, though not without disagreement, by authors who try to restore the "individual sensibility" of the artist, forgetting that in ancient cultures "the consciousness of individual-

ity, even that of the artist, is much less accentuated than in the modern West" (Nodelman 1970, 91). Though, in the Western tradition, the name of the classical Greek sculptor Phidias and the identities of some medieval cathedral architects are known, it is perhaps with Michelangelo that the glorification of artistic genius as the supreme culmination of the individual sensibility begins. But, here again, the history of Western art should not be permitted to interfere with a clear appreciation of pre-Hispanic art.

Neither is it beneficial to distinguish, as Burger does, between "style" and "content." To explain the formation of the Chavín artistic vocabulary, he uses examples from the Old World. The artistic styles of Judaism, Christianity, and Islam were taken from traditions already well established by the time the religions emerged, which made the understanding and diffusion of those religious traditions viable (Burger 1988, 105). But Burger forgets that the orthodoxy of those religious doctrines was codified in writing, and, therefore, the artistic style that represented them was instrumental in indoctrination but was in no case crucial with respect to doctrine. In this respect, Christianity's adoption of the representational forms of Greco-Roman art—a long-established tradition but one that was philosophically opposed to Christian doctrine—is very illustrative.

The example above differs substantially from the Andean phenomenon: not only were there no "scriptures," but it is impossible to say whether a doctrinal corpus in the Old World sense—even an oral one—existed, from which we could determine in what measure the "Chavín style" came to differ from a "Chavín content," or orthodoxy. Even if such a doctrine did exist, today it is irretrievably lost to scholars. The use of the Western concept of "style"—a formal appearance that can be distinguished from "content"—can lead to dangerous confusion in the context of pre-Columbian art, unless its use presupposes, as I explained earlier, that "style" and "iconography" are the visual signifiers of basic cultural codes. In other words, that style and iconography are, simultaneously, *art* and *text,* traits that perhaps provide the best foundation for an approximate reconstruction of Andean cultural history.

The high degree of conventionalization in Andean art seems to reach its apex during the periods in which the unification of vast territories and diverse peoples was undertaken, either through the religious indoctrination of Chavín or by the bellicose expansion of Wari-Tiwanaku or of the Incas. These conventional forms, which radiated from the centers of power, were certainly the unfolding of a system of signs. As Alana Cordy-Collins notes, fabrics painted with Chavín icons "were used from Chavín de Huantar to transfer ideas, especially religious ideas, to remote areas of Peru, thus serving as a kind of catechism" (1982, 360). If this function of art—to transmit basic cultural information—was connatural in societies that lacked writing, the systematic codification of forms appears to reach an extreme when a dominant culture urgently needs to facilitate the diffusion and imposition of its codes.[4]

Tiwanaku

Tiwanaku or Tiahuanaco is a name of ancient and enigmatic origin, as well as imprecise translation, which designates the ruins of a habitational and ceremonial center located to the south of Lake Titicaca in the Bolivian

highlands.[5] It already had been abandoned by the time the Inca Pachakuti conquered the region around the mid-fifteenth century, and it made a lasting impression on Cieza de León, who admired "the large structures it has, which are certainly something notable and to be seen" ([1553] n.d., 456). In the nineteenth century it was visited by Ephraim G. Squier, who called Tiwanaku's "Wall of Balconies" the "American Stonehenge" (1877, 277).

On the basis of the principal studies (Stübel and Uhle in 1892; Wendell C. Bennett in 1934; Posnansky in 1945 and 1958; and Ponce Sanginés in 1972), it can be established that the site's "classic" splendor is posterior to the fourth century A.D., the period in which its most famous sculptural works must be dated.

Most authorities date the beginning of the Middle Horizon around the ninth century, which is when the archaeological record of Ayacucho and Wari (or Huari) appears in the Peruvian southern highlands—a ceremonial ceramics of great importance, painted with images derived from the sculptural iconography of Tiwanaku. These cultural codes are diffused widely over a vast territory until approximately the twelfth century.

The remains of buildings found in Wari also have been related to the architecture of Tiwanaku because of the quality of their stonemasonry. But a consensus there still does not exist on how the cultural models of the highlands reached Wari. Dorothy Menzel believes it was the work of missionaries (1978, 146), while other scholars suggest the hypothesis of military conquest. It is certain that, at least until the ninth century, the expansion (perhaps due to religious or military imperialism) of this cultural movement continues, the center of which must be located in Wari, as mentioned above. It also has been speculated that even during the expansive phase, the ceremonial center in the highlands continued to be a religious metropolis, but the cause of its final decline is one of the various enigmas in the history of this site.

Five centuries of destruction and looting have left us with a spectral image of the original appearance of the ceremonial center of Tiwanaku. All of the proposed reconstructions have been criticized, sometimes acerbically; Gasparini and Margolies call the restorations carried out on the Wall of Balconies and the gateway to the enclosure of Kalasasaya "unscrupulous" (1980, 17). The superb quality of the stonework, which still can be admired today in what remains of the walls or in the painstaking finish of the blocks abandoned in the area of Puma Punku, has sufficed to excite the imagination of visitors to the site. Thus, a technological and even stylistic influence on Inca stonework has been suggested (a subject I will discuss later).

A long tradition of lithic sculpture flourished from approximately 500 B.C. in the basin of Lake Titicaca. Few examples have survived: Rowe writes that in 1894 certain Tiwanaku statues were used as targets for the Bolivian army's rifle practice (1978, 126). It is almost miraculous that any of the sculptures have survived.

Kubler, taking into account lithic sculpture and ceramics, considers that a "highland style" existed, of which Pucará would be the earliest phase characteristic of the northern basin of Titicaca, and Tiwanaku proper would represent the latest phase that flourished in the southern region (1975, 341).

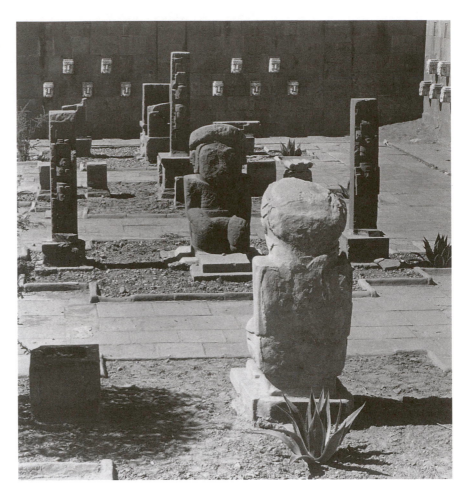

Pucará is a site located to the northeast of Lake Titicaca, in Peruvian territory; it was excavated by Alfred Kidder in 1939. His findings included architectonic remains of considerable dimension, but the ceramic fragments and the sculpture he found have contributed particularly to establishing the filiation of the "Pucará style," which goes back to the sixth century B.C. In general, this sculpture represents generous human forms resolved in rounded planes (Plate 2, center), which obviously differ from the "columnar" monoliths with fine bas-relief incisions (Plate 3) that appear later in Tiwanaku. Two colossal statues of kneeling figures, located in the courtyard of the church in the colonial town in Tiwanaku, must also be considered "Pucará," like others found in the towns of Wancani and Pokotia to the south of Tiwanaku.

Also attributed to Pucará is a stela covered with bas-relief carvings of an unmistakable abstract geometric conception, though certain zoomorphic characters are discernible. Sergio J. Chávez (1982) has recounted the story of this sculpture, known as the Arapa Rayo, which consists of two fragments that were found on opposite sides of Lake Titicaca (Fig. 9). Though the subangular forms of the aforementioned figurative statues cannot be said to belong to a naturalist style, such a sharp discrepancy exists between them and the abstract language of the Arapa Rayo, that it is intriguing to attribute the latter to Pucará. In any case, the Arapa Rayo stela could represent a decidedly glyphic example, which appears to be analogous to other works described by Kubler (1975, 316) that were also

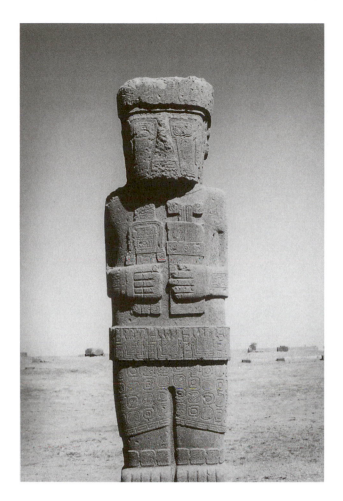

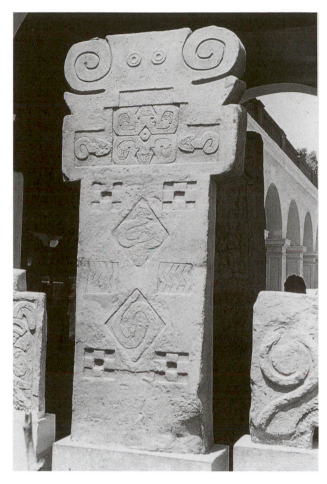

found in Wancani, and, of course, to the stela of the Pucará plaza (Plate 4), though on that stela the animal forms are clearly legible.

Each of the carved faces of the Arapa Rayo is divided into five panels or modules: the designs are repeated on both faces, but the order of reading is inverted—those that were above move below and vice versa. Something similar to this system of inversion is found in Wari-Tiwanaku textiles, which were not developed until centuries later but which, in the final analysis, belong to the same highland tradition (Plate 126). The structure and abstract flatness of the Arapa-Rayo stela's (glyphic) designs are therefore an early example of a sculptural conception indebted to the textile medium. In fact, this influence appears to become even more conspicuous in the late phase of classic Tiwanaku sculpture.

The frieze in high relief on the frontal face of the Gate of the Sun (Plate 5) in the ceremonial center of Tiwanaku is the first notable example: it represents a central deity surrounded on both sides by rows of figures, often called "attendant angels" (Fig. 39). The arrangement of ordered sequences of repeated units, organized along an axial symmetry extending from the central deity, gives the frieze a marked resemblance to a wall hanging (cf. Isbell 1988, 179).

In addition to the frieze on the Gate of the Sun, the monoliths and tenon heads (Plate 6) are also attributed to this period. Though the present placement of the tenon heads is entirely arbitrary (I have already mentioned that the reconstruction of the Kalasasaya precinct has been criti-

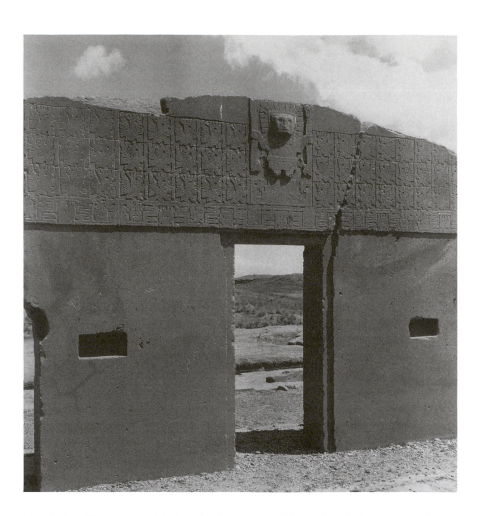

cized), it still can be said that the insertion of those heads into the walls represented a sort of wall relief that could, like the frieze on the Gate of the Sun, ultimately be associated with the textile influence. On the other hand, Kubler publishes examples that typify, according to him, a brief period prior to the so-called "classic period," including a curious vertical relief in the manner of a stela, with duplicated human figures one of which is inverted (1975, Plate 179B; see Plate 2, to the sides of the kneeling figure and the background). They apparently carried staffs in both hands, but these have been destroyed. The design suggests that they may have been used as slabs in a ceiling, to be contemplated from below and from different positions. But it is also apparent that the process of symmetrical inversion—as occurs in a mirror—emerges from textiles.

However, it is in the monolithic sculptures known as "Bennett" and "Ponce" (Plate 3) that the textile influence becomes even more obvious: the human features, treated as reliefs, hardly alter the prismatic, columnar configuration; most importantly, the idols are incised with fine bas-reliefs that repeat certain of the motifs of the Gate of the Sun. The line, as subtle as it is intricate, indicates the possible use of metal tools, perhaps made of cold-tempered copper (Kubler 1975, 319). The designs have been seen as a vestment; Kubler signals that Tiwanaku art in general evokes textiles and basketwork (1975, 323). Bushnell agrees: "The flat relief carvings on statues and doorway may reasonably be supposed to have been derived from textile patterns" (1967, 185). Evidently these patterns are the

WORKING THE STONE AND THE THREAD

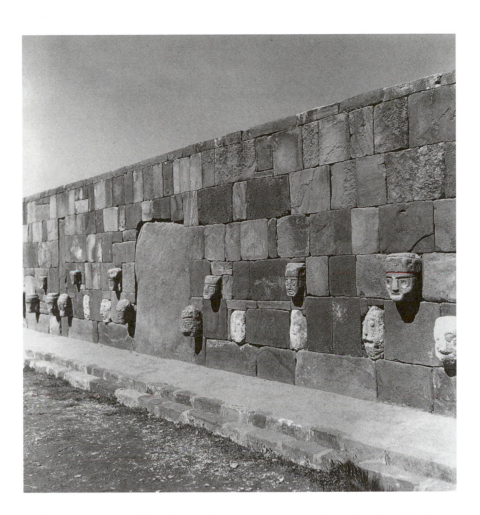

medium most suited for the development of an art determined mainly by semantic needs (see Introduction above).[6]

Excavations carried out at the beginning of the twentieth century (Kubler 1975, 322) revealed that both the architectonic remains and the statuary of Tiwanaku had been painted. This applied polychromy seems to be the logical extension of the coloristic gamut developed in the textiles with a coded meaning, which, in turn, was in manifest consonance with the semantic character of Tiwanaku art. Moreover, it can be observed that the stone, in both sculpture and architecture, had become a support, a material that needed to be "finished" with the application of color. Something similar happened with the sculpture of ancient Mexico and that of Greece. Thus, paradoxically, the cult of "honesty towards the materials"—the stoniness Henry Moore admired in Aztec sculpture, for example—is the result of an erroneous Western presumption: the "truth" of the stone could only be appreciated once the colors that covered it had dissolved away. The conclusion is obvious: the sculpture of the Incas, to which paint was never applied, was truly faithful to the stoniness of the stone.

In the frieze of the Gate of the Sun, the anthropomorphic "attendant angels" (which could also represent "heralds" or "couriers") are aligned in three rows on both sides of the central deity: they are in an attitude of march, in profile, and are also carrying staffs. In the upper and lower files, the figures have feline heads; in the central files they have the heads of birds of prey (see Plate 5 and Fig. 39 for details).

The central divinity is an anthropomorphic figure in a frontal pose, with unfolded arms clenching staffs. Serpentiform elongations radiate from the quadrangular head, some of which end in feline heads that are repeated in other parts of the composition. The lower extremes of the staffs are finished with bird-of-prey heads. We find ourselves, then, confronting another Staff God. Grounding his explication on myths of the colonial era, Max Uhle, whom Kubler follows (1975, 322), interpreted this divinity as a solar symbol, which may be the origin of the name by which the portal is designated today. Rowe, for his part, believes that this figure has the attributes of a deity of atmospheric phenomena, possibly lightning, and that it is not the sun, even less a supreme creator god (Rowe 1976), as others have wanted to see it. Jiménez Borja (1984, 21) observes that "whoever has lived in the Andean highlands, more than eleven thousand feet above sea level, has to agree that one of the most overwhelming experiences is a thunderstorm. The flashing zigzag of the lightning and the fearsome voice of the thunder is unforgettable"—a numinous event, I would add. A conceptual analogy with the Arapa Rayo stela, a product of the same tradition, might also be mentioned.

Despite the attributes given to this Staff God, his configuration appears to reformulate in its basic elements the Chavín icon of the Raimondi Stela. The tenon heads embedded in the walls of the sunken temple in front of the Kalasasaya of Tiwanaku also refer us to an identical Chavín sculptural conception; and a golden plaque of the same origin—which is in the collection of the Museo Larco Herrera in Lima and has been reproduced by Rowe (1962, Fig. 27)—shows, as in Tiwanaku, attendant angels surrounding an image of the Staff God. Though the ubiquitous and threatening Chavín fang does not appear in Tiwanaku, it reappears, summarily and with less emphasis, in mythical figures on Wari-Tiwanaku ceramics. Are we therefore confronting a renaissance of Chavín culture? This is a legitimate question; Chavín archetypes do indeed appear to have cast a long shadow over posterity. But the answer is problematic, since the period when Tiwanaku flourished is separated from Chavín by more than eight centuries and possibly as long as a thousand years, and no evidence has been found of a culture that would have mediated as a transmitter. Rowe carried out an extensive study (1968), but finally resigned himself to admitting that, despite the lack of traces, there was an uninterrupted tradition. Edward B. Dwyer, though, offers a suggestion: "I would guess that, beginning in the middle of the Early Horizon, a complex trading relationship between the South Coast and the highlands transmitted wool and weaving ideas to the coast. Perhaps the religious ideas went the other way; we can't tell" (1979, 74). We cannot eliminate the possibility that, for example, textiles painted with Chavín images may have reached the highlands, thus constituting the link that united the two cultures. Since the climatic conditions in the mountains are adverse for the preservation of textiles, we should not be surprised that the textiles have disappeared.

INCA STONEWORK

I touched the stones with my hands; I followed the undulating line, unpredictable as a river, along which the blocks of rock are joined. In the dark street, in the silence, the wall seemed alive, the jointure of the stones I had touched was burning the palms of my hands.

JOSÉ MARÍA ARGUEDAS,
Los ríos profundos

The incredibly precise fit of the blocks of Inca walls, which are joined without mortar or any type of bonding material, has fascinated generations of visitors and scholars since the time of the Spanish Conquest. "You can't even slip a piece of paper between the blocks" has been the reiterated observation, which, in truth, one cannot help repeating.

This fanatical precision becomes even more extravagant in the case of the "megalithic" walls of Saqsaywaman (Plates 34 and 35), built out of colossal blocks of irregular shape, each of which weighs several tons. But it is no less fascinating in the walls of Cuzco or Ollantaytambo (Plates 7 and 90), where the polygonal blocks appear to be molded to each other as if they were made of clay.

In the walls that did not have structural functions of retention—like those already mentioned—regular rows of rectangular blocks were used (Plate 8), as can be seen in the Qoricancha, or "Golden Enclosure," which was the principal Inca temple in Cuzco (Map 3, Plates 9–13), as well as in P'isaq (Plates 14–16) and in Machu Picchu (Plates 58 and 64). The high degree of perfection in the assemblage remains unchanged, but within this style a "rusticated" effect is generally accentuated: the faces of the blocks are rounded, and their jointures are countersunk and beveled.

Finally, for the lowlier buildings—common houses or agricultural terraces—dry-stone construction was used: smaller, uncut stones merely accumulated or joined with clay.

Between 1978 and 1979, the architect Santiago Agurto Calvo, commissioned by UNESCO and Peru's National Institute of Culture, carried out a survey of the Inca remains in the city of Cuzco. In the course of this task,

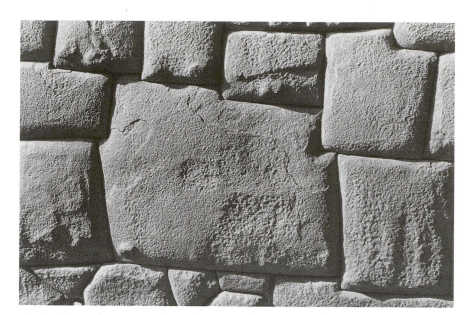

PLATE 7
Stone of the Twelve Angels, wall of the former palace of Inca Rocca (also known as Hatun Rumiyoc), Cuzco. Polygonal-style masonry. (Photo by the author.)

PLATE 8
Rectangular-style masonry, Cuzco. (Photo by the author.)

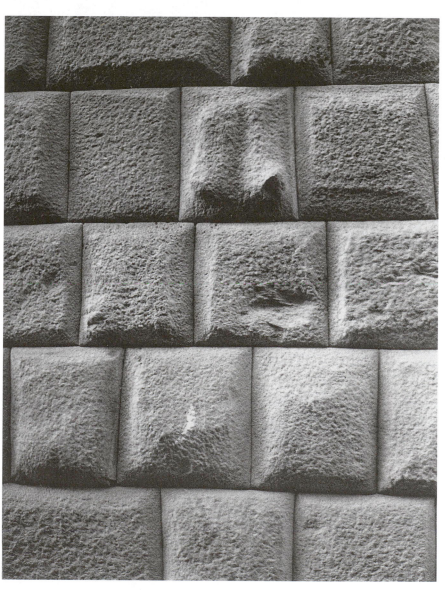

PLATE 9
View of the Circular Wall, remains of the Qoricancha Temple at the Church of Santo Domingo, Cuzco. (Photo by the author.)

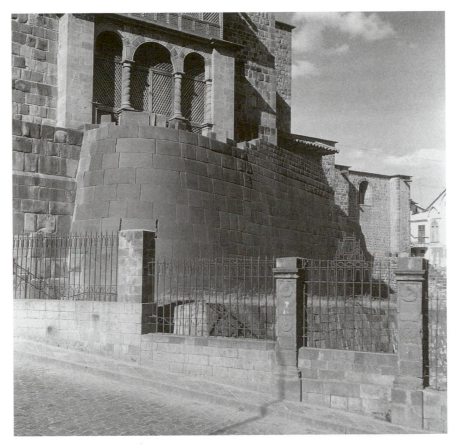

PLATE 10
Circular Wall, Qoricancha Temple, interior view. (Photo by the author.)

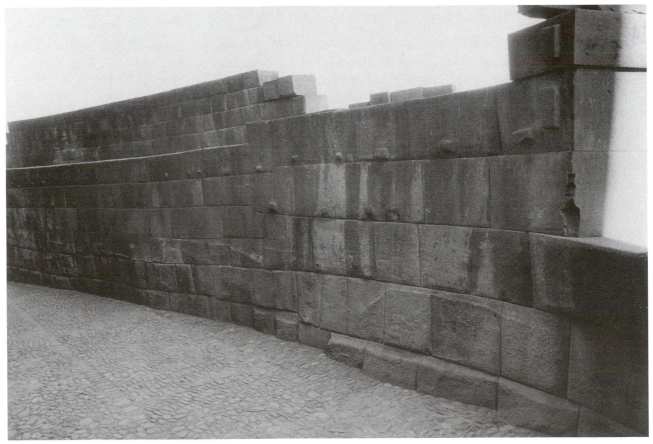

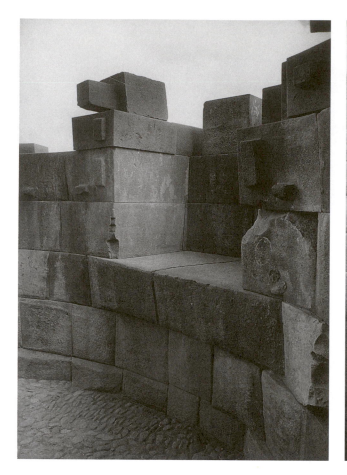

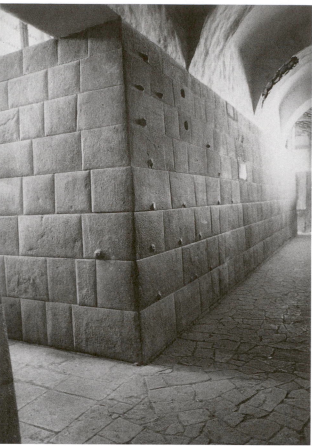

PLATE 11 (ABOVE, LEFT)
Niche, Circular Wall, Qoricancha Temple. (Photo by the author.)

PLATE 12 (ABOVE, RIGHT)
Wall, Qoricancha Temple. (Photo by the author.)

he tried both to regularize the terminology and to set forth a basic typology of the Inca walls. But he succeeded in adding only one new category to those commonly recognized up until then:

1. "rustic" is the new denomination for the type of construction known as dry-stone;

2. "cellular" is a new category in which the components are ordered in a way that is similar to the disposition of cells in organic tissues; the stones are polygonal with rectilinear sides;

3. "fitted" is the more suitable name chosen for the type known until then as "polygonal"; "polygonal" is associated with irregular rectilinear forms when, in fact, the blocks often have curved edges that fit together like pieces of a puzzle;

4. the "cyclopean" type, which differs only quantitatively from the previous type; its components are also *"engastados"* or "fitted," though worked, as we know, on an extraordinarily huge scale;

5. finally, "sedimentary" is a new name for the type of construction commonly called "rectangular," a name I do not find particularly well suited to this type of construction. The predominantly geometric and regular character of this modality's rows of ashlar belies the presumed "natural" appearance of a sedimentary layer of geological strata, whose horizontality is not always constant (see Agurto Calvo 1987, 144).

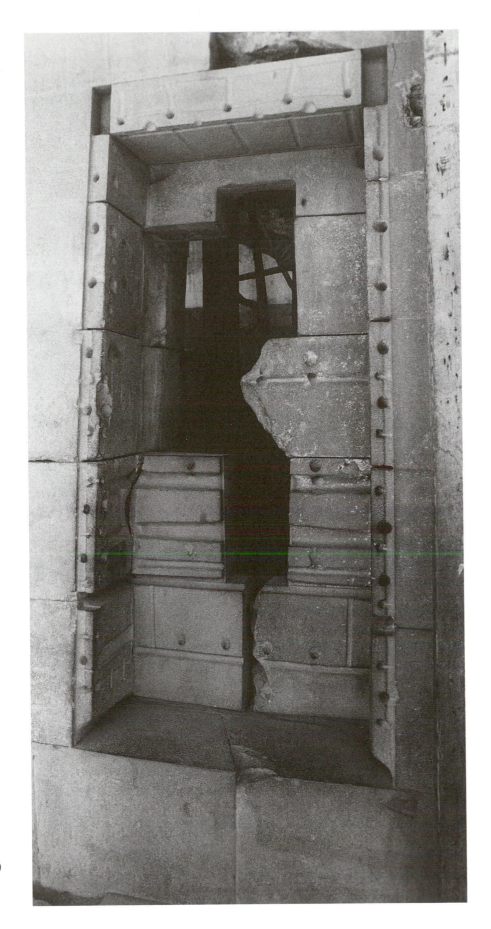

PLATE 13
*Tabernacle (according to
Garcilaso de la Vega [1604] 1991)
or throne, Qoricancha Temple.
(Photo by the author.)*

INCA STONEWORK

PLATE 14
*Wall at the ceremonial center of
P'isaq, Peru. (Photo by the author.)*

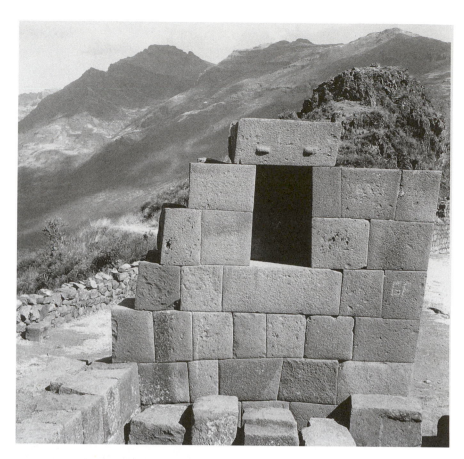

PLATE 15
*Intiwatana, ceremonial center of
P'isaq. (Photo by the author.)*

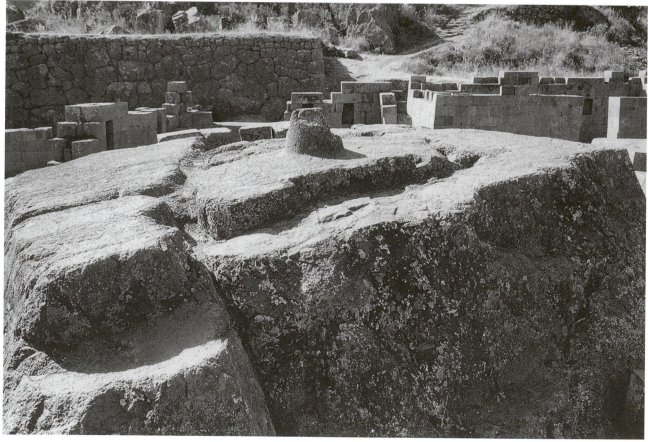

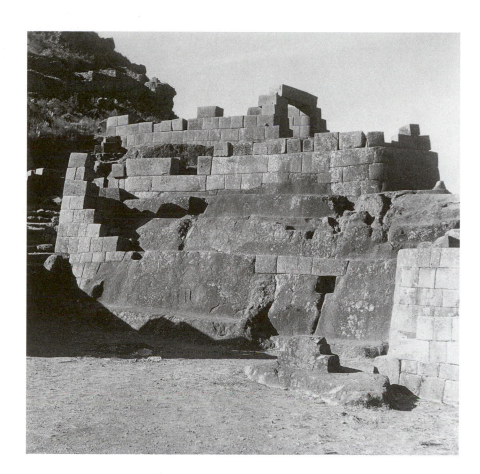

The Incas were ignorant of iron, a circumstance that seems to confer an almost mythical epic status on their stonework. Nevertheless, they had mastered the technology of bronze; numerous bronze levers, conveniently hardened by means of special alloys, have been found. In the Kline Geology Laboratory of Yale University, Robert Gordon carried out a study of the use of metal instruments in Inca construction and was able to determine that, of the 150 metal objects found in Machu Picchu by Hiram Bingham, at least thirteen had been conceived as tools, ten of which had been used as chisels to carve stone.

Nevertheless, the basic implements were hematite or hammers made of other hard stone. Rowe argues that the work was not as arduous as one might suppose (1963, 225). González Corrales has affirmed that rough-hewing stone using other, harder stones is not so difficult; in 1979, he told me that, while working on his doctoral thesis, he put this technique to an empirical test. In 1986, the architect Jean-Pierre Protzen published the results of an extensive investigation of similar characteristics.

Despite all this demystification, certain aspects of the constructive method have remained unexplained. Though the Inca state had the uncontested power to mobilize millions of *mit'a* workers, exactly how these multitudes were organized to drag the gigantic blocks used in Saqsaywaman or in the Temple of the Sun in Ollantaytambo is, for Protzen, an unanswered question.[1] Moreover, though we know that the blocks were moved to their places in the walls by means of earth-and-stone ramps that were only six to eight yards wide, we still do not understand how the numerous workers necessary to drag the blocks could all fit into

such a narrow space. Protzen dismisses the possibility that the large blocks were transported on wooden rollers—despite the evidence for it—because in the course of his investigations he found striations on certain stones caused by the friction of having been dragged.[2] However, by summarily rejecting the idea of rollers—the principle of the wheel—he uselessly complicates his working hypothesis.

Another interesting aspect of the construction of Inca walls is that the perfect juncture of the blocks is only a few inches deep. In the internal part of the wall, the irregularities and fissures between the ashlar blocks were filled in with mud and gravel. Thus, the desire to offer a finished "front" of sculptural plasticity manifests itself; later I will discuss the symbolical intention underlying this desire. I will also discuss the meaning of the protuberances, which, according to all the evidence, were left *ex profeso* and contributed decisively to the rich effect of bas-relief that the walls, without other accessory, sometimes reached.

Origin and Evolution

The origin and evolution of Inca stonework poses problems that are still far from resolution. Is it reasonable to suppose, for example, that the refined building techniques in stone suddenly appear during the period of the reconstruction of Cuzco? Obviously not, but the proposed answers to this question seem inadequate and therefore worthy of lengthier analysis.

Many years ago there was some speculation as to the existence of a "megalithic empire," a supposition based on a comparison of the walls of Saqsaywaman and Tiwanaku. Their presumed similarities, which go no further than the use of gigantic blocks, would indicate a common origin anterior to the remodeling of Cuzco, especially insofar as masonry in regular rows is concerned. However, since Rowe's fundamental work (1944), these speculations have been discarded. In general, it is acknowledged that most Inca edifications date from the beginning of the imperial expansion launched by Pachakuti Inca Yupanqui, the ninth Inca of the dynasty. The expansion began after the victory over the Chanka, estimated by Cabello Balboa to have taken place around 1438 (a date Rowe adopted as the point of departure for the chronology that most authors accept); the expansion ended after the arrival of the Spaniards in 1532.

This chronology indicates, moreover, simultaneous use of the diverse constructive techniques enumerated above. It is obvious that the Incas reserved the most refined techniques, which define the "imperial" architectural style, for the construction of temples, palaces, and ceremonial centers. This selective use of the most elaborate stonework acquired a symbolic meaning that went much further than what could be called the prestige of the building.

The question, nonetheless, remains: how did this consummate tradition of stonework emerge in the valley of Cuzco around the middle of the fifteenth century?

Gasparini and Margolies (1980, 7) have suggested that after the conquest of the Lake Titicaca region, where the enigmatic ruins of Tiwanaku are located, a double transference took place: first, the introduction into the valley of Cuzco of high-quality stonework by the *mit'a* workers brought from that region of the state, the Qollasuyo; second, a decisive

contribution of formal elements of Tiwanaku architecture to the formation of the Cuzco style. This argument is picked up by John Hemming (Hemming and Ranney 1982, 26).

Though the high degree of civilization of the Tawantinsuyo is the result, in large measure, of the absorption and re-elaboration of the technical advances achieved by the Andean societies that preceded it and fell under its domination, I do not believe this explanation is applicable here.

It is thought that the conquest of the Lake Titicaca region was carried out by Pachakuti around 1450. As Bernabé Cobo tells it, the vision of the ruins of Tiwanaku so impressed Pachakuti that he ordered those who accompanied him to study them with great care. Though it can be supposed that the ruler was influenced by the excellence of the architecture, the hypothesis that Inca stonework was generated by masons brought from the area of the Qollasuyo does not have, in my estimation, an acceptable basis.

Gasparini and Margolies provide sufficient sixteenth-century ethnohistoric documentation to confirm the involvement of workers of one of the ethnicities of the Qollasuyo—the Lupaqa—in the reconstruction of Cuzco. But it is impossible to conclude, only on the basis of this fact, that these were the same workers who introduced the stonework techniques to Cuzco. Indeed, as the same two authors admit, it is problematic to demonstrate the continuity of a stonework among the Lupaqa because, between the monuments of Tiwanaku and the constructions in Cuzco, several centuries passed without stone edifications. On this basis, they conclude that the Lupaqa had to learn how to work stone as well (1980, 11).

Furthermore, supposing that this decisive transference of a craft had taken place, we would then confront another difficulty: if the conquest of the Titicaca region took place around 1450, as is generally accepted, the beginning of the vast program of imperial construction must be dated much later. And when the period of work is so drastically reduced, it becomes so brief as to be extremely implausible.

In short, the ethnohistoric documentation does no more than testify to the involvement of numerous Lupaqa workers in the Inca constructions, and indicate that the Lupaqa were preferred over workers from other areas of the Tawantinsuyo because ruins of impressive stone constructions existed in the Lupaqa's region.

If we then admit that the workers of the Qollasuyo had to learn to work stone, the answer can only be that they did so in Cuzco, from Inca master stonemasons.

It is an inescapable fact that no archaeological proof exists to sustain the hypothesis of the vernacular evolution of Inca stonework. Neither is there any proof that decisively contradicts this hypothesis.

Today it is assumed that the origin of the Cuzco dynasties can be established around the thirteenth century. It is thus reasonable to suppose that from that date until Pachakuti's ascension to power, as material resources were developed to sustain armed forces that made territorial conquests possible, a numerous contingent of specialized workers may have been formed in the same way. The sudden appearance of consummate stonework in the reconstruction of Cuzco is inconceivable without a lengthy formative period in the same region, though we know little or nothing about such a period.

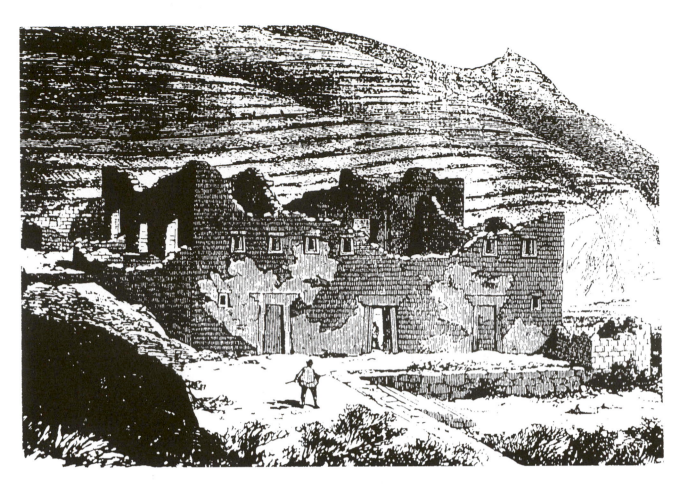

FIGURE 10
Pilco Kayma palace, Island of the
Sun, Lake Titicaca, Bolivia
(from E. G. Squier, 1877, 562).

The vernacular evolution of Inca stonework is implicit in Rowe's classic study. He writes: "Inca architecture, like most other great architectural styles, had its roots in the homes of its peasants, and, without some attention to this humble origin, it can never be properly understood" (1944, 24). Rowe also observes that in the valley of Cuzco the boundary walls of properties, as well as the houses, "are not built of stone and adobe, but of square-cut blocks of sod" (1944, 25). Over the passage of time, these blocks acquire a grayish color similar to that of certain local stones, and the walls constructed in this way have a texture that differs from both stone and adobe. Moreover, the faces of the blocks are rounded, curving toward the edges to leave the jointures buried.

Rowe then affirms: "Inca masonry of the ashlar or rectangular course type, generally has a surface appearance that is too similar to that of sod wall to be accidental. The stones are cut with a rounded surface and countersunk joints, details which serve no structural purpose, are not natural to the medium of rectangular blocks, and hence are a purely decorative convention. The construction with blocks of sod is the most probable source of this convention." It should be clarified that the concept of "decoration" was completely alien to the cultures of ancient America. Rowe continues, "Polygonal masonry, on the other hand, grows naturally out of wall construction with fieldstones and boulders in an area where the fieldstones have no special tendency to break flat. . . . The so-called 'modified polygonal' walls, where the stones are small and of nearly uniform size, are merely a sophistication of construction with chunks

PLATE 17
Remains of a temple in Koati Island, Lake Titicaca, Bolivia. Above, *the stepped tabernacle, door-jamb niches;* left, *a stepped diamond niche, badly deteriorated (cf. Plate 94). (Photo by the author.)*

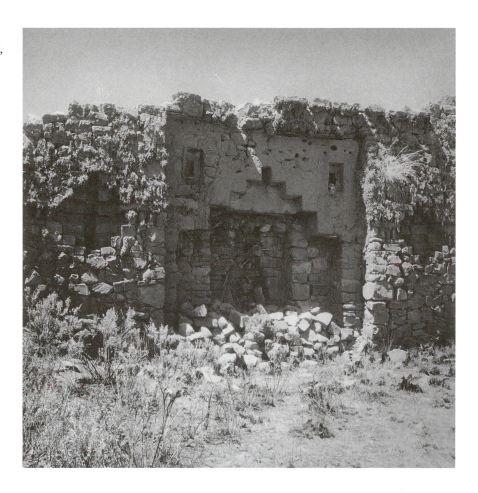

FIGURE 11
Fusion of architectural elements (C): Tiwanaku (A) and Inca (B). Reprinted by permission from Gasparini and Margolies 1980, 14.

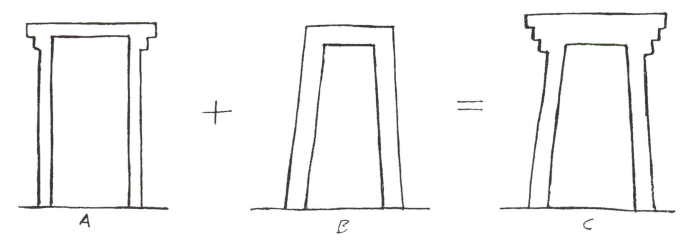

of local limestone which is easily hammer broken to such forms" (1944, 25). It is clear, though Rowe does not specifically take up the subject, that for him the evolution of Inca stonework in the Cuzco region is itself unquestionable.

The use of large numbers of *mit'a* workers in the vast program of constructions begun by Pachakuti has no influence whatsoever, in my view, on the origin of Inca stonework and the quality it achieved. The workers came from different areas of the Andean world, where, in the majority, no stone buildings existed. Initially the *mit'a* were probably destined to work in the quarries or in transportation, just as they were required to apprentice with the Inca master stonemasons.

Today it is impossible to establish the evolutionary sequence of Inca stonework; this is especially true since the hypothetical chronology that dated the constructions with massive blocks (Saqsaywaman, Tiwanaku) as the oldest has been discarded. Rowe's perceptive analysis of the vernacular sources of Inca architecture not only reduces outside influences to a minimum but also indicates the existence of a formative period in the same region. This period, however, is not immediately discernible. The walls of Qoricancha, the plastic forms of the Hatun Rumiyoc, make it apparent that, as soon as the reconstruction of Cuzco—the sacred center of the nascent empire—was decided upon, the Incas invested in it all of the highest technological capacities at their disposal. The past appears to have been obliterated with tenacious meticulousness.

The intimate relationship between the symbolic hierarchy of the building and the refinement of its construction is consistently maintained in P'isaq, Ollantaytambo, and Saqsaywaman, which are all posterior to the reconstruction of Cuzco.

Though not as primitive as the rustic dry-stone style, a lower-quality stonework can be observed in the habitational and ceremonial centers discovered by the expedition to the Vilcabamba cordillera (funded by the Wenner Gren Foundation), or in Huánuco Pampa or Chinchero, which are examples of the period of expansion. We might speculate on whether these examples represent an arrested evolution of stonework technique and are therefore suggestive of a formative stage. In support of this view, Fejos observed certain walls in Wiñay Wayna in "which the adjustment of the blocks is not as finished as in the best masonry of Machu Picchu, but which does not compare unfavorably with the average at this site" (Fejos 1944, 50).

None of the distinctive traits of Inca architecture and constructive technique suggest a re-elaboration of Tiwanaku formal elements and even less a direct influence: not the construction with polygonal blocks joined without any mortar whatsoever, the bossed surfaces of the ashlar blocks with countersunk and beveled joints, or, even less, the openings and trapezoidal niches. The very systematic insistence with which these solutions are repeated suggests a symbolic declaration of a primarily aniconic character that is foreign to Tiwanaku culture. In this sense, it is significant that the fusion of architectonic elements of both cultures is found principally in the region of Lake Titicaca, as can be observed in the Inca ruins of the Island of the Sun (Fig. 10) and those of Koati Island (Plate 17). The fusion is, moreover, perfectly legible (Fig. 11), as Gasparini and Margolies demonstrate (1980, 13–14).[3]

In sum, Inca stonework cannot have appeared suddenly. Everything leads us to believe that the idiosyncrasy of its style, like the parallel evolution of the monumental sculpture that is so intricately related to it, had been developing in the region over a long period of time. The rock outcrops sculpted in situ—Kenko, Suchuna, Chinkana Grande—appear to indicate that these were among the sites where the acquisition and development of the sculptural techniques, and consequently of the stonework, had taken place since ancient times.[4]

A Sculptural Stonework

If we accept the vernacular origin of Inca stonework, the meaning of the idiosyncrasy underlying this mode of construction will become clear to us. The selective use of the most refined techniques in the construction of temples, palaces, and ceremonial centers had the character of a symbolic decision of religious, mythical, or heraldic order, which until today has not been appreciated in its true dimensions.

From a post-Renaissance, Western point of view, Inca architecture seems naked, bare of "ornamentation," almost intolerably stripped down, even in comparison with the architecture of Mesoamerica. For Gasparini and Margolies, the Incas seemed to "waste no time on architectural decorations" (1980, 320). From a similar point of view, Hemming observes that "pre-Inca civilizations on the Peruvian coast had covered their buildings with intricate frescoes, elaborate latticework, and sculpted ornaments. The Incas were too restrained or too sophisticated for such obvious decoration." He then wonders:

In an architecture so poor in decorative elements, why was such attention lavished on the shaping and fitting of stones? Why incorporate huge blocks into terrace walls, or devote so much labor to achieving perfect interlocking of masonry joints? There is a striking contrast between the perfection of Inca stone walls, which have survived successive earthquakes, and the far less durable adobes often used alongside fine stonework or the thatch roofs resting on frames of crudely worked logs. Inca masonry sometimes seems to adopt the most complex solutions and difficult methods. Was this an official aesthetic intended to proclaim the state's success in mobilizing great reserves of labor? Was it an expression of the mason's own virtuosity—an outlet for their artistic expression in the face of official restriction? Or did it have a forgotten mystical significance? It could well have been a product of patriotic or pious devotion, a desire to build in the finest conceivable techniques for the most holy purposes. (Hemming and Ranney 1982, 53)

Hemming's tentative answer to these questions assumes, in my view, a decidedly asseverative character: the use of the most refined methods of work establishes in and of itself an inextricable relationship between the stonework and the symbolic hierarchy—religious or mythical—of the building.

The virtuosity Inca stonemasons manifested is plainly evident in their creation of polygonal sculptural forms that fit together with exquisite precision. Nevertheless, it would have been alien to the meaning of pre-

Hispanic sculpture for this exceptional skill to have been the manifestation of individual expression disregarding "official restrictions." An official preceptive symbolics existed, from which the mason-artist could not depart. Though this normative symbolism immediately makes us think of a totalitarian state suffocating all expressions of the free artistic spirit, such ethnocentric interpretations must be put aside. The symbolic normativeness established by the state was only the reflection of ancestral religious feelings, a primordial cohesive factor in the societies of ancient America. The stonemason's art could not fail to unite with the collective spirit: as Paul Westheim wrote, "what they created were not proofs of their personal talent, but symbols" (1985, 68).[5]

It is also apparent that the Inca lacked the *horror vacui* that the anthropological mentality attributes to "primitive man," as if the baroque and rococo styles in European art and architecture did not amply demonstrate fear of the unadorned void. As Hemming suggests, the Inca were indeed very sophisticated, since the stripped-down minimalism of the walls was a fundamental factor in the straight functionality of their architecture.

It should be noted that the use of adobe along with stone did not diminish the symbolic hierarchy of an edifice because, among the Inca, this material did not have the connotation of "poverty" that it has acquired today. Moreover, Hemming himself has pointed out that "it is deceptive to believe that thatched roofs were too humble or indecorous for the royal palaces or the holiest temples" (1982, 21). Ephraim G. Squier had the opportunity to examine the remains of an original thatched roof; his testimony confirms that of Cieza de León and Garcilaso de la Vega, who praised the dense and beautifully woven roofs. These outstanding examples of what could be considered a textile macrotechnology were, probably in the temples and the palaces, up to three feet thick. Nevertheless, based on Santa Cruz Pachakuti, Rostworowski writes that "the rather poor appearance of these roofs is remedied during the fiestas and important events by recovering the straw with colorful blankets of feathers" (1988, 77). The mountain climate, with its rainy seasons, made constant maintenance of the roofs necessary. The same climatic factors made stone construction predominate and limited the use of adobe.

The walls of the most refined masonry have survived devastating earthquakes. The slight tapering of the walls, the trapezoidal form of the openings, and the perfect cut of the ashlar blocks have demonstrated excellent antiseismic qualities. The powerful symbolism of this technological efficiency should not be discounted: the temples, abode of the gods, and the palaces, residences of the semidivine Inca, were constructed for eternity. The perennial quality of these constructions acquired the sense of an homage. "Technology creates meaning," Conklin said of the evolution of Andean weaving, and his phrase is fully applicable to the selective use the Incas made of their constructive techniques.[6]

In any case, this technological efficiency was inseparable from the high degree of plasticity Inca stonework achieved. In certain instances, if we consider the formal variety of the polygonal blocks for example, the distinction between "sculpture" and "architecture" seems to evaporate: while some of the blocks acquire a distinctive individuality—verging on abstract sculpture—others, worked in the same way, have a more functional character because they are embedded in the walls.[7] Rigorously cut,

WORKING THE STONE AND THE THREAD

these blocks constitute a true "sculptural masonry," a concept that defines both the plasticity of the whole—the totality of components of great formal beauty—and the fact that this masonry was conceived as a continual bas-relief. As I pointed out earlier, the perfect joining of the blocks is only a few inches deep, which signals an intention to offer an irreproachably finished "front."

Greek temple architecture also can be contemplated as sculpture: it was built with "dry-jointed," painstakingly proportioned parts, and, beyond the narrative/symbolic content of the figural reliefs adorning it, its abstract form was seen as embodying the sacred qualities of the god whose image it housed. Vincent Scully sees the "hard white forms, touched with bright colors" of the classic Greek temple as standing in geometric contrast to the shapes of the earth (1969, 1). Yet its geometric conception acquires other connotations: "The columns transform the building into a sculptural body like a Greek phalanx of vertically standing, individual units." Thus, as the embodiment of an Olympian god—specifically conceived as a home for the god rather than for a large congregation of believers—"each temple, though of the same species as the others, is different, as individuals differ. At Paestum, the Temple of Hera, goddess of childbirth, weighs heavily on the land" (Scully 1992, 77).

In Inca architecture, as a rule, the intricate working of the ashlar blocks confers on the polygonal walls a structural function of containment. Nevertheless, in the walls of Saqsaywaman, as in the western sector of the hill of Suchuna—the "slide"—there is, behind the enormous blocks, a previous containing wall made of rustic stone similar to that of the agricultural terraces. Apparently, in some cases this wall was removed once the blocks of the formal walls were in place; in other cases it was left standing. This indicates that the gigantic blocks were not absolutely structurally necessary. In a disconcerting constructive display, they are there as sculptures, as a megalithic abstract relief defined by a harsh play of light and shadow. If we take into account that the "toothed" walls in zigzag were supposed to correspond to the head of an outlined puma—the general plan in which the construction of Cuzco was conceived—it is clear that the huge, sculptural walls were fulfilling a symbolic function. This appears to be confirmed by the fact that the walls were built along the significant east-west axis.

In the walls made of regular courses of ashlar blocks, the effect of bossage and the beveled and countersunk joints heighten the animation of the surfaces—in themselves more monotonous—through the play of light and shadow, which is rarely so stark as beneath the pitiless light of the Andean highlands. Here and there, enigmatic protuberances like "knots," "breasts," or "sprouts" accentuate the bas-relief character of the walls. Doors, windows, and trapezoidal niches, obsessively repeated, complement the austere symbolic design of Inca architecture, its declaration of cultural identity.

A Reflection on Muralism

Above I presented an interpretation of the meaning of the stripped-down, minimalist sculptural masonry of the Incas. Now we must attempt to define the extent of the relationship between this refined masonry and a

mural art, of which practically no traces remain. According to Rowe, "the Inca decorated wooden cups, pottery, and probably the walls of their houses with geometric patterns and life designs. . . . Wall paintings and decorative hangings prevented monotony and added a touch of color without destroying the structural lines of the wall" (1946, 287). For his part, Bennett observed, "Some adobe or stone walls were covered with a clay plaster which was painted in various colors. Definite wall-painting designs have not been found in the Highland sites, but on the Coast good frescoes are preserved" (1963, 61).

And in *Antigüedades peruanas* (1851), Mariano Eduardo Rivero and Juan Diego de Tschudi are probably referring to these last examples when they observed "in some ancient edifices the remains of abstract, or architectonic, paintings" (cited in Bonavía 1985, 152).

Everything invites us to think that Inca muralism was acquired through contact with the elaborate and long tradition that existed in the coastal cultures. The majority of the examples Bonavía studies come from that region, where a fusion of Inca architectural designs and the local constructive techniques took place, typified by the use of adobe, limestone, and painted plaster. Tambo Colorado in the valley of Pisco, Huaca de la Centinela in the valley of Chincha, the "fortress" of Paramonga, and Maranga in the valley of Rimac (Lima) are the most characteristic examples. But Tambo Colorado is perhaps the most notable case as a typical expression of this fusion of traditions: the formal elements that define Inca architecture—openings and trapezoidal niches—are heightened by the application of red, yellow, and white paint in wide, geometrically defined areas.

Here it is interesting to examine the testimony of Max Uhle (Bonavía 1985, 153) who saw, before its deterioration, the work with adobe blocks and bas-reliefs in plaster that certain walls of Tambo Colorado displayed, a more "constructivist" aspect of mural art.[8] The designs of these works basically were stepped forms, which, as Uhle rightly affirms, "correspond in some way with the textile patterns of the Kechua [Inca] civilization." He therefore attributed to these forms the character of "ornamental crests," which denoted the hierarchical rank of the building.

With the evidence we have today, it is impossible to affirm that mural painting emerged spontaneously in the mountains. The references of the chronicler Pedro Sánchez de la Hoz to the palace of Huayna Capac in Cuzco, Pedro Pizarro's description of the temple of the oracle of Apurimac, and Francisco de Jerez's account of the residence of Atahualpa, point toward later examples. It is thus possible to conjecture that the incorporation of a mural art had already taken place after the occupation of the coast, though it could be that the artists of that region were not sent themselves to work in the mountains, as happened with the Chimú jewelers.

The testimony of Chávez Ballón, who remembers having seen vestiges of red, orange, and white paint on the walls of Machu Picchu, is very important, but the same reasoning applies. If the annexation of Tampu—the basin of the Urubamba River where Machu Picchu is found—took place before the conquest of the coast, nothing prevents us from concluding that mural painting was added later, after the assimilation of this coastal tradition. The same can be said of Squier's testimony on the

southern sierra or about the faded traces of plaster painted in stepped patterns in the Temple of Wiracocha in Raqchi.

In the mountains, mural painting presents itself adventitiously. All evidence seems to indicate that the Incas—a culture of the sierra par excellence—originally used the legendary sculptural stonework, naked and without accessories, to establish the relevance of a building. Otherwise it would be difficult to imagine the exquisite, extreme fit of the rows of blocks in the walls of Qoricancha or P'isaq, or the elaborate plasticity of Hatun Rumiyoq or Ollantaytambo covered by painted plaster.[9] Their significant self-sufficiency is manifest.

In any case, as Ann Kendall has observed, given the climatic conditions in the sierra, the application of a layer of mud or clay and paintings on the walls was done only in the interior of the buildings. She notes examples of exterior plastering only in certain cases in Ollantaytambo, "covering constructions of ordinary masonry" (1973, 59).[10]

Architecture or Sculpture?

While in Western culture the differentiation between painting, sculpture, and architecture inaugurated its academic reign after the Renaissance, the arts of ancient America repeatedly confront us with anomalous forms, foreign to these canonical distinctions.

"The pre-Columbian and Egyptian pyramids have only one thing in common: the word pyramid," writes Paul Westheim (1985, 121). In ancient Mexico, the pyramid was composed of stepped platforms and can be considered primarily a gigantic pedestal or base for the statues of the gods or for the temples that were built at its summit. With the exception of one early example—the Stepped Pyramid of King Zoser in Saqqâra—the "true" Egyptian pyramid is a stereometric body of uninterrupted faces that culminate in a naked pinnacle: a funerary monument, the mere dressing of the tomb where the mummified corpse of the Pharaoh lies. Westheim also affirms: "In order for the pre-Hispanic pyramid to emerge, no extra-American model was needed. It emerged from the religious conceptions of those peoples, from the 'cult of heights,' and from the techno-constructive conditions which had barely surmounted the primitive conditions imposed by the law of gravity. It is certain that the pyramid's destiny is to lift the image of the divinity far above the human realm" (1985, 123).

The function that the acropolis, the natural hill, plays in Greek architecture—elevating the temples (conceived as sculptures more than as a space for believers)—was realized in Mesoamerica by the construction of the pyramids. But the Sumerian ziggurat is the most concrete analogy to the Mesoamerican pyramids within the Old World tradition. The structure of ancient Mesopotamian edifices, with their superposed platforms united by stairways leading to the temple located at the summit, has great similarity to the Mesoamerican conception.

The gigantic proportions of the Pyramid of the Sun in Teotihuacán, for example, evince the "cult of height" that Westheim points out. In ancient America, the pyramid is a metaphor for the mountain. This can be appreciated most clearly in Peru, with its ecologico-cultural "coast-mountain" antinomy. In the flat desert of the northern coast, the peoples of the Moche River valley built the pyramids of the Sun and the Moon with adobe. In

the sierra, on the other hand, the imposing Andean mountain was, in itself, an object of worship: the *Apu*.

The brilliant murals and reliefs worked in elegant plaster that covered the Mesoamerican pyramids, as well as those of Moche, gave them another plastic dimension. Today, only an effort of the imagination, stimulated by a few museum maquettes, can grant us a vague image of this ancient visual splendor. But this deterioration strips bare the sculptural function of the pre-Hispanic pyramid; its powerful volumes constructed of stone and cement or adobe are, as among the Incas, an anticipation of the constructivist aesthetic of the twentieth century.

In the sense that the pre-Hispanic pyramids with their animated volumetric play of stepped platforms (Plate 18) were the pedestals of temples and statues, they bring to mind, despite the enormous differences in scale, the pedestals Brancusi constructed for his sculptures. Made with a high degree of artisanal and formal interest, Brancusi's pedestals acquired not only an unusual relevance but actually came to form an organic whole with the terse synthesis of his sculptures.

The supreme examples of Teotihuacán and Monte Albán define an architecture of monumental forms that embodies the will of a collective religious spirit. The solid volumetry of the pyramidal platforms demarcates the space engendered between them and organizes it by inscribing the volumes along accentuated directions, determined by ceremonial rigor. The interior space, as defined by the modalities of Western religious architecture, is, in the Mesoamerican conception, practically nonexistent; the poor solution of the "false arch" or corbel-vault used assiduously by the Maya could only generate narrow interior spaces that were inadequate for congregations of the devout.

In ancient America, religious rituals generally took place outdoors. It could not have been otherwise; nature was fundamentally a numinous ambiance. Natural phenomena were deified; the workings of the divine powers were read in the stars.

The lines, geometric figures, and animal shapes traced in the arid plains of Nasca (Plates 19 and 20) in the Peruvian southwest are among the most famous works of American antiquity. Their profusion and enormity, their location in a "lunar" landscape, and, principally, the unresolved enigmas they pose have given place to numerous, often fantastic interpretations. "As happens with Stonehenge, every epoch offers its own answer to the ancient mystery, generally one which reflects its own preoccupations," Anthony Aveni states perceptively (1986, 33).

The lines and even the effigies were in all probability religious paths used for ritual processions or pilgrimages, as Mejía Xespe suggested as early as 1927 (cited by Aveni 1986, 33). This hypothesis has proven to be one of the most lasting and comprehensive, since later interpretations seem to be articulated in such a way that the religious motivation appears as their final referent. In this sense, those who have seen the lines, in Western terms, as the graphing of an astronomical science forget that the American pantheon was inconceivable without a knowledge of the sky and the movements of the astral bodies, fundamentally of the sun and the moon, and thus created an appetite for such knowledge.

Aveni and Zuidema, taking as their point of departure the Inca system of *ceq'e* (see Introduction above) with its radial structuring and plurivalent

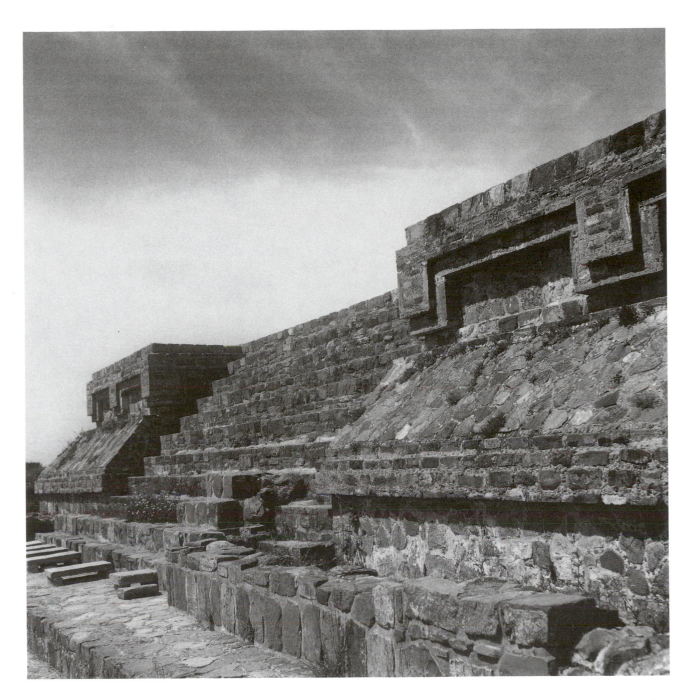

PLATE 18
Pyramidal structure, ceremonial center, Monte Albán (Classic period), Oaxaca, Mexico. (Photo by the author.)

levels of significance—religious/agricultural calendar, mythological/ritual record, patterns of social organization—have sought equivalencies with the myriad of lines and geometric figures at Nasca, which also radiate from diverse centers, opening out onto the desert plain. They concluded that this intricate network of lines is ruled by a set of ordering principles. All the keys point toward a ritual schema that involves transit across the desert, springs and movement of water—symbolic irrigation—and agricultural rhythms, mingled with calendrical-astronomical elements. But the megadrawings or "geoglyphs," which continue to be the most impenetrable enigma, remain outside of this interpretation.

Kubler formulates an interesting interpretation. He takes up the idea of the lines as "processional paths for celebrants," but adds:

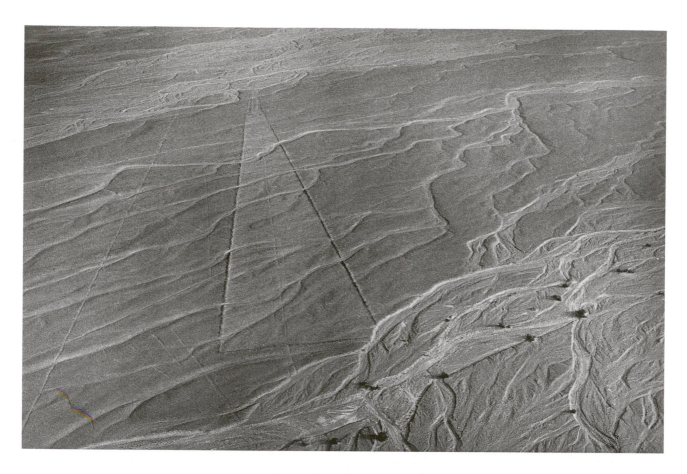

*It is perhaps unexpected, but it is not improper, to call these lines, bands
and effigies a kind of architecture. They are clearly monumental, serving as
an immovable reminder that here an important activity once occurred.
They inscribe a human meaning upon the hostile wastes of nature, in a
graphic record of a forgotten but once important ritual. They are an
architecture of two-dimensional space, consecrated to human actions
rather than to shelter, and recording a correspondence between the earth
and the universe, like Teotihuacán or Moche, but without their gigantic
masses. They are an architecture of diagram and relation, with the sub-
stance reduced to a minimum. (1975, 45)*

Though the specific meaning of these works escapes us, I believe that
their function is indissociable from their symbolic, religious, or mythic
nature. It can be corroborated repeatedly that the monumental art of
ancient America, especially that requiring large mobilizations of workers,
had a sacred character. "We can suppose that what we call 'profane art'
was virtually non-existent," writes Westheim (1985, 62).

It should be pointed out that, given the placement of the megadrawings
in the Nasca plain, their total configuration, which is linked stylistically
with early Nasca ceramics, is only legible from the air without distortions
(to be seen only by the gods?). This modality forces us to consider another
analogous form: the configuration of the city of Cuzco as a supine puma,
formed by the territory between the Huatanay and Tullumayo Rivers.
The line of the Aucaypata plaza was the puma's belly (Fig. 12, Map 2),
the head was represented by the promontory and constructions of

WORKING THE STONE AND THE THREAD

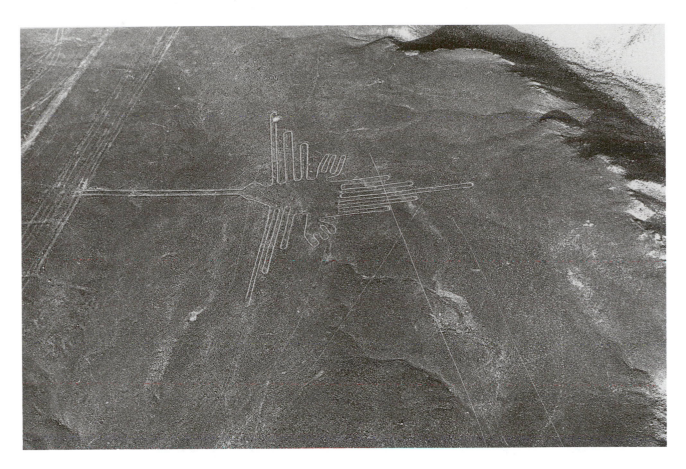

PLATE 20
*Hummingbird, Nasca desert,
Peru (approx. 95 yds. long).
(Photo by the author.)*

Saqsaywaman, and the tail by a place that still is known today as Pumac Chupan, "the tail of the puma," at the confluence of the two rivers.

Rowe was the first to advance this interpretation (cited by Gasparini and Margolies 1980, 45), and he has been followed by the majority of scholars. Gasparini and Margolies, who propose that the shape of the prone puma does not contemplate the expansion of the city, suggest another more extensive configuration that includes the area bordered by the Chunchulmayo River, which runs further south; they delineate a seated puma (Fig. 12), which agrees with a drawing published by Squier and a sculpture found in Wari. They also cite Garcilaso de la Vega in support of this idea ([1604] 1991, 112).

This interpretation has been criticized by R. T. Zuidema (1985). He demonstrates that Rowe's ideas were based on the chronicle of Pedro Sarmiento de Gamboa (1572), who for political reasons, and despite the fact that he had obtained the original facts from Juan Díez de Betanzos (1551), was interested in demonstrating to the Viceroy Toledo (who had commissioned the report) that the constructor of Saqsaywaman was not Pachakuti but Pachakuti's son, Topa Inca Yupanki, who thus gave the puma its head (Zuidema 1985, 234).

Cuzco was the fundamental cell of the Inca cosmos and culture: it had the character of the omphalos, "the navel of the world," a space of mythic origin that acquired a sacred significance, since the places from which the city was seen for the first or last time were made into shrines.[11] But when the imperial expansion began, Cuzco was a poor conglomeration of houses unsuited to the prestige it was beginning to acquire. It was the Inca

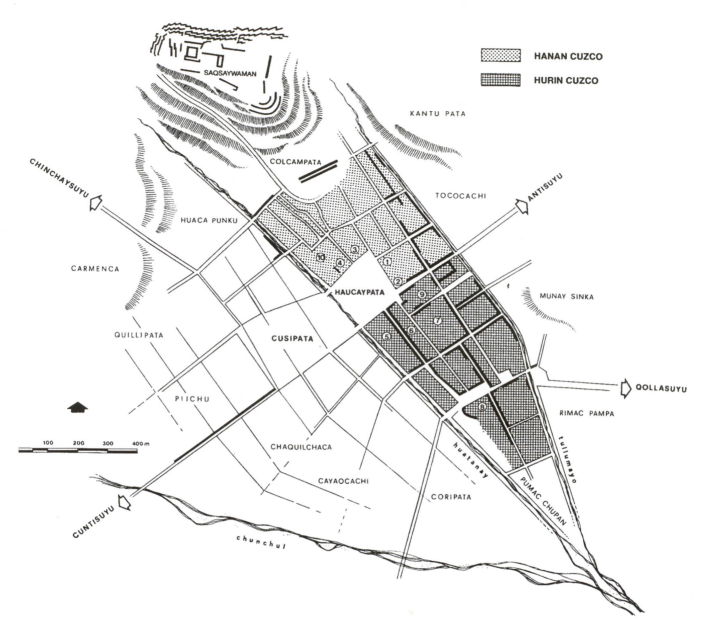

MAP 2

Plan of Inca Cuzco. From Gasparini and Margolies 1980, 46. Reprinted by permission of the authors.

1. *Kiswarkancha* 2. *Cuyusmanco*
3. *Coracora* 4. *Cassana*
5. *Amarukancha* 6. *Aqllawasi*
7. *Pucamarka* 8. *Qorikancha*
9. *Hatunkancha* 10. *Yacha Wasi*

Pachakuti himself who decided to reconstruct it and designed its plan, along with the urbanization of the neighboring areas, including in all probability that of the ceremonial center of Saqsaywaman, though its construction was completed later.

It was Betanzos who originally referred to Pachakuti as the architect of the reconstruction of Cuzco. After the defeat Pachakuti inflicted on the Chanka—an epic whose crucial characteristics we will soon examine—he decided first to construct the "house of the sun" (the Qoricancha, the central temple of the solar cult), for which he even went to the quarries and "measured the stones for the edifice" (Betanzos [1551] 1987, Chap. 11, p. 50). In order to avoid any damage from the flooding of the "two streams" (the Huatanay and Tullumayo Rivers), he ordered their embankment, and then, using clay models, he planned the reconstruction of the city. Once the work, which lasted "twenty years," was finished, he distributed "the houses and sites already built" among the lineages of Cuzco; the oldest families, "from the beginning of Mango Capac," occupied the lower

part (Hurin Cuzco), which "is the far end of this point," and he ordered that it be called "Pumachupa which means lion's tail"; and "from the houses of the sun and beyond everything that the two streams take up to the hill where now is the fortress" (or Hanan Cuzco, which culminates in Saqsaywaman), was destined for the lords of Pachakuti's own lineage and descendence. (It should be pointed out that "the two streams" were always seen as the city's limits [Betanzos (1551) 1987, Chap. 16, p. 77].) Thus, after having "distributed the city of Cuzco in the way you have already heard he gave names to all the sites and buildings and to all the city together he gave the name body of lion saying that its residents and dwellings were the members of this lion and that his person was its head" (Betanzos [1551] 1987, Chap. 17, p. 81).[12]

Though what we consider to be Inca history has been gleaned from stories collected by chroniclers, in which mythical content predominates, it is possible to infer that there must have been a critical moment in the life of the Inca empire—the siege of Cuzco by the hostile and warlike Chanka people, a siege that placed the Inca cosmos, the sacred city, in serious danger. The victory of a young commander who would then be crowned as the Inca Pachakuti (whose name means "cataclysm"), and who himself remodeled Cuzco and began the territorial expansion—the Inca empire's era of greatness—are all tales that are interwoven with this epic. Cieza de León tells us that before the decisive battle with the Chanka, the Inca captain Yupanqui (the future Pachakuti) "went out to the plaza where the war stone was, with a lion skin on his head, to make it understood that it was necessary to be strong as that animal is" (Cieza de León [1554] 1973, Chap. 45, p. 163).

Nevertheless, Zuidema maintains that there is no basis for perceiving Cuzco in the shape of a puma (the American mountain lion), but that Betanzos must be understood to be speaking metaphorically. Zuidema emphasizes the fact that Betanzos was influenced decisively by the medieval Christian concept of the "mystical body of Christ, He being the head and the faithful the body," which was widely believed during the time Betanzos was writing, and that therefore the "body of a lion" was an abstract concept with no physical basis.

Zuidema's linguistic and structural interpretation of the mythical discourse, like the ethnohistoric facts on which it is based, contribute decisively to an understanding of the symbolism of the puma in the Inca context, a symbolism associated with the moment of royal succession (installation) and also linked with irrigation and agricultural rites. Nonetheless, Zuidema greatly weakens his interpretation by basing it on the Western concept of the "mystical" and, by extension, the secular "body politic" (even the use of the word "lion" instead of "puma" can be traced to its use in Spanish heraldry). His refusal to appreciate the physical evidence also functions to the detriment of his interpretation.

The original establishment of Cuzco between the Huatanay and Tullumayo Rivers, precisely modified by Pachakuti's design for the plaza of Aucaypata and the promontory of Saqsaywaman, with the geometric design of the zigzag walls (and the circular tower of Muyuc Marca, in a place which could vaguely be situated as "the eye" of the puma), all constitute physical evidence whose configuration alludes to the shape of an animal. Though perhaps it has a greater resemblance to a lizard—which,

FIGURE 12
Contour of Cuzco in the shape of a puma. Reprinted by permission from Gasparini and Margolies 1980, 48.

judging from other sculptural representations, also appears to have its own symbolism—here the toponym Pumac Chupan, "the puma's tail," acquires the character of a definition: after all, according to Betanzos, it was Pachakuti who gave it this name ([1551] 1987, Chap. 16, p. 77), which agrees with what Betanzos writes later (Chap. 17, p. 81): that "he gave names to all the sites and buildings." Though I believe it is appropriate to read the inescapable physical evidence as a symbol, here Betanzos's chronicle offers the necessary reconfirmation.

The long American tradition of the feline as mythical animal or object of worship was not alien to the Incas, though it did not occupy as prominent a place among them as in the iconography of Chavín or Tiwanaku. In addition to the chronicles, evidence of this can be seen in the sculptural representations in the Monolith of Saywite (Plate 71)—to whose meaning I will return later—in the rocks of Lacco, and, most notably, in the venerated rock in Kenko, in whose shape the Inca saw a puma and which was placed in an amphitheatrical space to great effect (Plates 21 and 22). But the rock in Kenko—whose enthronement, for reasons I will explain, can be supposed to be prior to the redesign of Cuzco by Pachakuti—is a formal synthesis whose symbolic meaning should lead us to consider the topographic profile of Cuzco/puma in the context of the same tradition.

The zigzag walls of Saqsaywaman, which some have seen as the "teeth" of the puma, should, in my view, be perceived within this whole semi-abstract symbolic configuration. In any case, the "teeth" should be understood metaphorically rather than literally, which reinforces the interpretation of the megalithic walls that I presented above: constructed along the east-west axis—an accentuated direction par excellence—the zigzag form is dramatically underscored by the contrast of light and shadow (Plate 34). With regard to the name "Saqsaywaman"—which means "royal eagle," according to Gonzalez Holguín's *Vocabulario* ([1608] 1952)—Zuidema observes the incongruence of a puma with the head of an eagle (or falcon). If the Incas were, in large measure, foreign to the Andean iconographic tradition of zoomorphic recombinations—the iconographies of Chavín and Tiwanaku are the most striking examples—in this case it could be observed that the eagle, with its sky/height association, would be defining the *hanan*/high (north) part of Cuzco, while the puma/earth is associated with the *hurin*/low (south) half of the city. It is, moreover, the same symbolic association of cosmic totality found in the name of the chronicler *Guaman Poma* de Ayala. I will return to this dichotomy of opposition/complementarity, *hanan/hurin,* which is central in the Inca cosmovision.

Finally, there is another previously unasked question: Are the city of Cuzco, in the shape of a puma, and the megadrawings in the Nasca plain configurations to be read *from the air?*

Should all the questions raised by the Nasca lines be brought up again here? Perhaps not, since Pachakuti's design seems to correspond intrinsically to the topography of the terrain, a peculiar aspect of much of the architecture of the "imperial" period after the reconstruction of Cuzco, which establishes the model to be followed. But the configuration Cuzco/puma only acquires perfect legibility from the air, and, as such, belongs to an Andean tradition that in all probability was inaugurated by the Nasca peoples. In this sense, taking into account the most recent interpretations of the Nasca lines as a conglomerate of geoglyphs (the megadrawings) and

MAP 3

*The Qoricancha. Adapted from
Gasparini and Margolies 1980, 224.
Reprinted by permission of the
authors.*

*Dark areas:
Inca walls and foundations
Shaded areas:
Possible location of other buildings
of the Qoricancha*

systems of radially structured lines—which are seen as an antecedent of the
system of the *ceq'e* (see Aveni 1986)—we must conclude that in the valley
of Cuzco there was a similar coexistence: the city as puma (geoglyph),
combined with the system of the *ceq'e.*

In Andean architecture, as well, we find sacred spaces delimited by walls
or pillars without a roof. These are the so-called *kalasasaya,* according to
Valcárcel (1964, 151), who translates *kalasasaya* as "standing stones,"
though in general this name was specifically reserved for a sector of the
ruins of Tiwanaku. In Machu Picchu and in Ollantaytambo, where there is
an unfinished *kalasasaya,* they are known simply as "open temples" (Plates
64 and 87). In any case, the closed temples were constructed to shelter the
objects of worship, the priests, and their assistants, since the rituals were
celebrated in the open air (Rowe 1963, 298), which, as we saw before,
closely parallels the function of the Greek temple.

But unlike the inhabitants of Mesoamerica, the Incas designed enclo-
sures destined for important functions within social life. Some of them
were of generous dimensions, like the *kallanka,* where festivals and public
meetings were held, according to Garcilaso de la Vega. Moreover, the
temple of Wiracocha in Raqchi was probably the largest man-made
enclosure in all of ancient America (perhaps the worshipers congregated
here on exceptional occasions?). In the reconstruction proposed by
Gasparini and Margolies (1980, 220), the Inca architects' knowledge of
the use of columns as supports for roof structures to generate large interior
spaces can be appreciated. In general, if accidents of topography did not
impose other solutions—a circumstance by no means infrequent—the
enclosures were organized symmetrically around an open space, a kind of
interior plaza called the *cancha.* The plan of the city of Ollantaytambo

(Map 5) is the clearest example of this kind of urban design and the only one that has survived, continuously inhabited, with its original characteristics. The temple of Qoricancha (Map 3), in Cuzco, was designed within this schema and perhaps may have been the primordial model.

The relations Inca architecture establishes with its natural surroundings constitute, in my view, one of its most relevant traits, and the one least often noticed by scholars. For example, the edifices of Machu Picchu seen from the air are hardly distinguishable from geographical accidents, an efflorescence of the mountain, we could say, so close is its relation to the topography.

The Andean people ancestrally venerated height, mountains, caves or singular rocks, and rivers, or those springs that were believed to be the residences of transcendent energies; the Incas belonged to this same tradition. Thus the predominant physical adhesion, the close "embrace" uniting Inca architecture with natural accidents (Plates 16, 57, and 67), was undoubtedly charged with mythical and religious significance. But this was only one aspect of the symbolic intention of the Inca architect; the structures were also built in conformity with ceremonial necessities, singling out the east-west axis. And windows oriented in this way often framed mountains that must have had a sacred character. Perhaps this constant interrelation with the numinous Andean environment is most remarkable in Machu Picchu, with its superb location on the vertiginous canyon of the Urubamba, but it is no less significant in Ollantaytambo or in P'isaq, two other notable examples of Inca architectural conceptions. Again, a parallel with ancient Greece can be pointed out here, for, as Scully has emphasized, the site where the temple was built was itself holy and "embodied the whole of the deity as a recognized natural force"; therefore, the consistent appearance of the temples in relation to the sacred forms of the landscape "is never coincidental" (1969, 3).

It is in the "nature of an organic architecture to grow out from its own site, to go out of the earth toward the light," said Frank Lloyd Wright. "No house should ever be on a hill or on anything. It should be of the hill. Belonging to it" (cited by Tedeschi 1955, 17).[13] By theoretically defining his own architecture, Wright seems to be characterizing the architecture of the Incas, which he certainly was well aware of, though it did not influence his work to the extent that Mayan or Japanese architecture did. (See Braun 1993, 137–179, for the influence of pre-Columbian sources on Wright's oeuvre.)

The volumetric density and formal concentration of the Intiwatana of Machu Picchu (Plate 55) or of the Monolith of Saywite (Plate 71) define a genuine sculpture in the round (the volume of the Third Stone of Saywite [Plates 76 and 77] has a directional modality). The Valley Stone or Rumihuasi ("house of stone"), also in Saywite (Plate 74), was directly carved into a rock; but, equipped with stairways, it becomes a transitable structure that, though of much smaller size, can be related in its functional sense to the pyramidal platforms of Monte Albán. Should it thus be considered architecture?

The rocky formations of Kenko (Plates 21 and 26), sculpturally modified by innumerable cuts in the form of steps and cubical facetings, are also transitable. Are they therefore another "virtual" architectural conception, without dividing walls, like the Nasca lines?

A number of transitable sculptural works built in Mexico in modern times also have posed the question of their canonical identity. I am referring to the works created by Fernando Gonzalez Cortázar—especially the *Gran Puerta*—in Guadalajara between 1969 and 1975, along with those of the Gucadigose group (A. Gurría, H. Cabrera, J. L. Díaz, M. Goeritz, and Sebastián), of which Juan Acha writes, "Instead of erecting a sculpture in every public square or intersection, they decided to make every square a transitable, colored sculpture tending toward horizontality" (1979, 285).

Obviously, this also applies to the imposing *Espacio Escultórico* (illustrated in Manrique 1984 and Paternosto 1989, Plate 26), built in 1979 on the grounds of Mexico City's Ciudad Universitaria. Planned by a team of artists—Helen Escobedo, Manuel Felguérez, Matías Goeritz, Hersúa, Federico Silva, and Sebastián—it is a circle of sixty-four regularly spaced concrete prisms, twelve feet tall, enclosing an abrupt terrain of volcanic lava about 120 yards in diameter. The space between the prisms is doubled at the points that coincide with the four cardinal directions, in a manifest allusion to the geomantic sense of similar works in ancient Mexico. It is the only such work of this magnitude in Latin America, but it nevertheless has antecedents in recent Mexican art, in particular the works of architect Luis Barragán: the *Pedregal* (1945–1950) and the *Towers* of Ciudad Satélite, created in collaboration with the sculptor Matías Goeritz (1957). Yet, unlike the Mexican pyramids and the sculpted rock formations in Peru, the *Espacio Escultórico* is only transitable in the intersticial space between the prisms, as Acha also observed (1979, 285).

In coining the term "transitable sculptures," Acha warned that "we are walking on quicksand here [because] in the final analysis we have to confront a new artistic phenomenon" (1979, 285). All of these works ultimately can be traced back to the pyramidal platforms ("transitable" by definition) of ancient Mexico that are, as I stated before, foreign to the canonical distinctions between "sculpture" and "architecture." Therefore it is not at all paradoxical that these Mexican works, precisely because of their roots in the atypical forms of antiquity, placed themselves in the artistic vanguard of our times.[14]

In the sculpted rock outcrops of ancient Peru, the modified stone can literally be walked on. For that reason, I am inclined to call those works "sculptarchitecture," a neologism that accentuates the hybridization of categories inherited from Europe. With the ancient lithic technique, the Andean sculptor carved the living rock into the altars, niches, and steps of rustic ceremonial spaces, emphasizing the (horizontal) residence of the numinous, unlike his Greek counterpart who created the (vertical) statuary of ideally proportioned human forms.

"The only really original creations of America are the pre-Columbian creations," Octavio Paz observes (1983, 93). He adds: "original because the *origin* was in them."

An architecture of solid monumental masses that articulate open spaces, lineal configurations, and drawings realized on a scale that makes them legible only from the air; a sculpture of tectonic forms that are often transitable; and a masonry of plastic elements—all immediately declare their unmistakably native ancestry. The canonical distinctions between sculpture and architecture belong to the European tradition and are only partially adaptable to the American context.

CHAPTER 3

NATURE AS THE GRAND SCALE

Like a simple lapidary script cut on a large scale in the living rock.

HEINRICH
UBBELOHDE-DOERING,
On the Royal Highway of the Inca

It is easy to believe that the faceted boulders are the beginning of ritual modification of a material and an environment.

TERENCE GRIEDER,
The Origins of Pre-Columbian Art

Stone, in and of itself, is powerfully significant in the Andean context. However, the veneration of stone was not a cultural pattern exclusive to the Andes. As Mircea Eliade has written in his study of the forms by which the sacred manifests itself, "The sacred tree, the sacred stone are not adored as stone or tree; they are worshipped precisely because they are *hierophanies,* because they show something that is no longer stone or tree but the *sacred,* the *ganz andere*" (1959, 11–12). In the Andes, this hierophany receives the name *wak'a:* the "temple," the "sacred," which is also an exteriorization of the primordial numen, called *camaquen* (see Rostworowski 1986, 10). The ancestral cult of the *wak'a* came down to the Incas from their Andean forefathers and remained a primordial religious archetype for them, along with the official cult of the sun. By adopting syncretic forms, the cult of the *wak'a* resisted the impious acculturation brought about by the Spanish Conquest, and today processions of devout Christians still move toward the peaks of the mountains—mountains that have remained sacred.[1]

The cult of the *wak'a* seems to have taken a somewhat peculiar form among the Incas. Though many rocks, hills, and caves were worshiped in their natural state, certain rock formations were modified sculpturally, with the apparent aim of distinguishing the space of the *sacred* from its *profane* and nameless surroundings. In other words, the sculptural work formally designates the *wak'a,* exteriorizes it.

The rock formations found in the region of Cuzco are known as Kenko (Plates 21–23, 25–26, 28–30, and 32–33), Suchuna (Plates 36–39), Chinkana (Plates 40–42), and Lacco (Plates 43 and 44). Titikaka and Mesakaka (Plates 51 and 52) and another Chinkana are located in

62

Chinchero. Even in the Americas these works are unique; though their dimensions are smaller, they resemble the lines and megadrawings of Nasca in their vast and horizontal élan; nature itself was the immense physical medium in which they developed. But they differ from the Nasca lines in that these rock outcrops carved in situ were sculptures. They were made by the millennial technique of hewing, carving, and polishing, and their effect is still disconcerting: countless stepped cuts, cubical facetings, "seats," holes bored into the rock, and undulating or angular channels. The few representations of natural forms that appear in this context can almost be disregarded; they seem intrusive and incidental.

For Kubler, the nonfigurative carvings serve to "mark the presence of man without representing him in images or statues" (1975, 334), a point of view that implicitly seems to deny relevance to any sculpture that does not represent human forms. In my view, however, the recurrence of nonfigurative tectonic forms is decisive proof of an unmistakable significative intention.

The sculptural markings of the *wak'a* constitute, it seems to me, the first utterances, often rudimentary and crude, of a vocabulary that would reach its apogee as a result of rapid improvement in construction techniques during the period of territorial expansion. This basic temporal sequence—the movement from settlement in the Cuzco region to dominion over the entire vast Andean area—enables us to posit a correlative sequence in the formal development of the sculpture; thus, works found in areas that were annexed, which generally are adjacent to works of architecture in the "imperial" style, should be considered to date from a later period than those found in the immediate vicinity of Cuzco.

Indeed, the works found in the Cuzco region are, to all appearances, the ceremonial sites of a society that has not yet engaged in imperial projects. On the one hand, the carvings affirm the sacred character of the sites; but, on the other, the innumerable flights of steps—in the rocks of Kenko, for example—must have made certain ritual processions possible. The altars and niches must have allowed for ceremonial rites. We can also imagine the *Sapa* (sole) Inca solemnly standing in the throne carved in Suchuna (Plate 36), contemplating the sunrise or presiding over religious ceremonies.

Perhaps these works reflect a more mystic moment in Inca religion, preceding the formalist climax of the architecture of the "imperial" period. We can conjecture that the necessity for a more immediate relationship with the dwelling place of the numinous gave rise to these transitable sculptural forms, a true sculptarchitecture. Like the ritual paths of Nasca—the lines and megadrawings—they constitute a "virtual architecture" that defines the space of the sacred without confining it within walls. In support of this hypothesis, it should be pointed out that, although works sculpted in situ are also found in the conquered regions, none of them have the scope of Kenko or Suchuna, for example. Neither the rocks of Chinchero nor the Yurac Rumi near Vitcos achieves the same magnitude, though both are large enough to walk on. (The rock formation of Samaipata in the Bolivian province of Santa Cruz is the only notable exception to this rule; its sculpted surface largely surpasses that of Kenko.)

However, though the works in the annexed areas do not achieve the dimensions of the Cuzco works, all of them reiterate the same sculptural

modes, or rather, the archetypal models inaugurated in the vicinity of Cuzco, the nuclear region, the omphalos.

According to Valcárcel, the area in the region of Cuzco where the rock formations of Kenko, Suchuna, Chinkana, Lacco, and Kusillochoj are found "is a much greater site called Hanan Kosko. This site extends over the plateaus and the steep slopes of the hills dominating the city of Cuzco from the north and the northwest" (1963, 179).

Hanan-hurin is one of the basic dualistic concepts of the Andean cosmovision, whose specificity eludes a clear formulation in terms of Western logic or reasoning. Fundamentally, *hanan* expresses the "high" and *hurin* the "low," but this is given in terms of opposition and complementarity: *hanan* and *hurin* are "antagonistic and adversarial halves which nevertheless complement and need each other" (Rostworowski 1986, 29).

Garcilaso de la Vega affirms that Manco Capac was the one who established this concept, which corresponded to the *ayllu* (consanguinary groups): in the mythical arrival in Cuzco, one group accompanied the "king" to the high part or *hanan* Cuzco, while the low region, *hurin* Cuzco, corresponded to those who accompanied the "queen." The first group consisted of elder brothers and the second of younger brothers, but the sexual connotation of the two halves is obvious: *hanan* is related to the masculine and *hurin* to the feminine ([1604] 1991, Book 1, Chap. 16, p. 43; and Rostworowski 1986, 132).

But the concept goes much further: Robert Randall (1982, 1–2) makes the suggestion, based on Garcilaso, that "*hanan* is not simply that which is higher, since it is also associated with the older brother (the primogenitor), masculine qualities, the right hand, and everything that comes from above; while *hurin* is the low, younger, feminine, left hand, and all that which is below. By extension, *hanan,* being above, is also light, and *hurin,* the underground, is darkness." Randall goes on to propose that "there is nothing that does not naturally fit into these categories, and creation is the interplay between them—*hanan* fertilizes *hurin.*" Thus a comparison to the Asian *yang-yin* acquires legitimacy; *hanan* can be equated with *yang,* since both refer to that which is luminous, masculine, and high, while both *hurin* and *yin* refer to that which is obscure, feminine, and low. Randall writes, "The Andean world is, nevertheless, much more vertical so that concepts of high and low dominate, while in China it is light-darkness" (1982, 49 n. 2). These accentuations become clear in the respective visual symbolizations: the *yang-yin* uses black and white to underscore the difference between two areas that are identical but facing in opposite directions and united by a circle. I would suggest that *hanan-hurin* is implicit in the textile symbol known as "the hourglass" (Fig. 33), which can also be seen as two pyramids, one of them inverted, that are joined at their summits. Within the unity of the figure, the directional opposition is signaled in a vertical sense.

In reality, long before the mythical origin Garcilaso ascribes to it during the time of Manco Capac, *hanan-hurin* appears to have "always existed, from the moment that people cultivating the high-altitude lands realized that they could not survive without certain controls and contacts with those of the lowlands, and vice versa" (Gasparini and Margolies 1980, 58). This close interrelation between agriculture—the sine qua non of life in the Andes—and physical space cannot in any way be minimized. In this

PLATE 21
Kenko Grande, general view, Cuzco.
(Photo by the author.)

sense, Zuidema observes that the same duality combined with the term *saya* (upward), *hanansaya-hurinsaya* for example, refers to a "binary, hierarchical and vertical distinction . . . within the political unities and the lands cultivated by a community and/or town," applicable to the entire Andean region (1977, 17). In any case, to avoid a simplistic interpretation of the "low" as "inferior," it should be noted that the Qoricancha, the central temple of the Inca religion, was situated in *hurin* Cuzco.

As mentioned above, the integral parts of the Tawantinsuyo were an extension of the division of Cuzco into four parts, a division that, in its turn, grew out of the city's bipartition into *hanan* and *hurin* Cuzco. This should be kept in mind because the majority of the sculpted works are located in the northern quadrant, the Chinchaysuyo—although, as I propose in Chapter 4, the constructions and sculptures of the Tampu, in the Urubamba River valley, formed with Cuzco a symbolic whole and, as such, did not belong to any of the *suyo*. Other than the works in the Chinchaysuyo, the few sculpted rocks in Puma Orco can be located within the Kontisuyo, and the ones (known locally as the "Seat of the Inca") at the Copacabana site, on the margin of Lake Titicaca to the southwest of Cuzco, belonged to the Qollasuyo.

But among all the sculpted rock formations, Kenko has a special significance.

PLATE 22
Puma Rock, Kenko Grande.
(Photo by the author.)

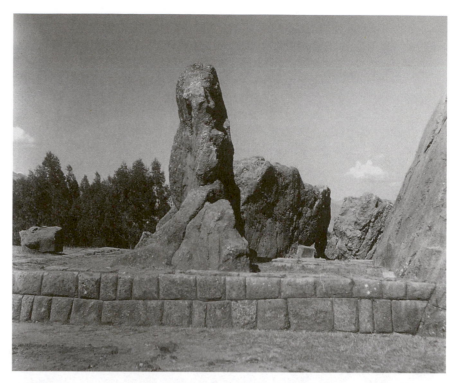

PLATE 23
Kenko *(zigzag) or* paqcha, *Kenko*
Grande. (Photo by the author.)

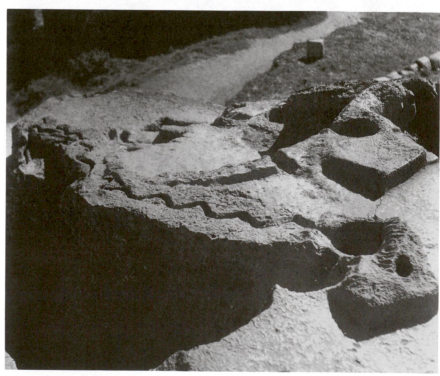

PLATE 24
Paqcha *cup, early colonial.*
Lacquered wood. National Museum
of the American Indian, Smithsonian
Institution, New York.

Kenko: Seminal Model

Near Cuzco, to the east of Saqsaywaman, this profusely carved rock formation covers an area of more than eleven thousand square feet, separated into two principal sectors, Kenko Grande (Plate 21) and Kenko Chico (Plate 28). The area was first described by Luis E. Valcárcel, who then entrusted Franco Inojosa with the more detailed excavation (Inojosa 1935, 209–233).

Both sectors were walled. As Ubbelohde-Doering observed, "The natural Kenko outcrop is set in walls of very evenly cut ashlar blocks in order to emphasize the sanctity of the natural shrine" (1967, 200). The unmistakable quality of the masonry suggests that it was erected during the imperial period, and thus, in accordance with our proposed sequence, *after* the original sculptural works were executed. Were we to take the walls to be contemporary to the sculpted rocks, we would have one more proof of the autochthonous origin and evolution of Inca stonework, since the walls display a highly developed technology, which then would have existed *prior to* the reconstruction of Cuzco. In any case, and in complete agreement with Ubbelohde-Doering, enclosure by walls was the architectonic recourse that symbolically demarcated the sculpted rock, sign of the sacred place.

In Kenko Grande, we find a cut in the form of a channel that undulates in a zigzag or, in Quechua, *kenko* (Plate 23), which gave origin to the name by which we now know the entire formation. (Its ancient designation has been lost.) This groove, carved into a sloping rock, joins two receptacles into which probably were poured either *chicha* (the corn beer used during rituals), llama blood, or perhaps human blood, on the exceptional occasions requiring human sacrifice. There are grounds for suggesting that these rituals were also associated with soothsaying.

Rebeca Carrión Cachot relates this part of Kenko to the ceremonies of the water cult (1955, 18, Plate viii). The cups joined by the channel would, in this interpretation, be the *paqcha* (Plate 24 and Fig. 14 "F"), the central symbol of this extremely ancient Andean cult, which manifested itself among the Incas (in contrast to the societies that preceded them) in this abstract and functional way.[2] Occasionally the water cult also was manifested in certain Inca artifacts where it was symbolized by representations of amphibious animals, such as frogs, toads, or eels.

Curiously, however, a bird of prey and a feline in repose are sculpted near the *kenko;* these zoomorphic representations are reiterated on a small scale in the nearby area of Kusillochoj ("the place of monkeys"; Plate 46) to the northwest, where the figurative modality of the sculpture in situ is more evident.

The *paqcha* reappears in the neighboring rocks of Kenko Chico; it is the cup adjacent to a series of curved cuts (Plate 29) with manifest organic connotations that, instead of imposing planar forms on the rock as appears to be the general trend, tends instead to underscore its natural sphericity (Plate 30). (As the sculptor Isamu Noguchi pointed out to me at his studio in 1982, this sector bears a strong similarity to some of his early landscape-sculptures and projects for playgrounds, such as *Contoured Playground* [Plate 31] of 1941, which, like *Monument to the Plow* [1933] and *Sculpture to Be Seen from Mars* [1947], anticipated the concerns of

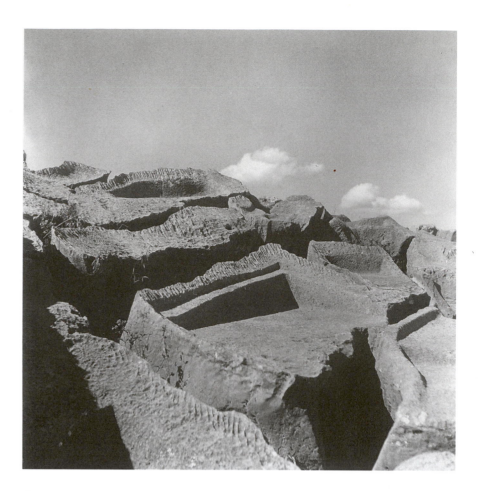

PLATE 25
Kenko Grande, detail of sculpting.
(Photo by the author.)

the generation of "earth work" artists of the 1970s. Ultimately, however, the inspirational source for these works came from the characteristic embankments built by the indigenous peoples of Ohio and of the Mississippi Valley, known today as the "Mound Builders.")

We know that this type of carving is extremely ancient; zigzagging lines and small cups incised onto bones and molars begin to appear during the Lower Paleolithic (300,000 B.C.) and the Middle Paleolithic (50,000 B.C.) (Grieder 1982, 21). Much later, toward the end of the Stone Age and in the Neolithic (5,000–10,000 B.C.), a variety of geometric forms appear; carved into rocks and caves, they take the place of the parietal paintings of bison and other animals that were then predominant. Spirals, concentric circles, and ring and cup carvings are the most common forms of this new geometric repertory; but zigzagged or diamond-shaped carvings can also be found.[3] Although Marija Gimbutas has concentrated primarily on the study of ritual artifacts of smaller scale—carved bones, stones, and ceramics—she sees the zigzag incisions and cupmarks as part of a vast "script for the religion of the Old European Great Goddess" (1989, 15), datable to the early Neolithic and associated with water in its basic symbolism of life-nurturing. "A cupmark is a miniature well," writes Gimbutas (1989, 61) perceptively.[4]

For these reasons, it can be said that the strikingly archaic character of the zigzagged carvings and the cups in and of itself suggests the antiquity of Kenko. As we know it today, Kenko must be the result of several generations of labor, going back, in all probability, to the origins of Inca

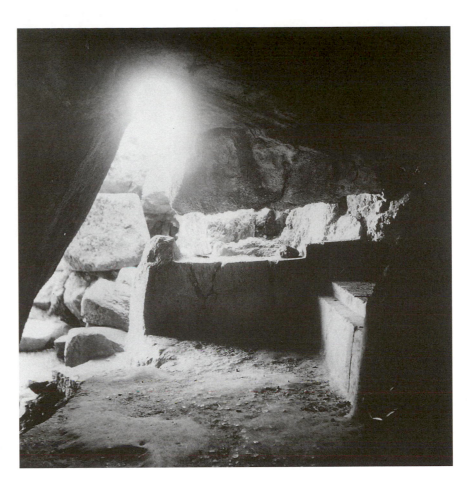

settlement in the region. Within the entirety of works on the scale of nature, Kenko appears to be the most ancient, and thus acquires an archetypal resonance.

Beyond the profusion of sculptural works (Plate 25), however, the true focal points of Kenko are a rock in which the Incas worshiped a seated puma (Plate 22) and, not far away, an ominous cave (Plate 26).[5]

The puma-monolith is framed with dramatic emphasis: located on top of a walled platform—the monolith is more than eighteen feet tall—it faces the remains of a semicircular wall where nineteen full-body niches can be counted in addition to a doorway. Because the wall has been partially destroyed—today only the lower part remains—the niches look like seats, and for that reason the structure has habitually been called an "amphitheater."[6] In any case, its semicircular form and the quality of its masonry clearly indicate the sacred importance of the monolith.

The worship of this rock, which is similar in shape to a seated puma, appears to emphasize even further the ancient date of the symbolic complex that is Kenko. Although this archetype did not have, for the Incas, the primordial role it had in the religious beliefs of Chavín or Tiwanaku, the Incas did participate in many ways in the primitive American tradition of feline worship: we must not forget that Pachakuti designed the reconstruction of Cuzco in the shape of a puma. And, curiously enough, the synthetic form of the seated puma of Kenko's *wak'a* has a strange resemblance to the shape proposed by Gasparini and Margolies (Fig. 12) as the outline of Cuzco's borders, as the city anticipated growth (1980, 48).

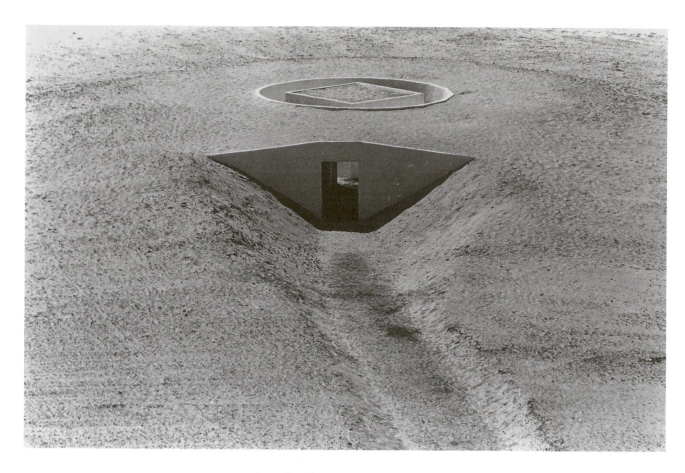

PLATE 27
Suzanne Harris, Locus Up One, *1976,*
Battery Park landfill, New York.
Wood, concrete, sand. Circle 21 ft.,
diameter 9 ft. high; cube 15 ft. x 9 ft.;
tunnel 4 ft. x 8 ft. x 20 ft.

The other focal point of Kenko is the cave that opens below the surface
of the rock outcrop; in fact, it has two entrances and thus can be consid-
ered a passageway. The cave has been identified as entirely man-made, but
this is erroneous; although it has been sculpturally modified, it is primarily
a geological accident. Caves form a notable part of the varied repertory of
wak'a; we need only think of the caves of Tamputoqo, one of the mythical
settings of the origin of the Inca world. Ubbelohde-Doering writes: "The
heart of Kenko is enclosed in a cave entered between overhanging and
smooth hewn walls, a gateway to the underworld. Inside the cave we are
in the realm of the dead. Altar-like pedestals and tables are carved into the
wall. . . . Perhaps it was the seat of a mummy during ancestral celebra-
tions, like the many other stone seats in the open air about Cuzco" (1967,
200).

According to Valcárcel, within the Inca cosmogony the universe is
stratified into Hanan Pacha, the world above, the place of the gods—the
sun, the moon, the stars, the rainbow; Kay Pacha, the world of the here
and now—of men, plants, and of all living beings and their spirits; and
Ucu Pacha, the underworld, the amphisbaena, place of the dead and of
germs. The three worlds did communicate: the transfer between Kay Pacha
and Ucu Pacha takes place through the earth's cavities, caverns or caves,
volcanic craters, lake bottoms, and fountains or springs (Valcárcel 1964).
Undoubtedly, then, the sculptural modifications to the Kenko cave—the
tables or altars—were intended as much to enhance the ominous quality of
the space, impregnated with chthonic mysteries, as to facilitate ceremonial
functions.

In relation to the cave, art critic Lucy R. Lippard wrote: "The cave is the archetypal shelter for both living and dead. In many cultures it was considered to have been the home of earth spirits before it was inhabited by people. Caves are unique spaces; they are all entrance and interior" (1983, 198). Lippard also has observed biomorphic connotations in the work of contemporary sculptors Alice Aycock, Jody Pinto, and Suzanne Harris, all of whom are influenced by the ancient monuments and their integration into nature. "The dwelling, the interior space," Lippard added, "is the classic symbol of the female body. Architecture is called the 'mother of the arts' and may well have been invented by women. Its history runs from the cave/womb to the skyscraper/erection, paralleling the relationship of female to male, matriarchal to patriarchal values" (1983, 197).

Alice Aycock has constructed subterranean passages, water wells, towers, and refuges that refer back to the *kivas* of the Hopi Indians and the peoples of the southwestern United States, as well as to the habitational cave-pits of Tunisia and Egypt. Jody Pinto excavated old cisterns in abandoned lots in Philadelphia, a process she described as permeated with a primordial urge "toward the center" (Lippard 1983, 200).

Locus Up One of 1976 (Plate 27) is the most notable work of sculptor Suzanne Harris. Worked in earth reclaimed from the Hudson River in New York's Battery Park, it represents, according to Lippard, "a typically modernist adaptation of abstract form and allegorical implications" (Lippard 1983, 201). The cubical construction traversed by a tunnel and surrounded by a circular corridor conjures up the sensation of being simultaneously under the earth and outside it.

The meaning of all these works, which are decidedly oriented toward the creation of spaces that "are all entrance and interior," stimulates a rereading of the simple modifications made to the archetypal cave of Kenko, whose receptive, shadowy hollowness resonates with chthonic mysteries. It also is possible that this cosmogonic stratification reveals the symbolism implicit in the omnipresent steps carved not only in Kenko but in Suchuna, Chinkana, Lacco in Hanan Cuzco; Inkamisana in Ollantay-tambo; the rocks at Machu Picchu, and so on. These stepped cuts were often functional, but many of them are completely useless or, in other words, merely symbolic. Were they perhaps the obsessive metaphoric representation of a communication, a transition between the world of the here and now, the Kay Pacha, and the world beyond, Hanan Pacha? This is what I believe them to be, and I will return to the subject later in my discussion of stepped cuts that are purely symbolic.

The predominantly chthonic significance of the cave of Kenko cannot be doubted, but it should be pointed out that the natural configuration of this subterranean passageway coincides with a southeast-northwest orientation, as does an enormous crevice in the rock that is like a parallel "corridor." I already have described the importance that this intercardinal axis, and the cardinal axis east-west, had in Inca cosmology as *accentuated* directions. It is possible to guess, then, that this coincidence was another source of significance in addition to the immanent sacredness of this space, and that, in consequence, it gave rise to the sculptural activity that "formalized" it. This orientational principle is reiterated in other large rock formations such as Titikaka and Chinkana in Chinchero.

Nonetheless, this norm of orientation in certain accentuated directions

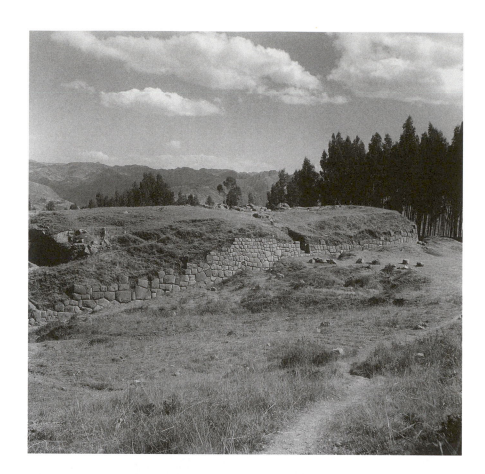

PLATE 28
Kenko Chico, general view, Cuzco.
(Photo by the author.)

PLATE 29
Paqcha, *Kenko Chico.*
(Photo by the author.)

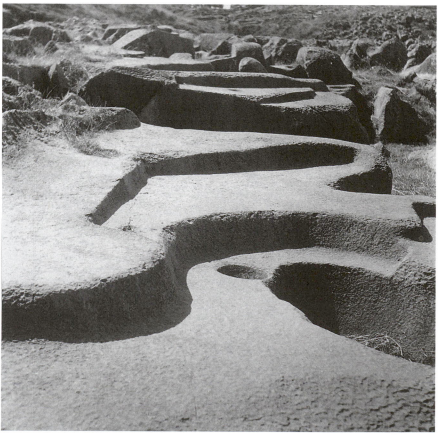

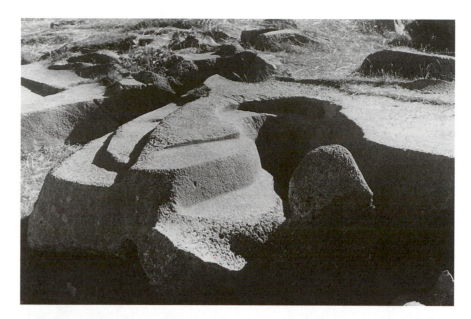

PLATE 30
Sculpted rock, Kenko Chico.
(Photo by the author.)

PLATE 31
Isamu Noguchi, Contoured
Playground, *1941. Plaster.*
3 in. x 26 in. Collection of the
Isamu Noguchi Foundation.
(Photo courtesy of the
Foundation.)

does not offer, in the hypothesis of the sculpted rocks near Cuzco, a formulation that can be systematized in a straightforward manner, which is precisely what does occur with the symbolic structures erected in the valley of Tampu.

Despite the difficulty of establishing any hierarchical order based on the accentuated directions within the innumerable sculptural modifications to these rock formations (steps, seats, geometric rectifications), it is possible to define two aspects of the problem that invite further reflection.

First, the accentuated directions could have a ritual significance whose millennial origin was on the same order of sacredness as the *wak'a*. Thus, if the configuration of a particular rock was adapted a priori to the orientational principle, it would appear to establish a symbolic distinction between such a rock and another that was not so morphologically adapted but that, nevertheless, could also be *wak'a*. If we have no references today to distinguish the specific nature of these differentiations, we can at least

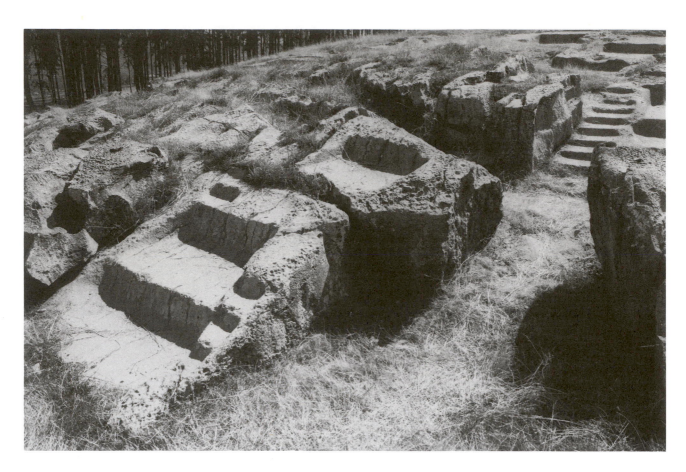

PLATE 32
*Alternate steps, Kenko Chico.
(Photo by the author.)*

infer them. Both were the object of sculptural modifications that, once again, might or might not accentuate the orientation. It is obvious that up to this point we are referring to the sculptures in situ in the rock formations of *hanan* Cuzco; in the case of the Intiwatana of Machu Picchu in the region of Tampu, or of the Rumihuasi in Saywite, the sculptural activity has practically erased the memory of the rock's original shape to produce *ex novo* a symbolic and ceremonial form that in my judgment betokens a later evolutionary period.

The geological formation known as Kenko Chico (Plate 28), like its twin Kenko Grande, is located on a hill whose ovoidal configuration extends along the east-west axis. As I already observed, this natural expanse was demarcated by a wall of sizable polygonal blocks that recalls the neighboring walls of Saqsaywaman, though its proportions are smaller. Approaching the hill from Kenko Grande, which lies to the north of it, the remains of a portal indicating the ancient entryway can be seen (Plate 28). Finally, to accentuate the distinctive character of this natural enclosure, it was surrounded by a moat, like a medieval castle.

Within the "enclosure," the general character of the sculptural modifications does not differ from Kenko Grande; here, too, we find innumerable steps (Plate 32), "seats," and rectifications of the rocks (Plate 33). Among these I will single out two sections that manifest a very pertinent difference in significative intention. One of the best-defined works in Kenko Chico is a recess in the rock that has been altered with well-finished cuts in the form of a somewhat trapezoidal niche, open at the top, with a cup at the bottom (Plate 33). Its face opens unmistakably to the southeast, and thus

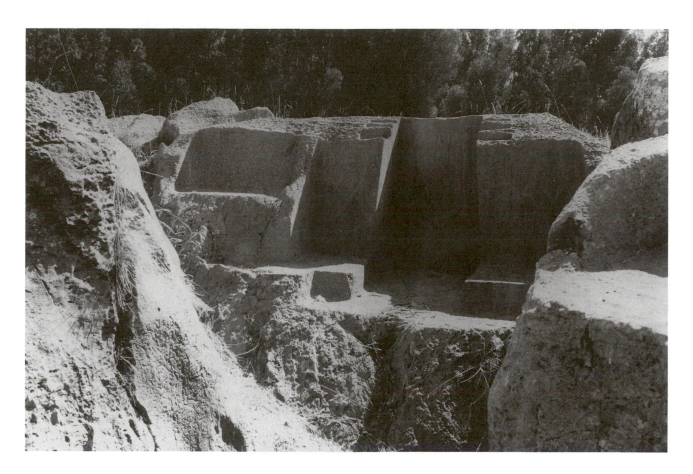

the ceremonial function of this "sanctuary," "tabernacle," or "altar," is defined.

The other work that should be singled out has been discussed already: it belongs to a series of carvings that appear to accompany the sphericity of the rock. Among these, I have mentioned an area where a certain cup carving or *paqcha* appears (Plate 29). Here, the accentuated direction is not easily discernible, and thus it can be inferred that it was not decisive in the establishment of an explicit symbolic meaning—not, in any case, for the sculptural modifications. But the decidedly archaic character of the cup suggests that this work belongs to an early phase.

And this brings us to the second aspect. The principle of the accentuated directions was slowly reaffirmed: while, in the formations of Kenko or Suchuna, numerous exceptions to it can be found, by the time the symbolic constructions in the valley of Urubamba—Machu Picchu and Ollantaytambo—were undertaken, the fundamental cosmological meaning of the southeast-northwest axis, the route of the god Wiracocha from his appearance in Lake Titicaca to his disappearance in the sea, had acquired an ineluctably normative character.

Other data appear to reaffirm this normativeness. According to Molina "El Cusqueño," during the summer solstice (December) a procession of priests moved toward the southeast, the horizon on which the sun appears in summer, time of the fertilizing rains. They walked in a straight line toward a point in the waters of the Vilcanota River, today known as La Raya. The chronicler states that "the reason they followed that path in that month is because they say that the sun is born in that region" (Molina

[1573] 1943, cited by Urton 1981, 201). The priests returned in the opposite direction, following the course of the Vilcanota and walking toward the northwest. Gary Urton writes:

I suggest that the route traveled by the priests from Cuzco to the southeast was thought of as more than a terrestrial pilgrimage; it was equivalent to a walk along the Milky Way to the point of terminus and origin of the universe. The return to Cuzco from the southeast, from the place of origin of the sun (the sun = the Inca), was an annual ritual of regeneration of the Inca and a reincorporation of the sun into the ritual, calendrical, and cosmological organization of the empire. But the journey to La Raya along the Vilcanota River involves more than the sun and the Inca for it also involves a reenactment of the creation of the universe by Viracocha, the creator god of the Inca. (1981, 201)

For his part, Randall observes: "Given that, as we have argued, the sun was 'born' in the December solstice, the priests following the direct line toward Titicaca were ritualizing its trajectory from June to December; but in their return along the river, they ritualized the flux of the waters and the fertility that would return to Cuzco from December to June" (1987, 79).

There can be no doubt as to the ritual importance of this accentuated southeast-northwest direction; however, it is highly improbable, if not impossible, that these processions could have been made before this territory beyond the valley of Cuzco fell under Inca control. As the chronicler Pachakuti Yamki Sallqmaywa indicates, it was the Inca Qhapaq Yupanki who set the boundary, "marking out as his own all the land from the Villcanota" (cited by Randall 1987, 79). We may conjecture, then, that during the later epoch of the reconstruction of Cuzco and the annexation of the valley of Tampu, initiated by the Inca Pachakuti, the orientational principle had acquired a definitive ritual rigor that can be discerned in the major buildings and sculptural works on those sites.

Leaving aside the exceptions to the orientational principle, all of Kenko—both Grande and Chico—seems to be a decidedly paradigmatic site, a kind of microcosm encapsulating the whole of Inca culture in its primary state:

1. the *seated puma* is an example of the worship of stone in its natural state, a cult of extremely ancient lineage in the Andes;

2. the *cave,* soberly sculpted in order to enhance its chthonic connotations and facilitate religious ceremonies, is another archetype of the naturally occurring shrine;

3. the *sculptural modifications* to the rock outcrops can be grouped into four principal categories:

 a. structures with an apparent ceremonial function: zigzagged grooves and cups, "altars" or "tabernacles," niches, and "seats";

 b. transitable sculptural forms, or sculptarchitecture: flights of steps or "alternating" stairways connecting different levels;

 c. carvings that highlight the sacred or mythical character of specific rocks;

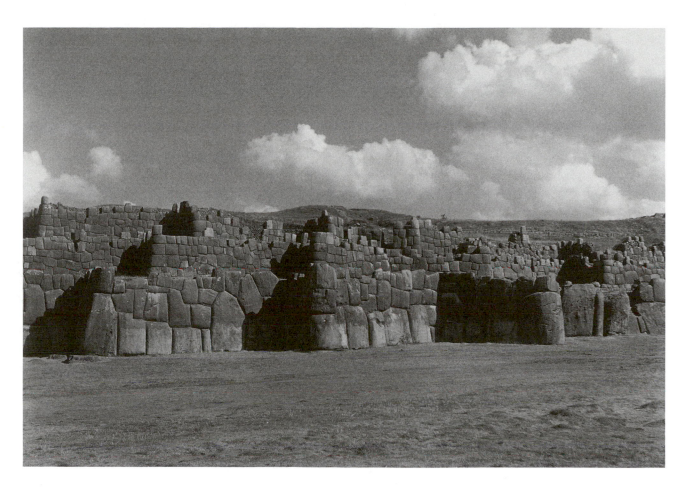

PLATE 34
Walls of Saqsaywaman, Cuzco.
(Photo by the author.)

d. zoomorphic representations, sculptures that appear to be the prototypes of those that would be elaborated on other rock formations such as Kusillochoj or the Saywite Monolith.

To all of this should be added Kenko's very possible function as a technical school, training the various groups of sculptor-masons or builders. Indeed, in light of the antiquity that reasonably can be attributed to Kenko, we can conjecture that in these works techniques were being refined that would later make possible the *sculptural stonework,* the masonry of exquisitely carved blocks that defines the imperial architecture. In other words: the autochthonous origin and development of Inca stonework presupposes not only places like the two Kenkos, but also Suchuna, Chinkana, and Lacco, ceremonial sites that also can be considered as existing before the time of the Inca Pachakuti. Decidedly, the realization of these works must have made possible the apprenticeship, the intensive practice, and the gradual perfection of Inca stonework.

Suchuna

Facing the cyclopean walls of Saqsaywaman to the northeast (Plates 34 and 35), and separated by an extensive esplanade—probably a place of congregation for religious festivities—is the rock outcrop of the "slide" (*suchuna* in Quechua). The entire area extends in an east-west orientation paralleling that of the formidable walls.

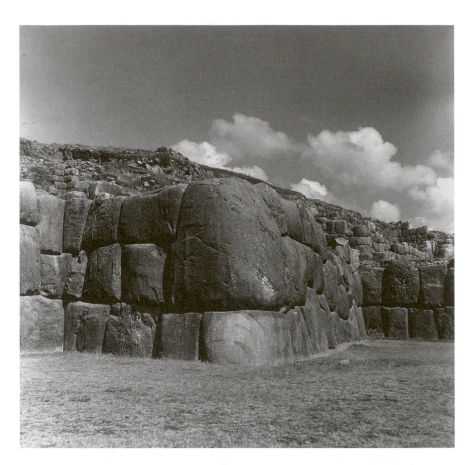

PLATE 35
*Saqsaywaman, detail of zigzagging
walls. (Photo by the author.)*

PLATE 36
Throne of the Inca or Usnu,
*rock outcrop of Suchuna, Cuzco.
(Photo by the author.)*

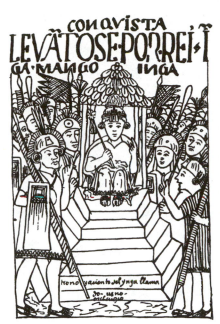

FIGURE 13
"Throne and seat of the Inca called usno," by Guaman Poma.

Upheavals of the immense veins of calcareous rock that are present in this region's subsoil gave rise to the rock formations we are discussing: Kenko, Suchuna, Kusillochoj, and Lacco. Inojosa calls these enormous outcroppings of rock the "system of Janan-Kosko [located] in the southern and southeastern foothills of the spur of Senka which, with the Pachatusan, forms the mountain range separating Cuzco from the valley of Vilcanota" (1937). An intrusion of igneous diorite within the calcareous rock brought about the "slides" or "toboggans" that can be seen on the northern slope of the Suchuna formation, which, according to Garcilaso de la Vega, was the place where the young noblemen of Cuzco went for physical training.

The focal point of Suchuna is a throne (Plate 36) carved into its southern slope, a stepped platform facing the direction where the sun rises during the December solstice (east-southeast). Moreover, in the same direction, the snowcapped peak of Ausangate appears, which is the most important *apu* of the Cuzco region. It can, for this reason, be supposed that this was where the Sapa Inca stood as he presided over ceremonies.

Hemming calls the throne at Suchuna "a symmetrical sculpture of great beauty" (Hemming and Ranney 1982, 72). Its symmetry is not rigid but is subtly affected by the natural configuration of the rock, to which the sculptor has adapted his formal solution. Ubbelohde-Doering's careful analysis makes some interesting suggestions as to the function of this work:

[The throne] consists of a series of steps cut in the rock, with a total width of nearly 40 feet. The Inca is said to have sat there to watch ceremonies on the little plain between Suchuna and Sacsayhuaman. This is an open question. The steps do not face the plain, but are oriented due east, a plan which is more readily related to sun festivals. The striking precision in the angles and surfaces of the steps, too, seems to have been dictated less by artistic considerations than by requirements which we can only suppose were those of astronomy, serving in this instance religious purposes.

There are three steps to the north and a flight of nine to the south of the central platform, which measures 6 feet by 2 feet 8 inches. The twelve steps—the number may have referred to the months of the year—are of approximately the same dimensions: 2 feet 9 inches wide (one exception being 2 feet 7 inches) and 2 feet 10 inches deep. (1967, 198)[7]

A group of carvings that can also be perceived as seats or platforms appears below the throne on the same slope; these may have been where the priests or lesser functionaries stood during the ceremonies. Also on these lower levels, toward the south side, certain tray-like carvings appear, which perhaps functioned as altars.

This throne was perhaps the prefiguration of the *usnu* (Fig. 13), another architectonic form that would eventually spread throughout the Inca territory. The *usnu* has been thought of either as a platform-like throne from which military parades were reviewed or as a platform from which justice could be dispensed or other governmental acts performed. But the majority of the chroniclers assign it a function in religious ceremonies, sacrifices, and offerings of *chicha*. In the regions distant from Cuzco (Huanuco, Vilcashuaman) the form assumed by the *usnu*—a platform of fine masonry erected in the center of a plaza—suggests that the throne of Suchuna could have been the original model.

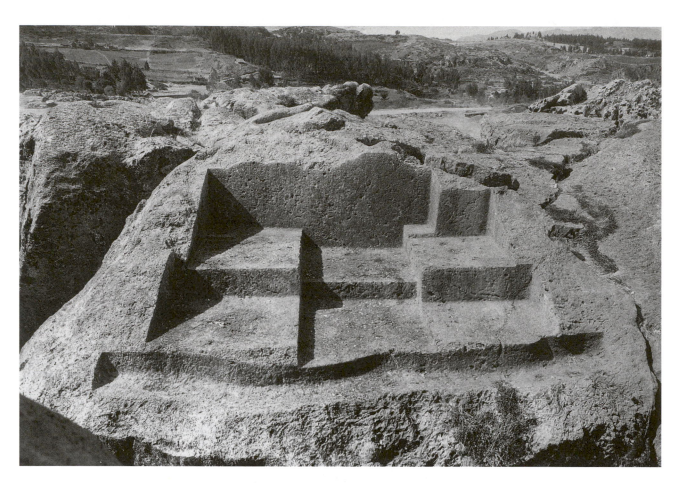

PLATE 37
Sculpted rock, Suchuna area.
(Photo by the author.)

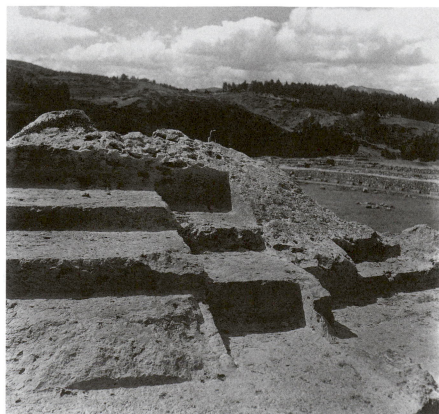

PLATE 38
Sculpted rock, Suchuna area,
excavated in the mid-1980s.
In the background, hemicycle also
uncovered in the mid-1980s.
(Photo by the author.)

WORKING THE STONE AND THE THREAD

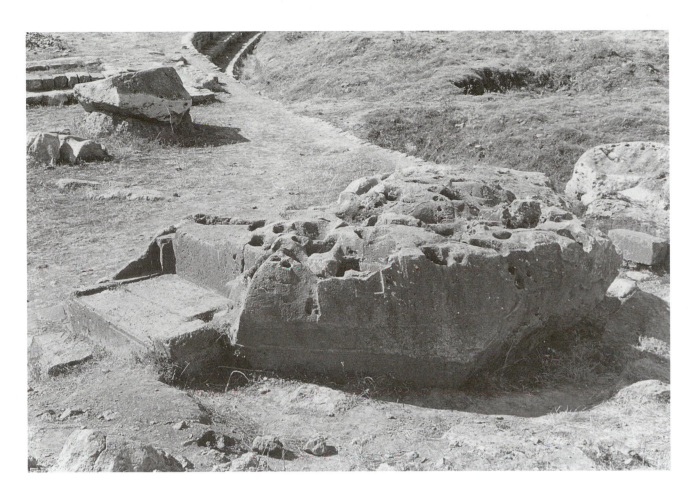

PLATE 39
Lizard Stone, Suchuna area.
(Photo by the author.)

In the rocks in front of the slides, isolated by a deep circular crevice, is one of the most beautiful conceptions of Inca sculpture (Plate 37). Of moderate dimensions—ten feet wide, four feet high, and seven feet deep—and without any known name, this work is a paragon of reticence: two series of volumes form steps on both sides of a lower central zone, but the predominantly symmetrical structuring is subtly altered by the intrusion of an extra volume that creates a poetic disequilibrium within a rigorously tectonic organization.

Though it does not manifest a clear directional sense, the structuring of this work is accented toward the southwest quadrant (later I will discuss the importance of the opposite intercardinal point, the northeast). The only significant thing about this direction is a link to the rites of the setting sun during the summer solstice. It is possible that this work was impregnated with a symbolism of another order, as the place in which it was created seems to hint: it is located on top of an imposing rock that is separate from the rest of the formation. The deep crevice that isolates it forms dark passages below it, passages that have been ritualized by sharply stepped cuts. Once more we can observe how the sculptural intervention signals or, rather, makes possible the incorporation of these natural formations into the sacred universe, since, in all probability, ritual processions passed through them.

Finally, among the infinity of individual carved rocks found in Suchuna, generally in the form of seats (Plate 38), we will rescue one from oblivion, which we must designate as the Lizard Rock, or Piedra del Lagarto (Plate

39). Solitary and eaten away by erosion (I only noticed it because it was pointed out to me by a local resident), its carving of a reptilian form makes the reason for its designation obvious. Along with the lizard, other, more ambiguous forms appear, which could be considered either snakes— *amaru*—or roughly hewn channels, now much eroded. These carvings can barely be distinguished among the asperities and cavities that centuries of rainwater have left on this calcareous rock. The smooth and geometrical sculptural alterations are far more noticeable: part of the upper section has been cut in the shape of a table, and a stroll around the rock reveals cuts and rectifications that establish a subtle counterpoint with its cragginess. The remains of a wall of fine masonry—the other means by which significant areas were demarcated—emphasizes the location of this sculpture. In my judgment, this work can be considered a primitive manifestation of the volumetric sculpture that would emerge later: the Saywite Monolith (Plate 71) in which natural forms were multiplied, as well as channels for the circulation of fluids; the Rumihuasi (Plate 74) in the same area; and the Intiwatana (Plate 55) in Machu Picchu.

When I returned to Cuzco in June 1988, after an absence of several years, I was able to observe the partial results of excavations that had been carried out in the area. Although the work is far from complete, it is already possible to appreciate works of unsuspected magnitude that lay buried at a depth of more than seven feet—works that, in general, only confirm my original analysis of the ceremonial centers defined by Inca sculptarchitecture.

For the time being, we have greater understanding of the innumerable rocks carved into "seats" or steps (Plate 38), or simply faceted such as the Piedra del Lagarto. The remains of walls with fine rectangular stonework have now been excavated near many of these rocks, emphasizing their location. The wall remains that were already discernible near the Piedra del Lagarto can now be appreciated in all their magnitude as they manifest the significance of that work.

But the biggest surprise is the impressive semicircular wall, more than seventy yards in diameter, in two levels (Plate 38 background). Its prototype appears to have been the amphitheater-like hemicycle surrounding the puma rock in Kenko Grande, though at this time no evidence of a similar focal center has been found. While the Kenko hemicycle was probably destroyed after the Spanish Conquest so that its stone blocks could be reused (though it could well be that the niches were used during ceremonies to house the *mallqui,* the sacred mummies of the ancestors, and were then dismantled as part of the campaign to extirpate idolatry), it is impossible to determine whether the "amphitheater" of Suchuna was still under construction at the time of the conquest or suffered the same fate as the Kenko hemicycle. One way or the other, the process of construction can be clearly observed and is analogous to the technique used in Saqsaywaman: here, too, the preliminary retaining walls are of rough stone, and on the lower level groups of two or three blocks of rectangular stonework are embedded in the rough wall at regular intervals. In the section closest to the slides, these blocks were placed with greater separations at the base, suggesting, as in Kenko, the base of a trapezoidal niche.

This wall is not the only work of this kind. Other semicircular walls with imperial types of masonry have been discovered, forming what

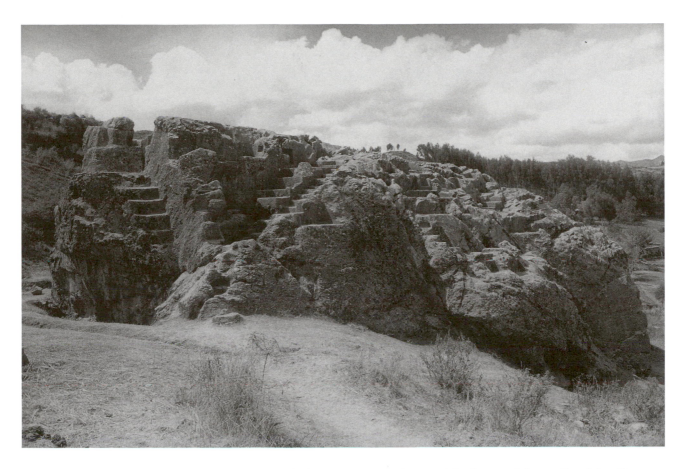

appear to be lesser ceremonial areas. The bases of the walls of dwellings
have been uncovered as well; one of them is particularly notable for being
laid out in a zigzag.

Chinkana, Lacco, Kusillochoj, Lanlakuyoj

The crag of calcareous rock known as Chinkana Grande (Plates 40–42),
two hundred yards north of the Suchuna "amphitheater," has been
erroneously associated with Garcilaso de la Vega's account of the "tired
stone" ([1604] 1991, Book 7, Chap. 29, p. 487). According to Garcilaso,
when a certain colossal stone was being pulled by some twenty thousand
workers toward the construction site of Saqsaywaman, the stone broke
free and fell, killing three or four thousand of them. However, it is easy to
see that Chinkana Grande could never have been moved: it is simply one
more of the many outcrops of the same geological vein of calcareous rock
as Kenko and Suchuna. Chinkana Grande is located near Suchuna, toward
the northeast, before Kenko.

The Quechua word *chinkana* (meaning "where one gets lost") alludes
to the still-common belief that this rock was the entrance to a vast subter-
ranean passageway. According to Guaman Poma de Ayala, this passage-
way led to the Church of Santo Domingo, which was built over the
remains of the temple of Qoricancha. When a large fragment of the far
northern section of the rock broke off, it revealed a small cave, which
could be the source of the ancient belief and of the rock's name. Moreover,
in the outcrop known as Chinkana Chica situated near the eastern end of

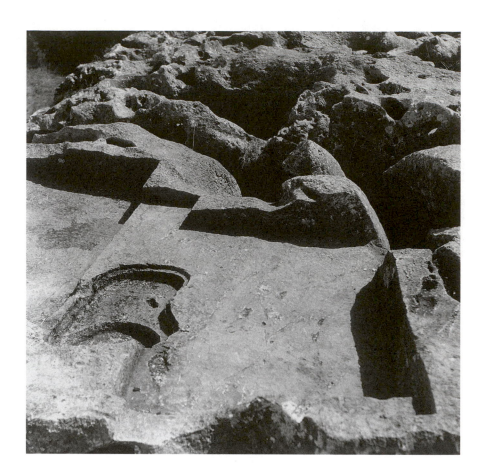

PLATE 41
Font or paqcha, *upper surface
of Chinkana Grande.
(Photo by the author.)*

PLATE 42
*Chinkana Grande, western sector.
(Photo by the author.)*

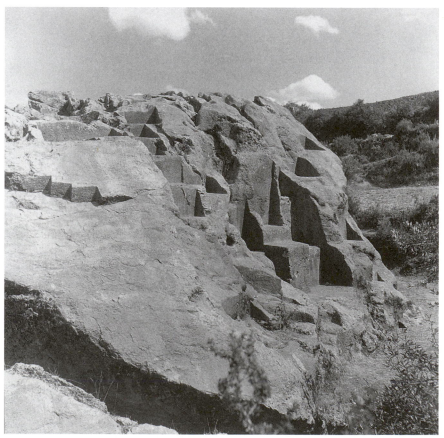

WORKING THE STONE AND THE THREAD

the semicircular wall, excavations have unblocked a subterranean passageway. Although it does not appear to form part of a larger network, the experience of going through it—when for long stretches you move in utter darkness—approximates the feeling of a metaphoric journey into the depths of the earth.

Ubbelohde-Doering writes of Chinkana Grande, "It is covered with a flight of steps, with seats and altars, many of which appear to overlap, like a model in which every corner has significance, fashioned in the belief that the whole stone is one magical complex" (1967, 200). It is clearly another work of sculptarchitecture in the image of Kenko, though smaller. Zuidema considers it a significant landmark because it indicates the presence of running water (see Sherbondy 1982, 21).

On Chinkana Grande's eastern side, among the numerous facetings and carved stairways, a single stairway stands out as purely symbolical since it eludes any kind of rational functionality. As I already observed, this sculptural formula is repeated with obsessive insistence, and each of its manifestations appears to point in the same metaphoric direction: the stairway represents the possibility of linking the "world above," Hanan Pacha, and the "world of the here and now," Kay Pacha.

There does exist, however, a functional staircase leading to the upper section where asperities and fractures caused by erosion predominate (Plate 40). A small area has been cut and smoothed into a "floor," and on it appears an appealing carving of curved forms that is, as far as I know, unique in the Inca sculptural vocabulary. It can undoubtedly be associated with the rounded shapes that accompany a *paqcha,* the cup symbolizing the cult of water, in Kenko Grande. The Chinkana carving is in the shape of a small "fountain" or *pila,* a vessel for collecting rainwater, and in that sense it also must have been related to the water cult. But while in Kenko Chico the forms appear to have been dictated by the natural shape of the rock, the design of the small fountain in Chinkana is much more geometrically rigorous: in the vocabulary of modernism, we could see it as a "bas-relief by Jean Arp"; or as the silhouette that, in a cubist painting, refers to a Spanish guitar (Plate 41).

In the section that faces the setting sun—*konti*—we confront a modality of Inca sculpture that we will see repeated frequently: the rock, in a sharp incline, appears to have been hollowed out; it looks as if cubical forms have been cleaved out of it by a single stroke of the chisel (Plate 42). This same kind of cubical hollow appears in the almost vertical slope of a hill near the ceremonial center of Ollantaytambo known as Inkamisana. In Chapter 6 I will have more to say about these works, which have a close relationship to certain atypical features that appear in Ollantaytambo.

Still moving away from Cuzco toward the northeast, less than a mile to the east of Kenko, we find the massive formation of Lacco.[8] It is a hill-sized rock formation, taller and wider than Kenko, covering an area of eighteen thousand square feet. Unlike Kenko, the crest of Lacco does not display major sculptural transformations; these occur in the lower part of its slopes.

Oriented precisely toward the northeast are two groups of emphatic, voluminous, and meticulous stepped cuts: one of the stairways is irregularly configured, with the steps divided in two by a rock protrusion; the other, called the "Grand Staircase" by Inojosa (1937), has notable varia-

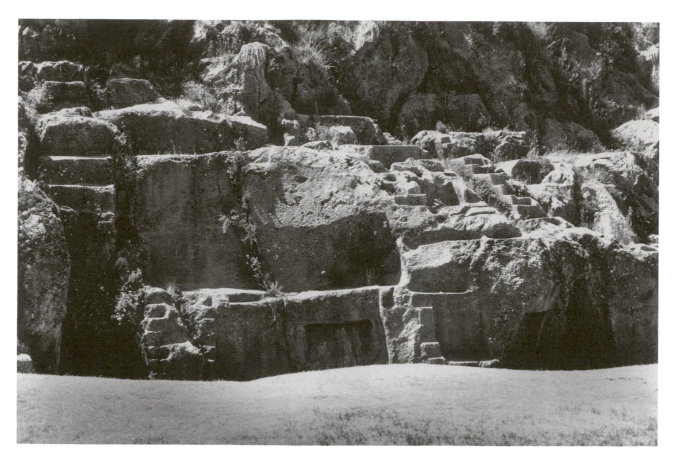

PLATE 43
Southwestern sector of Lacco,
Cuzco. (Photo by the author.)

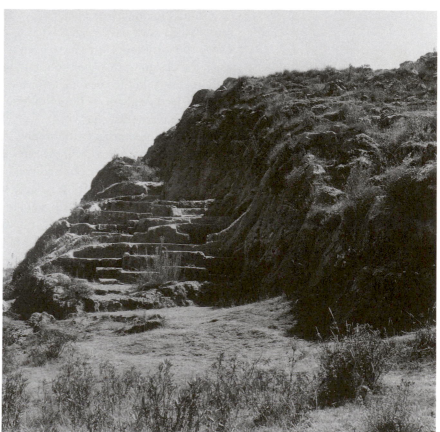

PLATE 44
Steps at Lacco.
(Photo by the author.)

WORKING THE STONE AND THE THREAD

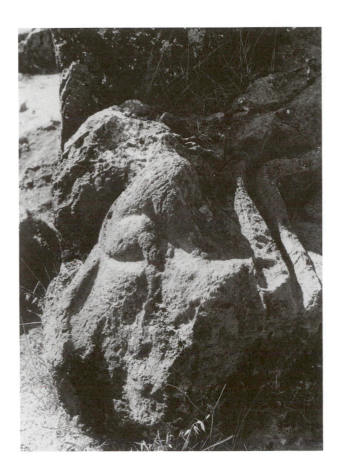

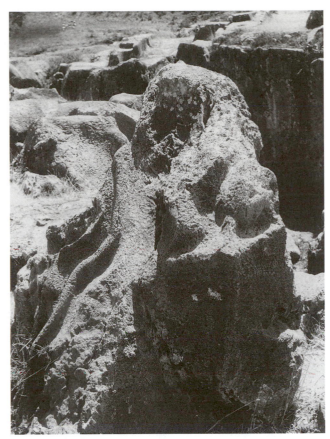

PLATE 45 (ABOVE, LEFT)
Sculpture of a monkey (kusillo),
Kusillochoj, Cuzco.
(Photo by the author.)

PLATE 46 (ABOVE, RIGHT)
Feline figure, rock formation of
Kusillochoj. (Photo by the author.)

tions in the height of the steps. Since it would be extremely difficult to climb these "stairways" (some of the steps are seven feet high), I believe that they are further examples of a purely symbolic order, perhaps a metaphorical reference to the Inca agricultural terraces, as well as a generic allusion to the importance of farming in this Andean society.

A deep fault runs through the mass of Lacco: like a passageway, it leads to the opposite slope that faces southeast. There we find briefer versions of the ubiquitous stairways, as well as other carvings that are perhaps the most notable features of Lacco: a series of niches, large enough for a human body, that look like false doorways (Plate 43), and appear to point out the entrance to one of the caves on this slope. There are three of these niches, and they reiterate the mysterious archetype of Kenko. Their interiors have been laboriously modified in the same way: tables, or "altars," and "seats" accentuate the analogies to Kenko. In one of the caves, a snake carved into a wall appears to point its head toward the dark interior of the deep cavity. Undoubtedly, we are in one of the passages into the chthonic realm of Ucu Pacha.

Toward the east of Lacco, a stairway with dynamic changes of height in its steps appears to lead toward the crest of the rock formation but comes to an abrupt end halfway up (Plate 44). Ubbelohde-Doering calls it an "unusual" stairway, since it "forces the person climbing it to move from side to side" (Ubbelohde-Doering 1967, 249).

Two hundred fifty yards south of Lacco is the so-called shrine of Kusillochoj, another, smaller rock formation whose fissures also have been

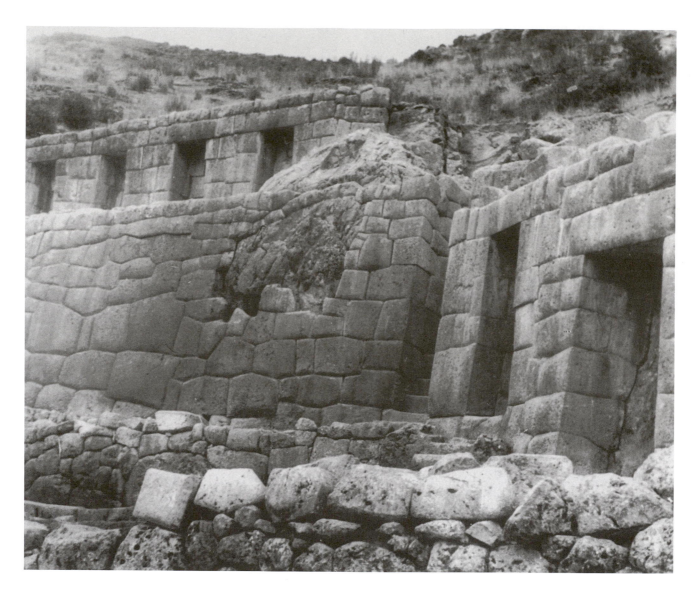

PLATE 47
Tampu Machay ceremonial center.
(Photo by Josef Albers, c. 1953;
courtesy of the Josef Albers
Foundation.)

used to carve "seats," "altars," and flights of steps. Its most distinctive feature is the appearance of zoomorphic representations. In one rock, the figures of monkeys (*kusillo* in Quechua) have been sculpted (Plate 45); in another, shapes resembling a feline can be distinguished, much effaced by erosion (Plate 46). The heads of the monkeys may have been destroyed after the Spanish Conquest during campaigns to extirpate idolatry. All of these rudimentary figures are closely related to those that appear on the Saywite Monolith (Plates 71 and 72). And, just as in Saywite, there is a rough channel surrounding the simian figures, through which ran water or other ceremonial liquids.

The excavations have extended to this area. As you approach Kusillochoj through the north section, the remains of the walls of dwellings can now be seen, along with a rough retaining wall and a monolith with sculptured facetings that was half-buried when I first saw it.

Lanlakuyoj (*lanlaku*, malignant spirit; *yoj*, with) is the enigmatic name that designates a "high crest of rocks" located almost a mile to the northeast of Lacco, beside the modern highway to Tampu Machay (Plate 47).

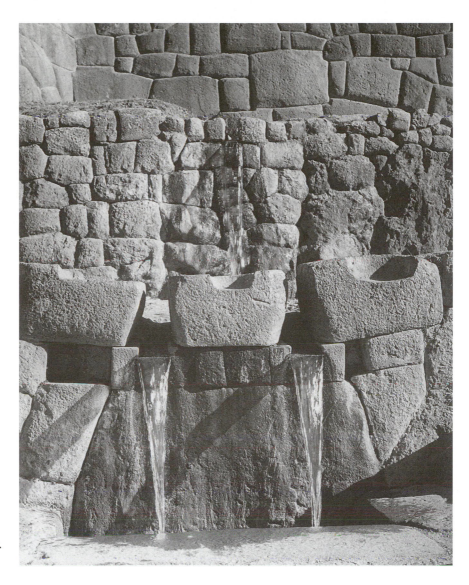

PLATE 48
Tampu Machay ceremonial fountain.
(Photo by the author.)

Little can be added to the careful description of it published by Inojosa in 1937. The sculptural works of Lacco are reiterated to some extent here, with one difference: the prototype of the fountain or *pila* is present (Plate 48). Its specific symbolic meaning of manipulating the course of water will be repeated in similar notable works in Ollantaytambo (such as the bath of the *ñusta*), Inkamisana, Machu Picchu, P'isaq, and so on.

Choqequilla, Quillarumi

On the road to Ollantaytambo, in the ravine of Huaracondo not far from the valley of Urubamba, is, writes Ubbelohde-Doering, "one of the most wonderful of the Inca sanctuaries, the cave of *Choqequilla*, the Golden Moon." At the entrance to the cave is a rock sculpted with exceptional rigor (Plate 49). "Even for the highly developed lapidary art of the southern Andes," the German archaeologist adds, "this is an extraordinary work" (1967, 249).

Despite partial destruction resulting from the greed of treasure hunters, the meticulousness of this work's finish, uncommon in the works in situ,

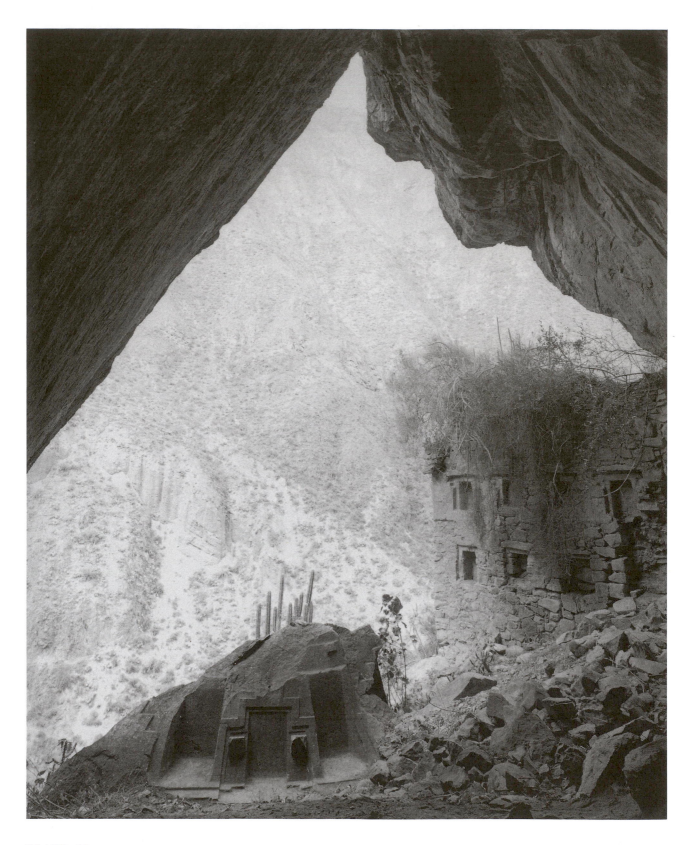

PLATE 49
Cave of Choqequilla.
(Photo by Edward Ranney, 1975.)

WORKING THE STONE AND THE THREAD

can still be appreciated. But it is even more extraordinary in another way: to all appearances it seems to constitute one of the few Inca works of precise symmetrical composition. Painstakingly squared cubical reliefs and stepped cuts are neatly ordered on both sides of a vertical axis in a design that is identical to that of the fountain known as the "bath of the *ñusta* (princess)" in Ollantaytambo (Plate 93), which suggests that both of these symmetrical designs connote a heraldic symbolism. This is understandable in the context of Ollantaytambo, a ceremonial and urban complex of great magnitude, but the prodigious care taken with the emblematic symmetry of this work in a place as isolated as Choqequilla is intriguing. We can legitimately assume that it is posterior to the works at Kenko. However, other works that we can suppose to be later than Choqequilla, or, at most, contemporary to it, are spontaneously adapted to the asymmetrical structure of the rocks, or, even where no impediment to symmetry exists, the dynamic equilibrium of masses and voids is preferred to symmetrical ordering.

I am well aware that my interpretation suffers from the very vice I am trying to combat. My identification of these symmetrical emblems as "heraldic" is based primarily on their analogies to the Occidental tradition of that type of design. Nevertheless, it is possible to establish a kind of correlation within Andean tradition: this symmetrical composition is one of the few cases in which Inca stonework has recourse to the type of duplications inherent in textile techniques. I refer to the V-shaped stepped designs of the collars of the tunics or *uncu;* it has often been suggested that these textile designs denote the hierarchical rank—military or aristo-cratic—of the person who wears them.

In any case, the location of such a meticulously realized heraldic symbol is perplexing in front of a cave regularly associated with communication with the Ucu Pacha. Was this the setting of some mythical event of exceptional importance for the Incas?

A wall has been constructed against the north side of the interior of the cavern; it is significant only in that it displays two sequences of superposed niches: four above and four below. All of them were built with double jambs, but those of the upper level—to complicate our interpretative labors even further—display the stepped pattern that defines the fusion of Inca and Tiwanaku architectonic elements, already observed in the con-structions of the Isla del Sol (Fig. 10) and Koati Island in Lake Titicaca (Plate 17). They are among the few examples of this fusion existing outside of that region.[9] The construction method used in the cavern is entirely comparable to that of the ruins of Titicaca and, notably, also to that of the two rear enclosures of the ceremonial area of Ollantaytambo. Undoubt-edly, the niches, whose ceremonial nature is evident, were there to magnify the symbolic importance of the cave.

The intrusion of Tiwanaku elements into these works is surprising; however, we should not forget that they are located within Ollantay-tambo's sphere of influence, where we will observe a similar degree of Tiwanaku interference. Nevertheless, the total context remains distinctly Inca. If the meticulously stepped relief on the rock at the cave's entrance can, in its textile origins, be associated with both cultures, it is impossible not to notice that this emblematic sculpture faces the dark inner space of

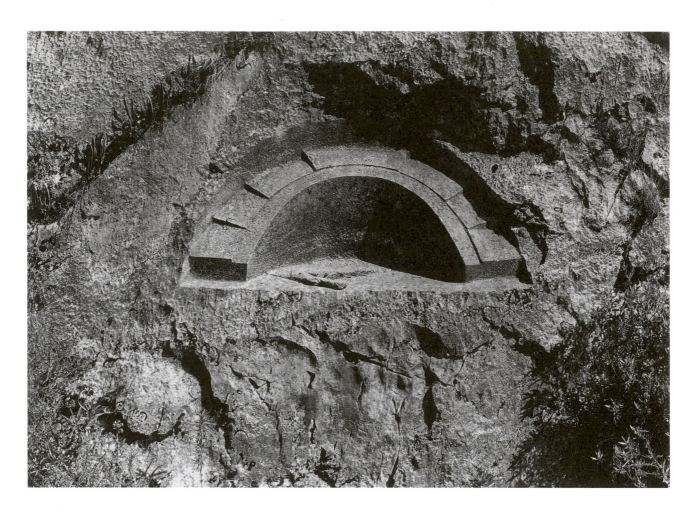

the cave, whose predominantly chthonic meaning—emphasized by the walls and the ceremonial niches—is foreign to Tiwanaku culture.

It can be inferred that this partial importation of Tiwanaku symbolic architectonic elements took place during the reign of Tupac Yupanki, son of the Inca Pachakuti. During the campaigns of consolidation of the Inca dominion in Kollasuyo, he was deeply impressed by the Isla del Sol, to such an extent that, according to Ann Kendall, "he ordered a palace (Pilco Kayma or Chamana) to be constructed and facing it, in Koati [Plate 17], a temple dedicated to the Coya and to the Moon (Inak-Uyu)" (1973, 79). Bernabé Cobo writes that the Inca ordered the construction of "palaces" in Ollantaytambo ([1653] 1979, 149); could these be the structures in the rear part of the ceremonial area? The similarity we already observed between these structures, those of Pilco Kayma and that of the cave of Choqequilla, provides a basis for this conjecture.

Quillarumi (moon of rock) is carved into the steep slope of a hill in Anta, near the Cuzco-Abancay road (Plate 50). Its name (another popular formulation, like Choqequilla) alludes to its semicircular shape. Its upper section, an inclined plane following the angle of the rock, displays seven raised planes, somewhat trapezoidal in shape, forming steps along both sides of a central relief. Quillarumi's strongly symmetrical structuring links it to Choqequilla, but it lacks any other symbolical referent. And the isolation of its location makes it even more enigmatic. I can only conjecture some sort of function related to astral observations.

Chinchero, an Arcadian Valley

The Inca Yupanki chose the enchanting region of the Chinchero valley as his private property and as an "estate" to be passed down to his descendents (see Sarmiento de Gamboa [1572] 1907). He also ordered the construction of the enclosures, whose "provincial" magnificence can still be appreciated in this archaeological site twenty miles to the northeast of Cuzco, where today is a town that grew up during the post-European period.

The principal enclosures are in the southern section of the Great Plaza—the Capellanpampa—after which, walking north, you descend toward the valley. This descent is marked by the agricultural terraces that form the district set aside for farming. The civil and religious districts have been identified as well, and it is quite possible that the latter district's ancient temple was the Inca construction, not yet identified, on whose remains the church is built. In that case, the Spaniards would have repeated here what they did in Cuzco when they built the Church of Santo Domingo over the ruins of Qoricancha. Nevertheless, the remains of Inca buildings should be the subject of an architectonic analysis, and here my interest is focused on the works sculpted in situ.

Toward the north of the Great Plaza, at the very edge of the steep incline toward the valley, is the impressive rock formation known as Titikaka (Plate 51). The Arcadian valley flows in a perfect east-west orientation, and, precisely parallel to the valley, two deep fissures split Titikaka like passageways. In the northern part of the larger fissure, an obscure *chinkana* is hidden deep in the rock. Nuñez del Prado and Cámara Barbachano's ethnographic studies of the region revealed, among other things, the belief that beneath this crag is a lake that can be reached through a subterranean pass that happens to be called Chinkana (Sherbondy 1982, 22).

In the other half of the massive rock, on the south side, is a passageway inside of which a lengthy and meticulous stairway has been carved, ascending to the upper part of the rock where the characteristic faceted cuts or "tables" have been elaborated. All of it represents a sculptural solution that is in large measure analogous to the works realized in Chinkana Grande of *hanan* Cuzco, described above. This type of repetition is thought provoking. Was Titikaka, with its natural cavities and passageways, immanently *wak'a*, or, on the contrary, did it become *wak'a* only when the characteristics of the rocks of *hanan* Cuzco—where the sacred archetypes originate—were found repeated? Indeed, this question can be extended to all the sculptural works in situ carried out in the territories that were annexed after Pachakuti came to power. It can be conjectured that as the Inca dominion expanded into unknown, unnamed regions, this type of sculpture was one of the means of signifying the incorporation of the physical space into the Inca cosmos. In other words, the sculptural activity "designated" the reiterations of the archetypal models, originating in the region of Cuzco, that were found in the foreign territories.

The rock Titikaka is only one part, though the most formidable one, of a system that extends along the east-west axis of the valley of Chinchero. Four hundred yards to the east, in a straight line from the passageway of

Titikaka, is another large rock, though of somewhat lesser proportions, which is indeed known as Chinkana and appears to reproduce precisely with even greater fidelity the Chinkana Grande of *hanan* Cuzco (Plate 40). Here, too, flights of steps lead to the upper section in which the sempiternal planar cuts, facetings, and "tables" modify the sphericity of this calcareous mass. As a distinctive feature, an emphatic carving in the form of "teeth" appears in the southeastern section.

To reconfirm this Chinkana's similarity to the model of *hanan* Cuzco, a brook splashes past the base of the rock on its way to the valley. Zuidema thought that Chinkana Grande was a landmark signaling a stream of running water: the Chacan canal passes near it, and Sherbondy observes that this canal "is one of the most important for the irrigation of the fields near Cuzco in the Inca epoch" (1982, 21).

The close relationship that the Chinkanas have with water cannot be overlooked; however, I do not believe that a normative principle of general validity can be extracted from it. The sculptures in situ of *hanan* Cuzco—Kenko, Suchuna, and Chinkana—can be related almost inevitably to currents of water because that area abounds with streams, belonging to the hydric system of the river Watanay, formed by the rivers Saphi and Choquechaca (called Tullumayo as it crosses the city of Cuzco). Indeed, the abundance of water was obviously the primordial reason for Inca settlement in the region.[10] But, though we would fall into a merely formalist analysis of the sculpture if we were to ignore completely the cosmological relationship with the currents of water, it is clear that many of the works of *hanan* Cuzco appear to respond specifically to other symbolic categories. From the point of view of an analysis of these works that is both formal and functional, three categories can be identified:

1. Works with a specific symbolism related to water or other ceremonial fluids: the *paqcha* of Kenko (Plates 23 and 29); the channels associated with the zoomorphic sculptures in Kusillochoj (Plates 45 and 46), which in turn anticipate the meaning of the Saywite Monolith or the Rumihuasi in the same area; and, more specialized still, the fountain, *pila*, or bath of Lanlakuyoj, which appears to anticipate many other works of the same character, such as the bath of the *ñusta* in Ollantaytambo, Tampu Machay (Plate 48), the magnificent stepped sequence of *pilas* (Plate 62) in Machu Picchu, and so on;

2. Works that may properly be termed "sculptarchitectonic," whose functional configuration responds to a cosmological orientation: the "tabernacle" of Kenko Chico (Plate 33) or the Throne of the Inca in Suchuna (Plate 36);

3. Works such as the sculpture facing the slide (Plate 37) and its analogue (Plate 38), recently disinterred, in which a ritual function is inseparable from a symbolism that could be called endogenous because it appears to be born in a specific stone and to refer, in principle, to itself. This is definitely applicable to the works in category 3c of the classification I made above in reference to the paradigmatic meaning of the works at Kenko.

In Chinchero we find two more beautiful sculptures that can be placed in this last category. Both are aligned precisely along an axis that extends

south from the Chinkana, thus completing a structured system based on the cardinal orientations, unlike the valley of Cuzco where the inter-cardinal orientation southeast-northwest predominates. (The cosmological importance of this orientation is described above.)

The first of these sculptures is located about fifty yards up the incline toward the valley. It is known locally as Mesakaka (rock-table), an evident allusion to the "trays" so skillfully carved in its upper section that confer on it the unavoidable sense of a table or altar (Plate 52). Its elongated form (I found it partly covered by vegetation; see Alcina Franch 1983, 561, for photographs of the entire stone) extends along a north-south axis in such a way that its ritual functionality is oriented toward the east-west; this is confirmed by a cup carved on its western edge, which establishes an immediate association with the *paqcha* of the works in Kenko. In accordance with our theory of the reiteration of archetypal models, we could call this work a fusion of elements from the above-mentioned analogue of the work facing the slides and from the *paqcha* in Kenko Chico.

Kondorkaka (another local designation), located about a hundred yards away in the same directional axis as Mesakaka, also combines the features of two prototypes in *hanan* Cuzco. It is an ovoidal calcareous rock whose characteristic cavities caused by erosion are in marked contrast to the cubical hollows that appear on its northeast side and immediately link it to Chinkana Grande. However, in an odd place near the base, several much-eroded zoomorphic carvings appear, which relate it to our Piedra del Lagarto as well as to the animal forms in the rock formation of

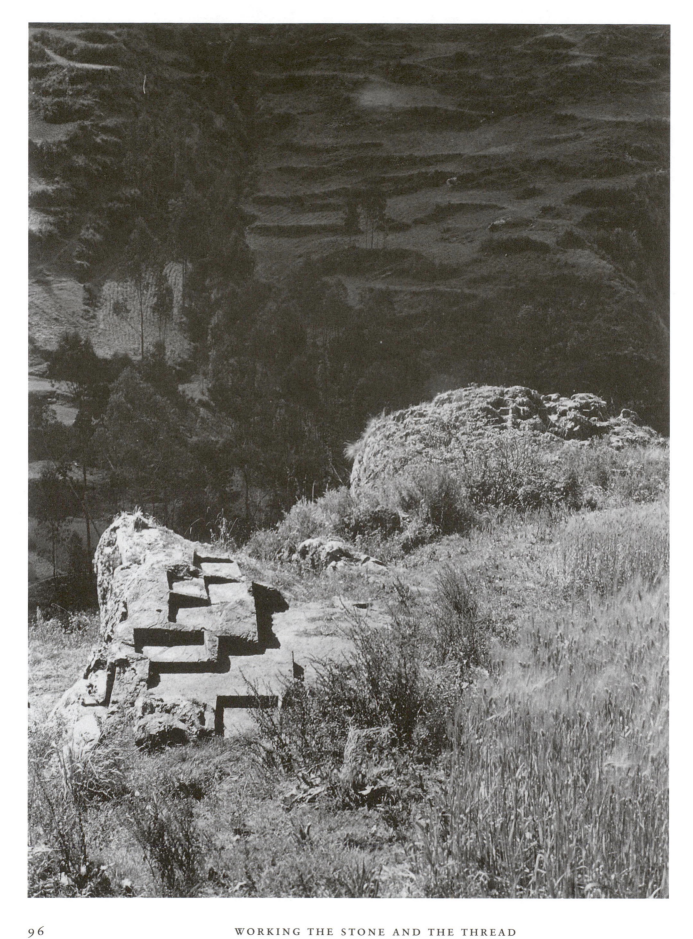

WORKING THE STONE AND THE THREAD

Kusillochoj, especially since one of the carvings in Kondorkaka appears to be a monkey.

In the urban zone of Chinchero, within the enclosure of structure XI—using Alcina Franch's maps (1983, 560)—is a work carved directly into the rock that is known as Pumakaka because of the felines carved into one of its sides. On first sight it appears to be a hybrid: from a structural and functional point of view it could be considered a platform or throne—in other words, an *usnu*, derived from the throne of Suchuna, according to our typology. Though its dimensions are smaller, it is oriented toward the ceremonial Great Plaza, the Capellanpampa, but inversely since it faces west-southwest. The carved felines reaffirm the sacred character of this structure and also remind us of the zoomorphic carvings of Kenko Grande and of the rock formation of Kusillochoj. It is unclear whether or not this *usnu* was completely enclosed within the structure; perhaps, in some unknown way, it "looked out" onto the ceremonial plaza through a window.

These, then, are the means by which certain of the sculptural models established in *hanan* Cuzco are repeated within the microcosm of Chinchero. In that sense, it only remains to be said that the area where the great sculpted rocks—Titikaka, Chinkana, Mesakaka, and Kondorkaka—are situated should be considered *hurin*, or lower, with respect to the plain where the architectonic remains (the urban zone) and the *usnu* Pumakaka are located. This apparent contradiction to *hanan* Cuzco can be resolved if we observe that, in its turn, the system of sculpted rocks would be *hanan* with respect to the valley that flows down from it and gives it the necessary cardinal east-west axis.

Samaipata

This huge and profusely sculpted rock formation is located in the Bolivian province of Santa Cruz, in an area that was the eastern boundary of the Qollasuyo quarter of the Inca state. It has an elongated shape extending about two hundred yards along the east/west cardinal axis by approximately sixty yards, which makes for an area of about twelve thousand square yards, quadrupling that of Kenko Grande's. The site was apparently associated with a nearby settlement, which must have been the seat of an Inca provincial governor and which is now covered by jungle (no excavations have been carried out yet).

Although a pre-Inca use of the site has been suggested (Boero Rojo and Rivera Sundt 1979), the sculptural works maintain a clear relationship with the Kenko prototypes: extending along the east/west direction for about a third of the upper surface of the outcrop are two straight channels (or elongated basins) intercalated between three rows of chains of rhomboidal grooves, all running parallel to each other. Longer than the straight ones, the rhomboidal grooves are associated with basins, which make them markedly analogous to the Vilcashuaman example documented by Hemming and Ranney (1982, 185) as well as with a portable *paqcha* (Plate 24; for Samaipata illustrations, see Hyslop 1990, Plate 4.22; also, Boero Rojo and Rivera Sundt 1979, 38 [for plan of the site], 79 [illustrations], 87 [photograph illustrating a Kenko Grande–like zigzagging groove issuing from a basin]).

NATURE AS THE GRAND SCALE

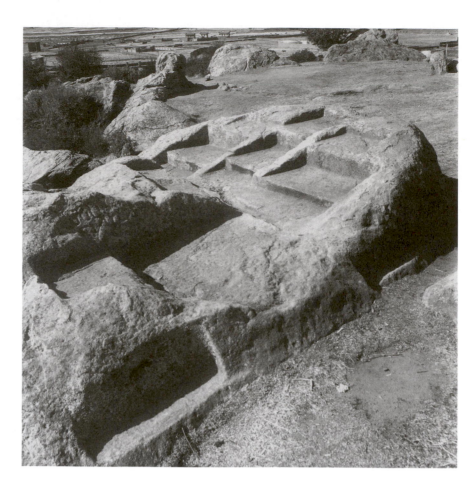

Shelves, niches, and step-cuts also abound; there is even a prone puma whose style recalls the carvings in certain walls in Huanuco Pampa (for illustration, see Morris and Thompson 1985, color plate 4), more than the primary examples of Kenko or Cusillochoj (for illustrations, see Hyslop 1990, 4.23; and Boero Rojo and Rivera Sundt 1979, 59, 71). Confirming the late character of these works, there appears on the north face (the entire formation stretches along the east-west axis, a manifestly accented direction) a series of niches, some of them full body and others smaller and double-jambed (Hyslop 1990, 123, Plate 4.21; Boero Rojo and Rivera Sundt 1979, 23, 75, 117). Though most of the niches basically are rectangular in shape, several of them openly verge on the trapezoidal, which gives them the appearance of "replicas" of architectural elements from the period of the Inca apogee. This sector of Samaipata is reminiscent of other architectonic examples carved into living rock, such as the Aztec temple of Malinalco, the Etruscan tombs of Cerveteri, the temple of Mahabalipuram in India, and the examples of ancient Egypt such as the tombs of Beni Hassan, the monumental temple of Ramses II in Abu Simbel (removed when the Aswan Dam was constructed), and, perhaps the most striking example of them all, the city of Petra in Jordan, although these examples are of much greater magnitude than Samaipata.

Since the nature of the establishment with which these carvings were associated is unknown, we could speculate indefinitely on the meaning of this manifest reversion to a ceremonial sculptarchitecture, combined, in this late phase, with the reproduction of the niches architectonically

perfected during the period that runs from the seminal works of Kenko to the Inca establishment in the Qollasuyo. Were they perhaps replacing a temple to the sun?

Seat of the Inca, Copacabana

The city of Copacabana, located on the peninsula of the same name (now a center of pilgrimage to the sanctuary of its eponymous virgin) grew out of a settlement inhabited by Incas and other *mitmaq* of the Tawantinsuyo (Hyslop 1990, 120). It has been suggested that, during the time of the Incas, the pilgrims who traveled to the sacred Islands of the Sun (from which, according to one of the origin myths, the sacred couple Manco Capac and Mama Ocllo emerged at the start of their foundational journey to Cuzco) and of the Moon (Koati) "would undergo purification rituals on the Copacabana peninsula before visiting the islands" (Ramos Gavilán 1976, 44, cited by Hyslop 1990, 120). These rituals may have taken place in the vicinity of the present-day city where a group of sculpted rocks known locally as the "Seat" or "Throne of the Inca" (Plate 53) is located.

The area (today fenced off with chicken wire in an unsuccessful attempt to preserve it from looters) measures around seven hundred square feet and resembles the rock formations of Kusillochoj. In their entirety, however, the sculptural modifications conform to several of the Kenko models: besides the "seats," steps, or "trays," we find a very crudely carved *paqcha,* with its corresponding ejecting channel, which, since it does not form a zigzag (*kenko*), is reminiscent of the channels adjoining the zoomorphic figures at Kusillochoj. The remains of crude and greatly deteriorated walls mark the boundaries of the sacred space and attest to its connection with the Kenko archetype.

The rocks displaying the most elaborate carvings do not have an a priori directional sense, but a close look reveals that the orientation of the sculptures is double-sided: some of them face the sunrise (*anti*), others the sunset (*konti*) (Plate 53). The eastward orientation is emphasized in another minor group. Only in a very generic sense could one speak of an orientation toward the Island of the Sun, as I did in the Spanish edition of this book.

CHAPTER 4

MACHU PICCHU

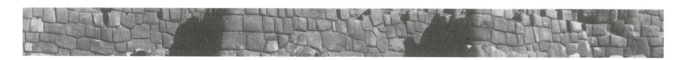

The sacred is impregnated with being.

MIRCEA ELIADE,
The Sacred and the Profane

I had come to the cut of the blade, the narrowest
channel in air, the shroud of field and stone,
the interstellar void of ultimate steps
and the awesome spiral way

.

Then up the ladder of the earth I climbed
through the barbed jungle's thickets
until I reached you Machu Picchu

PABLO NERUDA,
"The Heights of Machu Picchu"
(translated by Nathaniel Tarn)

Rising atop the imposing "old peak" (*machu picchu*), high above the vertiginous canyon of the Urubamba River (Plate 54), the astonishing achievement of the Inca empire, Machu Picchu, remained unknown until 1911. During the Spanish conquest, it lay well off the usual route between Cuzco and the Vilcabamba region, and neither the Incas nor the chroniclers mention its existence.

Beyond Ollantaytambo, the granitic gorge of the Urubamba once forced travelers to cross to the river's left bank by the Chuquichaca bridge. At the beginning of the twentieth century, the Peruvian governor had a road constructed from that point to facilitate exportation from the river's lower valley. In 1911, Hiram Bingham took advantage of the new road in his second exploratory journey. At the head of a sizable scientific expedition, he was led to the foot of Machu Picchu by a local man, Don Melchor Arteaga. On the mountain's summit above, buried under vegetation, were the fabulous ruins.

Was Machu Picchu the "university of idolatry" of which Fray Antonio de la Calancha wrote in 1638?

Its construction was probably planned by the Inca Pachakuti. Sarmiento de Gamboa states that, in the early stages of the territorial expansion, after Pachakuti had defeated the local caciques who had until then lived in a kind of confederative alliance with the Incas, Pachakuti "took as his chamber the Valley of Tampu, though it was not his" ([1572] 1907, 103).[1]

The region of Tampu is configured by the basin of the Urubamba River, which flows between the mountains and the unknown jungle region of

100

Amazonia. With its temperate climate and fertile valleys, it acquired a fundamental importance in the life of the growing Inca empire.

Other ethnohistoric references indicate that Yucay, in the region of the valley near Cuzco, was "the Inca's chamber," and that it did not belong to any of the *suyos* or provinces of the Tawantinsuyo (Wachtel 1976, 168). In my view, this reference should be taken as a complement to Sarmiento's statement, since there is no reason to exclude from the "chamber" the other substantial works that resulted from Inca settlement in the Tampu region: P'isaq, Ollantaytambo, and, finally, Machu Picchu, with its constellation of satellite centers: Runka Rucay, Sayac Marka, Chachabamba, Choquesuysuy, and Wiñay Wayna. Wachtel shares my view and assumes that the entire Sacred Valley, not just the Yucay region, belonged to the Inca. Moreover, the magnitude of the buildings in the unmistakably imperial architectural style only confirms what appears to be a will to expand Cuzco's jurisdiction. The expression "chamber" should be understood in this sense.

The Tampu region was also the setting for several crucial events in Andean history. When Manco Inca was thrown out of Ollantaytambo in 1537, he took refuge, along with his army and a large retinue of his subjects, in the region of Vilcabamba (Wachtel 1976, 127). From there he waged an active guerilla war against the Spaniards, but in 1545 he was assassinated by two Spanish soldiers to whom he had granted asylum. He was succeeded by his youngest son, Sayri Tupac, who would later ally himself with the Spaniards and convert to Christianity.

Meanwhile, in Vilcabamba, Sayri Tupac's half-brother Tito Cusi, Manco's illegitimate son, took power and continued resisting and harassing the Spaniards. Around 1560 he controlled a fairly wide territory, but after 1565 he began to negotiate with the invaders for the independence of the neo-Inca state, and he, too, was eventually baptized.[2] He died of a disease in 1571 and was succeeded by Tupac Amaru, another legitimate son of Manco Inca.[3] At that point the Viceroy of Toledo decided to finish off the Inca once and for all and sent a military expedition that overthrew the Inca Tupac Amaru, who was taken prisoner and executed in Cuzco in 1572.

As Luis Valcárcel tells us in his excellent work on Machu Picchu, Don Baltasar de Ocampo Conejeros, an old resident of Vilcabamba, left a description of the exaltation of the last of the Inca, whom he calls "Topa Amaro Inga." Ocampo Conejeros states that Topa Amaro Inga "was in the fortress of Pitcos, on a very high hill, where he ruled over most of the province of Vilcabamba, where he had a plaza of immense size and flatness of surface and most sumptuous buildings of great majesty made with great knowledge and art, and all the sills, of the principal doors and the lesser ones, in order to be worked as they are, are of marble stone, famously carved, from where they brought out the said Topa Amaro Inga and gave him their allegiance as their natural master" (cited by Valcárcel 1973, 89). Machu Picchu is the only constructed site in that region that corresponds to this description. Therefore, Valcárcel affirms, "Pitcos would be its true name—not an adulteration of Vitcos or Viticos (Manco Inca's first settlement in the Vilcabamba region) but of Piccho, the third toponymy that is associated with Machu Picchu and Huayna Picchu in the 18th-century document brought to light by García." He then points out:

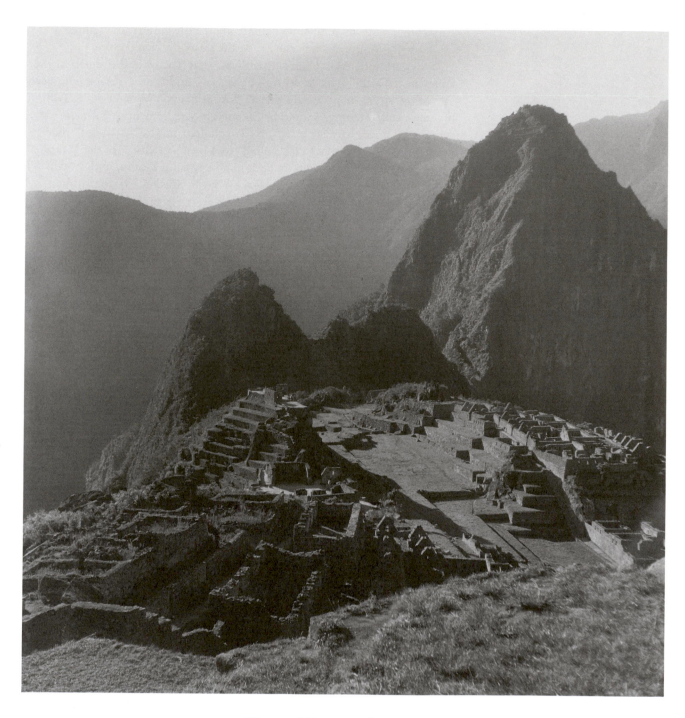

PLATE 54
View of Machu Picchu, Peru.
(Photo by the author.)

The word [Pitcos] refers not to a geographic accident but to a cultural product, an architectural construct which, as the narrator interprets it, was built with military ends in mind.

The suggested identification is also based on the fact that no other settlement which corresponds to that described by Baltasar de Ocampo is known to exist. None of them have the geographic location, the type of "marble stone" (in reality, white granite) architecture, the numerous "most sumptuous" buildings, or the great plaza. (1973, 90)

Fray Antonio de la Calancha, in his chronicle of the Augustine order in Peru (1638), refers to the difficulties two of its members had when they

requested the Inca's permission to visit the city where the convent of the "chosen" (*mamaconas*) was located. Valcárcel writes,

> *After many evasions the monarch finally consented and, in his company, together with several captains and his guard, they went by very rugged roads to the place.*
>
> *It took the Inca and the monks three days to arrive at the so-called Old Vilcabamba, the same amount of time needed to go from Pucyura (where the friars came from) to Machu Picchu. The monks did not lodge in the city but outside it, and it is very probable that they were unable to visit the temples and other buildings of the sacred city. The Inca took care to keep them at a distance so they would not learn about the city's rituals. (1973, 90–91)*

De la Calancha writes in his chronicle that Vilcabamba was the "largest city, where the university of idolatry was, and where the professors, wizards, and lords of abominations lived" (1638, cited by Valcárcel 1973, 91).

This is why Bingham thought he had discovered Old Vilcabamba, refuge of the Incas. However, for Valcárcel, Fray Antonio's "Vilcabamba" and Ocampo's "Pitcos" are one and the same place: Machu Picchu. Valcárcel also believes that "while the last rulers were situated in the sector of Vilcabamba, it is not impossible that, like the chosen virgins, the theologians and scholars retreated to Machu Picchu. Thus Bingham's hypothesis becomes admissible to a certain extent: Machu Picchu is Old Vilcabamba, 'university of idolatry,' (Pitcos!)" (1973, 96).

This interpretation is attractive indeed. I can find only one objection: If the settlement in Vilcabamba followed the model of Cuzco tradition, it is hard to understand why the leaders and theologians would have kept their residences separate, since in Cuzco, the sacred omphalos, it was the norm for them to live alongside each other. Nevertheless, it is possible that strict loyalty to the sacred tradition had weakened during the process of acculturation brought about by the presence of the other—the invader. Sayri Tupac and Tito Cusi, the Incas themselves, who were semidivine beings for the Inca religion of sun worship, had betrayed tradition by converting to Christianity. In the face of this, Machu Picchu may have been a "university of idolatry" indeed, dedicated to the preservation of religious orthodoxy.

The death of the Inca, and the consequent gradual breakup of the Tawantinsuyo, left this group of holdouts without a support system, without a universe of meaning. Thus, in their seclusion, defending something that no longer existed, they must have undergone a slow process of self-immolation.

To the secular mentality of our time, and especially to the scientific positivism that informs traditional archaeology, the magnitude of the public works undertaken by the Inca empire in the Tampu region is disconcerting, almost enigmatic.

From the urbanist point of view, none of these "cities" (except Ollantaytambo, which has an adjacent town), are cities at all in the strict sense of the term—neither P'isaq nor the satellite settlements of Machu Picchu nor even Machu Picchu itself. A calculation of its habitational capacity and the output of its agricultural terraces indicates that no more

than one thousand people can have lived in Machu Picchu, and many fewer in the satellite centers (perhaps only a few dozen in each of them). The same is true of P'isaq.

The difficult access to these centers, constructed atop steep mountains, has given rise to the belief that they were military fortifications—border cities. Bingham, impressed by the constructions that protect the entrance to Machu Picchu, believed this to be the case (1975, 165).[4] Both the ceremonial center of Ollantaytambo and the walls of Saqsaywaman have persistently been called "fortresses." It should be kept in mind, however, that while these constructions may indeed have had a military character, they were designed to defend those particular centers, which were of exceptional importance; it is a well-known fact that most Inca cities had neither defensive walls nor fortresses.

The idea that such immense effort was dedicated to building centers in which religious activity was paramount, if not exclusive, is now beginning to be accepted, though almost with disbelief.

The conclusions of Craig Morris and Donald Thompson with respect to the provincial Inca settlement of Huánuco Pampa are of interest here. Located in the central Peruvian sierra, 118 miles northeast of Lima and at 11,400 feet above sea level, this center comprises at least 3,500 foundations of buildings, which gives an idea of its magnitude. Many of the structures were *qollqa* (granaries or government warehouses) where food (principally corn destined for the production of the ceremonial drink *chicha*) and textiles were stored.

After carefully studying the abundant archaeological evidence and historical sources, Morris and Thompson do not conceal their surprise at finding that ceremonial life dominated the activities and the design of Huánuco Pampa. Though they observe obvious logistical aspects to the center's location on one of the principal roads, which made it part of the support system for the journeys that connected the various regions of the empire, they write, "The archaeological evidence does point to a clear emphasis on activities of a ritual or ceremonial nature. Furthermore, we suspect that most of the participants in these ceremonies and rituals were not permanent residents of the city. The point is that the rituals involved were a key aspect of administration" (Morris and Thompson 1985, 83; see also Morris 1988, 43).

The ceremonial spaces are three plazas placed along the east-west axis, which is manifestly an *accentuated* direction. But, according to Morris, "we will never know the exact nature of the ceremonies that took place in Huánuco Pampa" (Morris 1988, 47). Some of the evidence points to the celebration of ritual battles, which could have been observed by the authorities from the *usnu*, a rectangular stone platform in the imperial style, constructed in the vast central plaza.

This evidence sheds new light on the meaning of the Inca empire's immense constructions, which cannot be called urban centers, but which correspond to the functions of a governmental apparatus led by a semi-divine figure whose "administrative" functions, in the modern sense of the term, are almost impossible to differentiate.

The location in the Tampu region, which bordered on the unknown—the primordial chaos of the Amazon jungle—required an incorporation into

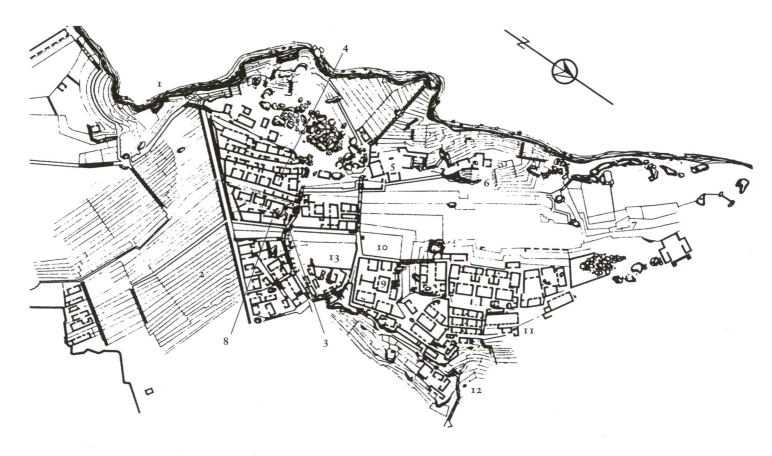

MAP 4

Plan of Machu Picchu. Key to places compiled by the author.

1. *Main entrance.*
2. *Agricultural terraces.*
3. *Sequence of stepped "baths."*
4. *Priestly residences.*
5. *Area of the "Open Temple" and the "Temple of Three Windows."*
6. *Intiwatana.*
7. *Northern agricultural terraces and access to Huayna Picchu.*
8. *"Royal Mausoleum/Torreon."*
9. *Mortar group.*
10. *"Industrial sector."*
11. *Kallanka.*
12. *Cemeteries.*
13. *"Prison group," "Condor" stone.*

the cosmos, a *consecration*: "to organize a space," writes Mircea Eliade, "is to repeat the paradigmatic work of the gods" (1959, 32).

Like P'isaq, the ceremonial center of Ollantaytambo, the buildings of Saqsaywaman, and the pyramids of Teotihuacán and Monte Albán in ancient Mexico, Machu Picchu was the symbol of the consecration of a space. In ancient America, religious motivation was the central and profound key to what we admire today as "works of art," however illogical their conception, or perhaps, because of that illogic. Wachtel puts it beautifully: "Machu Picchu, the astounding city, raised on a peak, a sculpted mountain whose vertiginous slopes dominate from a height of almost three thousand feet the curves of the rivers that embrace it: the Machu Picchu, high sacred place of the empire, sentinel of four worlds, between the sky and the earth, between the mountain and the jungle" (1976, 168).

By modifying a cave, a sculptor incorporates it into the sacred ambient and also creates the possibility of a communication with the underworld of the Ucu Pacha. The mountain, however, is the *apu,* the possibility of reaching the Hanan Pacha, the world of "above." Carved into the summit of a mountain, which is in itself a *wak'a,* Machu Picchu typifies at once the entrance to the cosmos and the *axis mundi* (Valcárcel 1973, 53).

As Mircea Eliade writes, "Religious architecture simply took over and developed the cosmological symbolism already present in the structure of primitive habitations" (1959, 56–57). The house is an *imago mundi,* the universe man constructs for himself in imitation of the paradigmatic creation of the gods. At first, the Tampu valley is the "chamber" the Inca took for himself "though it was not his." Later, the religious constructions

validate the paradigmatic model. Though the *axis mundi* of the Inca empire was Cuzco, one might posit that the entire Urubamba River valley was an extension of Cuzco's sacred ambient, constituting the nuclear axis of the Tawantinsuyo.

Machu Picchu is "like a mandala, enclosed in concentric circles within a square," Valcárcel observes (1973, 94). On the approach to the city by the actual route of the Incas, "One gate after another delays the traveller; each one must have had a name, but only the name of the last has been preserved: Intipunku or 'Gate of the Sun'" (1973, 63). Valcárcel concludes that "the modern entrance to Machu Picchu constitutes a sacrilegious rupture of its enclosure" (1973, 65).

Constructed on a spur that joins the summits of Machu Picchu (old peak) and Wayna Picchu (young peak), the city extends from the south—where its entrance is located—to the north (Map 4). Thus the great majority of its windows are ritually oriented toward the *anti,* the rising sun, or the *konti,* the setting sun (Plate 54).

"The whole is more impressive than the detail," write Gasparini and Margolies, "not so much for the spectacular beauty of the site as for the integration of architecture and environment" (1980, 79). Machu Picchu is an unparalleled example of "organic architecture": as the agricultural terraces flow down the steep slopes, the buildings adhere so closely to the topography that they appear to have sprung naturally from it. It is the consecration of an eminently *vertical* space; at every moment "above" and "below" stand out in a constant reiteration of the strata of the cosmos.

The principal temples and palaces lie in the *hanan* sector, the highest part of the city (Plate 54, left). Nevertheless, the quality of the masonry in the *hurin* sector (Plate 54, right) is not entirely mediocre (as would be the rule with secular residences). Moreover, certain architectonic and sculptural conceptions located there do not entirely fit in with the supposed "worldly" character of that sector, particularly the building called "prison" (Plate 67), one of whose walls is strangely contorted to "embrace" a crag in a way that is similar to something in the important Royal Mausoleum-"Tower" ceremonial complex (Plate 57, below). At the so-called prison, the sculpture in situ known as the "Condor" suggests a type of allegorical figuration whose meanings are different from those of a jail.

All of this reconfirms that the entire Machu Picchu complex had an all-encompassing sacred meaning that embraced the *hanan-hurin* hierarchies and the binary sense of opposition-complementarity.

The Intiwatana

On a crag that rises near the Open Temple—the pinnacle of Machu Picchu's *hanan* sector—lies one of the supreme works of Inca sculpture, the so-called Intiwatana (literally, "post where the sun is tied") (Plates 55 and 56).

The crag has been converted into a kind of stepped pyramid (an *usnu,* it has been suggested); the agricultural terraces sink along the eastern slope down to the principal plaza, while on the west they descend vertiginously to the river valley. Flights of carefully finished steps give access to the upper level. Some walls indicate that an enclosure must have existed there, perhaps to house the priest. The walls frame the first, surprising vision of

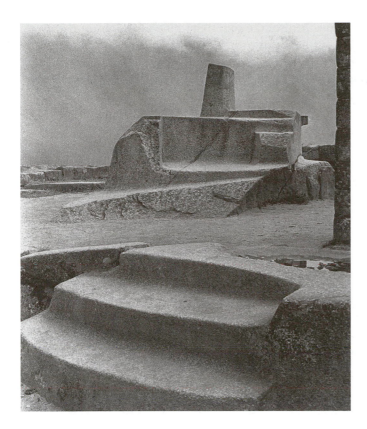

this magnificent work—could it be an abstract sculpture in the heart of the Andes?

Rowe has observed that the name Intiwatana does not figure in the chronicles nor in the first Quechua dictionaries, but it was evidently in use in the Urubamba when Squier visited Ollantaytambo and P'isaq and saw similar structures there. This leads Rowe to believe that the name came into use at a time when the function of these sculptures had been forgotten; he therefore proposes its elimination from the archaeological literature, though he allows its use as a toponym and in the sense of "cult objects, (which) may have symbolized the place spirit of the hills on which they stand" (1963, 328).

However, the visual evidence tells another story. Unlike other rocks carved in situ, this is a genuine sculpture in the round. Though the rear part is of less interest, the impeccable polish of the planes in the rear of the work denotes a total sculptural will. Like any magnum opus, it is a felicitous synthesis of the vocabulary: the stepped cuts, the concavity carved into the straight planes of a "seat," all structured in characteristic asymmetric form and graduated in a long ascent to the apex, the pillar where "the sun was tied." The symbolic design is crystal clear: the unquestionable emphasis placed on the pillar, which, as a gnomon, must always project a shadow, signals a link to sun worship, if only in a generic way. The modest size of the gnomon did not allow for complex observations, but it did provide the minimum necessary to establish the ritual patterns.

The Intiwatana was a "solar observatory," Valcárcel states summarily (1973, 94). And there are sufficient references in the work of Polo de Ondegardo, Cobo, and Garcilaso de la Vega to establish that the Incas did

indeed observe the movement of the sun. According to the chroniclers, there were a number of pillars—the *sucancas*—on the horizon of Cuzco, which were used to determine the extreme points of the sunrise and sunset during the year, thus indicating the times for planting. What's more, Polo states that the *sucancas* "were principal shrines to which various sacrifices were offered" ([1571] 1916, 16). These pillars were, no doubt, carefully destroyed during the Spanish campaign "to eliminate idolatry." The same fate was met by P'isaq's Intiwatana (Plate 15), as well as another pillar found on the slope of Lacco.[5] It isn't hard to imagine the haste with which the missionaries would have ordered the demolition of the Intiwatana of Machu Picchu, but fortunately the hidden location of that center preserved it for posterity.

All of this serves to reaffirm the symbolic meaning of these structures. But there is more: the frontal face of the Intiwatana, defined by the "seat," is oriented toward the southeast, as is the rectangular pillar, which is especially accentuated within Inca cosmology.

At Machu Picchu, the southeast is the direction in which Cuzco, origin of the Inca world, lies—like a Mecca. Etymologically, the word "origin" comes from the Latin *origo,* which in turn derives from *oriri* (the coming out of the stars). Toward the southeast, in precisely the same direction as Cuzco, was where "the sun was born," the sun of December, time of fertilizing rains that renewed the cosmic cycle.

Beyond the riverbed's meanderings, the fundamental orientation of the Urubamba valley (whose ancient name, according to Valcárcel [1973, 18], was Willkanuta, "house of the sun") is also northwest-southeast. This valley is the spine of the Tampu region, which the Inca "took for his chamber." We will see again and again how the greatest symbolic structures built in this area and oriented along the same cosmological axis validate the sense of virtual unification with the sacred space of Cuzco that is suggested by the ethnohistoric sources.[6]

"Royal Mausoleum-Tower"

The use of such terms as "king's quarters," "door of the snakes," "industrial sector," and "prison" has been perpetuated since the discovery of Machu Picchu. The narrowness of this interpretative criterion impedes an understanding of the enigmatic center. But it is especially damaging in the case of the "mausoleum" and the "tower": when they are separated, perhaps in order to be understood, and assigned different functions, the univocal meaning they must have had for the Incas is distorted. This is a single monument (Plate 57), which, like the majority of Inca symbolic structures, functioned on more than one level of meaning. Ubbelohde-Doering observes, "In any case, this complex must be treated as a unity and only thus can it be explained" (1967, 256).

In Machu Picchu's numinous environment, the sense of nature as a hierophany—stone and water as exteriorizations of the sacred—becomes even more evident. In the case of rocks that were especially venerated, the hierophany is intensified: the "formalist" impulse that begins in the works at Kenko heightens the venerated rocks with sculptural modifications.

The impressive rock where the "mausoleum-tower" was constructed was a *wak'a,* a sanctuary. The magnitude of the sculptural and architec-

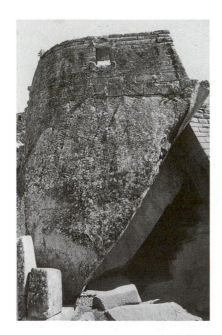

PLATE 57
"Royal Mausoleum–Tower (Torreón)," Hanan sector, Machu Picchu. (Photo by the author.)

tonic work that sets it off is a measure of its immanent sacredness. (In Plate 16, another architectonic setting is shown—the rock where the *intiwatana* of P'isaq are located.)

The cusp of this crag has been subtly sculpted (Plate 58) and girdled by a semicircular wall with two windows; Ubbelohde-Doering points out that "the tower is not an independent building, but curves in an irregular semicircle around the sacred rock. The mortarless masonry is so precisely adapted to the natural rock that the two appear to be continuous" (1967, 255).

The "strategic" orientation of this crag, the wall and its windows, made it seem at first to be a watchtower, a lookout point. In reality, it must have been exactly that but with a decidedly nonmilitary character: one of the windows opens toward the southeast, reaffirming the orientation of the Intiwatana; the other—apparently the more important one (Plate 58, center)—is aligned toward the northeast, framing both the rising of the sun and the reappearance of the Pleiades in mid-June, the winter solstice in the southern hemisphere. This constellation, called *qollqa* (granary), is intimately linked to the agricultural cycle.[7] Moreover, the rock has a natural, rectangular prominence accentuated by the sculptor, the long side of which is oriented in the direction of the solstice. In my opinion, the window that frames the celestial phenomenon does no more than formally define the natural orientation of the rock, which may have been the reason for its exaltation as a *wak'a*. In the lower part, the entrance to the "mausoleum" also opens in the same direction—an accentuated direction, with manifest ceremonial meaning.

The wall's external face has four protuberances, one at each corner of the northeast window. The other face presents a similar design but with only two protuberances, which are aligned with those of the base in the direction of the first window. It is evident that the number and disposition of these discrete projections, which I will discuss more extensively later, must have had a meaning, probably related to the observations (ceremonies) framed by the windows. Ubbelohde-Doering perceptively notes, with reference to the first window: "The four projections at the corners of the window serve no practical purpose; they must have had symbolic meaning for the ancients. They recall the projections on the Choquequilla stone in the Huaracondo gorge, which appear certainly pure symbols" (1967, 255).

The entrance to the "mausoleum" is covered partially by a sculpture composed of stepped cuts (Plate 59). To cover an empty space between the sculpture and the natural rock of the slope—a space that must have seemed indecorous—a section of masonry has been inserted in a display of virtuosity so extreme as to border on the extravagant. The masonry continues in the interior of the cave, covering two walls (the enclosure is completed by the gigantic natural rock), and is composed of regular rows of the most carefully finished blocks. The same care has been taken with the four ceremonial niches (two in each wall) and in the enigmatic cylindrical pegs inserted between them. On the floor, a smaller rock has been sculpted in stepped cuts, creating a formal echo of the one in the entryway; it has unthinkingly been called a gnomon (in the darkness?).

This whole laborious blend of sculpture and architecture serves only to heighten the sacredness of this space, "all entryway and interior." Hemming calls it "a hollow sculpture of great beauty, three-dimensional and

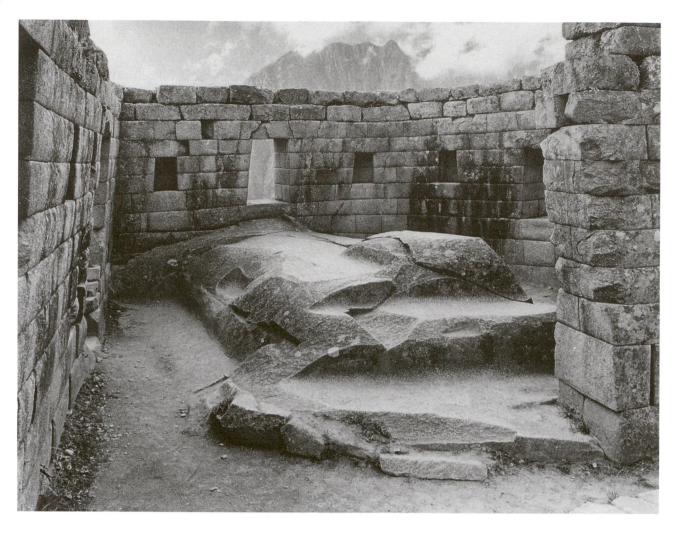

PLATE 58 (ABOVE)
Sculpted cusp of the crag, inside the "Tower" above the "Royal Mausoleum." (Photo by the author.)

PLATE 59 (RIGHT)
Rock sculpted as alternate steps, entrance to the "Royal Mausoleum." (Photo by the author.)

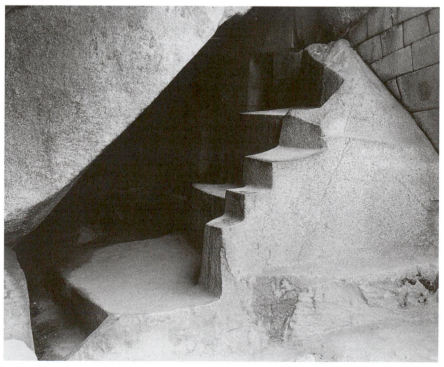

WORKING THE STONE AND THE THREAD

plastic, with strange shadows and a deep sense of religious mystery" (1982, 136).

The sculpture in the doorway is of particular interest as perhaps the most complete and explicit example of the "flight of steps" functioning purely as a symbol.

The symbolic intentionality of the stepped form or sign is perhaps better appreciated in its flat version, the abstract profile of a flight of steps, which probably originated in basketry and passed from there to weaving and ceramics. Together with the bird of prey, the feline, and the reptile, it is one of the primordial symbolic forms of ancient America, though of scant relevance in the Old World.

However, unlike the zoomorphic representations whose symbolism has been copiously studied, the stepped sign is generally included in the undifferentiated category of "geometric decoration" or, worse, "space-filler." In Andean architecture, it is invariably associated with the stepped reliefs in the Tiwanaku ruins, especially in the Gate of the Sun, and the long tradition this sign has in weaving and ceramics is forgotten. (In Chapter 6, which deals with the ruins of Ollantaytambo, I will discuss this limited interpretative criterion more extensively.)

The three-dimensional version of the textile sign is obviously the stairway or the simple flight of steps. Its primordial function as an architectonic element—to make possible ascent and descent between levels of different heights—has obscured, or rather has made us forget, its primitive symbolic meaning. Inca sculpture is unique in this sense: by creating "useless" steps, it validates the archetypal character of the form. As Hébert-Stevens writes: "The symbolism suggested by the stairway is vast. It expresses the passage from one region to another, from one state to another. The act of moving up or down steps plays an important role in the rites of initiation, in those of royal or priestly ascension, and, finally, in marriage rites. Through its diverse ramifications, the coherence of the stairway's symbolism resides in the association-opposition of high and low" (1972, 116).

In Western architecture, a concern for making ascent and descent easier exists, but in America the steep, laborious stairway of the Temple of Kukulcan in Chichén Itzá, for example, forces us to relive its severe ceremonial meaning.

The meticulous example of the "mausoleum" entrance is anticipated in the rocks at Kenko. In the infinity of stepped cuts at Kenko, some are easily transitable, others would require near-acrobatic skill to be ascended. These examples suggest the purely symbolic meaning of the stepped carvings, and their appearance in the steep slopes of the hill at Lacco or the rock at Chinkana, where they have been conceived only "to be seen" only as murals, reconfirms this first impression.

Moreover, among the rocks of Kenko Chico is a primary version of what I called the "alternating stair" (Plate 32). What could go unnoticed among the stepped cuts repeated ad infinitum at Kenko is unmistakable in the entrance to the "mausoleum." The rock has been sculpted in two series of steps: on the outer side are four cuts, while in the interior (Plate 60) the same distance has been cut into three ample steps, whose proportions more nearly resemble tables or shelves. The alternating, contrapuntal formulation of these flights of steps is repeated in one of the sculptures at

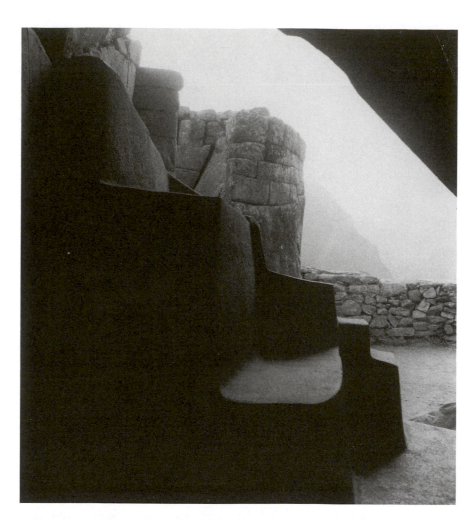

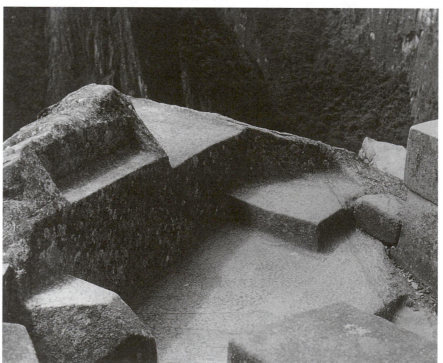

PLATE 60
*Alternate steps sculpture, interior
of the "Royal Mausoleum."
(Photo by the author.)*

PLATE 61
Throne or usnu, *Machu Picchu.
(Photo by the author.)*

Saywite (Plate 74), but there it also has the function of granting access to the upper platform.

This fundamentally asymmetric structure of alternating steps also appears, though in a more subtle way, in the Intiwatana (Plate 55). In each arm of the "chair," stepped cuts of different heights can be seen. Though here they are less cleanly cut than in the "mausoleum," they have an identical symbolic character: their mission is to guide the eye toward the apex.

If the symbolic intentionality of the sculpture at the entrance to the "mausoleum" is evident, its specific meaning eludes us. On the one hand, the inner space, like a cave, invokes communication with the Ucu Pacha, the chthonic underworld, within the Inca cosmogony. But the gradation of the steps seems to signal something more. Perhaps it linked the realm of the Kay Pacha, the "here," to the Hanan Pacha, the "beyond," a metaphor that appears to condense the sense of cosmic verticality of the *machu picchu,* the "old peak." Or perhaps, in a more restricted sense, it serves to underscore the ascent to the ceremonial cusp, the so-called tower.

The religious meaning of this "mausoleum-tower" complex is reaffirmed by the sculptarchitectonic works that appear in its immediate vicinity:

1. A throne (*usnu?*), carved into the living rock, at the edge of a terrace that is somewhat lower than the "tower" (Plate 61). It could be one of those "sentry posts" or some other similar designation, except that it turns its back on the city and is oriented exclusively toward the neighboring "tower" (it is visible from the so-called Door of the Serpents), as if to revalidate the transcendence of that site. The asymmetric composition (the result of an adaptation to the natural structure of the rock) and the animated change of levels of the flat cuts, as well as the alternating contrast of their polished finish with the natural roughness of the rock, make this one of the anonymous gems of Inca sculpture. Curiously, it escaped from the exhaustive photographic inventory carried out by Edward Ranney.

2. A stepped sequence of ponds. Water, *font et origo,* fundamental factor of life, was for the Incas another manifestation of the sacred, a hierophany. This series of ponds, or "baths" as they are generally called, exteriorizes what we had already characterized as a "water cult," following Rebecca Carrión Cachot. For that reason, we must consider them *paqchas,* the central symbol of the cult. Carrión Cachot bases her idea on the definition that Ludovico Bertonio gives in his 1602 *Vocabulario:* "Fountains that pour out water through a channel," and "wooden instrument from which they sip *chicha* as a pastime, running through a trough." She thus concludes that there are two classes of *paqcha* (which she spells *paccha*): the class that interests us here is the one cut "into the rocks with miniature wells, ponds and channels of simple or complex form" (1955, 24). In that sense, the cup and zigzagged channel in Kenko is prototypical; a similar sculptural concept is repeated in Inca votive and ceremonial objects (Plate 24 and Fig. 14), carved in wood or stone, which represent the other, "portable" version of the *paqcha.* Though the ponds of Machu Picchu differ somewhat from this description, they have a primordial religious meaning. They are fonts, like baptismal fonts (Plate 62).

A. indien du Chili en Macuñ jouant a la Sueca, jeu de croce.
B. indienne en Choñi, C. Cahouin touhan ou fête des indiens
D. Gardes Espagnols pour empecher le desordre. E. Pivellca ou Sifflet
F. Paquecha ou tasse a bec. G. Coulthun ou tambour. H. Thouthouca ou tromp

FIGURE 14
Drawing by Frazier, published by
T. A. Joyce, Inca, *vol. 1 (Lima,*
1923), p. 4. Reprinted by Carrion
Cachot (1955, 97).

Water is not abundant in Machu Picchu; the water that filled these fonts came from a spring and was collected in cisterns at the top of the hill. While the possibility that they also may have been "baths" cannot be ruled out, they must have had a high ritual meaning for those who used them, probably only the Sapa Inca and the priests of highest rank.

The ponds differ from the prototypical form of the *paqcha,* but only in that the channels connecting them are shorter and straighter. In any case, they are still "fountains that pour out water through a channel," as Bertonio defined them. It should be recalled as well that this work, belonging to the so-called imperial period, is posterior to the works at Kenko. While the works at the earlier site were purely sculptural, by the time of Machu Picchu's construction the fusion of architecture and sculpture was becoming more pronounced, and the ponds are a primary example of this fusion. It could also be conjectured that, with the passing of time and the development of increasingly advanced construction techniques, the original form of the *paqcha* was deliberately reformulated to accentuate its character as a religious monument.

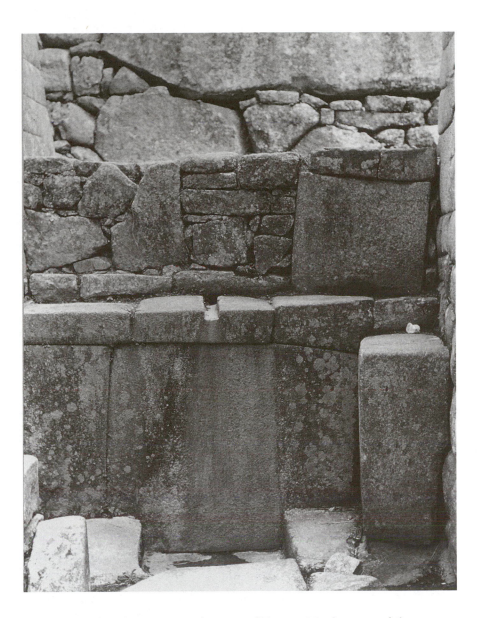

The works at the ceremonial center of Tampu Machay are of the same order (Plates 47 and 48). But in Machu Picchu, as in Choquesuysuy and Saywite, the stepped sequence of ponds is at once an organic adaptation to the natural slope and a revalidation of the general symbolism that communicates the "high" with the "low."[8]

The Temple of the Three Windows and the Open Temple, which follow each other in the trajectory delimited by the "mausoleum-tower" to the south and the crag where the Intiwatana stands to the north, conclude the description of this ceremonial complex.

Like the tower, the three windows (Plate 63) are oriented toward the northeast, toward the *anti* of the winter solstice. Bingham (1975) believed they represented the orifices of the cave of Tamputoqo, from which the Ayar brothers, mythic founders of the Inca lineage, emerged. The Open Temple (Plate 64), however, another structure of unmistakable ceremonial importance, opens toward the southeast, so as to reestablish the orientation of the Intiwatana and of one of the tower windows.

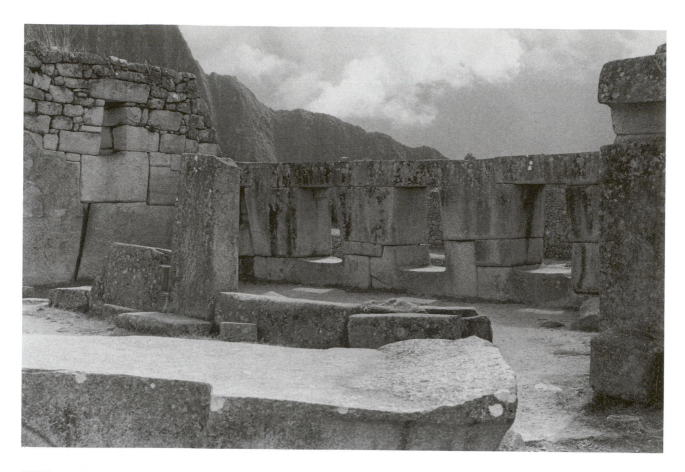

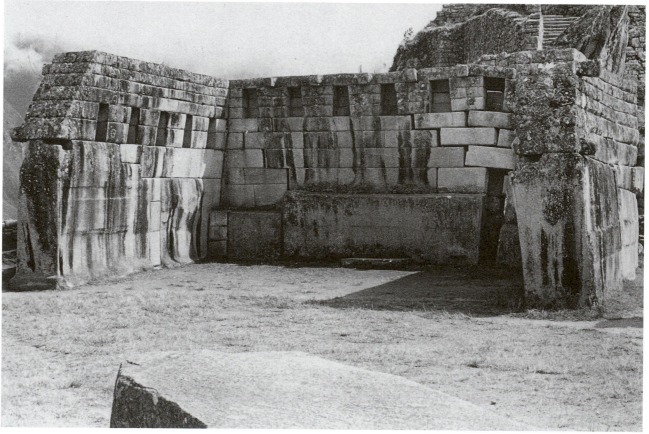

WORKING THE STONE AND THE THREAD

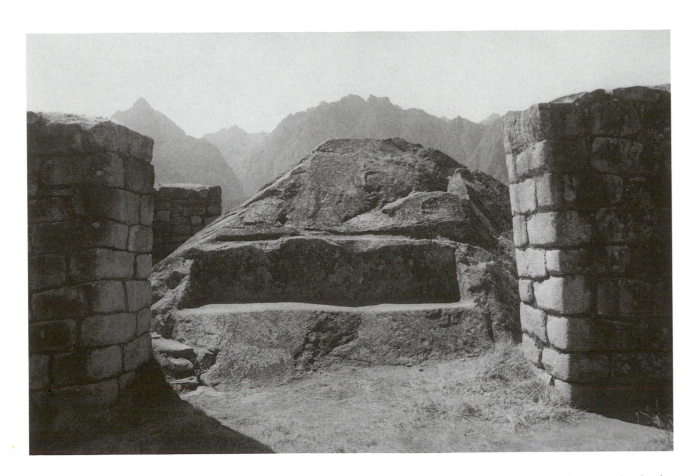

PLATE 63
(OPPOSITE PAGE, TOP)
Temple of the Three Windows,
Machu Picchu. (Photo by the
author.)

PLATE 64
(OPPOSITE PAGE, BOTTOM)
Open Temple, Machu Picchu. (Photo
by the author.)

PLATE 65 (ABOVE)
Sculpted rock, enclosed within
semicircular wall, Hurin sector,
Machu Picchu. (Photo by the
author.)

Though an architectonic conception predominates in these works, both present notable examples of sculptural stonework, a distinctive characteristic of Inca religious constructions. The use of large blocks, carefully carved to be incorporated into the walls, did not escape the notice of Ubbelohde-Doering, who called the Open Temple the "House of the Altar":

In the walls of this temple, even more than in those of the House of the Three Windows, there appear great monoliths reminiscent of Ollantay-tambo, the work of Inca master-builders of an earlier or later period. They cannot be far removed in time from those who built at that site. The terminal monolith in the left sidewall of the temple projects forward; it is ten feet, three inches long, eight feet high and two feet, six inches thick. The light-grey granite is wonderfully worked and the outcurving foot of the block is like the pedestal of a statue. The niches recall those at Ollantaytambo and at the Coricancha, the sun temple at Cuzco. (1967, 256)

Sculptures in the Hurin Sector

Finally we return to the Hurin sector of Machu Picchu to inventory the area's principal works sculpted in situ.

Though none of the works of Hurin approaches the quality of Intiwatana or of the symbolic steps at the entrance to the "mausoleum" in which the artist's labor has practically subsumed the original rock, the works in Hurin cannot be dismissed. At the very least, they establish a

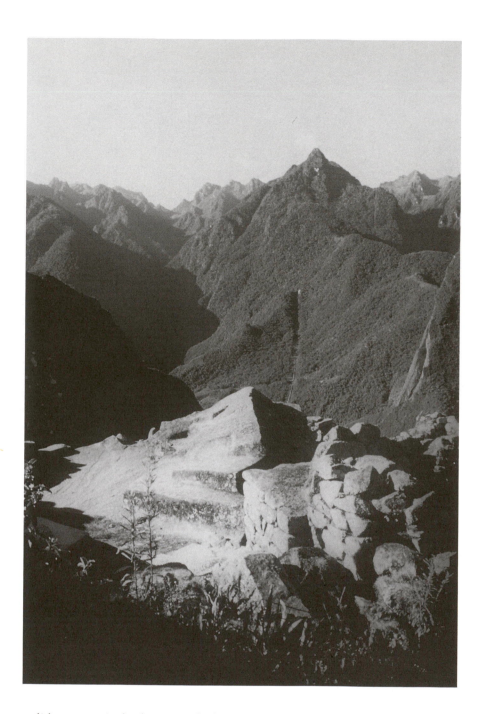

PLATE 66
Sculpted rock, eastern border
of Machu Picchu, Hurin sector.
(Photo by Francis Cincotta.)

valid symmetrical relation with those of Hanan, which, here in Machu
Picchu, appear to be their immediate archetypal models.

Two works in Hurin manifestly refer to the rock framed by a semicircu-
lar wall—the "tower." One of them, at the city's eastern edge, is power-
fully conic in shape—an *apu* in miniature that belies or "opposes" the
horizontality of the tower. It has been cut near the base into a well-defined
"seat," and it is set off by two walls, as if it had been placed in parenthe-
ses, but the walls do not have observation windows. Like the other rock
we will discuss later, this small *apu* duplicates the silhouette of one of the
peaks in the mountains beyond the Urubamba River valley (Plate 65). A
simultaneous view of the original mountain and its small duplicate is made
possible by the fact that the parenthetical walls open to the east.

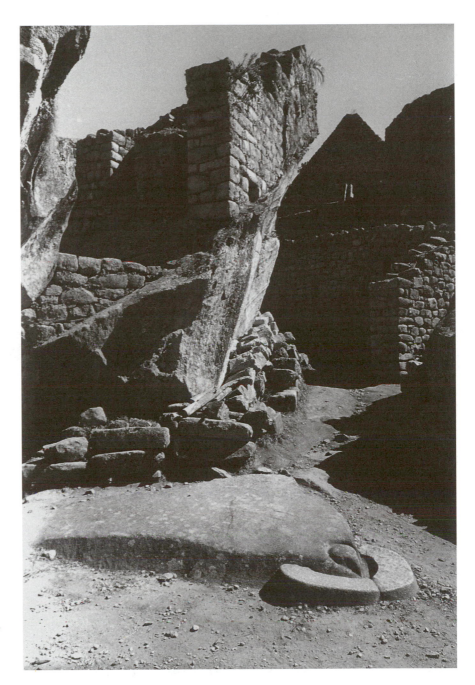

PLATE 67
"Condor" sculpture in the "Prison" area, Hurin sector, Machu Picchu. (Photo by the author.)

This rock is not far from the "prison" group, at the highest point of the Hurin sector, and near it appears the second of the sector's rocks framed by walls. This second rock is similar in shape to the first and could almost be viewed as a replica. As a distinctive trait, its wall has ceremonial niches (*wak'a* of a second order?). The wall's finish, however, is mediocre, though not much worse than the walls near the first rock.

Near the "intellectuals' quarter" and the enclosure "of the mortars," in the central zone of Hurin, is another rock outcrop set off by walls. Here a close relation is established between the rock structure and the architecture; on one face, more to the west, the rock has been cut into a meticulous platform surrounded at its base by well-crafted walls that are linked to the rock. The whole has the shape of a U open to the south-southeast,

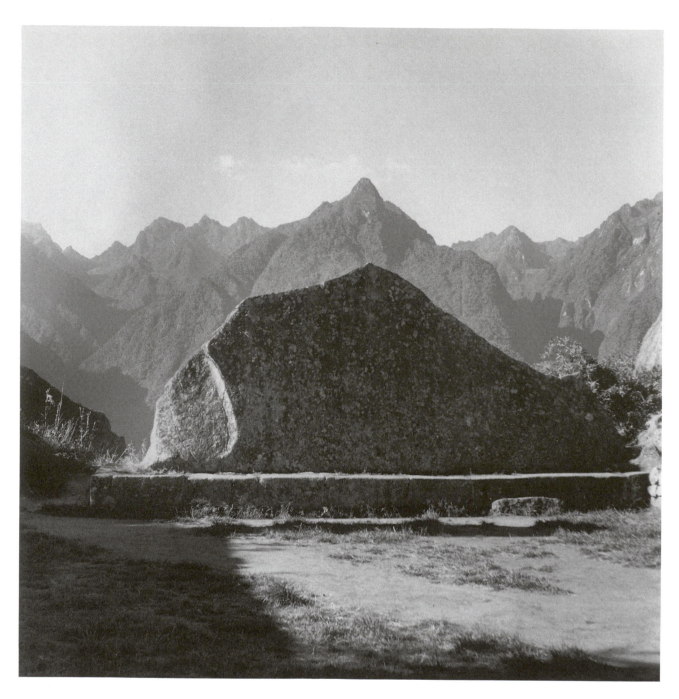

PLATE 68
Sacred rock, northeastern end,
Machu Picchu, Hurin sector.
(Photo by the author.)

the same orientation as the five ceremonial niches in the rear wall, which are an immediate reference to the imposing structure of the Open Temple in Hanan; but, while the Open Temple has a definitely architectonic conception, the Hurin work establishes a close dialogue between the construction and the carved natural rock. This is reconfirmed by another rock, directly beside it to the east, which presents some small carvings in its upper part while its base has been finished with two impeccable stairways.

In the eastern boundary of Hurin, farther to the north than the works just discussed, we find another rock sculpted in situ (Plate 66). But this rock, resolved in an exquisite counterpoint of polished stepped reliefs and natural texture, would appear to be a return to the models of an endog-

WORKING THE STONE AND THE THREAD

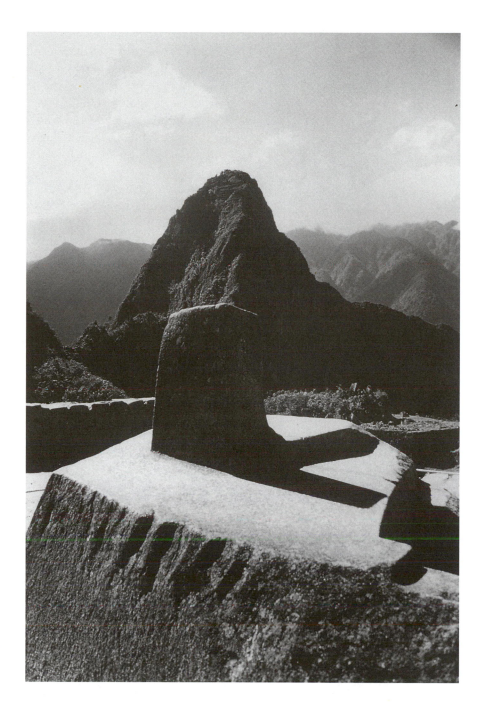

enous order that we observed facing the slides in the Suchuna area. We cannot fail to note that, although there is no enclosure, its horizontality takes the "tower" rock as its referent.

I have already mentioned the work associated with the edifice called "prison," which is known as Condor (Plate 67, below). But its figurative conception is such an extreme synthesis that it verges on abstract symbolism. This kind of reductive version of animal forms is more evident in the later examples of votive representations of llamas and alpacas (Fig. 35) than in the rustic naturalism of the figures at Kusillochoj, for example.

The natural rock found at the northeast limits of Machu Picchu is a *wak'a* (Plate 68). Its most distinctive feature—an immediate confirmation of its sacredness—is its triangular silhouette, which paraphrases the profile

of a mountain beyond the valley that was undoubtedly worshiped as an *apu*. In consequence, as was de rigueur, it was heightened by a pedestal of fine masonry, like the puma rock of Kenko.

To our Western minds, one of the most difficult aspects of Inca art to reconstruct in its totality is that of the relationship established between a work of sculpture or architecture and its natural surroundings. This difficulty arises simply because today we lack any concrete reference to the cultural patterns that made such relations viable and, therefore, we don't know where to look.

In his stimulating book *The Earth, the Temple and the Gods,* architect Vincent Scully expresses the symbolic power that, in antiquity, permeated the earth itself: "It was not a 'picture' but a true force which physically embodied the powers that ruled the world" (1969, 3). He identifies certain traits of the Greek landscape—"horn-shaped" mountains or conical hills in the form of breasts or bellies—as attributes of the earth goddess; the temples established an interaction with these traits that intensified their religious meaning.

The Greek landscape pales in comparison to the breathtaking grandeur of the Andean mountains, the venerated *apu*. And perhaps nowhere else is the interaction between cultural productions—architecture and sculpture—and the numinous natural environment felt as strongly as in Machu Picchu. In some cases, a spontaneous relationship like the one I have just mentioned is produced: the unmodified rock imitates the profile of the distant *apu*. It is the sculptor's work that establishes the formal and significant link in other cases as with the pillar of the Intiwatana, which seen from the south replicates the elevation of Huayna Picchu (Plate 69), or the "pillow" of the "Funerary Rock" near the ancient entryway to the city.

In any case, this aspect of the investigation would require a prolonged stay at the site in order to record, from a contemporary perspective (which may not be at all like that of the Incas) the diverse angles of relations between the sculpture, the architecture, and the landscape. Moreover, these relations must have depended on variations of light at different hours of the day and in different seasons.

Before concluding, I want to emphasize a fact that is particularly notable in Machu Picchu: the symbolic reading of sculptural stonework is manifestly clear here. In the entire enclosure the walls are largely of the rectangular order, with regular rows of blocks, but their quality is far from being as uniform as it is in the ceremonial area of P'isaq, another construction in the same style. Precisely for that reason, in Machu Picchu, walls with a higher-quality finish are an irrefutable indicator of the symbolic importance of the sector in which they are located.

SAYWITE

When Ephraim George Squier visited Saywite (Plate 70), he called it "the distant and elevated point known as Concacha, near Abancay" (1877, 555). Saywite also was visited by the French traveler Charles Wiener, who published an account of his journey through Peru and Bolivia in 1880. Ubbelohde-Doering explored the site in the 1930s and called the sculptures the "'Concacha Stones' . . . also called the Saihuite stones, since they are on a farm of that name. I use the first name which has become established in the literature" (1967, 250). Later, in 1954, Rebeca Carrión Cachot headed a commission that carried out exploratory work on the area, which at that point she called Saihuite. Like other authors, I used to use the name Sawite or Sahuite; but now, in accordance with a suggestion of Robert Randall's, I understand that Saywite—from *saywayta* (place of orientation)—is the more correct name for this archaeological site located 28 miles before reaching the town of Abancay, and 110 miles to the west of Cuzco, on the edge of the Curahuasi valley.

Given the vandalism suffered by the figures sculpted in the Saywite Monolith, as the first of the works seen from the road is designated, it can be inferred that the iconoclastic fury of Spanish missionaries passed through here in the sixteenth and seventeenth centuries during some of the various campaigns to eliminate idolatry. According to Ubbelohde-Doering, "The damage seems to be old since the surface of the broken parts is as weathered as the rest" (1967, 250) (see Plate 71 and Fig. 15).

No direct historical references to Saywite exist, but John Hemming believes that the sanctuary-oracle of Apurimac was located there. Hernando de Santillán relates that the important coastal oracle of Pachacamac told Inca Tupac Yupanqui (the tenth Inca, son of Pachakuti)

that Pachacamac had four sanctuary-oracle "sons," one of which was "near Andahuaylas," toward the Apurimac River (cited by Hemming and Ranney 1982, 165). Hemming then cites the descriptions of this sanctuary by Pedro Sancho (Francisco Pizarro's secretary) and Pedro Pizarro. The latter's very detailed account refers to a "painted room" where there was a thick post encircled by a band of gold and dressed in delicate women's clothing, along with other lesser idols (cited by Hemming and Ranney 1982, 165).

Cieza de León, whose testimony is greatly valued by scholars, also mentions the "Apurimac oracle," but unlike Santillán he places it on the right bank of the river: "Past this river [the Apurimac], it can then be seen where the lodgings of the Incas were, and where they had an oracle, and the demon answered (to what the Indians said) through the trunk of a tree, next to which they buried gold and made their sacrifices" ([1553] n.d., 424). Here Cieza is on the road to Cuzco, which is the subject of his next chapter, so there can be no doubt of the geographic location he gives. This discrepancy weakens Hemming's historical argument. And, though the remains of the ceremonial center of Saywite are indeed on the left bank of the Apurimac, though not precisely "near Andahuaylas," I think it would be hasty to assume that the Saywite works belong to the sanctuary-oracle of Apurimac until the ruins of the "painted room" of which Pizarro speaks are located.

This site could be considered within the zone of influence—the basin—of the Apurimac River (a name meaning "he who speaks," or "god who speaks," according to José María Arguedas's translation [1972, 26]); nevertheless, it should not be concluded that Saywite's ceremonial functions were related to the torrential river. Here, the sound of the river's "speaking" has been left far behind, more than forty miles behind as you arrive from Cuzco. The Saywite works are in a zone of *puquios* (springs) and all the archaeological evidence suggests the celebration of rituals linked to the worship of water and of the fertilizing rains.

The Inca affiliation of these works is unquestionable. We have already observed the figures of monkeys, felines, and birds carved into the rock formations of Hanan Cuzco, and in Kusillochoj especially (Plates 45 and 46); the close stylistic relation that these carvings have with the figures of the Saywite Monolith (Plates 71 and 72) did not escape Ubbelohde-Doering, who perceptively pointed out this formal kinship (1967, 250). Curiously, he did not notice a detail that makes the link even more intimate; a rustic channel was carved beside the figure of a puma and beside that of a monkey, though in separate rocks. Thus, the Saywite Monolith evinces a decision to unite in a whole, in a great *paqcha* or "symbolic fountain," these archetypal models that in Kusillochoj are separated.

The abstract, aniconic symbolism of the remaining works, the so-called Rumihuasi (Plates 73–75) and the one I call Third Stone (Plate 76), is also anticipated in the prototypes of Hanan Cuzco: I am thinking of the cup with its zigzagging channel—the *paqcha*—in Kenko (Plate 23) and, obviously, of the profusion of facetings and stepped cuts.

The zoomorphic carvings and channels of the Saywite Monolith also create an intriguing analogy with the Fountain of Lavapatas (Fig. 16) in the archaeological area of San Agustín in southern Colombia, which is generally assumed to be associated with the statuary of that region. The

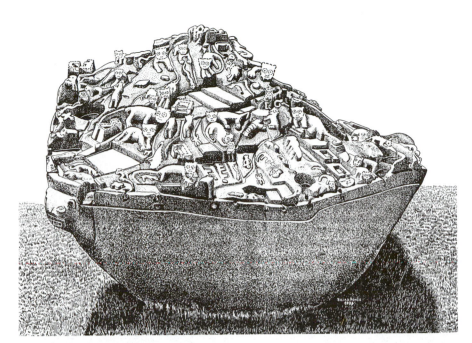

FIGURE 15
Saywite Monolith. Drawing and reconstruction by P. Rojas Ponce (1955).

FIGURE 16
Lavapatas, San Agustín, Colombia. Drawing by P. Rojas Ponce, based on an original plan by the Archaeological Museum of Bogota.

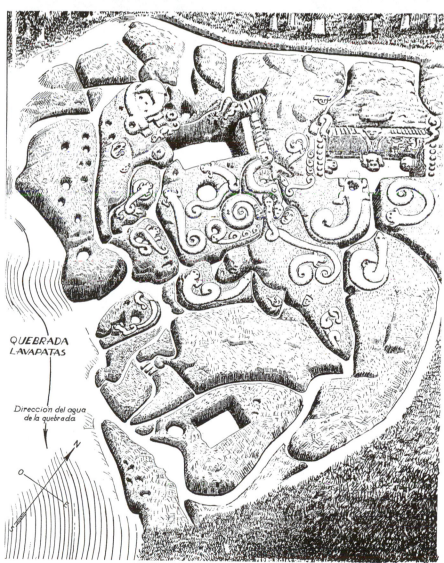

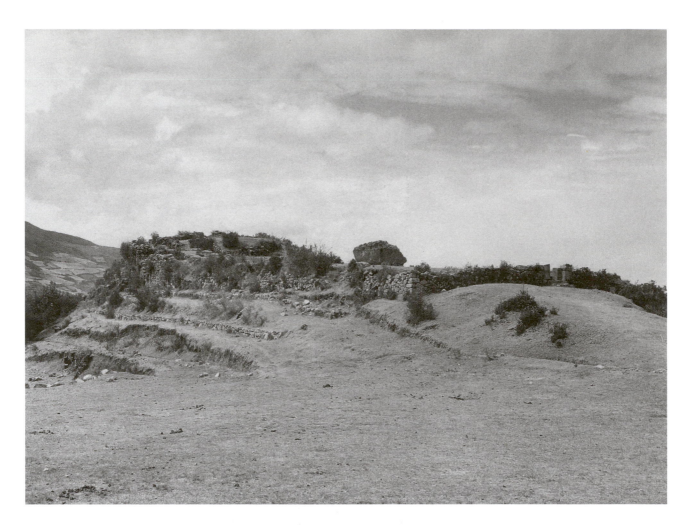

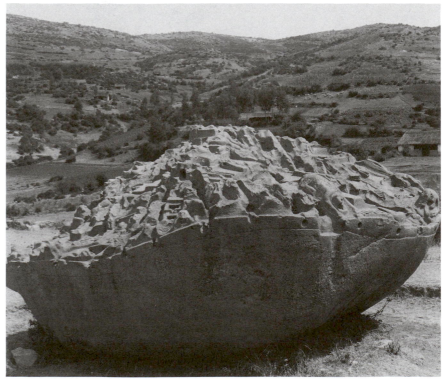

majority of sculptures there (more than three hundred have been counted) represent anthropomorphic figures with formidable feline-like fangs and were used to mark burial sites or as tablets or sanctuary idols. Their stylistic traits almost certainly locate them temporally in the Formative or Early Horizon, contemporary to Chavín or to the Olmecs of eastern Mexico (see Kubler 1975, 235, 237).

The Fountain, however, was carved in situ into the rocky bed of the Lavapatas stream and therefore is also a work "on the scale of nature." The figures of lizards, snakes, frogs, and combinations of the three are surrounded by channels that divert the stream's waters, like an ingenious hydraulic work. According to Pérez de Barradas, the whole thing "is surprising for the beautiful play of water in close relation to the reliefs . . . despite all its technical perfections, it should not be considered simply a hydraulic marvel; its artistic and religious aspects are more interesting still, and I do not doubt that it is a sanctuary dedicated to aquatic and subterranean divinities" (cited by Carrión Cachot 1955, 15).

The Saywite Monolith is an ovoid rock about ten feet in length, nine feet wide, and eight feet high, which lies on top of a hill. Ubbelohde-Doering (1967, 250) calls it the "Hill Stone" (Plates 70 and 71). It is not a geological outcrop, and, though it could have been transported there, it is more likely that this "lithic egg" was already there, waiting. The evidence indicates that it has been moved from its original location on the hill, probably by treasure hunters, which prevents us from knowing with certainty the original orientation of the rock. The remains of masonry and of a double-jambed gate indicate that the ceremonial area was once enclosed. Moreover, the hill on which the rock sits was stepped in walled terraces, a now-familiar strategy for demarcating and magnifying sacred space.

In the upper part of the rock a large number of animal forms have been sculpted: mostly pumas, but also reptiles, frogs, shellfish, and a few human figures (Plate 72 and Fig. 15). Carrión Cachot gives great importance to these "couples" of man and woman, which she considers "anthropomorphic gods" (1955, 17). This interpretation perhaps should be read in the context of a "fertility-water-semen" symbolism. We should note also that the composition emphasizes the representation of animal forms, among which the feline predominates. This characteristic appears to correspond to the typology developed in Kusillochoj but also to a metaphor that is very pertinent here: "feline-water-fertility," a symbolic modality considerably more elliptical than the somewhat literal linkage of "amphibian animal-water," which is also represented in the Saywite Monolith.

At the rock's apex, a receptacle has been hollowed out (Plate 72, lower left) from which a series of channels descend, snaking among the figures; in certain places, the channels become rectilinear meanders. Some orifices at the edge of the sculpted part indicate that, ultimately, the water or liquid that was being offered fell to earth. This, of course, is the fundamental structure of the *paqcha*.

Repeated stepped cuts (agricultural terraces?), ponds, and other cuts that look like buildings or open temples confer the symbolic meaning of microcosm on the entirety of this impressive sculptural form: a microcosm carved into an ovoid rock. Could this be the archetypal Cosmic Egg?

This ancient notion of genesis, which is recounted in the Upanishads—the Hindu scriptures—is the last trace of an orphic cosmogony that

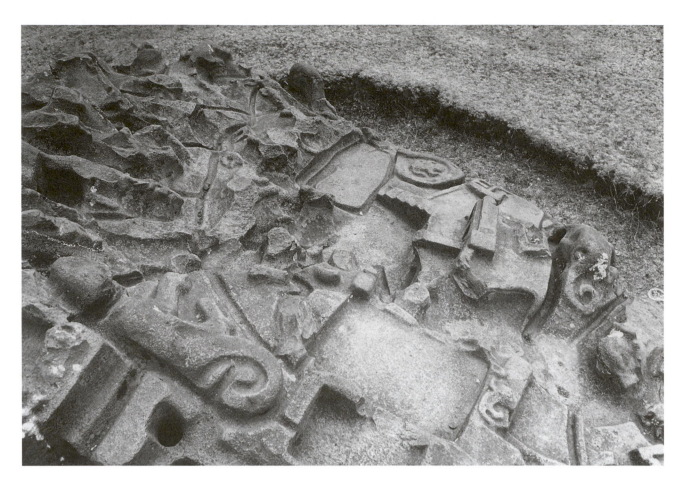

PLATE 72

*Saywite Monolith. Upper part,
detail of animal carvings and cup
(paqcha). (Photo by the author.)*

survived into Greek antiquity: the first of creation's divisions is between "what is," in the form of a radiant egg, and "what is not," in the form of dark waters (Rawson 1978, 144).

A Cosmic Egg in the Andes? It should not surprise us. Not long ago, in the community of Misminay, a Quechua interlocutor told Gary Urton that the earth is something like "an orange floating in a bowl of water." To the north and south are enormous mountains, the Volcanos, which rise at the limits of the earth, the sky, and the cosmic sea, completely surrounding them. Through the center of the earth flows the Vilcanota River (Urton 1981, 37).

The Saywite Monolith is, clearly, a *paqcha*, an imposing symbolic fountain, but on another level of meaning I think the sculptural representations also indicate that it is an archetypal, genetic form, the validation of a cosmos.

We have seen that the outline of Cuzco—the germinal nucleus of the Inca orb—represented a puma, a symbolic form strongly associated with, among other things, the city's renovator, the Inca Pachakuti. The representation of this same feline abounds among the figures on the Saywite Monolith. Moreover, the entire sculpture has the head of a puma (Fig. 15).

The sense of a "foundation," a reimplantation of the symbolic model of the Inca empire, is enormously suggestive. But why here, in the "heights of Concacha"?

The site is located in territory occupied by the Chanka, and the epic war with the hostile Chanka acquired cosmic proportions in the life of the Inca

empire. Inexorably, the Chanka took control of a wide territory, extending to Ayacucho, Huancavélica, and Andahuaylas. When Cuzco's defenses were reeling, Wiracocha, the ruling Inca, fled, and the young Yupanki, one of his sons, assumed command of the army and successfully repelled the attack, going into battle wearing a puma skin. (At a critical moment, the stones become soldiers who fought beside the Incas. Their intervention was decisive and therefore they were later enshrined in Cuzco as *pururaucas*.)

Yupanki pursued the Chanka beyond the Apurimac River and defeated them in their own lands. Then he returned in triumph to Cuzco and was crowned with the name or Pachakuti Inca Yupanki. The name alludes to the Copernican changes that were to take place during his reign.[1]

I used to wonder if the site today called Saywite was the mythic setting for the definitive victory over the Chanka. It is definitely within Chanka territory: Cieza relates that, when Pachakuti's conquests began, he crossed the Apurimac River at the head of forty thousand men and arrived "at the lodgings of Curahuasi"—the valley where the Saywite works are located. There "they say he gave a captain of the Chancas, named Tupac Uasco, a Cuzco *ñusta* for wife" (Cieza de Léon [1554] 1973, Chap. 47, 167). Later, in Vilcas, he overcame the last shreds of Chanka resistance.

The Inca cosmos, the *cusco,* had been seriously threatened by the Chanka. With the final defeat and the subjugation of the former invaders, the Saywite Monolith seems to symbolically reimplant this cosmos on enemy territory. And though this remains conjecture, it is easy to verify that the magnitude of the sculptural work undertaken in Saywite yields in importance only to those of the Tampu. Clearly, the region had a meaning in the life of the Inca empire, which, in large measure, can be envisioned in direct relation to the serious threat posed by the Chanka at any given time.

The attachment to the figural models in the rocks of Kenko or Lacco, still in use until Pachakuti's ascension, suggests that the monolith is the oldest work in the Saywite sequence. Ann Kendall enumerates this site as "one of the constructions that took place during the reign of the Inca Pachakuti" (1976, 78).

The symbolism invoked by the *paqcha* should be appreciated in a broad sense. I have already indicated this in reference to the *paqcha* at Kenko: in addition to water, *chicha* or perhaps even sacrificial blood must have been poured into it.

Rebeca Carrión Cachot has identified some phallic *paqcha* belonging to Inca culture that, because of their "portable" nature, must have been considered votive. She affirms:

Their morphology helps us to understand the indigenous concept of their function. . . . They take the shape of a virile member. They are composed of two parts: the basin or cup, round or ovoid, with a perforation at the base, and the undulating, elegantly carved canal along which the liquid runs and pours out through a perforation at the end, in which the head of a snake is sketched. . . . In the religious ceremonies to invoke rain and good harvests celebrated in Cuzco—during which the effigies of the gods were brought out, and even the mummies of the ancestors—large quantities of chicha were offered up, sprinkled at the feet of the idols in drains or pacchas which conducted it inside the earth; and another part was dedi-

cated to libations, at times so exaggerated that the chronicler Estete, describing a feast celebrated in that city, says: "because of all the drinking and eating, it is certain, without any doubt, that two hollow spillways more than half a vara *wide that under flagstones to the river, must be made for cleaning and draining the rains which fall in the plaza; or else, the most sure way for this effect, urine ran all day, which they urinated in such abundance as if they were fountains that flowed there, of course according to the quantity they drank." (1955, 43)*

While photographing details of the Saywite Monolith, I realized with some disgust that the central cup (Plate 72) contained urine. What I did not then understand has now become clear: five centuries later, the ancient ritual to invoke fertility is still alive in this isolated region.

Carrión Cachot also points out that the phallic *paqchas* suggest ceremonies of a sexual nature in which those objects were "symbols of the fertilizing power of certain gods, protectors of the earth's resources, and their favor was obtained, possibly, by materializing in this way the aim of the ceremonies" (1955, 43).

All this helps us understand the meaning of water as hierophany. While the *paqcha* could be used with other liquids, the worship of water would appear to be symbolized particularly by the basins or fonts. Indeed, on the descent from the hill where the monolith is located to the valley adjacent to the half-destroyed stairway, one can see basins, also on different levels and connected by a channel—another version of the sequence of fonts we have observed in Machu Picchu and in Choquesuysuy. It is clear that in Saywite, too, ceremonial ablutions were performed.

Below, in the valley, the Rumihuasi can be seen (Plate 73).

The Quechua name "Rumihuasi," meaning "stone house," appears to be of a more recent date. As I understand it, Carrión Cachot is the first to use it, and perhaps she heard it used in the region as a vernacular designation. Ubbelohde-Doering calls Rumihuasi "the Valley Stone"; he considers it "fascinating . . . more like the work of the gods than of men. The stone has been treated geometrically like the monuments of the Sacsayhuaman region" (1967, 250). Indeed, with this work we return to abstract lithic symbolism, to those forms that, according to Hébert-Stevens, "attest to a certain restraint in the representation of the sacred" (1972, 115).

Ephraim G. Squier considered the Rumihuasi "one of the many remarkable sculpted rocks of Peru"; when he saw the rock, it was deeply cracked (Fig. 17) but not fragmented as it is today, perhaps due to a lightning bolt or an earthquake. But the measurements he records do not correspond to reality. The sculpture measures twelve and one-half feet in width, fourteen feet four inches in depth, and six feet three inches in height.

Despite the total absence of figures, Carrión Cachot saw the Rumihuasi as a "frog form." I think, however, that if this had been the Inca perception, they would not have modified the rock (remember the rock-seated puma of Kenko).

The Rumihuasi has been carved directly onto a local rock. The double stairway, of the "alternating" type, makes it a transitable platform (Plate 74). As I pointed out above, its functional meaning is analogous to that of the pyramidal platforms of Monte Albán, though of considerably less

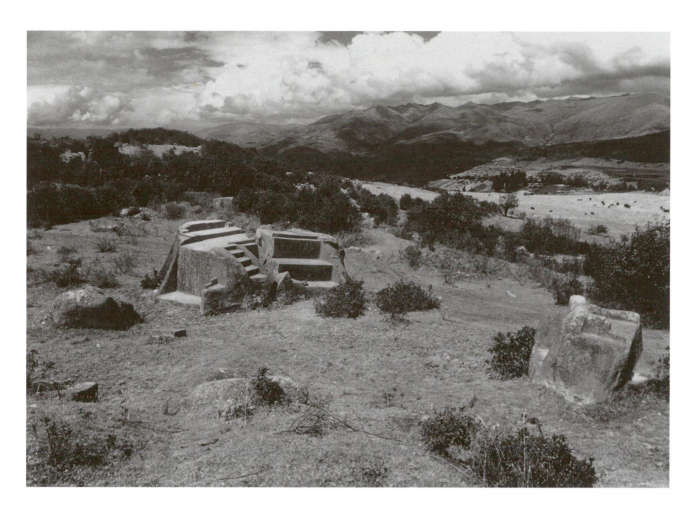

breadth. And, like the anomalous architecture—without inner space—of ancient Mexico, this indigenous sculptural form fulfills, above all else, a ceremonial and symbolic design. Its disconcerting modality is totally foreign to our artistic categories.

The alternating stairway—two series of different-sized steps—exquisitely designed and cleanly finished, is the predominant and irresistible characteristic of this work. The double row of steps must have had the same meaning as those we have observed in Machu Picchu (Plates 59 and 60) and as the rudimentary model for both rows of steps in Kenko Chico (Plate 32). Though here it fulfills a function—granting access to the upper platform—one of the flights of steps is superfluous and merely symbolic.

Above, in the eastern face, a group of seven cups have been carved (Fig. 18). At the same end, an eighth cup has a channel that descends along the side of the sculpture, bifurcating into an inverted Y and ending in two small niches. This element illustrates the fundamental ceremonial function of this work: it is, clearly, another *paqcha*, another symbolic fountain. The total number of eight basins was probably related to rituals celebrated over a period of eight days, the length of the Inca week.

On the north side, a concavity or niche has been carved, large enough to hold a person (Fig. 17). It has been suggested that the priest retreated there and, by means of fasting and abstinence, invoked the sacred essence of the stone, one of the central traits of the Andean cosmovision.[2]

In any case, the Rumihuasi appears to be the central piece of a ceremo-

FIGURE 17
*The Rumihuasi, Saywite
(from E. G. Squier 1877, 555).*

FIGURE 18
*Plan of the Rumihuasi, Saywite.
(Ink drawing by the author from
notebook sketch, 1979.)*

nial group. Other rocks seem to support it; a few steps to the south, a rock has been modified with flat cuts, of the "seat" variety. Very close by on the west side, another rock has been sculpted in such a way that its flat cuts create a very harmonious relation with the Rumihuasi. Seen from another angle, it looks like a work by Henry Moore (Plate 75, behind).

Finally, the remains of walls of the rectangular type indicate a will to delimit the sacred space. I am not aware of any excavations that would allow us to learn more about the original design of this center: in any case, its specific ceremonial function, like that of the Saywite Monolith, seems to be defined by the *paqcha*.

Hébert-Stevens writes, without citing any source, that "this stone is used by the inhabitants of the region for their marriages: the bride and groom kneel before each of the two small channels and drink the water that the village chief, after having climbed the steps, pours into the holes in the upper part. This living practice testifies to the persistence, among Andean peasants, of an ancient symbolic ritual" (1972, 115).

After my experience at the Saywite Monolith, I have no difficulty believing that ceremonies still take place today that keep the ancestral rites alive. Moreover, the isolation of Saywite, which is at some remove from the tourist traffic that beleaguers other ceremonial centers such as Machu Picchu and Ollantaytambo, makes it a truly auspicious place.

Saywite's Third Stone (Plates 76 and 77) is not visible from the Rumihuasi. Approximately eighteen hundred feet to the east, it stands alone in the Arcadian landscape with no architectonic reference underscoring its placement, as occurs with the previous works.

Saywite's Third Stone was first published by Hébert-Stevens, who succinctly represented it as "a solar stone, different from that of Machu Picchu, which is pierced by a square needle and was also used as a solar indicator" (1972, 115). I believe it is the "carved monolith" that Rebecca Carrión Cachot called an *intiwatana* in her survey of the Saywite area (1955, 16).

John Hemming makes no mention of this stone in *Monuments of the Incas,* and Edward Ranney's photograph shows only its eastern face—the least significant—and describes it as a "pumalike stone" (1982, 176).

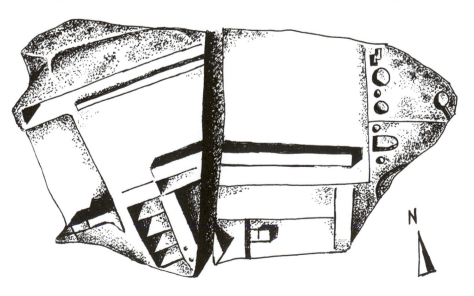

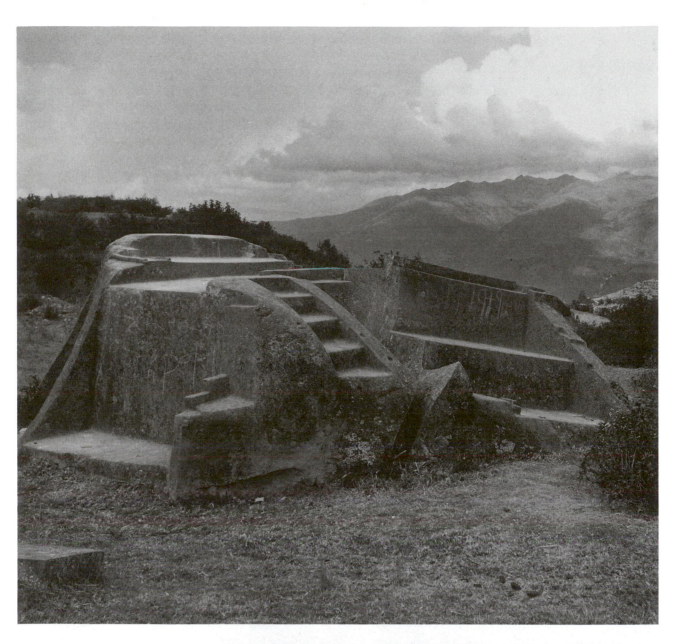

PLATE 74
The Rumihuasi, Saywite.
(Photo by the author.)

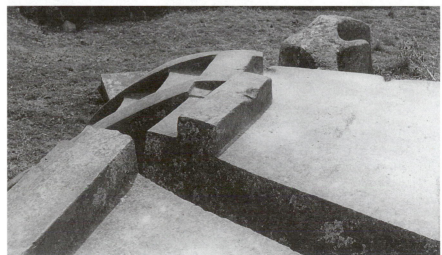

PLATE 75
The Rumihuasi, detail of upper
surface. (Photo by the author.)

PLATE 76
Third Stone, Saywite.
(Photo by the author.)

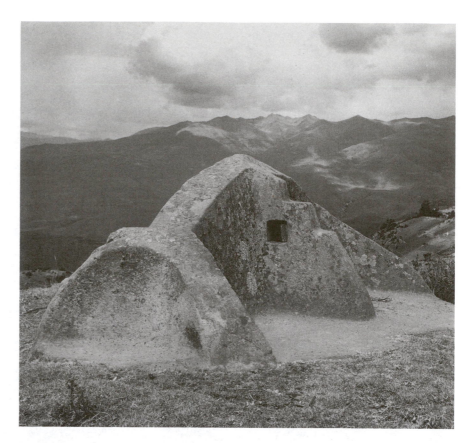

PLATE 77
*Third Stone, view of the western
side, Saywite. (Photo by the author.)*

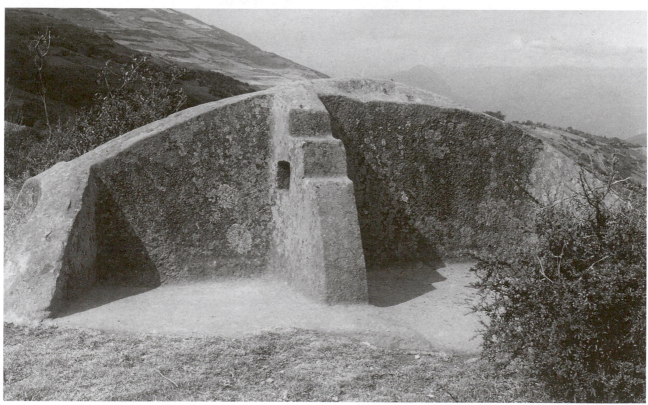

This sculpture seems to be surrounded by a halo of enchantment that originates, for the most part, in its enigmatic bifrontal character. The side that first comes into view has conspicuously organic connotations, while the other face—abruptly and drastically separated from the first with no gradual transition—offers a surprise: the curving forms are subtly altered by rigorous geometric cuts, the square "window," the ubiquitous steps.

To all appearances, this is the face that defines the sculpture's function. I mentioned that this work has a directional sense: carved in situ, the natural structure of the rock "anticipated" its destiny. In fact, one can see that the "half-disc," which is the axis of the sculpture, has been achieved by carving vertically toward the inside. It aligns on a north-south axis (fifteen degrees to the west of magnetic north). The stone clearly had that basic orientation already, before it was touched by the sculptor's hand. The north and south extremes have been finished with curving forms, smaller half-discs cut across the primary axis. In the same sense, in the middle of the western face, a quarter-disc cut in steps and perforated by a mysterious window (resembling a strange eye) projects toward the setting sun.

Of all the sculptural works described here, this Third Stone is the best instrument for watching the movement of the sun between the solstices, as the shadow projected by the stepped quarter-disc—the "gnomon"—demonstrates; the photograph in Plate 77 was taken in early August, in late afternoon, after the southern hemisphere's winter solstice (see also Fig. 19). A total absence of shadow, when the gnomon is aligned with the sun, marks the equinoxes.

We cannot yet know with certainty what the shadow that appears in the dial in the afternoon signified. It was probably associated with the agricultural cycle, but what was the meaning of the stepped cuts and the window? I prefer to give this sculpture the neutral name "Third Stone"; though it is a solar stone, that designation is restrictive and does not reflect the multiplicity of meanings these structures generally had.

OLLANTAYTAMBO, THE OTHER PARADIGM

Vertical
cubic rose

Tits bursting
out of pure stone

Porphyry
trapezoid

CECILIA VICUÑA,
"Ollantaytambo"
(translated by Suzanne Jill Levine)

The "Inn (*tampu*) of Ollantay," as it is called in viceregal documents, is in the lower Urubamba River valley, about thirty-seven miles to the northeast of Cuzco.[1] It was a town of the gentry, or *behetrías* as the Spaniards called them, until the Inca Pachakuti occupied the region (c. 1460) in one of the initial phases of the Inca territorial expansion. The town was reconstructed, and the architectural evidence indicates that it must have been reserved for royal or priestly dignitaries. Still inhabited today, it is the most perfect example we have of Inca urban planning.[2]

But the ceremonial center of Ollantaytambo (Plate 78) is a late work, the swan song of Inca constructive stonework. Rowe sums it up nicely: "In 1537, after the failure of his attempt to retake Cuzco from the Spanish invaders, Manqo Inka set up his capital at Ollantaytambo and held the place for two years against Spanish attacks until he was forced to withdraw to the fastnesses of Vilcabamba. He evidently undertook an elaborate construction program at the temporary capital, for many of the buildings show evidence of having been abandoned in an unfinished condition" (1961, 321). Thus, the audacious construction of a ceremonial center that was meant to emulate the ancient splendor of Qoricancha was abandoned.

It was only after my first few visits to Ollantaytambo that I clearly perceived the temporal sequence of the sculpture of the Inca empire and its relation to the construction of the empire's apogee. The archaic and formative meaning of the rock outcrops sculpted in situ became evident: if Kenko was the paradigm of the beginnings, at the other end of the path Ollantaytambo emerged as the concise and final lithic discourse.

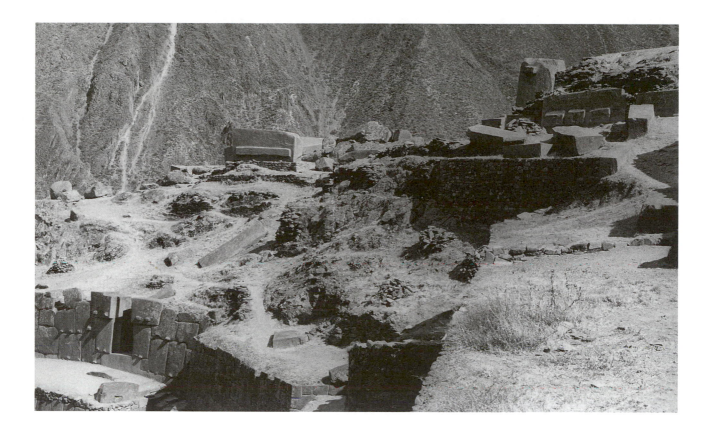

The trapezoidal "minimalism" of the monoliths, the fiendish constructive prowess that went into what is today called the Temple of the Sun, was the first and indelible impression. Then, gradually, the meaning of the formal instances of this mute text became more legible: the progressive refinement of the walls bordering the terraces, which establish a hierarchy ascending to the ceremonial center, and the rhythmic sequences of "lithic knots" that swell on the faces of the extraordinary monoliths and expand into sharp reliefs, the display of a powerful, forgotten symbolism.

Machu Picchu is an inconceivable architecture, with its univocal sense of coronation, an astonishing *wak'a* on the crest of a mountain. The ceremonial complex of Ollantaytambo is also the luxurious installation of a sacred space. But, built in a different historic context, Ollantaytambo articulates the last enigmatic signals of a world about to disappear.

The Temple of the Sun

The imposing Temple of the Sun is the dominant monument of Ollantaytambo's ceremonial center (Plate 79). It is composed of six monoliths of rosy porphyry, between which stone slabs have been inserted as linking elements (Plate 81). The scale is majestic: thirty-six feet across by approximately ten feet eight inches of median height, and an average of three feet in depth. Among the Inca ruins known today, nothing comes close to it.

The Temple of the Sun has been interpreted as a wall or as the foundation of an unfinished building. But its monumental autonomy is evident; it surmounts the rocky spur that crowns the plane of the ceremonial area,

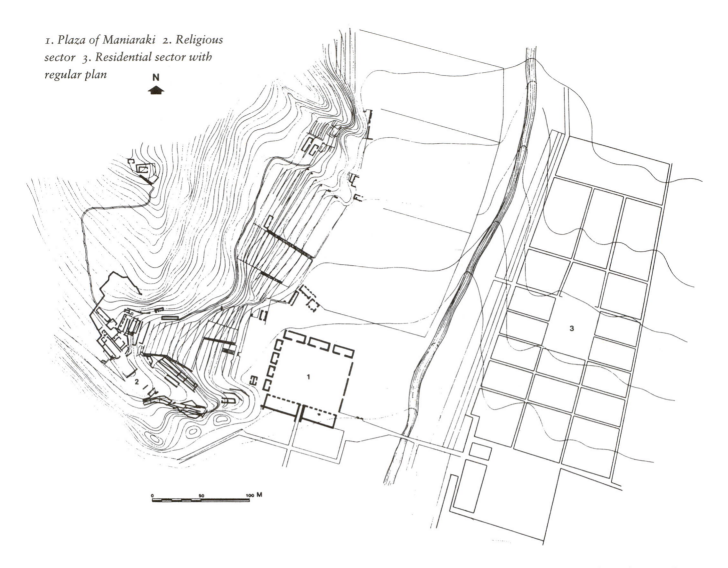

1. Plaza of Maniaraki 2. Religious sector 3. Residential sector with regular plan

N

0 50 100 M

MAP 5
Plan of Ollantaytambo. From Gasparini and Margolies 1980, 69. Reprinted by permission of the authors.

PLATE 79
(OPPOSITE PAGE, TOP)
Temple of the Sun, ceremonial area, Ollantaytambo. (Photo by the author.)

PLATE 80
(OPPOSITE PAGE, BOTTOM)
Johann Moritz Rugendas, Fortaleza de Ollantaytambo, *c. 1845. Pencil drawing. 13.8 cm x 22.9 cm (5 3 /8 in. x 9 in.). Collection of the Museum of Graphic Art, Munich. (Photo courtesy of the Museum.)*

and it is completed by two walls of stone slabs that are set directly into the rock. No area exists for interior space, and we know that acts of worship took place in the open air. But it should be noted that beyond the row of monoliths is a "trench" approximately three feet wide. There, the side opposite the monoliths has been finished with rustic masonry, which, nevertheless, has niches, indicating this was perhaps space for preparatory rituals, or for those rituals strictly reserved for the officiating priest.

The Temple of the Sun is an immense trapezoid—one of the highly symbolic forms of Inca architecture. The reliefs and protuberances that animate the surfaces of the monoliths and the linking slabs make the temple a frontal sculptural work, a relief. Moreover, the collection of the Munich Museum of Graphic Art contains a drawing by Johann Moritz Rugendas—the German painter who traveled extensively through South America during the middle of the nineteenth century—which shows other blocks with protuberances above the monoliths, as a sort of capital (Plate 80).[3]

On the fourth monolith, a stepped relief appears. Ubbelohde-Doering considers it an "ornament" and affirms that it is a "very frequent symbol in ancient Peruvian art which must have referred to ascent and descent, to the sky and the earth" (1967, 252). Today it is impossible to say if other

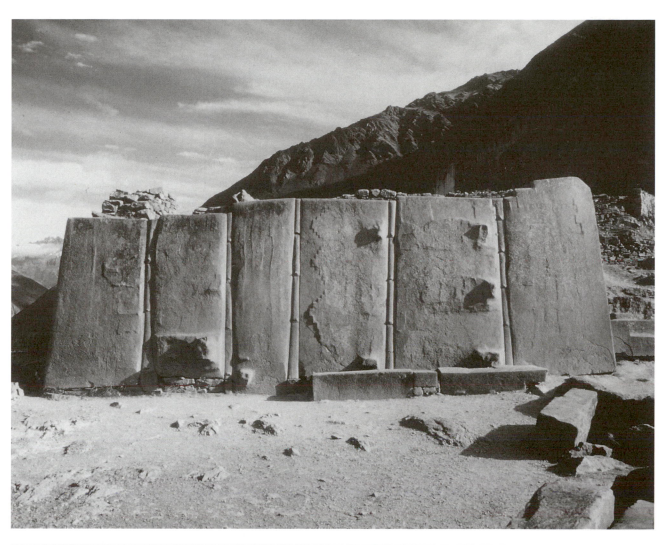

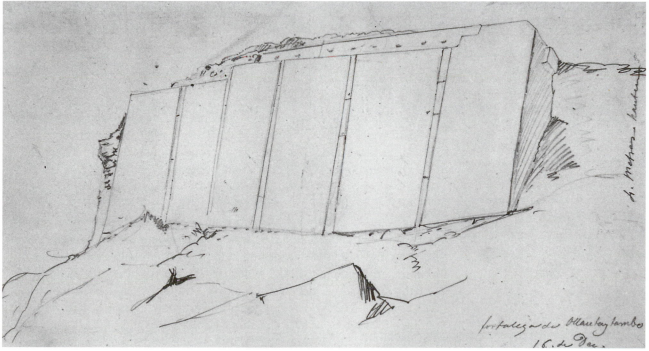

OLLANTAYTAMBO, THE OTHER PARADIGM 139

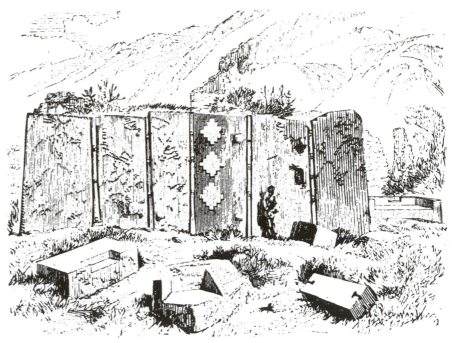

reliefs were planned, similar or not. Nevertheless, we can posit that this relief was designed for its intrinsic significance and was intended to remain without a counterpart on the other monoliths, given that asymmetry is one of the definitive traits of Inca monumental sculpture. It can also be conjectured plausibly that in its final state the relief would have been finished as it appears in Squier's book (1877) (Fig. 20), in which it looks more like certain hollowed bas-relief blocks found in the Kantatajita sector of Tiwanaku (Plate 94). This formal similarity indicates a certain infiltration of Tiwanaku elements in the monument's conception. However, as we have already observed in the cave of Choqequilla (Plate 49), this influence is strongly countermanded by the preeminent Inca constructive symbolism we know so well. In this sense, the massive trapezoidal form of the monument is decisive. Moreover, the stepped sign is a textile structural image that—whether in ceramics, in architectural reliefs, or in its three-dimensional form (the stepped cuts so profusely used by the Incas)—is far too widely diffused in all the cultures of ancient America to be assigned an exclusively "Tiwanaku" filiation.

Unlike the stonework of Chavín and Tiwanaku, whose flat iconography is derivative of textiles, the relief in the Temple of the Sun appears to be one of the few examples in which a plectogenic image is reproduced (the others are, as I pointed out, the Choqequilla rock and the bath of the *ñusta* (Plate 93) in Ollantaytambo.

Completing the frontal sector, adjoining the sixth monolith, is a throne that is oriented, like the whole temple, toward the southeast where the sun appears during the December solstice (Plates 79 and 82). In winter, however, the first light of morning in mid-June illuminates the front obliquely, from the northeast, in such a way that an unparalleled contrast of light and shadow is produced, sharply outlining the reliefs and protuberances. This evinces an intentional and painstaking selection of the temple's location in order to heighten the majestic symbol. We have already discussed the cosmological importance of the southeast-northwest

PLATE 82
*Throne and northeastern wall,
Temple of the Sun, Ollantaytambo.
(Photographic collage by the author.)*

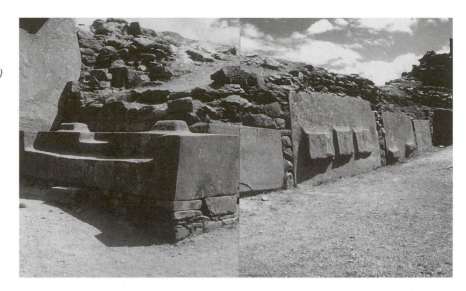

PLATE 83
*Rectangular reliefs on the
northeastern wall of the Temple
of the Sun, Ollantaytambo.
(Photo by the author.)*

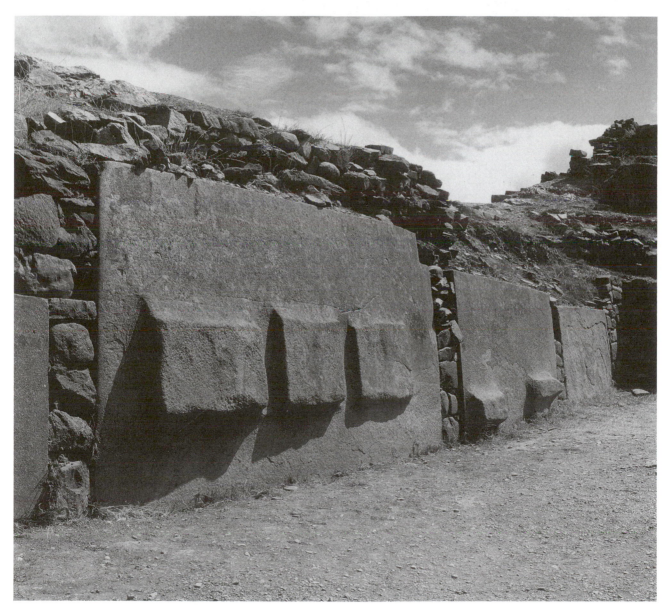

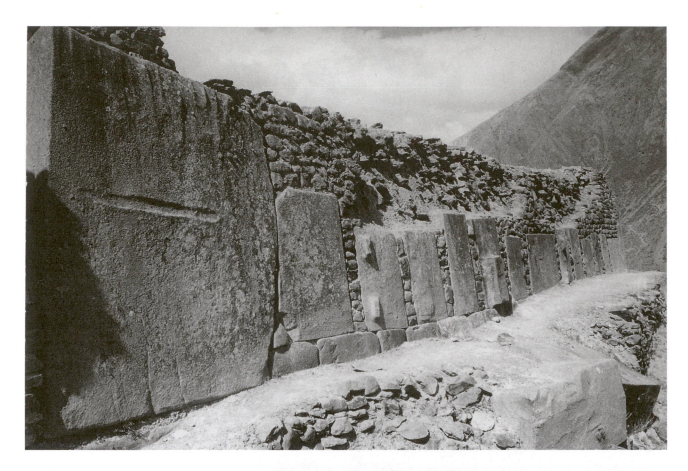

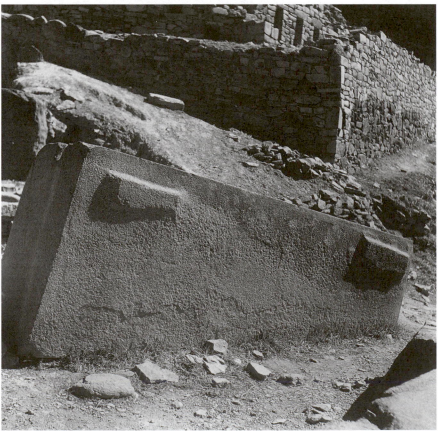

PLATE 84
*Southwestern wall, Temple of
the Sun, Ollantaytambo.
(Photo by the author.)*

PLATE 85
*Block with rectangular projections,
northeastern side of the Temple of
the Sun, Ollantaytambo.
(Photo by the author.)*

WORKING THE STONE AND THE THREAD

axis; this orientation defined the meaning of the lithic structures the Incas built in the Urubamba region and thus determined their virtual unification in a symbolic continuum with the sacred space of Cuzco.

Two lateral walls of similar design complete the temple. The wall oriented toward the northeast (Plates 82 and 83) extends about forty-five feet, with a median height of nine feet, including the retaining wall. Four enormous slabs, whose median height is six feet three inches, have been inserted vertically into the retaining wall; thus, the clean, severe line of the two central slabs' rectangular reliefs is underscored by the rusticity of the retaining wall. The opposite wall, to the southwest (Plate 84), presents, as I said, a similar method, but the slabs—some with reliefs—are smaller and more numerous (fourteen in all). The clear definition of all these rectangular reliefs suggests that, had the work not been interrupted, the monoliths' abrupt protuberances would have had a similar degree of finish. The rustic stone used in this retaining wall has been bonded with clay; its median height is about ten feet, and its length is more than seventy-five feet.

In my discussion of the cylopean walls of Saqsaywaman, I dealt with the functions of these retaining walls. In Ollantaytambo, their temporary end can be appreciated even more clearly; in the exit gate of the fourth terrace (Plate 91), for example, there is a block shored up by rustic stone and mortar, awaiting the future components of the wall, which were never put in place.

Though a much more prolonged study of this archaeological site is necessary, it can be suggested, based on a series of preliminary measurements of the large blocks that lie scattered in the ceremonial area—many of them with rectangular reliefs (Plates 78, above, and 85)—that the lateral walls of the temple were to be completed using some of these blocks until they reached a height equal to that of the monoliths. In light of the constructive method used here, it can be conjectured that the spaces between the slabs of the lateral walls—today filled in with rustic stone—were to be completed with linking slabs.

The use of these great blocks in the homogenous edifices of the Inca apogee is as atypical as the stepped relief: both indicate a Tiwanaku influence. Moreover, in the same ceremonial area are blocks with small T-shaped channels (Plate 86 and Fig. 20), another typical Tiwanaku method of joining the blocks in the wall. (When matched with another block with the identical cut, a small H-shaped channel resulted, into which melted copper was poured, bonding the two blocks together when it solidified.)

The Tiwanaku influence is, in any case, very limited, given that the aforementioned techniques were being used in a construction project whose symbolic meaning was decidedly Inca. This is evinced by the extreme severity of the monoliths grouped into a trapezoidal form and their rectangular reliefs, a minimalism that is alien to the iconographic reliefs of Tiwanaku architecture. To confirm the Inca significance, the foundation of an incomplete "open temple" similar to the one in Machu Picchu can be discerned in front of the Temple of the Sun (Plates 64 and 87). There, too, the bases of the walls of the ceremonial structure are composed of immense monoliths that bear ample protuberances as in Ollantaytambo. Like the Temple of the Sun that rises up imposingly a few steps beyond it, this open temple is oriented toward the southeast, and a

PLATE 86
*Block with "T" grooves,
northeastern side of the Temple
of the Sun, Ollantaytambo.
(Photo by the author.)*

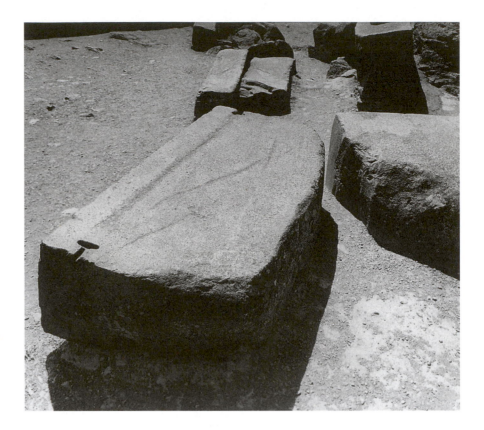

PLATE 87
*Foundation blocks for an
open temple, ceremonial area,
Ollantaytambo.
(Photo by the author.)*

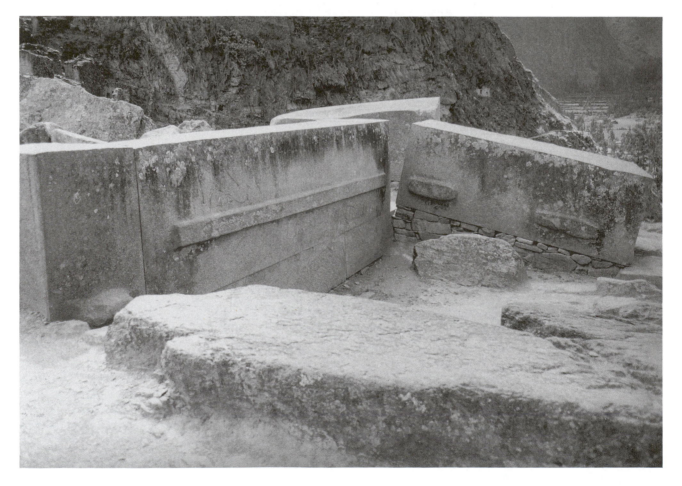

WORKING THE STONE AND THE THREAD

block with a meticulously cut, elongated tenon is the part that faces sacred Cuzco. The architectural function of this element is difficult to understand; perhaps its gratuity indicates a symbolic meaning.

As I mentioned above, the Tiwanaku stylistic infiltration can be attributed to the Inca Tupac Yupanki, who, according to Cobo, ordered the "construction of palaces." It may have conditioned later architectural developments, such as the construction of the ceremonial center, apparently decided by Manqo Inca. Considering the critical historical moment of this resolution—during the wars of the Spanish Conquest—one could conjecture that the technique of construction with large blocks offered the most efficient solution to the presumed urgency of completing the buildings.[4]

The Protuberances in the Walls

Like a signboard, small protuberances appear on the wall of the fourth terrace, the retaining wall for the elevated plane on which the ceremonial center was erected. They are noticed first as one reaches the end of the long stairway that leads to the fourth terrace; then they flank the so-called passageway (Plates 78, 88, and 89) and continue to rhythmically punctuate the "wall of the ten niches" (Plate 90). To conclude this supremely well-finished surface, protuberances surround the exit gate (Plate 91).

The passageway (Plates 88 and 89), one of the most notable pieces of Inca stonework, must have been a sanctuary similar to the one Garcilaso de la Vega called "Tabernacle" in the Qoricancha (Plate 13); the magnificent full-body niche in the central patio of the temple was presumably used by the Sapa Inca as a throne or an altar. Like that niche, the passageway is oriented toward the northeast quadrant, where the sun rises during the winter solstice. This evinces, to my view, an intention to duplicate the ceremonial functions of the Tabernacle.

One of the blocks that finish the upper part of the passageway has a cut that suggests, as in the Temple of the Sun, the bed for a lintel (these blocks, which were displaced by a slide of earth and large stones, have recently been replaced in their original positions [Plates 88 and 89]). This is one of those curious, ambivalent Inca architectural solutions: it could be a passageway, a gate, or a tabernacle (noticeable protuberances can be observed inside it, as well).

The sense of passageway or gate has become clearer in the last few years. Indeed, there is a point at which the wall of the ten niches and that of the passageway-tabernacle are disconnected, evincing two different constructive methods: the latter has the characteristic inclination of Inca walls, while the former is vertical. The hollow that separates them was to be completed with a wall dividing the two sections. This is something that could easily have been deduced, but my original fascination with the sequence of protuberances that appears in this fourth terrace made me focus on their continuity (see Paternosto 1984). But recently, at the point of the walls' disjuncture, the foundation of a wall has been excavated, an element that indicates a different functional meaning (Plate 92). According to the indicators I documented, the excavated blocks are carved as "bases" to receive the blocks of the upper rows, from which it follows that the sector of the ten niches and that of the passageway-tabernacle were meant

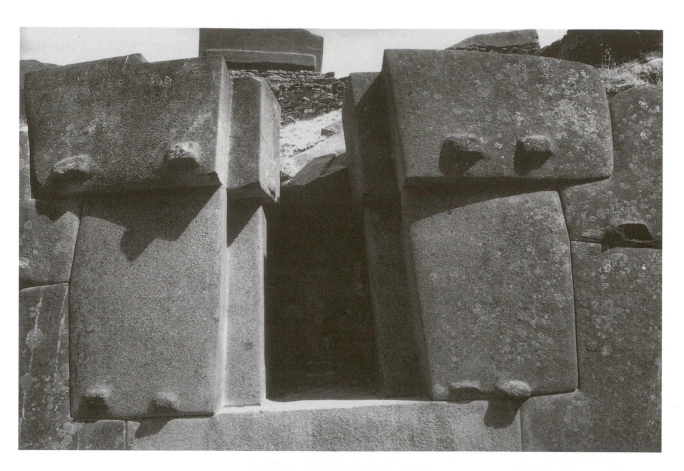

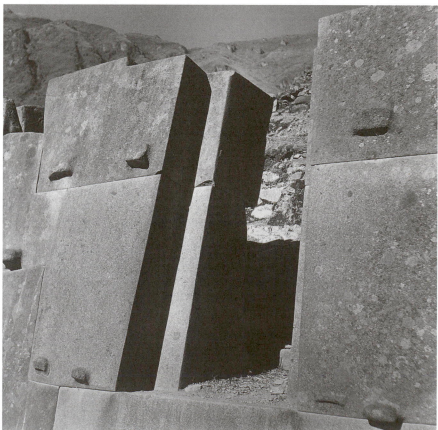

PLATE 88
Passageway-tabernacle, ceremonial center, Ollantaytambo, 1979.
(Photo by the author.)

PLATE 89
Passageway-tabernacle, ceremonial center, Ollantaytambo, 1988.
(Photo by the author.)

WORKING THE STONE AND THE THREAD

PLATE 90
*Sector of the Wall of the Ten Niches,
ceremonial center, Ollantaytambo.
(Photographic collage by the author.)*

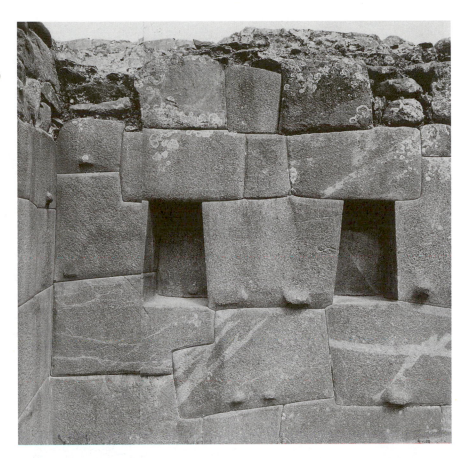

PLATE 91
*Gate at the end of the Wall of
the Ten Niches, ceremonial
center, Ollantaytambo.
(Photo by the author.)*

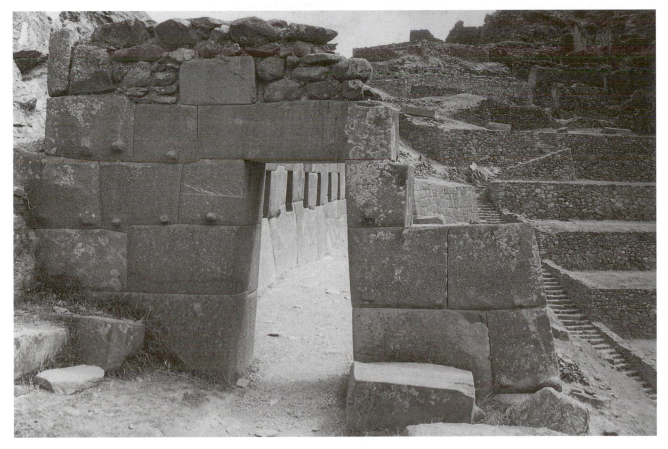

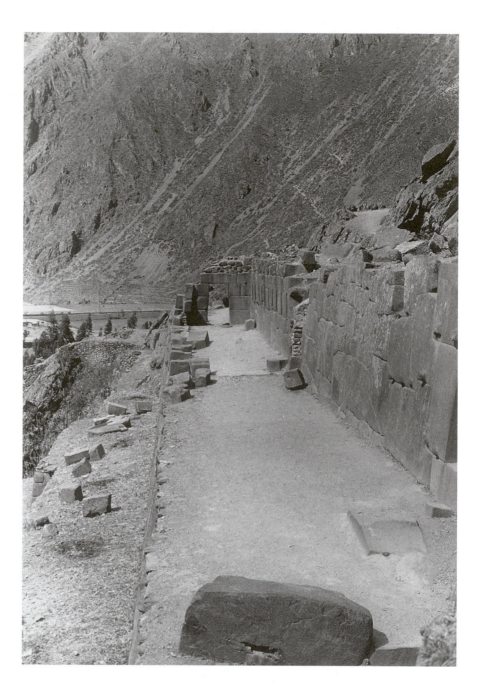

to be two separate enclosures, the former covered. At the edge of the terrace, in the area of the ten niches, the base of a future enclosing wall is evident, but nothing similar to it is in front of the wall of the passageway-tabernacle. On the facing slope across the valley there is a construction that, though of inferior quality, hints at the way the enclosure of the ten niches would have been finished: the closing wall would have had trapezoidal windows opening to the northeast, perhaps ten of them to correspond to the niches. It can also be conjectured that the wall dividing this enclosure from the passageway-tabernacle would have had a window.

In that way, on the ascent to the fourth terrace, the passageway-tabernacle would have been the only access to the ceremonial area that is farther up (Plate 78); half-covered by fallen dirt, the steps in the inner part of the passageway corroborate this impression. But the rest of the circulation

WORKING THE STONE AND THE THREAD

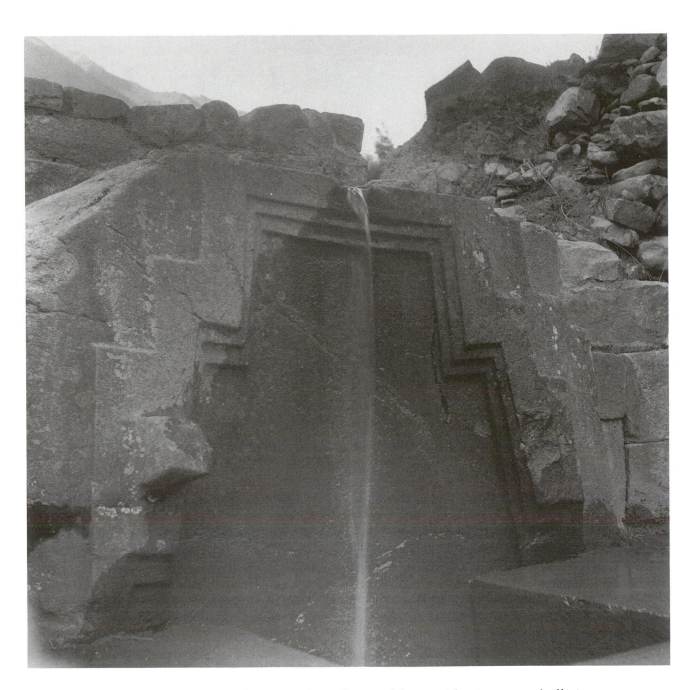

PLATE 93
Bath of the ñusta (princess),
Ollantaytambo.
(Photo by the author.)

plan—once the enclosure of the ten niches is separated off—is not easy to define. Perhaps further excavations in the ceremonial area will shed more light on the functional sense of this imposing work of the Inca empire.

On scrutinizing the Temple of the Sun, beyond the initial impact of its majestic presence, reading its protuberances becomes more complex. Those on the monoliths, which are more conspicuous, impose a dominant rhythmic model. As a counterpart, those on the linking slabs enrich the reading even more, creating an almost isochronic punctuation, which is repeated five times (Plate 79 and Fig. 21). Everything suggests that this is a symbolic enunciation, the final significance of which eludes us but which appears to reach its culminating moment here: there is evidence that this was where the entrails of the Sapa Incas, semidivine beings, were buried.[5]

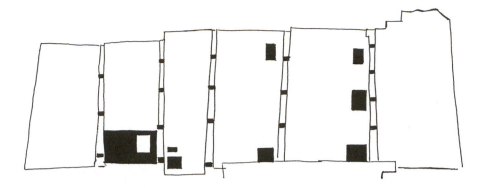

FIGURE 21
*Diagram of reliefs and
protuberances, Temple of
the Sun, Ollantaytambo.
(Ink drawing by the author.)*

Apparently, the blocks in the wall of the fourth terrace and their protuberances (Plates 78 and 90) have been immoderately enlarged here to accentuate their significative capacity; this reasoning is also valid for the rectangular reliefs on the lateral walls (Plates 82–84). However, as we have seen, in the interior of the curved wall of the Qoricancha discrete models for rectangular reliefs already existed (Plate 11).

It is generally speculated that these protuberances are either the residue of the stone's cutting or have some practical function, whether to support levers or to secure the ropes for the transport of the blocks.[6] But these utilitarian interpretations do not take into account the fact that the Incas used the most refined techniques in the construction of temples and palaces. It therefore would have been unacceptable for the soiled traces of labor to be left on those constructions. González Corrales informed me that, at the foot of some of the walls, the detritus from the polishing of the stone has been found, indicating that the blocks were finished in situ. Clearly, if the protuberances were not eliminated at that point, then they were left intentionally. To what end? They were left simply to mark, to designate the importance of the areas where they appear, to "announce" the proximity of the Temple of the Sun. In other words, it is their context that begins to define the protuberances as visual signs. As Roland Barthes has pointed out, "The sign derives its value also from its surroundings" (1977, 48).

The sequences of protuberances also suggest the rhythmic structuration of a discourse, given that there is no axis of symmetry,[7] a trait that seems to define semantic symbols, be they pictographic, ideographic, or alphabetic.[8] It can be affirmed that the significative capacity of these prominences resides as much in their context as in their asymmetrical structuration. Evidently, a basic syntactic relation exists, "protuberance-surface," which in turn lends itself to consideration as a binary code, articulated by the alternative "mark-no mark" (Barthes 1977, 48).[9] Though today we cannot know if a convention or informational model existed that made the system "legible," both the context and the asymmetrical configuration of the protuberances lead us to believe that they must have constituted a system—at least to denote highly significant areas—a system that, in the case of the Temple of the Sun, could reach the intensity of a symbolic enunciation. Thus, denotation would be the minimal function or content of these sequences of protuberances.

The occurrence of these stone nodules on other Inca ruins corroborates, with greater or lesser clarity, the denotative function I attribute to them. Their legibility is not always as clear as in Ollantaytambo, which is a late

example of sculptural stonework, and this fact may indicate that they were a system of signification-signalization that still was being developed at the moment of the final collapse.

We know that Cuzco was the initial chapter of the architecture of the imperial period. There, the asymmetrical sequences of protuberances are present on several of the Inca walls: Hatun Rumiyoc, for example, which is considered to be the remains of the palace of the Inca Rocca. But it is in the walls of Qoricancha, the central temple of the Inca sun cult, that we can best appreciate the meaning of these visual-tactile signs; their formulation in this sacred space configured an archetype par excellence, like everything that occurred in Cuzco, the omphalos of the Inca orb.

Within Qoricancha, the protuberances appear almost at random on the walls surrounding the *cancha* (central courtyard), perhaps most notably on the exterior of enclosure A (according to the map by Gasparini and Margolies; see Map 3 and Plate 12). But their function as signs is most clearly perceptible in the interior of the famous circular wall (Plate 9) at the northeast end of the temple (Plates 10 and 11). There, the asymmetrical series of nodules seems to underscore the sacred importance of the niche—of which only the lower part remains—which faces the *anti*, the rising sun. Discrete rectangular reliefs that are highly finished appear on both sides of the niche (Plate 11); a little further to the left, one of the blocks bears two curious reliefs: a "moon" and a rounded prominence (perhaps the planet Venus).

In Machu Picchu these protuberances are scarce and less conspicuous as sequences: on the outer wall of the tower, they only punctuate the corners of the windows (Plate 57); on the outer wall of one of the enclosures along the way to the Intiwatana, four prominences also can be seen (a very simple "notice"); on the foundational blocks of the Open Temple (Plate 64) and on the walls of the Temple of the Three Windows relief projections can be observed as well. In P'isaq, with the exception of a protuberance carved in the same rock as the Intiwatana, the nodules are practically nonexistent.

But in the imposing gate of Rumiccoloca (Plate 95) the asymmetrical series of protuberances are formulated with a rigor comparable to those of Ollantaytambo, which makes me think that Rumiccoloca also must be a relatively late work. This massive monument marked the solemn entrance to the valley of Cuzco: the enclosing walls are of rustic stone assembled without mortar, while one of the walls flanking the principal entrance—a short corridor, in fact—has been exquisitely realized with regular rows of ashlar blocks, the "rectangular" masonry. The refinement of this construction, whose inherent symbolic meaning I have reiterated, is exalted by the contrast with the rustic enclosing walls. In this refined wall, we see the sequences of nodules as plastic elements that heighten the symbolic meaning of this edifice. The feeling of confronting a significant "notice" is inescapable.

The importance of the gate of Rumiccoloca is confirmed by its intercardinal orientation: not only is it located to the southeast of Cuzco, but the gate—or corridor—itself is rigorously aligned on the cosmologically significant southeast-northwest axis.

The sequences of protuberances disappear beyond Cuzco and the Tampu region, "the Inca's chamber," whose symbolic unification repre-

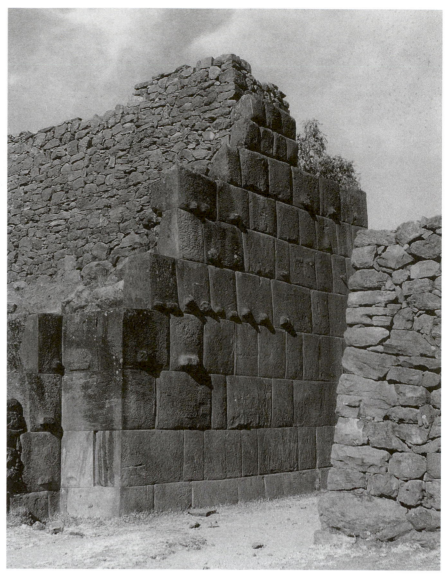

sented the capital region of the Tawantinsuyo. As denotative signs, surrounding niches or gates and marking the walls of the temples, the protuberances are not present in Huánuco Pampa, Vilcashuaman, or Tarahuasi, to cite some examples of imperial architecture of considerable magnitude. Herein lies one weakness of the utilitarian interpretation of the nodules' meaning: it can hardly be suggested that, by getting rid of the protuberances, the Incas took greater care in constructing those provincial edifices than they did in building those of the capital.

Inkamisana

The symbolic intentionality of the protuberances is unexpectedly confirmed by a detailed analysis of the sculptarchitecture of Inkamisana, which was called a "shrine" by Luis Llanos in his 1936 report.

But first, it should be pointed out that, paradoxically, and despite the paradigmatic nature of these Ollantaytambo ruins, almost no literature on the subject exists, with the exception of Llanos's report, which is valuable

as a substantiation but is without interpretative suggestions. Ollantay-tambo is still waiting for a scholar who will do for it what Valcárcel did for Machu Picchu.[10] This archaeological site has been so neglected that, to my knowledge, no one has taken the trouble to establish the *hanan* and *hurin* sectors of Ollantaytambo, though, of course, this hierarchy was inherent in every Andean settlement.

The topography strongly indicates that Inkamisana, located on the valley floor, must have been the (most ancient?) ceremonial site of Hurin Ollantaytambo, which also bordered the urban sector; while the ceremonial area crowned by the Temple of the Sun on the hilltop would constitute the Hanan sector.[11]

The magnitude of the Inkamisana shrine is appreciated more easily since recent excavations uncovered the remains of a considerable habitational group directly linked to the shrine. Within the group, certain enclosures stand out, constructed in the purest "rectangular" style out of green andesite, which presents a curious contrast with the rosy porphyry that is prevalent in Hanan, the ceremonial area. These enclosures were probably the residences of highly ranked priests. But the architectural modality—rectangular blocks, some with double-jambed niches of different proportions from those of the Hanan wall—as well as the stone used, represent a disconcerting stylistic intrusion within the context of Ollantaytambo, where walls of sculptural polygonal blocks and immense blocks of rosy porphyry brought (precut) from nearby quarries predominate. The material used in the Hurin enclosures appears to have been brought from somewhere else, also precut.

Stairs and rites
not for the foot
.
Carved rock
praying
as it buds

CECILIA VICUÑA,
"Inkamisana"
(translated by Suzanne Jill Levine)

The most interesting thing here is the sculptarchitecture of the shrines, the extensive facetings and steps cut directly into the vertical slope of the hill. There are two defined sectors: the first is associated with the agricultural terraces of Ollantaytambo, which ascend toward the area of Hanan and, in turn, connect with the remains of some habitations. The rock, a promontory projecting from the hill, has been worked on two faces: the one oriented toward the northeast (like the passageway-tabernacle of Hanan) has meticulous cubical shafts on two levels. Like the Temple of the Sun, the other face is oriented toward the southeast; here the rock has been cleanly worked into vertical planes and a seat has been carved into its base. Halfway up is the first surprise: three cylindrical protuberances that formally recall those inside Machu Picchu's mausoleum but here are *carved directly into the rock wall.*

In the second sector, farther to the east, the hillside has also been profusely faceted and cut into steps. A flight of steps allows for laborious access to two terraces: small and discrete, two protuberances appear carved directly into the rock wall of the lower level. Another more conspicuous protuberance is present on the upper level (Plate 96). All these rock nodules, of the kind found on the walls of the Hanan ceremonial area, are an unexpected reaffirmation of a symbolic significance. Though the cylindrical protuberances mentioned prior to this may be considered "hooks" or "hangers"—most likely for ceremonial paraphernalia—what possible function could these restrained prominences in the second sector have?

PLATE 96
Shrine at Inkamisana,
Ollantaytambo.
(Photo by the author.)

In the construction of Inca walls, the protuberances must *originally* have served some useful purpose—supporting levers would appear to be their most logical function—but the crucial decision not to eliminate them, precisely in places of greatest symbolic relevance, transformed them into significant notations. Here, in Inkamisana, the gratuity ab initio of these nodules carved directly into the rock defines, once and for all, their signifying nature and indicates that they were sculpted at a time when the signifying system they belong to had been fully developed. This visual-tactile semiotics is one of the most idiosyncratic traits of the Andean cultures.

The shrine of Inkamisana was linked intimately to the ritual meaning of water. In the second sector, precisely in the area of the presumed remains

WORKING THE STONE AND THE THREAD

of priestly residences, is the man-made channel of a stream, which at that point runs parallel to the Patacancha River, a tributary of the impetuous Urubamba River that flows further west. Carved directly into the side of the hill, a deviation from the channel passes the foot of the shrine, heightening the ceremonial sense of its sculptarchitecture, then turns and flows toward a "font" painstakingly cut into a monolith, which also faces northeast. This font is comparable in importance to the bath of the *ñusta*—also located in Hurin Ollantaytambo about six hundred feet to the southeast—but its "minimalist" form lacks the heraldic design that the bath of the *ñusta* displays. And though water again flows through the channel, present-day irrigation needs apparently have eliminated the stream of water flowing to Inkamisana, which is lamentable, because it would enhance visualization of the site's ancient ceremonial meaning.

A Visual-Tactile Semiotics

The "protuberance-surface" syntax and the "knot-cord" logic articulated by the *qipu* (Plate 97 and Fig. 24) are of the same order, as the two systems' morphological similarity immediately suggests. I have been calling the protuberances "nodules" or "stone knots" in anticipation of this obvious analogy.

The *qipu* (knot) is generally considered to be a mnemonic device. Leland R. Locke (1923) observed that in China records made of knots preceded writing, and they are typical of all cultures in which the arts of threadmaking and weaving were highly developed. The immemorial evolution of the *qipu* in the Andean region should therefore come as no surprise; the region's overwhelming orientation toward textiles was impregnated with meanings that are only gradually beginning to be understood.

(It is interesting to note that in his *Writings,* Chuang-Tzu characterized the times in which the Tao reigned as a paradisiacal state in which "people made knots on cords in carrying on their affairs," while living a simpler, bucolic life: "In those times perfect good order prevailed" [1962, Book 10, p. 4].)

The *qipu* consisted of a series of cotton or wool cords, dyed in codified colors, knotted at regular intervals, and tied to a principal cord from which they hung. The knots symbolized numbers that were organized in a positional system based on the number ten (a decimal system). The task of interpreting the *qipu* was reserved for a body of specialized civil servants, the *qipucamayoc.*

In their excellent study, Marcia and Robert Ascher make it clear that the elaboration of the *qipu*—which was a record and not a calculator—involved concepts of number, logic, and spatial configuration, indicating that it may have been much more than a mere mnemonic artifact to store governmental information, which is the definition of the *qipu* that was originally recorded by the chroniclers. The Aschers also observe that, unlike the Sumerian scribe who used a stylus to mark tablets of fresh clay, or the Egyptian who used pen and ink to draw signs on papyrus, the *qipucamayoc* composed his record directly, without instruments. Thus, turning the cord in different directions in the process of making knots, he traced figures in space, and this direct construction "required tactile

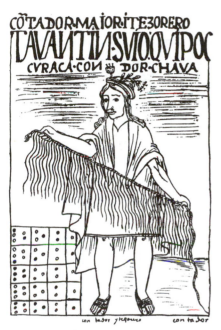

FIGURE 22
"Quipucamayoc,"
by Guaman Poma.

PLATE 97
Qipu, *knotted cotton cords. Collection of the American Museum of Natural History. (Photo by Logan; courtesy of the Museum's Department of Library Services.)*

sensitivity to a much greater degree. In fact, the overall aesthetic of the *qipu* is related to the tactile: the manner of recording and the recording itself; the former in the activity, the latter in the effect" (1981, 61).

The use of color is another evident difference. The Sumerians did not use it; they left cuneiform marks on monochromatic clay. The Egyptians used only red and black. The *qipucamayoc,* however, used hundreds of colors. Old World scribes needed keen eyesight, but the Peruvian had to recognize and record a large number of shades of colors in order to use them with skill and precision. This aspect of the use of color underscores the *qipu's* close interdependence with the meaningful visualization developed in textile art from ancient times and decisively incorporated into daily experience.

We also know that the imperial messengers—the *chasquis*—often carried the *qipu* as a message, along with a red cord (the royal color) or a stick with certain marks that conferred authenticity on the verbal message (see Garcilaso de la Vega [1604] 1991, Book 6, Chaps. 7 and 8). Cabello Balboa has related that the Sapa Incas recorded their final will by means of colored marks on staffs or boards, though no example of this has survived ([1586] 1840, cited by de la Jara 1964, 4). All of this leads to the conclusion that in a society like the Inca, which had not developed a written alphabet, the protuberances on the walls, the knotted cords, and the colored marks are a harmonically organized system of visual, or visual-tactile, signs that operate as an efficient substitute for writing.

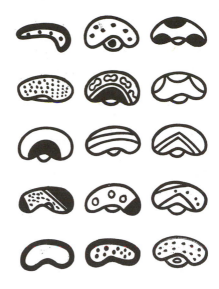

FIGURE 23 (ABOVE)
Mochica ideograms. Reprinted from
Rafael Larco Hoyle 1944, Lámina 1.

FIGURE 24 (RIGHT)
Figure from a Paracas Necropolis
mantle. Embroidery.
(Ink drawing by the author.)

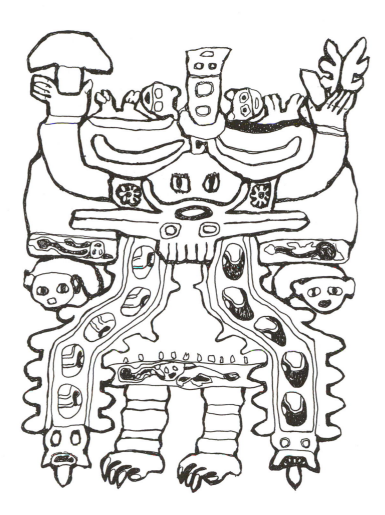

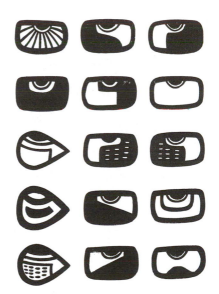

FIGURE 25
Nasca ideograms. Reprinted from
Rafael Larco Hoyle 1944, Lámina 2.

This visual-tactile semiotics has deep roots in Andean cultures. Other forms of visual communication, like the *qipu,* had been in use long before the advent of the Incas.

Rafael Larco Hoyle (1944) has assembled a collection of archaeological evidence that consistently demonstrates the existence of beans with painted glyphic signs as a form of nonverbal communication developed in the Mochica, Paracas, and Nasca cultures (Fig. 23). He first observed that in Mochica pottery, representations of runners (*chasquis?*) carrying bags of beans appear. In other examples, the beans are held up by personages (scribes or interpreters?) or spring from the mouth like words, as in the spirals the Maya used to represent the human voice. At other times, beans are painted in series, on both Mochica and Nasca ceramics. They also frequently appear in the sumptuous embroidered robes of Paracas Necropolis (Fig. 24); within that same tradition, a textile attributed to the Nasca culture is entirely dedicated to representing beans with colored marks.[12] Organized in diagonally repeated series, it would appear to be a graphic display of the typology of this "alphabet." Corroborating these examples, Larco Hoyle found among the holdings of the National Anthropological Museum in Lima a bag that contained beans with traces of paint on them.

Larco Hoyle points out other parallels with Maya hieroglyphs as well—the morphology, the ideographic elements (bars, points, and so on)—but concerning these I want to emphasize that, in the Maya and Andean

systems, both the "bud" or germinative point of the bean and the germination itself appear clearly represented as glyphic notations (Figs. 23 and 25).

The choice of the bean as a signifying element is profoundly coherent with the agricultural nature of the Andean societies. If cultivation of the earth had the fundamental meaning of perpetuating life, then the total process of planting, and even more, of the seed's germination and growth into a plant that would become a source of nourishment, may have had a numinous effect in the Andean mentality, to the point that those aspects were adopted as ideographic signifiers.[13]

I believe that the solution of leaving the protuberances on the blocks of the walls, as well as sculpting them directly onto the rock as in Inkamisana, is a response to a very ancient and uninterrupted Andean cultural pattern: the protuberances were metaphorical "sprouting stones," and therefore were considered "expressive" and significant.

This characterization of the protuberances as "lithic beans" should not keep us from seeing them in the more general context of a "morphology of grain." The cultivation of corn was of the greatest relevance in ancient American cultures. In the Andes corn was grown almost exclusively for ritual purposes, and much of it was destined for the preparation of *chicha*, the ritual drink. Thus, one of the creation myths attributes to the royal lineage the introduction of corn to the Cuzco region and refers to it as "the seed of the cave" (Paqaritampu) from which the Inca dynasty emerged.

I have called the protuberances "lithic knots," pointing out the syntactic analogy with the *qipu*. But I believe that the archaic roots of this visual-tactile semiotics can best be understood if the metaphor of grain, the "sprouting stones," is equally emphasized. The discrete prominences on Inca walls have been, until now, a totally misunderstood aspect of the possibility of signifying, of symbolizing, without writing.

THREADING SIGNS: AN ANDEAN GEOMETRY

During 1910–1911, Picasso and Braque produced a series of paintings that would change the artistic perception of the post-Renaissance West: spatial homogeneity is fragmented into an infinity of facetings and lines, mere abbreviations alluding to empirical reality, the color, applied in brief strokes, is cerebral, barely insinuated by a muted, earthy range. Kasimir Malevich and Piet Mondrian then took up the language of Cubism, and with an impeccable and reductive plastic logic they completely broke away from the hegemony of the natural model, proposing to replace it with a rigorous vocabulary of geometric forms.

This early evolution of twentieth-century art—rudimentarily simplified here—and the consequent Copernican changes that occurred in aesthetic definition do not appear to have left any traces on the scholars of pre-Hispanic art. Impervious, they continue to interpret the flat or cubical geometric forms of Andean art as "ornamentation."

Here I will not repeat the reasons, discussed in the Introduction, for eliminating this Western interpretative category from the study of the ancient art of America. Suffice it to say that as long as geometric signs are neutralized as "decorations," the historical picture of pre-Columbian cultures will remain incomplete.

Neither has attention been paid to the prehistoric moment in which these geometric signs appeared. Paleolithic man, in a clear act of intellec-tion, abstracted symbolic images from the natural world and painted them on walls; there is, however, a second moment in which an abstractive process of another order appeared in the practice of crafts such as bas-ketry, pottery, and carpentry. Of course, thousands of years had passed; this specialization of labor was only possible after the development of

agriculture brought about a more sedentary way of life, the domestication of animals, and the beginnings of village life—all of which took place during the Neolithic.

Within this picture, basketry is crucial. It is the progenitor of more sophisticated forms of weaving with vegetable (especially cotton) and animal (wool) fibers. It also presupposes a long apprenticeship based on the rudimentary knotting of nets or the construction of stick frameworks, which very possibly emerged from observations of animal constructions, birds' nests or spiders' webs.[1] Mary Frame likewise notes that "the structuring processes used to order chaotic loose fiber into utensils and shelter may have provided a tangible model for understanding and reflecting observed structures and phenomena in the natural world" (1984, 57). A. T. Vandermonde wrote in his 1771 treatise, *Remarks on Problems of Position* (cited by Ascher 1981, 166), "The craftsman who fashions a *braid*, a *net*, or some *knots* will be concerned not with questions of measurement, but with those of position: what he sees there is the manner in which the threads are interlaced. It would therefore be useful to have a system of calculation more relevant to the worker's mode of operation, a notation which would represent his way of thinking, and which could be used for the reproduction of similar objects for all time." Today, the study of *position* is the mathematical discipline called topology, but thousands of years ago it gave rise to basketry, weaving, and ceramics, making possible their later development (Francastel 1970, cited by Acha 1979, 258).

Once it had evolved, basket weaving was where the process of abstraction first occurred that enabled the weaver to extract and systematically replicate the essence of formal patterns previously immersed in natural chaos: the stylization of animals or vegetables, or, perhaps more importantly, the development of diamantine forms (the rhomboids on a snake's skin?), the zigzag (lightning?), the meander (the course of a river?), or the spiral (the rotation of the night sky, or the structure of a sea shell?). The question of whether these forms were first used in body painting remains open. In any case, they quickly assume an archetypal—numinous?—meaning and exert an influence on other activities. "In other words," writes Bremer (1925), "the Susa potter copies basketry models and the peculiar forms he gives to animals obey the demands of weaving. . . . At the same time the birds and animals, as well as the geometric symbols are the antecedents of the magical or divine signs later engraved on seals and that with the passage of time would *become elements of writing*" (italics mine; cited by Read 1957, 221).

This is an essential point: the so-called geometric decorations are the first expressions of conventional ideas, the ancestor of writing, and, very possibly, efficient substitutes for writing in many cultures. Here I can do no more than briefly sketch a question that requires an entire study dedicated to it alone. As the basis for my discussion, I will briefly touch on Greek geometric art, since its study clearly has manifested the "decorativist" prejudice.

During the twelfth century B.C., traces of the Minoan-Mycenean civilization were extinguished. The disappearance of the palace bureaucracies also meant the loss of the arts they sustained. "Even the art of writing was forgotten for over 400 years," John Boardman observes (1978, 53), during the period in which Greece was devastated by the Doric invasions.

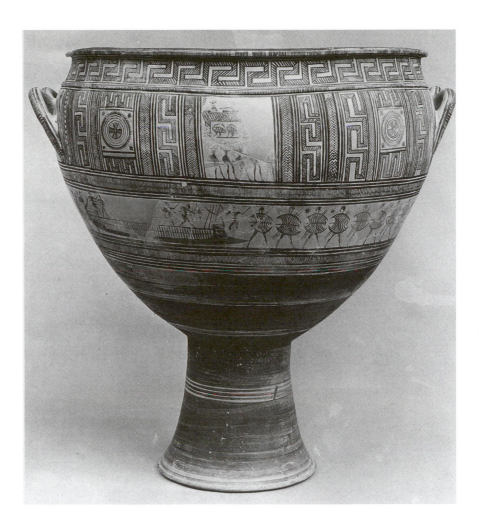

Athens, however, was hardly affected by the invasions, and its Mycenean past remained relatively intact. Here a ceramic art gradually reemerged whose initial phase can be dated toward the end of the tenth century B.C. and whose apogee took place during the eighth century B.C. At that point, vases painted with rigorous and angular geometric designs take on monumental proportions; from funerary urns, they have become grave markers: some of them are the height of a person, measuring more than five feet (Plate 98).

Ceramics was, at that point, the central artistic medium. Bernhard Schweitzer believes that the tectonic plastic forces that transformed the funerary urn into an idealized monumental form are "the same [that] . . . expressed themselves hundreds of years later in the columnar architecture of Greek temples and in Early Archaic statues of young men. The Geometric funerary vase is simultaneously both architecture and sculpture" (1971, 25)—and *painting,* it should be added. Nevertheless, since paint was applied to the surface of the ceramics, it is consistently referred to as "decoration," without consideration of the fact that no other "central" medium existed (such as easel painting would become in the post-Renaissance West); the idea is never suggested that in those historical circumstances, far from being a mere embellishment, the painted designs may very possibly have had a semantic function as the substitute for the lost art of writing.[2] Schweitzer himself suggests that from ancient times (the

FIGURE 26

Figure of a male condor from a Pre-Ceramic period fabric from Huaca Prieta. Drawing by Junius B. Bird. Reprinted by permission.

FIGURE 27

Double-headed figure from a Pre-Ceramic period fabric from Huaca Prieta. Drawing by Junius B. Bird. Reprinted by permission.

FIGURE 28

Human figures from twined fabric from Huaca Prieta. Drawing by Junius B. Bird. Reprinted by permission.

FIGURE 29
Bird figures from a woven textile from Huaca Prieta. Drawing by Junius B. Bird. Reprinted by permission.

Neolithic) these geometric designs could represent "intellectual concepts" by means of "patterns with symbolic meanings" (1971, 13).

It is my contention, therefore, that when geometric funerary urns are gradually displaced during the late eighth century B.C. by the representation of humans and animals in ivory, bronze, and vase painting, first under the aegis of Near Eastern influence and then of Egyptian stone sculpture (the *kouroi* and *kore* of the sixth century B.C.), the full use of writing has "absorbed" the function of the signs of Geometric art. One can also see sketched out here the basic tenets of what Western culture has extolled as the hallmarks of "high civilization": writing on the one hand, and an art grounded in the representation of natural forms on the other, which is to say, a mirror image of itself.

In any case, the development of a textile technique is the necessary condition for the appearance of these geometric "decorative" patterns. Schweitzer defines the plectogenic nature of these forms: "The Geometric style is without doubt entirely a pottery style, as it has come down to us. But a series of phenomena suggests that it developed alongside a lost textile art and that this may even have been the origin of Geometric art before 900 B.C. The early history of the meander in the tenth century can probably not be explained satisfactorily without the hypothesis that its roots lay in textile work. Surface ornaments such as the checkerboard, saw-tooth and lozenge patterns seem to be developed directly from weaving techniques" (1971, 13).

Franz Boas also observed that the artistic form most developed by a community imposes its style on the other "industries" and that "weaving and basketry have been particularly influential in developing new forms and powerful in imposing them on other fields" (1955, 182). Perhaps nowhere else is this phenomenon as evident as in the Andean region.

Several centuries before the appearance of ceramics, weaving was the primordial artistic form in the Andes. This can be proven beyond doubt thanks to the excavation Junius B. Bird undertook in Huaca Prieta, in the Chicama valley on the northern coast of Peru, in 1946–1947. More than four thousand pieces of cotton fabric were recovered, from some of which Bird was able to reconstruct the most ancient textile versions of the cultural archetypes of pre-Hispanic America: the condor, the puma, the two-headed snake, the human figure, and the geometric forms of the rhomboid or diamond and the chevron (Figs. 26–29). They were dated between 3000 and 2500 B.C., about one thousand years before the development of pottery. With the exception of some pyroengraved gourds, none of the other materials found—matting, basketry, wood, bone, shell, and stone—bore any trace of a design (see Bird 1967, 62, and Skinner 1984, 11).

It is possible that an investigation of the genesis and role of textiles in pre-Hispanic America, particularly after Bird's discoveries in the Andean region, would indicate that the coordinates of the textile medium—warp and weft—played a function similar to the coordinates of the Renaissance system of perspective in the West. While in Western culture this system made possible the representation of the appearances of empirical reality, in American antiquity the textile medium not only gave rise to geometric forms that later became archetypes, but also appears to have opened up the possibility of configuring far more inaccessible images: those of the

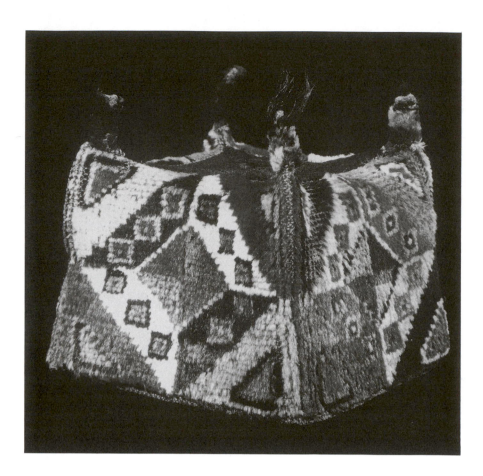

gods and mythic beings. Mary Frame has observed that "the grids and symmetries of fabric structures operate as a construct for the *conceptualization of space, giving it form, division, direction and unity*" (italics mine; 1984, 55). Furthermore, in a recent work on Andean four-cornered hats (Plate 99) subtitled "Ancient Volumes," Frame writes, in the same vein, "The human-scale art of fabric-making, practiced by virtually everyone in ancient times, may have been used *to codify mathematical concepts such as space and number,* concepts that had application in diverse realms of daily life" (italics mine; 1990, 4). In other words, she is intimating that the construction of these three-dimensional textiles, the four-pointed hats, represented the application of the principles of a volumetric geometry.

No other artifact of Andean culture attained the primordial meaning that the symbolic and ritual use of weaving did in Andean life. Almost no religious, political, military, or diplomatic activity was complete without the presence, offering, interchange, or sacrifice of textiles. They were, as is known, buried with the dead, but they were also the trousseau the bride brought to her wedding. And despite five centuries of acculturation, today many of the ritual uses of textiles persist in Andean life. Its very fabrication was part of the textile's symbolic function: the use of selected fibers and of diverse forms and techniques in every kind of garment defined the social rank of the person who used it and/or the region from which he or she originated. We have observed the fundamental role of the *qipu* as a census record: we should also point out that textile technique entered into the manufacture of containers (bags and baskets), fish nets, and scales, and

into the weaving of protective garments, the making of slings for war, and the construction of reed boats. Moreover, a textile macrotechnology was used in the construction of suspension bridges and in the elaboration of thatched roofing. Such was the crucial importance of textiles that Conklin has suggested we could speak of Andean antiquity as a Textile Age, in the same way as we speak of a Stone Age or a Bronze Age in the Old World (1981, 132). (The fact that today the importance of textiles has diminished very little, principally in its ritual uses, allows us to glimpse its past role.)

Summing up: I mentioned before the degree of mathematical knowledge involved in the two- or three-dimensional textile constructions; this knowledge was paralleled by the chemical advances involved—the invention of dyes, mordants, and paints. Certainly, textiles were the high-tech field of the period: it shouldn't surprise us, therefore, that they would have an effect on other artistic media, decisively influencing the iconographic development of Andean art. As Rebecca Stone-Miller wrote: "[T]extiles acted as a foundation for the entire aesthetic system to a degree unparalleled in other cultures of the world" (1992, 23).

Frame also pointed out that the astounding quantity of ancient Andean textiles known to us exhibit a "command of complex structure and construction" that is similar to the ancient peoples' sophisticated mastery of engineering and mathematics, which went into the building of terraces, canals, and edifices (1990, 4). This brings to mind a reflection on the etymology of the word "tectonic," an adjective I have used often in relation to sculpture because it refers to everything having to do with construction and the architectural. "Tectonic" derives from the late Latin *tectonicus,* which derives from the Greek *tektonikós,* from *tekton,* carpenter or constructor. Inspired by Cecilia Vicuña's poetic work with metaphors that are hidden in the intimate heart of a word, I discovered that the Indo-European root *teks*—the etymon, the true meaning of the tectonic— means "to weave," and also to make a wicker or wattle framework for mud walls; in Latin, *texere* (to weave) is the word from which "text," "texture," and context are derived. And one of the root's suffix forms, *teks-la,* is in Latin *tela* (net, warp, spiderweb), while another of its suffix forms, *teks-nà,* means "artisanry" (weaving or fabricating), which in Greek is *tekhnè* (art, artisanry, skill). Thus, in its hidden meanings, the word "tectonic" illuminates the primordial meaning of art, in which weaving and constructing are identified with the same semantic resonance—a resonance that, from my point of view, becomes the subtext, the weft that interweaves with the expositive warp of the history of Andean art. Furthermore, this structural paradigm, which I would call the *tectonic principle,* casts a long shadow that, as we will see, reaches well into the art of the twentieth century.

Woven Information: The T'oqapu

The obstinate or unthinking neutralization of geometric designs as "ornaments" appears to be slowly reversing itself in recent years. In practice, certain scholars have begun to consult the information codified in textile geometric designs.

R. T. Zuidema, for example, observed that, unlike the Mesoamerican calendars, which are articulated through a representative system of gods,

PLATE 100

Inka tunic. Interlocked tapestry, wool and cotton, 91 cm x 76.5 cm. Dumbarton Oaks Research Library and Collections, Washington, D.C.

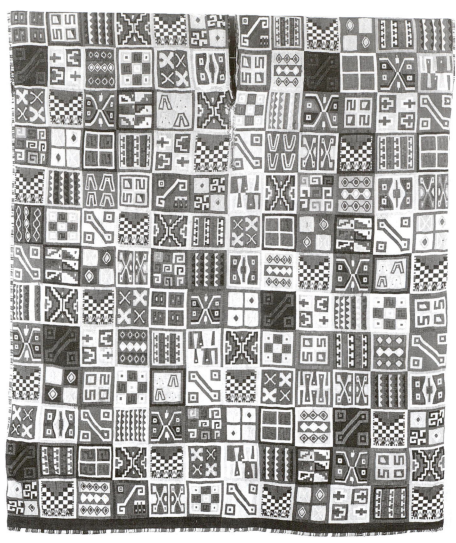

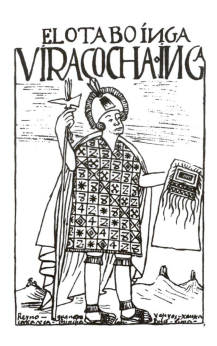

FIGURE 30

"The eighth Inca Viracocha Inga," by Guaman Poma.

animals, and symbolic colors, the Inca calendar was recorded in the abstracted language of the *qipu* or the *ceq'e.* On that basis, Zuidema analyzed the organization and number of figures with calendrical connotations in two textiles. Those figures might have been overlooked as "geometric decorations" by other scholars.[3]

Some of the most remarkable examples of geometric designs in Andean art are found in Inca-style tapestry tunics—the *t'oqapu* (Plates 100, 101, and Fig. 30)—or carved or painted on ceremonial cups—the *kero* (Plate 102) or *paqcha* (Plate 23)—also from the Inca period. Cieza de León describes the "shirts without sleeves or collars, of the finest wool, with paintings in different manners that they called *tocapu,* which in our language means garments of the kings" ([1554] 1973, Chap. 6, p. 25). The portraits of Inca rulers drawn by Guaman Poma to illustrate his *Nueva Crónica* of the early seventeenth century ([1615] 1988) show seven of them wearing the all-over *t'oqapu*-patterned tunics (Fig. 30) that are similar to the Dumbarton Oaks tapestry example (Plate 100); portraits of *ñustas* (Fig. 31), as well of prominent warriors, also depict them wearing garments with horizontal or, less often, vertical rows of *t'oqapu.* Although the Inca textile tradition did not come to a sudden end with the Spanish

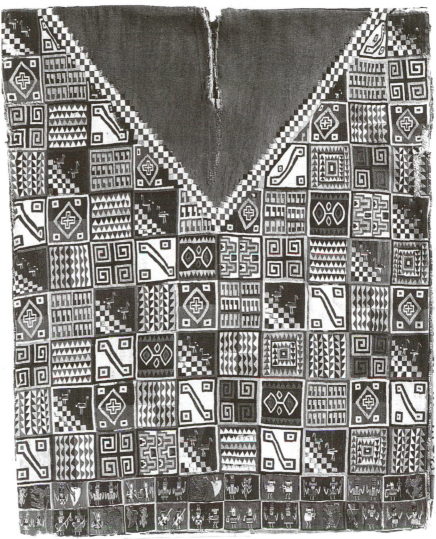

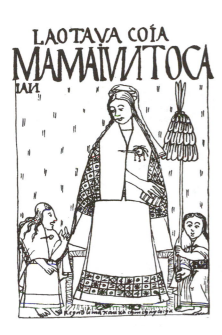

FIGURE 31
"The eighth Coya Mama Iunto Caian," by Guaman Poma.

invasion, the textile designs increasingly absorbed the figural, organic motifs of European filiation demanded by the new patrons as well as new materials, such as threads wrapped with silver or gold tinsel; the tapestry tunic example in the collection of the American Museum of Natural History in New York (Plate 101) is a case in point. Yet the predominance of the *t'oqapu* modular geometry suggests an early colonial dating, while other examples in which vestigial *t'oqapu* designs coexist with European flora or fauna representations would indicate a later, though imprecise, dating (seventeenth or eighteenth century) (for illustrations, see Stone-Miller 1992a, Plates 69a and 69b; and Dockstader 1967, Plate 179). A similar transitional period is observable in the production of the wooden ceremonial cups, *keros* and *paqcha*: while the introduction of figural motifs and the lacquer inlay technique indicate the European influence (coexisting, nonetheless, with bands of geometric patterns akin to the *t'oqapu*), predominantly incised geometric designs—only occasionally painted—would indicate pre-contact origin (Fig. 32; see Rowe's meticulous survey of the archaeological record, 1961). (The example illustrated in Plate 102, belonging to the collection of the Museo de Ciencias Naturales de La Plata, illustrates a curious example: while the goblet shape of

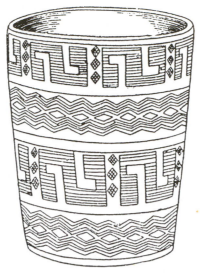

FIGURE 32
Keros, *incised wood. Reprinted from Luis A. Llanos 1936, Lámina 7.*

PLATE 102
Kero *(ceremonial cup), Inca culture (sixteenth century). Collection Museo de Ciencias Naturales de La Plata, Argentina. (Photo permission of the Museum.)*

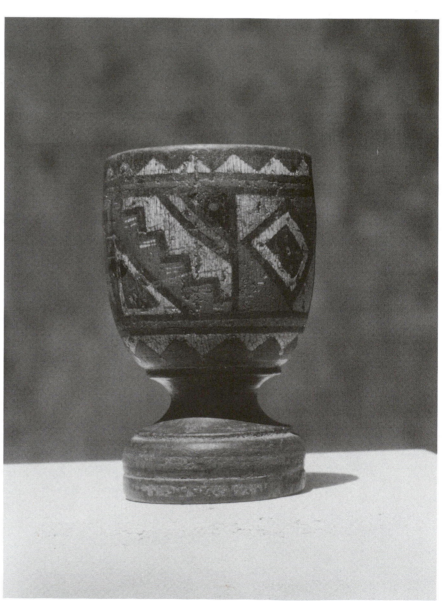

the cup denounces the European influence—the traditional Andean shape is tumbler-like as far back as Tiwanaku—the designs are thoroughly geometric.)

Thomas S. Barthel (1971) and Victoria de la Jara (1964, 1967, and 1975) have studied these geometric designs, both the *t'oqapu* and the ones occurring on ceremonial cups—though without distinguishing between pre- and post-contact origin—concluding that they are semantic units. Although the entire Andean cultural context, pre- and post-Hispanic, appears to sustain the past viability of the system, it must be acknowledged that a convincing reading of the whole system has not yet been advanced.[4] And only recently are the conclusions of Barthel and de la Jara gaining qualified reception among Andean scholars.[5]

"The writing system brought by the Spanish explorers to the Amerindians in the New World was a measure of the distance which separated the two cultural entities," writes Regina Harrison (1989, 55). To a large degree, the chronicles written by the Spaniards bespoke the derision with which they referred to the Andean peoples' lack of script—at least one the Spaniards could identify as such, as we will see below. The Andeans, on the other hand, confronted with the written papers carried by the invaders, "concluded that their Iberian lords possessed a magical means of communication" (Harrison 1989, 55). Native testimonies "reveal a prolonged curiosity regarding the Spanish writing system. . . . The alphabet, seen through the indigenous eyes, assumes magical properties," adds Harrison (1989, 56). Nonetheless, the Quechua speakers assimilated "writing" or "book" to the *existing* Quechua word *quellcca*, which primarily meant "painting" or "drawing" and is the root of the verb *quellccani,* whose meaning, as collected by sixteenth-century lexicographers, is "to write," "to draw," "to carve on hard surfaces," "to embroider," "to dye."[6] This semantic equation, once contact with Spanish writing had occurred, is a strong indication that the Andeans already had visual forms of communicating meaning resulting from the art practices of the period—painting, drawing, carving, and, most important, weaving (embroidering, dying). This linguistic analysis, first put forth by de la Jara (1964), should suffice to understand that the *t'oqapu* designs were more than "adornments" of clothing or drinking paraphernalia. In this light, it is most significant to quote from one of the Andean narratives, that of Tito Cusi Yupanqui's (1570). As he is characterizing the Spaniards, he makes special mention of their ability "to speak by *means of a white cloth,* and to name several of us by name without anyone having told anyone. [They do this] merely by *looking at the cloth* in front of them" (italics mine; cited and translated by Harrison 1989). Leaving aside the wonderment expressed by this pristine ethnohistoric source (Tito Cusi belonged to the Inca nobility), we find here irresistible evidence that "cloth" (weaving, that is), was in Inca society a most suitable means of transmitting information.

On the other hand, de la Jara observes (1964) that fifteenth- and sixteenth-century Europeans were ill-equipped to identify a pre-alphabetic system among the Incas because it was not until 1822 that Champollion began to decipher the Egyptian hieroglyphs; only after that did nonalphabetic semantic systems begin to be taken seriously. De la Jara cites Father Joseph de Acosta who, with great lucidity, was able to discern the ideographic nature of the designs and pointed out that the Incas "made up for

the lack of writing and letters, partly with paintings like those of Mexico, though those of Peru were very crude and rough; and in greater part with *qipus*" ([1590] 1940).

In his *Historia de los Incas,* Sarmiento de Gamboa offers a valuable testimony:

A very great diligence is attributed to the Pachacuti Inga Yupangui, ninth Inca, who made a general call to all the old historians of all the provinces he had conquered and even of many more of all those kingdoms, and had them in the city of Cuzco a great while examining them on antiquities, origin and notable things of their past kingdoms. And after, he made them paint *by his order on* large boards, *and set aside in the Houses of the Sun a great hall where the boards were kept, that were embellished with gold, they were like our libraries, and he constituted* doctors who knew how to understand and declare them. *(emphasis mine; [1572] 1907)*

De la Jara (1975) maintains that these boards may have been painted with the geometric designs of the logographic signs, in the manner of the painted ceremonial vases, the *keros.* She believes the vases are partial transcriptions of the content of the boards.

It does not necessarily follow from the existence of "doctors" (*camayoc?*) who "knew how to understand and declare them" that the paintings were (geometric) logographs. Even a group of figurative paintings would have needed the *camayoc*'s narrative to explain it, since there was no writing. It should be observed, nonetheless, that Molina "El Cusqueño," referring to the existence of these painted boards, does so in the same paragraph in which he mentions the lack of writing: "And to understand where the idolatries had their origin because it is thus: that those men did not use writing and had in a House of the Sun *Poquen Cancha* which is near Cuzco the life of each one of the Incas and of the lands he conquered, painted *by their figures* on some boards and there they had their origin" (italics mine; [1573] 1943, 7).

A contextual reading suggests that Molina glimpsed the existence of some idiosyncratic *figures* ("their" figures—were these the symbols?) that sustained a "narration." It can be conjectured that, indeed, these belonged to the geometric repertory of the textiles and the *kero,* which began to reflect a more intensely figural modality only *after* coming into contact with the European tradition, as I mentioned before. In 1572, the boards were sent to Spain by order of the Viceroy Toledo, and they have subsequently disappeared. Only the woven symbols and the *kero* remain.[7]

First I would like to point out that in some superb examples of tunics, the designs are repeated in an intermittent and irregular fashion, such as the one in the Bliss Collection at Dumbarton Oaks, Washington D.C. (Plate 100), the one at the Museo de América in Madrid, and the one in the American Museum of Natural History in New York (Plate 101). What is, for Rowe, "the lack of a simple pattern of repetition" (1979, 257) offers, in my view, a striking parallel with the asymmetrical ordering that defines linguistic structure. If this perspective is dismissed, it then remains to be explained why, in these scarce and sumptuous examples, the repetitive organizational principles applied to the modular designs are so decisively subverted.[8] Since the reiteration of modular units appears to be

FIGURE 33
"Hourglass" design, from a
t'oqapu *in an Inca tapestry tunic.*
(Ink drawing by the author.)

inherent to the textile language, it is important to note here some observations made by Edward Franquemont, who has done a great deal of intensive ethnographic research in the area of Chinchero where the Peruvian textile tradition is still extremely vital. He suggests that, rather than trying to decipher the textile symbol, we should pay attention to the operative modality in which it developed. The textile is a chronicle of basic thoughts "full of language"; the weaver expresses mathematical principles, the most fundamental being that of *formal symmetry*: a basic cell that generates forms by means of repetitions, spatial reflections, rotations, and so on (1987). It is clear that the formal conception of the *t'oqapu* signs internally responds to this process, but the asymmetry of the total composition of the aforementioned examples remains highly significant as an exception to that norm.

Second, leaving aside those examples of exceptional construction, the design of such textiles was standardized as a general rule, which indicates a central state policy involving the systematization of cultural codes in order to facilitate their diffusion and imposition (see Chapter 1). The reductive geometric design of the *t'oqapu* is the culmination of a process already observed during other moments of unification and centralization: Chavín and Wari-Tiwanaku. "Standard" implies uniformalization but also a convention, a preordained use, the sine qua non for the existence of a code, a system of signs. This systematization obviously is another aspect of the ubiquitous repertory of visual signs we have been analyzing: the protuberances on the walls—the unobtrusive sculptural version of a geometric language—the *qipu*, the painted staffs. And while certain scholars acknowledge the symbolic character of these designs as heraldic designations of rank, like military insignia, we should not forget that these classifications are made from within our alphabetic culture. In societies where writing was not developed, these visual ways of transmitting meaning—which were the *only* graphic way of transmitting meaning— must have had an importance and an intensity that is difficult to imagine today.

A most compelling argument in favor of the viability of the *t'oqapu* as a sign system is made by Regina Harrison in *Signs, Songs and Memory in the Andes* (1989). Although she concludes that "no researcher has yet deciphered the meaning of these symbols," she states flatly: "we must assume that they possessed more than mere decorative value within Incaic culture" (p. 60). She analyzes the chronicle by Santacruz Pachacuti Yamqui (1613) and particularly emphasizes its description of the crucial moment when the conquistador Pizarro and the priest Valverde confront the Inca Atahualpa. While Pizarro is depicted as "nakedly bereft of symbolic trappings," the chronicler is attracted to the liturgical significance of the priest Valverde's pointed miter and cape, and, even more markedly, to the symbols that define Atahualpa's authority, the symbols "he knows best from his Andean heritage. He mentions the royal litter, the ornate garments and royal plumage, the *suntopaucar* (the royal staff) and the royal insignia instead of describing the individual characteristics of the Incan ruler." Harrison concludes that "Santacruz Pachacuti Yamqui is disposed to write in this fashion because of his exposure to the *tocapu*, an Inca sign system, which was still in use in his lifetime" (1989, 60). Indeed, seventeenth- and eighteenth-century colonial paintings of the Cuzco school

portray members of the Inca nobility wearing traditional woven garments displaying rows of *t'oqapu* designs (color illustrations in Gisbert 1992, 153, 154; see also Figs. 31 and 33). Rowe mentions the existence of ten colonial paintings in the church of Santa Ana in Cuzco that represent scenes of the Corpus Christi procession in which some of the participants are also wearing Inca style clothing (1979, 243). In light of all of this evidence, Harrison writes, "it is safe to assume that the [*t'oqapu*] symbols portray a hierarchical reference to the elites in Inca society" (1989, 60). In short, the *t'oqapu* were an emblematic sign system. Harrison is fully aware of the signifying power of this system in a society without alphabetic script. From Santacruz Yamqui's description of the way people identified their towns of origin through an emblematic code, Harrison concludes, "Knowledge, then, was conveyed through visual signs, and this cultural mapping was so complete that one could identify at a glance the participants at a ceremonial gathering" (1989, 62).

The importance of ethnographic study in understanding the pre-Columbian past is often proclaimed today. One of the areas where there has been the greatest continuity of tradition is textiles, despite the disappearance of many of the traditional techniques. At the last Conference on Andean Textiles in honor of Junius B. Bird, held at the Textile Museum in Washington, D.C., in 1984, no distinction was made between pre- and post-Hispanic textiles, in recognition of that continuity.

Recent studies on Aymara textiles (Plate 123), which inherited the ancient highland tradition—extending farther back than Tiwanaku textiles—to which Inca weaving must be ascribed, point out that the designs are chosen for their meaning and not for their "aesthetics." In general, the placement and number of stripes symbolically represent the physical and social world of the Aymara (see Cereceda 1986). In particular cases, certain colors can illustrate the vertical property of the land and even the crops that can be cultivated at different altitudes (Joseph W. Bastien, cited by Adelson and Tracht 1983, 45). This still occurs in the Andean region, which is as besieged as anyplace on the planet by the unprecedented development of the means of mass communication propelled by Western technology, and therefore it can be supposed that in antiquity the semantic function of the geometric textile designs must have been in wide use.

Angelika Gebhart-Sayer has studied the designs of the Shipibo-Conibo (1985, 143–175) and believes that, though their intricate geometry does not constitute a true writing, they may have been graphic artifices that included semantic or symbolic unities, perhaps in a mnemonic form, to be used in ritual contexts. She also observes that the Shipibo come from the same northwestern region of South America—on the eastern slopes of the Peruvian Andes, in the Ucayali River basin—where other mnemonic codes were developed. Among these, she mentions the *t'oqapu,* which represented, according to her, the Inca custom of weaving highly important information into ponchos or painting it on ceremonial cups.

David M. Guss has recovered the mythic content that informs the designs on the basketry of the Yekuana, a tribe that inhabits the isolated region along the upper course of the Orinoco River in Venezuela. The memory of the origins of this culture's artifacts—canoes, weapons, instruments, and, primarily, baskets—is not only recorded in myths, but is also

incorporated in designs. Guss writes, "By simply making an artifact, one repeats the message codified in the history of its origin" (1989, 101). The symbolism of the compositional design of each basket at once amplifies and repeats the meaning of its origin, name, and physical properties.

The rigorous designs of the Yekuana have, in their finest examples, the effect of kinetic structures in which the interminable perceptual movement of the components seems to absorb the spectator (Plate 127). This dynamic relation, unlike other figurative designs of static images, is the simultaneous description of a dual reality: image and counterimage constantly compete for the perceptual focus.

I mention Yekuana basketry for two reasons: First, because it shows how these rigorous geometric compositions, far from being "decorations," are the signifiers of mythic content. The very process of making them, as we have seen, implies a reduction of the nature-culture opposition, allowing their entrance into the Yekuana cosmos. My second reason is that basketry, as the progenitor of weaving, establishes the ancient ancestry of the geometric signs. I will return later to the geometry of the Yekuana basket designs.

STONINESS

Inca art is generally studied in a descriptive manner. The technical excellence of its textiles, ceramics, stonework, and metallurgy is unfailingly depicted. But then, the clear predominance of geometric symbols—obviously originating in textiles—and their deliberate repetition, gives rise to judgments that should, by now, be familiar: "lack of freshness or originality," "mass-produced art," "designs almost mechanically imprinted."[1]

It is forgotten that these "stereotypes" form a system of signs. They are the signifiers of basic cultural codes diffused by a central power as a means of homogenizing diverse territories and populations. This is true not only of textiles (Plates 100 and 101) and ceramics (Fig. 34), but also of architecture, which systematically reiterates its minimalist designs throughout the Tawantinsuyo, leaving, together with the abstract volumetry of its sculpture, an unmistakable cultural imprint.

In other words, in Inca art a manifest distancing from received figural traditions is produced, though those traditions were not of a "naturalist" order to begin with. In ancient Peruvian art, only the sculptural ceramics of the Moche show a naturalist vocation because, without rejecting ceremonial symbolism, their crude descriptive realism seems to open up before our curious eyes like an ethnographic catalogue (Plate 103). Decidedly, they represent the chapter of Andean art that is furthest from the synthetic, geometrizing configuration that prevails in all other places and periods.

This reductive synthesis of natural forms is evident, as I have observed, in the monumental sculpture of Chavín and Tiwanaku. But despite reductive treatment, these forms are perfectly legible: the metaphoric recombina-

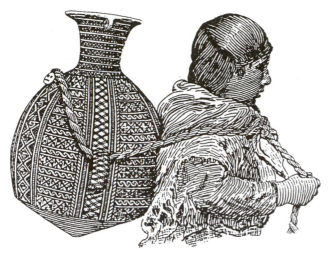

FIGURE 34 (ABOVE)
Inca woman carrying a large aryballos
(jug). Drawing by A. H. Bumstead.

PLATE 103 (RIGHT)
*Model of a temple pyramid, ceramic,
Mochica. The Metropolitan Museum
of Art. Gift of Nathan Cummings,
1963 (63.226.13).*

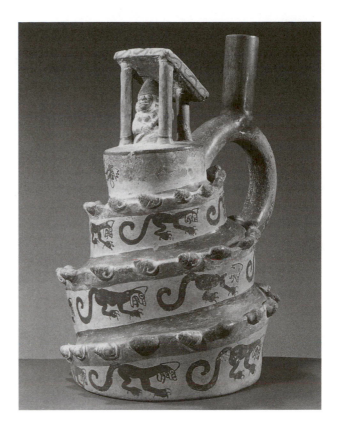

tions of the feline, the reptile, the bird of prey, and the human form—the principal figural archetypes of America—give rise to a theogonic iconography that is central to those cultures. While the figure has not disappeared totally in the monumental stonework of the Incas, it has lost its central place: abstract forms predominate dazzlingly.

Until not long ago, scholars considered the sculpture that is representative of natural forms on a small scale to be the only Inca sculpture.

Votive Sculpture

Three aspects of Inca figurative sculpture are clearly apparent:

1. The rudimentary representations of animals sculpted in situ in the rocks of Kenko Grande (puma, bird of prey), Kusillochoj (the place of monkeys, where simian figures predominate; Plates 45 and 46), and Suchuna (the Lizard Stone), and the archetypal character of the sculptural forms of Hanan Cuzco, which include zoomorphic representations, has already been pointed out.

2. The figures carved into the Saywite Monolith (Plates 71, 72, and Fig. 15) must be considered a prolongation of the mode inaugurated by the aforementioned representations of Hanan Cuzco, though in this example greater care and formal refinement is evident. The solitary figures of pumas, which appear in the provincial establishment of Huánuco, can be considered stylistically linked to the production of the period of the Monolith, though probably of later date, since they are found even farther from Cuzco.

3. Miniatures in stone or metal, which, according to all the evidence, were votive objects. Representations of alpacas or llamas carved in stone (Fig. 35) are characteristic of the dominant mode of this aspect of Inca art.

Alpacas and llamas were—and still are—an extraordinarily valued possession in the highlands and mountains, where they are essential for human survival. Their meat provides protein, their dung is dried and used as fuel, and their wool provides the protection necessary to survive the hostile climate, not to mention having made the ancient and sophisticated textile art possible. They were probably first domesticated in the highlands, and, therefore, the symbolic, ritual power of these small, stone alpaca figurines, which are scarcely if ever found on the coast, must significantly precede the Incas, who only multiplied the versions of the small, votive statues.

During the Inca empire, the record of llamas and alpacas was only slightly less important than the human population census that was carried out by means of the *qipu;* llamas, in turn, took precedence over textiles. Moreover, the sacrifice of an alpaca or llama was of such transcendence that it was performed in ceremonies presided over by the Sapa Inca. One of the most important of those ceremonies was related to the cultivation of corn, which was very hazardous in those mountainous regions (see Murra 1978, 105).

The highly propitiatory meaning of the sacrifice of alpacas or llamas appears to be reflected in the insistence with which they are represented; but this is only one aspect of the multiple symbolic referents attached to these icons. Carved in fine-grained stone—quartzite, basalt, or granite—and often dark-colored or black, these llamas and alpacas have a cup or rounded orifice carved into their backs (Fig. 35). The figures are known as *illa* or *qonopa,* and the cup is a *qocha* or "lake." Initially, they were used for burning incense (a reference that is familiar to us), and in the home they were closely linked with rituals for the fecundity of the flocks: to that end the animal's fat (*wira*), which when mixed with coca leaves could be used to predict the future, was burned in the cup, or *qocha* (Murra 1978, 89).

In the representations of alpacas, the *qocha* or lake directly refers to their origin; they "came from the springs and the places where water is" (Flores Ochoa 1977, 219), and "they would have to return to water, when the world reached its end" (Randall 1987, 73). But in the same flocks there were animals considered *illa:* "at times an alpaca whose wool had been left to grow until it reached the ground could be found" (Gow and Gow 1975, cited by Randall 1987, 73). This fact, still true today, throws light on the pre-Hispanic figurines.

Because of the uninterrupted continuity of symbolical patterns and rituals, the ethnographic information given by Flores Ochoa permits us to come even closer to the meaning of these miniature sculptures. Observing the propitiatory ceremonies—the "send-off" or "payment"—of Bolivian highland shepherds, he notes the anxiety produced in this inhospitable environment, the care of the flocks, their protection from predators and natural calamities, and assurance of their fecundity. In the elaborate supplicating rituals, the *illa* or *qonopa* occupies a central place; Flores Ochoa notes that "some of them are of pre-Columbian origin" (1977, 216).

Moreover, the shepherds say that the *illa* "are" and "have" *enqa*, "the source and origin of felicity, well-being, and abundance" (Flores Ochoa 1977, 218). Here, an important digression: *enqa* is a late deformation of *inka*, "the creative and ordering power of the universe," the primordial moment in which "nonbeing" became "being" and the world "was," writes Marco Curátola:

In all probability the monarch of Cuzco, in assuming the appellative Inka, was attempting to center in his person the metaphysical principles of the word inka. . . . *Once the Tawantinsuyo had fallen and the imperial structure, the sun cult, and the physical person of the Inca had disappeared, there still remained the concept of* inka, *which pre-existed all of those things. . . . [T]he "kingdom of the Inka" became an ideal world of peace and perfection, an archetypal model of the past and the future, original innocence and coming salvation. (1977, 84)*

The production of cups and plates carved in stone with representations of animals was also widespread. Rebeca Carrión Cachot illustrates several examples of cups, which she interprets as representing lakes or ponds (1955, 19–21, Plates xii and xiii). She also reproduces examples of *paqcha* or symbolic springs, carved in wood and polychromed; their symbolic function is determined by the zigzagging drainage channel, as we have already seen (Plate 23 and Fig. 14). The animals represented do not seem to have, at first glance, a close relation with the water cult. Perhaps their explanation exists elsewhere.

The collection in Cuzco's archaeological museum contains a basin—which Kubler describes in detail (1975, 335, illustration 191 [a])—worked in a double sheet of silver, with gold incrustations and with a urinating human figure inside it. The luxurious materials suggest a reference to the ceremonies of *chicha* libations described by the chronicler Estete, to which I have already referred (see Chapter 5). This would explain the meaning of the figures connected with the *paqcha*, which may allude to ceremonial micturitions.

The production of metal objects notably increased after the annexation of the prosperous and sophisticated kingdom of Chimor, because the Incas began to bring the best Chimu gold and silversmiths to Cuzco. In addition to their technical excellence, these Chimu craftsmen also left their mark on the figural style, which can be seen in objects that survived pillaging by Spanish invaders. I do not need to go into what is one of the saddest and most lamentable aspects of the Spanish Conquest. But in order to learn about the principal aspects of the work in precious metals, we must rely on the testimony of the chroniclers.

Juan de Betanzos tells us that, when the Inca Pachakuti decided to rebuild Cuzco, he ordered the construction of a "house of the sun" (Qoricancha) in which a *bulto* was to be revered as the sun, and to which sacrifices were to be offered ([1551] 1987, 49). Here we encounter the problem not only of how to translate *bulto* but also of the exact meaning it had in sixteenth-century Spanish. A *bulto* can be a bulk, volume, shape, form, bundle, package, bale, swelling, or bump, as well as a bust or statue (a context in which it means "sculpture in the round"). Here we must understand *bulto* in this last sense—though in other instances it can mean

"mummy bundle," or just "mummy," in reference to the Inca cult of the ancestors and their mummified bodies—because later the Inca specified that this particular *bulto* was to be cast of solid gold, in the shape, size, and proportions "of a one-year-old boy, naked," which was then to be dressed in fine garments "woven with gold and wool" ([1551] 1987, 51–52). Until this sacred piece of sculpture was finished, the Inca ordered a general fast, carnal abstinence, and sacrifices. (Compare this with the meaning of artistic work in Mesoamerica described below in "The Tectonic Forms.")

Betanzos also points out that the Incas "at some times have the sun as the Maker, and at others they say the Maker is Wiracocha" ([1551] 1987, 49). Molina "El Cusqueño" also describes the "statue of the Maker, in gold, the size of a boy of ten years, which was the figure of a man standing, right arm held high" ([1573] 1943, 20). (Below, in "The Tectonic Forms," I refer to the contradiction between the Christian concept of the "creator god," reflected in the chronicles and the Andean cosmovision.)

Betanzos relates that when the image of the maker ("the golden boy") was enshrined, the common people did not have access to Qoricancha. Pachakuti erected for them a "stone made like a sugar loaf formed into a point at the top and enveloped in a sash ["*faja*"] of gold [which Pachakuti] ordered to be carved the same day he ordered the *bulto* of the sun to be made" (Betanzos, ibid.). This stone was later enshrined in the "middle of the Cuzco plaza" (Cusipata). The rather careful description Betanzos makes of this conical stone clearly indicates its aniconic symbolism, as opposed to the anthropomorphic nature of the sun image enshrined within the "house of the sun" (Qoricancha). Furthermore, Betanzos follows with a detailed account of the gold offerings made by the populace to this (conical) "stone that signified the sun" ([1551] 1987, 53). This dual representation of the sun deity attested by Betanzos's chronicle—one figural and anthropomorphic, made for the worship of the elite, and the other abstract, for the adoration of the common people—raises the question of whether the latter is more true to the Andean tradition of the *wak'a,* as I will elaborate later, than the anthropomorphic representation of a central deity that, in my view, smacks so much of a conflation with the Christian artistic symbolism ingrained in the chroniclers' European culture. In the whole archaeological record of Inca art there is not a single anthropomorphic image that could compare with the symbolic importance evidenced, for example, by the Staff Gods of the Chavín or Tiwanaku cultures. If here we can surmise the continuity of a cultural archetype, this tradition is certainly interrupted among the Incas.

Descriptions of the original state of the Qoricancha (literally, "the golden enclosure"), the central temple of the sun cult, all agree that some of its enclosures were sheathed with gold. Rowe writes, "Nothing impressed the conquerors more than the amount of gold that was used to decorate Coricancha. There is no reasonable doubt that some walls of the building were faced with gold plates. . . . Hardly a single writer of the sixteenth century who refers to Cuzco at all fails to speak of this feature of the Temple of the Sun . . . as the most incredible of marvels. Passing through so many hands, the story inevitably grew somewhat and it is difficult now to say exactly what part of the building was originally so covered" (1944, 37). Each version gives a different set of details, and the

true design and size of the gold sheathing is impossible to determine. Yet, the various testimonies incline me to believe that the sheets of gold were used for their gleam, an abstract representation of sunlight, and that if they had any design, it, too, may have been abstract.

A ceremonial garden also existed in the Qoricancha, dedicated principally to the cultivation of corn, which was enormously significant since it was used to make the ritual beverage *chicha*. It is striking to note that replicas of corn made of gold were also "planted" there as fertility rites. In the inventory of the recapture of Atahualpa, one of the golden corn plants is mentioned. This "garden of gold" took on fantastic dimensions in later accounts.

From the formal point of view, a reticence, an extreme synthesis of natural forms predominates in this figurative sculptural phase. Kubler rightly observes that "detailed surfaces are avoided in favor of extreme geometric clarity of form. The representation of individuals is sacrificed to generic likenesses" (1975, 335). It is difficult to pinpoint the sequence of these figurative expressions. With the obvious exception of the figures carved into the rocks in the vicinity of Cuzco, which are the most ancient, the bulk of the miniatures appear to date from the era of the imperial apogee. Rowe points out that "the wealth and pageantry that characterized the Inca court created a greater demand for beautiful objects than had been the case in any previous period of Andean history" (1963, 287).

The Tectonic Forms

To apply the norm of naturalism to that which is extrasensory and divine, would be to enfeeble the gods.

K. TH. PREUSS,
Ursprung der Religion und Kunst

The Peruvians loved stone; the Egyptians . . . made use of it.

ISAMU NOGUCHI

In trying to discern the symbolic meaning of Inca abstract monumental sculpture, we must confront, literally, bare stone: the figure has vanished. Ethnography, which was of invaluable help in elucidating the ritual function of votive figurines, can no longer help us here.

The complexity of the motivations and intentions underlying the monumental sculpture is not exhausted by an explication of its close relation to the development of constructive technology during the expansive program of public works—the "constructivist" aspect that I will discuss later. The more advanced constructive techniques had been in preparation for a very long time in the embryonic sculptarchitecture of the rocks of Hanan Cuzco. And while the functional meaning of these labors—the creation of ceremonial spaces—has been made clear, it ultimately does not illuminate the question of *why*: why these enigmatic tectonic forms?

First, the notion that these conceptions could have been the work of one or a few sculptors must be set aside. Of Mesoamerican creative labor Paul Westheim writes:

The execution of works of art in stone, clay, wood, was surrounded with mystery. The artists remained isolated during their work. They underwent a peculiar ritual: they had to burn copal, shed their own blood as a sacrificial offering, fast and abstain from carnal relations. Like the priests during ceremonies, they painted their faces black, "as a symbol of fasting and abstinence." A transgression of this ritual was considered a grave offense and a serious danger. . . . It hardly needs to be added that the

content and form of the work created under such circumstances were subjected to no less categorical prescriptions. To depart from the demands of worship and ritual tradition would have seemed to be a sin. The "interesting artistic personality" did not exist. (1985, 68).

The chroniclers of Peru have left us no descriptions of artists' working conditions, but the circumstances must have been essentially analogous. The conception of the ceremonial centers and the symbolic forms of the sculpture must also have followed the dictates of the state religion or of established mythological tradition.

The chroniclers inform us that it was the Inca Pachakuti who decided and architecturally planned the reconstruction of Cuzco (see Chapter 2), as well as the cyclopean edifications of Saqsaywaman, which were completed by his successors. Valcárcel has argued very convincingly that Pachakuti also designed the constructions in the valley of Tampu, when he "took it for his chamber" (1973, 58 ff.; see also Chapter 4 above).

Pachakuti, the dynasty's ninth ruler, is a crucial figure. The very meaning of his name, "to turn time or the earth," or "cataclysm," symbolizes the magnitude of the reforms he introduced. In addition to initiating the territorial expansion and the consequent program of public building and infrastructure, he sanctioned legal norms that had a lasting effect on the cultural patterns of the region. Molina "El Cusqueño" tells us, "It appears that this Inca was the first who began to take account and reason of all things and the one who took away cults and ceremonies and who made the twelve months of the year, giving names to each one . . . for his *qipus* were never governed in such harmony as after this lord" ([1573] 1943, 19).

At first I thought the predominantly aniconic symbolism of the monumental sculpture was the result of the Inca Pachakuti's religious reform, which had a marked iconoclastic character (see Valcárcel 1973, 58 ff.). But I abandoned that interpretation once I understood the seminal character of the sculpted rock formations surrounding Cuzco.

The idiosyncrasy of Inca sculpture is manifested, more than anywhere, in this kind of *stoniness in abstracto,* which I have so often mentioned. This stoniness responds to deeper causes: stone appears to represent itself, its own essence, because it was, beyond all other things, a transcendent material, significant in and of itself, heavy with symbolic potential. A Western artist uses sterile, neutral materials, but among the Incas, the sculptural medium itself was numinous.

A rock reveals itself to be sacred because its very existence is a hierophany: incompressible, invulnerable, it is that which man is not. It resists time; its reality is coupled with perenniality.

MIRCEA ELIADE,
Cosmos and History

From time immemorial stone has been contemplated as the intrinsic structure, the very foundation of the universe, and has had a multiplicity of referents and meanings in different cultures. Among these meanings, stone represents the antithesis of biological matter, which is subject to change, decay, and death. The whole stone—the rock—symbolizes cohesion and a harmonious relation with being and, in this sense, is the opposite of sand, dust, and splinters of stone, which represent phases of disintegration.

"What the inhabitants of Delphi call *omphalos* is made of white stone and is considered to be at the center of the earth," Pausanias writes (X, 16, 2, cited by Cirlot 1971, 243). Apparently the *omphalos* is shaped like a pillar, but Guénon maintains that it was, in fact, *Bethel,* from the Hebrew

WORKING THE STONE AND THE THREAD

Beith-El (the house of God); Genesis 28:22 says, "And this stone which I have set for a pillar, shall be God's House" (Guénon, *Le Roi du Monde* [Paris, 1950], cited by Cirlot 1971, 314).[2]

The black stone, which is in the Kaaba (from *ka'ba*, cube), the central shrine of Mecca, is one of the best known aniconic sacred stones. Others are in the "Gardens of Longevity" in China and Japan, which, in many ways, epitomize stone's sense of cosmic perenniality. While in China the rocks are chosen for their fantastic, spectral form—and thus are almost iconic—in Japan, in the fourteenth century, the Zen masters of Kyoto joined the rock compositions with the other forms of Zen teaching, calligraphy and landscape painting. The Zen gardens of rock and sand, more subtle and abstract than the Chinese, are the closest analogy to the consubstantiation with stone found in Andean culture.

The work of the Japanese-American sculptor Isamu Noguchi seems to establish an atemporal relation with the stonework of all places and times. Dore Ashton writes, "Each sculpture, each ensemble of sculptures, each enclosure in his oeuvre, bespeaks his freedom from specific time and place. Or rather his mythic presence in a specific time and place" (1983, 8; see also Ashton 1992). *Double Red Mountain* (1969), or, in the same year, *Vertical View* (Plate 104) or *Radiant Square* (1979) suggest a deep awareness of Inca sculpture. But these works were all created before his first trip to Peru in 1982. Noguchi once told me that those associations emerge from the processes inherent in working with stone itself, a material with which he appears ultimately to have reached an essential communication. Noguchi reflects, "I love the use of stone, because it is the most flexible

and meaning-impregnated material. The whole world is made of stone. It is our fundament. . . . Stone is the direct link to the heart of the matter—a molecular link. When I tap it, I get an echo of that which we are. Then, the whole universe has resonance" (see Hunter 1980).

Myth "embraces the first attempt at a knowledge of the world," Cassirer affirms (1975, 23). Hidden in its verbal imagery, we find a hypothesis about the ultimate reality of things. Through myth, the inhabitant of ancient America understood the cosmos and his own position in it; he found the meaning of his terrestrial condition (Westheim 1986, 19).

A series of recurring formulations in Andean mythology indicates that stone was a primordial part of a hierophany—a manifestation of the sacred; together with water, trees, and mountains, it "made up the numinous ambient" Valcárcel affirms (1973, 53).

Wiracocha the Creator made the world and left it in darkness. Then he decided to people it and so made stone statues in the form of giants and gave them life. But later he petrified them in punishment for the anger they provoked in him. In a second emergence, he made the sun and the day and then the stars and the moon, and again he created stone models of the people he was going to produce. Then, also in stone, he created a certain number of people, gave them a lord to govern them, and made them appear in springs, rivers, caves, and rocks in the provinces where he sent them.

This myth, based on a "creator god," was originally recorded by the chroniclers, but in recent years it has been seriously questioned because it is considered contradictory of the Andean cosmovision. One of the first to question the concept of a creator god in the Andes was Duviols, who points out that "wherever they went in America to propagate the Christian faith, the European evangelists wanted, forcibly, to find the 'creator god' of the indigenous peoples, especially among peoples of an advanced political and cultural level, such as those of Peru and Mexico" (1977, 53 ff.). This could be attributed ultimately to the Augustinian concept that all peoples of an advanced intellectual level must necessarily arrive at the idea of a supreme, omnipotent, and wise god, creator of all that exists.

More recently, Rostworowski has made decisive contributions to an understanding of the Inca cosmovision. In her *Estructuras andinas del poder,* she fully affirms that "in the indigenous beliefs there existed no abstract idea of god, nor any word to express it. This did not mean that there were not a multitude of gods, and even a hierarchy among them. The divinities were known by their proper names without any term that would mark them as divinities. The sacred was expressed with the word *huaca* [*wak'a*]" (1986, 9). This was because, Rostworowski continues, "the idea of *huaca* opposes the idea of a god in the abstract sense. In the Andes, *the sacred involved the world and gave it a very particular dimension and depth* [italics mine]. This ideology is explained with another Quechua word which indicates the vital or primordial force animating creation: *camaquen*" (1986, 10).

Rostworowski observes that Fray Domingo de Santo Tomás in his *Lexicón* interpreted *camaquen* as "soul," thus distorting the Andean meaning in an attempt to adapt the words of the autochthonous language to the needs of Christian indoctrination. She cites Raúl Porras Barrenechea, in his prologue to another of the original Quechua dictionaries, that of

González Holguín. Porras Barrenechea affirmed that the Quechua expressions in the dictionary "are a simple theological transplant which in no way express the Andean mode of thinking" (1986, 13). Rostworowski believes that the appropriate methodology for approaching the Andean mind is to dig deep into Spanish administrative and judicial documents and the inquests on the native idolatries during the colonial period, as well as into current ethnographic studies. The documents on idolatry contain a dense and disorderly accumulation of facts concerning the minor gods and mythical heroes, ceremonies, sacrificial rites, and *wak'a,* which are of enormous ethnohistoric value: from them emerges "a proliferation of gods, *huacas,* hills and *sacred stones*" (italics mine; 1986, 62). Rostworowski then affirms that:

> To *clarify the Andean concept of the* guanca: *they are closely united with the representation of gods and civilizing heroes, and of mythic ancestors, since Andean thought produced the transformation of such divine persons* into petrified form.
>
> *According to Arriaga([1621] 1968, 196), stones were the image or representation of hills, streambeds, canyons, and of the ancestors. These stones could have diverse forms and the shapes of men or women, but most often they were blank, without drawings or sculptures. (emphasis mine; 1986, 62)*

In another work, Rostworowski states that "the *guanca* were also boundary stones used to indicate the possession of a space" (1988, 33).

It is clear from these sources that the natives said they came from specific *pacarisca* or *pacarina* (places of origin), most of which were *stones,* caves, springs, lakes, rivers, animals, or trees (Rostworowski 1986, 31). This legitimates the myth of the Ayar brothers, founders of the primitive lineages. They were four pairs of brothers who emerged from the caves of Paqaritampu on the hill of Tamputoqo. One of them, Ayar Cachi, scaled the peak of the Huanacauri and with a sling threw enormous stones down from there, which made crevasses when they hit the ground. Ayar Ocho, another of the brothers, remained in Huanacauri while the others went their separate ways, and he turned into a stone, which was worshiped in the sanctuary that was built there. In the strange myth of the "Shining Mantle," Manco Capac, another of the brothers from Paqaritampu who later became the founder of Cuzco, covered himself with small plates of silver and walked beneath the sun: the blinding reflection made people believe that he was the Son of the Sun. Afterward, the "great Manco Capac was transformed into a stone which was greatly venerated."[3]

What follows is my attempt at defining the fundamental characteristics of stone as hierophany:

1. The *beings created in stone* are images that take on the ontological sense of the foundation of being ("the sacred"—stone—"is impregnated with *being*"). If we leave aside the Judeo-Christian ideological transplant of the creator god, the fundamental meaning of the *being which begins in stone* persists. And in that way, the image does not differ from the origin of the beings in the *paqarina,* the rocks, caves, and so on.

It is illustrative to recall the Greek myth of Deucalion and Pyrrha, who were the only survivors of a flood sent by Zeus that depopulated the world. They went to pray at the sanctuary of Themis, and the goddess ordered them to cover their heads and throw the bones of their mother behind them, over their shoulders. Since they had different mothers who were both long dead, they decided that Themis meant Mother Earth and that the bones were *stones* lying on the riverbank. As they were thrown, the stones became men and women, and thus the human race was renewed. Robert Graves observes that, "ever since[,] a 'people' (*laos*) and a 'stone' (*laas*) have been the same word in many languages" (1978, 139). He suggests as well that the transformation of stones into human beings may be "another Helladic borrowing from the East" (the other borrowing being the Flood) and that "St. John the Baptist referred to a similar legend, in a pun on the Hebrew words *banim* and *abanim,* declaring that God could raise up *children* to Abraham from the desert *stones* (Matthew 3:3-9 and Luke 3:8)" (1978, 1, 142).[4] In Quechua, the word *runa* (man) is indeed similar to *rumi* (stone), and the true name of the Quechua language, in Quechua, is *runa simi* (human tongue). This suggests that in the Andes, too, language was the source of the myth that described the origin of being in stone.[5]

2. *Petrification* defines the eternity of punishment or the perennial nature of the founding of a cult or an icon-idol. Duviols (1973; cited by Rostworowski 1986, 63) thinks that petrification signified perennation and sanctification. It should not be forgotten that the beings or gods transformed into stone retained their ability to speak: they could give oracles and answer questions.

3. The first beings who *emerge from caves, rocks, springs, rivers, trees,* and so on (the *paqarina*), or the *stones that open crevasses,* elucidate, to my mind, the origin of the places that were *wak'a,* pointing to the birth of their millennial worship. This also includes the worship of the mountains, especially the imposing snowy peaks, the *apu*—patterns that have lasted to the present day.

4. The image of *the salvation of the cosmos through the intervention of the power of stones* should be added; when the Chanka invaders seriously threatened Cuzco, center of the cosmos, the city was saved by some stones that transformed themselves into warriors and were later enshrined. These are the Pururaucas that Cobo mentions in his list of the *wak'a* that are aligned on the *ceq'e.*

The numinous character of stone is so potent that it has persisted to our time, having survived in mythic forms that were reelaborated during the colonial period. The concept of *inka*—which, though altered during the Tawantinsuyo, has survived as an archetypal model of past and future, peace and perfection—gave origin, under the weight of the imperious catechization, to Inkarri, "Inca king," a "Messiah" and a "creator god." The myth tells us that the Inkarri transformed the world by moving stones: "he beat the stones with a whip, putting them in order" (Arguedas 1964, 229), an image that is frequently repeated. "They say that the Inkarri, when he wanted to, only pulled the stones with a whip and then they made themselves into buildings." And elsewhere, according to the same myth, it

is said, "the stones were carved *to fit very well with each other. So there was a lovely wall*" (Juan Ossio, in conversation with Pease 1973, 85).[6] The myth of the fabulous Inca edifications comes into play, and the Inkarri acquires an illuminating quality: he becomes a *constructor*.

Citing Curátola, it can be added that "the *wak'a* were the gods of always, those to whom men traced their origins" (1977, 82); moreover, like the Inkarri, these were *tectonic divinities*. This affirmation, which Curátola does not develop, is full of fertile suggestions that can be added to my repeated use of the concept.[7]

The tectonic is, in its principal usage, all that which is related to construction, to the architectural, as we have seen. But in another usage it refers to the earth's crust and all its structural deformations. If we think of the geological deformations that gave rise to the Andean landscape—the mountains, the valleys, and the riverbeds—we can conclude that the innumerable *wak'a* worshiped in the region are included within both usages of tectonic. The lists of *wak'a* that we know of refer both to constructed works such as temples, palaces, houses, bridges, and ancestral tombs, and to natural formations such as mountains, caves, rocks, springs, rivers, and so on: "The most numerous were springs and stones, which together formed nearly half of the total number of *wak'a* listed by Cobo as being aligned on the system of *ceq'e* within a radius of twenty-five miles around Cuzco" (Rowe [1946] 1963, 297). In any case, these are only a small fraction of the innumerable shrines that exist throughout the entire region of the Andes.

If occasionally a figurative allusion could exist, as in the venerated rock at Kenko—a *guanca*, according to Rostworowski's definition—which from a certain angle alludes to the form of a seated puma (Plate 22), it can be affirmed that, almost by definition, the immanent sacrality of the *wak'a* lacks an image. It can also be affirmed that this preponderantly aniconic character constitutes precisely the primordial symbolic underpinnings of Inca sculpture. In other words, the aniconic character of the *wak'a* gives rise to the stoniness *in abstracto* exhibited by the sculpture. In the final analysis, stone is *in and of itself* significant; one need not force it to represent an image: "Any modification of the strictly geometric forms, any approximation to the animal or vegetable world, mitigates and weakens the implacable clarity of the monumental tectonic and subjects that on which everything depends to the conditions of growth and life, to temporality" (L. Schmarsow, *Grundbegriffe der Kunstwissenschaft,* cited by Westheim 1985, 75).

The specifically lithic—the stoniness—also becomes evident from another point of view: though we have observed the obsessive repetition of certain elements, such as the stepped cut, these reiterations never appear in symmetrical fashion, as in the plectogenic repetitions that can be seen in the lithic iconography of Chavín or Tiwanaku. On the contrary, the fundamental *asymmetry* of Inca sculpture is the direct result of its adhesion to the primordial form of the chosen rock, the *wak'a*—an adhesion that is substantially analogous to the accommodation to topography typical of Inca buildings, which are the true outgrowths of an "organic architecture."

The sculptural transformation of rock, as I have insistently stated, involves its incorporation into the cosmos: therefore it takes place in situ,

within the numinous natural surroundings. At times a few cuts are enough, as in the cusp of the Mausoleum-Tower crag in Machu Picchu (Plate 58). In other cases, as in the Intiwatana (Plate 55) or in Saywite's Rumihuasi (Plate 74) and Third Stone (Plate 76), the modifications are more invasive. Nevertheless, and contrary to what occurs in anthropomorphic sculpture, the "memory" of the stone's original form is never totally erased. It remains rooted, immobile, in a landscape with which it establishes an infinite number of relations.

Finally, the basic vocabulary of tectonic forms in which the modifications are resolved—flat cuts, cubical volumes, geometric reliefs—is the vocabulary best known to a race of constructors, and, at the same time, the vocabulary that seems most suited to underscoring or liberating the symbolic enchantment that dwells in stone. A restraint, an economy of means, would appear to be the most viable means of establishing a connection—a communion—with stone's intrinsic holiness, the *camaquen*. This singular economy of means for working stone—a rustic immediacy, it could be called—which makes possible the consubstantiation (communion) with the numinous environment, is the expression of a more archaic cultural essence. Compared with the technological sophistication of textiles, ceramics, and metallurgy also inherited from preceding cultures, this economy of means appears to suggest a specifically Inca trait, rooted, perhaps, in a tribal idiosyncrasy. Despite the fact that the sculptural forms physically coexist with the architecture of hegemonic, imperial power, I think that the *modesty* of their scale embodies the opposite aspect of Inca culture: the intimate reverence for the holiness of the overwhelming natural environment.

In any case, from an objective point of view, the tectonic forms of the Inca sculptural vocabulary, together with the crystalline Mesoamerican examples—the pyramidal architecture of Teotihuacán and Monte Alban, the reliefs at Mitla—and the forms developed in the structure of the textiles, define an entire *archetypal geometry* impregnated with meaning. Though these can differ in their particular cultural contexts, it will no longer be appropriate to perpetuate the neutralizaton that archaeology and historiography have imposed on them by considering them "ornamental." On the contrary, the forms of this archetypal geometry will inevitably have to be seen as distant forerunners of the modern evolution of art or, more specifically, as the true foundation of an abstract art of the Americas.

TWENTIETH-CENTURY REVERBERATIONS

CHAPTER 9

BEYOND EUROPE: REREADING THE ARTIFACTS

Ceramics are not futile things. In the remotest times among the American Indians the art of pottery was always popular. God made man out of a little clay.

PAUL GAUGUIN

Toward the end of the nineteenth century, certain European artists began to direct their gaze to artifacts produced by dark, inscrutable "savages," the "primitive" peoples of the colonial dominions. In the recently created ethnographic museums, objects from the Americas were mingled with Oceanic and African artifacts: they were all considered "primitive." Yet for these artists, those strange forms, pregnant with religious or mythical symbolisms, seemed to represent a spiritual means of transcending the stiflingly materialistic values of bourgeois society.

Undoubtedly, the best known of these European artists is Paul Gauguin, whose flight from Europe to live in Tahiti and the Marquesas is legendary.[1] Gauguin led the way; later, during the first two decades of the twentieth century, the German Expressionists, Picasso, Braque, Paul Klee, Giacometti, and the Surrealists (notably Max Ernst and Matta), as well as Brancusi, Modigliani, Lipchitz, and Henry Moore, all either frequented the ethnographic museums, were collectors themselves, or were otherwise conversant with the arts of the "primitive." Their interest would eventually change both art history and the history of ethnography: the incredible transformation of European art that resulted from that cross-fertilization forced ethnographers to reevaluate the status of their "primitive artifacts." In his classic work *Primitivism in Modern Art,* Robert Goldwater points out that, "though in isolated instances the scientists appreciated their objects as 'art' long before the artists, the general ethnological revaluation [which came about in the 1920s] was due to the influence of the painters and sculptors" (1986, xxii).

The tribal arts of Oceania and, in particular, Africa prompted the most radical changes in the complexion of Western art. While the intrinsic

symbolism of those foreign forms would remain alien—but nevertheless inspirational—to the Western artist, the synthetic "primitive" forms accelerated the renewal of an artistic language that had already been challenged by the Impressionists' first blurring of the natural model. I am thinking in particular of Picasso, whose exemplary assimilation of the sculptural syntax of African sculpture preceded and is in no way separable from his subsequent articulation of the Cubist language.

Nevertheless, the perception and exaltation of primitive artifacts *as art*—an art with compelling, if foreign, aesthetic qualities—had to do with the fact that they were primarily representational: no matter how abstracted the natural referents may be (in African masks, for example), they are always recognizable. In other words, if the discovery of the primitive's departure from lifelike natural representation fueled the avant-garde's search for new expressive means, what gave the tribal sculpture immediate currency *as art* was its basic anchorage in the representation of natural forms.

Goldwater observed that sculpture was the tribal art that had the greatest influence on European artists; he attributes its predominance to the difficulty of importing "rock paintings" or "wall decorations" (1986, 226). Trapped in the rigid post-Renaissance distinction between arts and crafts, he fails to recognize that what we still call "crafts" were, in fact, the *arts central to those cultures:* like the artistic productions of the West, the *art*ifacts, in their cultural and temporal context, involved a manipulation of matter toward an expressive/symbolic end (fiber dyeing and weaving; pigment manufacture and painting on various supports; handling of clay, modeling, and coloring; chiseling of stone or wood, and so on). The often geometric "ornaments" appearing in "craft objects" embody the *pictorial art* of the primitives. Goldwater was not the only scholar ensnared in such a quandary: to this day, there is an overwhelming tendency to project Western concepts of art onto the art of non-Western societies, past and present. With regard to ancient American art, the specious distinction between "tribal" art and the art of ancient American civilizations, quali-fied as "archaic" or "courtly" because of the high social stratification and economic specialization of those civilizations, has been discredited (see Rubin 1984, 74–75, n. 14–15). In my view, no such distinction can plausibly be applied to the art of societies that, whatever their differing social and technological achievements, never developed the specifically Western category of "fine" or "high" art.

With the benefit of hindsight, we might say that it was too soon for Picasso and other members of the avant-garde to perceive a geometric art in the "ornaments" of the ethnographic artifacts. But that would imply that such an appreciation did take place later, when in fact it never did. As I pointed out earlier, it was the reductive reading of the Cubist grid by Mondrian and Malevich that finally led to a rigorous vocabulary of abstract/geometric forms.

The New World

The European avant-garde appropriated the "primitive" in a kind of vicarious colonialism, but no such pattern is discernible in the American former colonies. In the Americas acknowledgment of the arts of the pre-Columbian past and of contemporary native cultures has been, to say the least, protracted and uneasy. In Latin America, where the major remains of ancient American civilizations are located, this issue mirrors the conflictive growth of a cultural consciousness—the "identity" debate. The struggle with colonial status that was in many ways prolonged by ruling elites—which acted as internal colonial powers intent on suppressing aboriginal cultures—is still an ongoing process in Latin American countries, with the exception of post-revolutionary Mexico. From the Arctic to Tierra del Fuego, the actual elimination of particular native peoples since the arrival of European colonists cumulatively takes on the proportions of virtual genocide. And though some native communities and their cultures survived, the establishment of an all-pervasive, European-inspired, neocolonial statute has successfully institutionalized the denial of native cultures.

Within this general framework, the European scientific paradigm dominated the relationship with the otherwise unavoidable remnants of aboriginal cultures: the imposing past as well as the enduring present. A few enlightened artists were the only exceptions to this rule.

The creation of the Societé des Américanistes in Paris in 1876, two years before the foundation of the Musée Ethnographique du Trocadéro, formalized the same scientific criterion derived from nineteenth-century positivism: the aboriginal artifacts were understood as auxiliary documents for anthropology, archaeology, or ethnography, thus establishing the (official) pattern that still prevails.[2] Even today the most compelling works of ancient American art are housed in museums of "anthropology," such as the Museo Nacional de Antropología in Mexico City and the Museo Nacional de Antropología y Arqueología in Lima, or of "natural history," such as the American Museum of Natural History in New York. The existence of the occasional fine art museum that includes works from non-European cultures (usually lumping together the arts of Africa, Oceania, and the Americas, as in the "Rockefeller Wing" at the Metropolitan Museum of Art in New York, and the departments of Africa, Oceania, and the Americas at the Brooklyn Museum, New York, and at the Art Institute of Chicago) does not seriously undermine the prevailing perception that the art of ancient America is the alien province of specialists, separate from mainstream art discourse.

It is significant that the Metropolitan Museum of Art in New York City only accepted the donation of the Rockefeller Collection of "primitive art" in the 1960s, after having refused it for almost thirty years. This telling story, recently brought to light by Braun (1993, 43), involves one of the foremost repositories of Eurocentric art in the Americas and epitomizes the segregationist attitude of the mainstream art establishment regarding "primitive" or native arts.[3]

On the other hand, specialized institutions devoted exclusively to pre-Columbian art, such as the superb collection at Dumbarton Oaks in Washington, D.C., reflect alienation from the mainstream even more clearly. Andean weavings, one of the most sophisticated pre-Columbian

artistic expressions, which are *central* to Amerindian societies, are treated as "crafts" in the Textile Museum collection in Washington D.C. The National Museum of the American Indian in New York (now a Smithsonian Institution) also displays beautiful examples of Amerindian art in a specialized context.[4] One exception to this is the Boston Museum of Fine Arts, which duly treats its superb collection of pre-Columbian and colonial Andean textiles as artworks. In Latin America, too, cities that have Eurocentric "fine art" museums have separate institutions for collections of pre-Columbian art: there are two such institutions in Santiago de Chile, the most important of which, the Museo Chileno de Arte Precolombino, has become so sophisticated that it has even exhibited contemporary art related to aboriginal traditions. In Montevideo, there is the Museo de Arte Precolombino, which houses the collection of Francisco Matto, one of Torres García's disciples. In Bogotá's Museo del Oro, banklike vaults isolate the most remarkable small-scale metal sculpture of the hemisphere.

Argentina is a different case: while the main collection of pre-Columbian art, basically from the Andean region, is housed in the Museo de Ciencias Naturales in La Plata, the staunchly Europhile National Museum of Fine Arts in Buenos Aires has recently incorporated an important private collection of pre-Columbian art, thus following the example set by New York's Metropolitan Museum of Art.[5] Ecuador is also a special case: the country's rich collections of pre-Columbian art belong to the Central Bank, which also owns collections of European art. However, the pre-Columbian works are treated as "archaeology" or "anthropology" and shown separately in the bank's exhibition spaces in Quito and Guayaquil.

In addition to the above-mentioned Latin American collections, there are collections put together by artists, who have been the true twentieth-century "discoverers" of Amerindian art. The most notable of these collections were assembled by Diego Rivera and Rufino Tamayo in Mexico.

In short, the relationship with the past is by definition fraught with ambivalence. While it can take the form of recognition, it is also separation: *pre*-Columbian, *pre*-Hispanic. The past is what was *before,* and therefore different.

Thirty years ago, George Kubler, in his book *The Shape of Time,* described the work of the Mexican muralists, Frank Lloyd Wright, and Henry Moore as *prolonging* the Amerindian arts: "[T]hrough its formal vocabulary alone, the sensibility of an extinct civilization survives in works of art to shape the work of living artists in a totally unrelated civilization half a millennium later" (1962, 108). Kubler's book was very influential; though its formalist philosophy, influenced by the thinking of Henri Focillon, has become anathema to the politically energized art-thinking and art-making of late, the statement above is still quite challenging.

The key question remains: Can the Amerindian arts—meaningful within an alien cultural and social context and conceived with a sense that went beyond the merely aesthetic—be assimilated by European culture transplanted to the New World? I believe that the European experience itself can tell us something: Was it not true that for the Renaissance mind the Romanesque and Gothic styles were the product of alien, barbaric societies

ignorant of the Greek canon? This is easily forgotten today; it took the Romantic poets and artists to "discover" that strange Gothic past, a past that for Renaissance historians was just as alien (Vasari repeatedly referred to it in his *Lives* as the barbarous German style [(1568) 1965]) as the pre-Columbian past is now. Or, even further back, can we think of a more odd association than early Christian artists borrowing their forms from the crassly alien, "pagan" art of the Greco-Roman tradition? This obviously leads us to the question of (cultural) *mestizaje,* for these are but two examples of intercourse between often contradictory cultural strains—religious beliefs and philosophical thought, art styles, languages, and technologies—that went on for millennia in the Mediterranean basin and later spread to all of Europe, until that highly syncretic construct, "Western Culture," was transferred to the Americas. What else was this amazing synthesis, if not a cultural *mestizaje?* (See Uslar Pietri, 1980.)

Though classical antiquity had its hint of "art for art's sake" (see Introduction), European art making was not divested of a primary symbol-shaping function widely absorbed by the society, and in that sense it was not entirely dissimilar to the arts of American antiquity, until the Middle Ages (when its symbol-shaping function was strongest) had ended. By refusing to recognize the process through which Europeans compacted these layered aggregates into a synthetic construct perfected by the hegemonic post-Renaissance evolution, we in the Americas continue to segregate the ancient cultures—the only distinctive imprint of the "New World"—relegating their artifacts to the status of half-breeds: scientific specimens, some of tantalizing beauty, always kept separate from the mainstream.

The only way out of this dilemma is, it seems to me, to accept that the aesthetic component of the Amerindian works is *commensurate with its symbolic intensity* and is inextricable from the decision-making process involved in the shaping of the symbol. Therefore, anthropology, archaeology, and ethnography only provide the means for understanding the symbol and its sociocultural context, which is the methodology that informs this study. Thus our "guilt" about displaying the objects in museums as "works of art" would be assuaged—I hope. The sculptor Isamu Noguchi once called the museum the stopgap between today's (Western) society and the ancient ceremonial place.

This is not to say that evaluations of ancient Amerindian art as such have been lacking. The German art historian Franz Kugler's *Handbuch,* a general history of the arts published in Stuttgart in 1842, was the first such evaluation, affirming the autonomy of Amerindian art in relation to the arts of Europe. At about the same time, Stephens and Catherwood began their survey of the Mayan ruins in Yucatan, which Stephens defined as "works of art." Even earlier, at the beginning of the nineteenth century, the *Expediciones* by Captain Guillermo Dupaix evinced a fine perception of the Mesoamerican remains as unprecedented artworks. In the twentieth century, Spinden's writing on the Maya,[6] Pijoan's general art history, and, in Mexico, the work of Covarrubias, Justino Fernández, Salvador Toscano, and Paul Westheim are other pioneering efforts at delineating a history of pre-Columbian art. And we must not forget Franz Boas's *Primitive Art* (1927); though Boas came from a scientific field, his book, despite its "misleading title, . . . conceals a major advance in the compre-

hension of non-European aesthetic systems" (Kubler 1991, 175). Also outstanding is the New York Museum of Modern Art's remarkable attempt to discern the hemispheric sources of modern art in an exhibit organized by Holger Cahill in 1933 titled *American Sources of Modern Art*. And in 1962 came the first edition of George Kubler's all-inclusive *The Art and Architecture of Ancient America* (1962, 1975, 1984). All of these studies, however, tend to focus on Mesoamerican arts; meanwhile, Andean arts remained enmeshed within the nets of archaeology and anthropology, owing to the preponderance of textiles and ceramics, traditionally viewed as "crafts" or "artifacts."

A new and more confident evaluation of ancient arts sprang up during the past decade, culminating in recent studies appearing in books and catalogues accompanying the comprehensive exhibitions of 1992, which are perhaps the most positive outcome of the embattled "celebration" of Columbus's arrival to these shores.

One of the remarkable exhibitions of 1992 was *To Weave for the Sun: Andean Textiles in the Museum of Fine Arts, Boston,* curated by Rebecca Stone-Miller, which presented the stunning collection of a museum that has long been committed to the textile arts. Stone-Miller's writings for the catalogue of that exhibition, as well as her contribution to the catalogue of another 1992 exhibition, *The Ancient Americas: Art from Sacred Landscapes at the Art Institute of Chicago,* represent a fresher attempt at using modern abstract art as a tool in interpreting the geometricizing language of Middle Horizon Andean textiles. Moreover, Stone-Miller makes no bones about declaring that she is dealing with "art works" produced by "artists," not craftsmen. (Less recently, another beautiful exhibition was called *Master Craftsmen of Ancient Peru* [Guggenheim Museum, New York, 1968], a title that, in many ways, sums up the still-prevailing Western misperception of the art of ancient America.)

A closer reading of Stone-Miller's articles, however, reveals the perils of going to the other extreme, that is, of relying on a formalist Eurocentric approach. In "Creative Abstractions" (1992a, 36) she states, "As levels of abstraction increase [in the Wari-Tiwanaku tapestries], the subject matter becomes the pattern of colors and shapes itself," thus reiterating the position she had advanced in 1986. In her essay for the Art Institute of Chicago exhibition, on the other hand, she writes that a rare Wari *qipu* (in the collection of the American Museum of Natural History in New York), which codifies oral information through color pattern alone, without using knots, "also supports the hypothesis that the formal aspects of the tunics themselves convey information" (1992, 337). In my view, this comes much closer to the sense that abstraction had in the ancient arts: the geometric reductions to which the natural forms are subjected, as well as the color patterning, which must have functioned as a code, are the means of distilling and intensifying the symbolic meanings (see Introduction and Chapter 1 above). Stone-Miller's statement in "Creative Abstractions" is unfortunately indebted to the formalism that suffuses Anglo-North American art writing on abstraction, a conception entirely alien to ancient America and to all non-Western cultures for that matter. Yet the exceptional nature of Stone-Miller's essay is reconfirmed by its contrast with other pieces in the *To Weave for the Sun* catalogue, in which aspects of textile creation are called "decorative technique," or it is stated that

"painting was used to embellish cotton plain-weave cloth" (!), or that a cotton weave presents a "painted decoration" (1992a, 46, 57; in reference to ancient Peruvian painting, see Introduction above).

The above-mentioned exhibition, *The Ancient Americas: Art from Sacred Landscapes,* held at the Art Institute of Chicago, was the other major show of 1992. It represents the most consistent effort yet to contextualize an exhibition of Amerindian art within the all-encompassing factor that enveloped all the symbolic expressions of ancient America: the "sacred landscape." Obviously, in a museum setting, this attempt to reconstruct the relationship between the work of culture and the land has to take place through the fictive medium of large photomurals. However, what matters is decisive acknowledgment of the cardinal importance of the sacred land; until this exhibit, awareness of this factor had been expressed only from partial, separate points of view.

Richard F. Townsend, general editor of the catalogue that accompanied the Art Institute exhibit, contributed an essay to the catalogue, called "Landscape and Symbol," in which he tells of his own commitment to the subject, which he first explored in his doctoral dissertation on Aztec art in 1970; in 1978 he started searching for "key sites of a sacred geography" (1992, 36) in the Valley of Mexico.

Having read Vincent Scully's *The Earth, the Temple, and the Gods* (1969), a seminal work on the relationship of Greek architecture to its natural setting, I went to Peru in 1979 to carry out a photographic survey of the Inca in situ sculptural works, which unequivocally emphasize the sacred nature of the landscape by carving it.[7] In their rustic immediacy, these Inca sculptings of large geological formations or single rocks embody, in my view, the most compelling Amerindian manifestation of such symbiotic relationship between art and the sacred environment.

I cannot engage here in a review of these exhibitions or of the wide range of subjects covered by the different essays appearing in the catalogues, but I do wish to emphasize that none of these contemporary evaluations remove Amerindian art from the prevailing scientific context, or, to put it another way, from the scientific tutelage. Most evaluations of Amerindian art continue to be made by anthropologists and ethnographers whose art perception rarely goes beyond deep-seated, nineteenth-century Western codes. Of the twenty-six authors whose essays are featured in the catalogue of the Art Institute of Chicago exhibition, only seven have even a partial art and architecture historical background.[8]

Nor do the essays in these catalogues give us a sense of being anywhere near a rethinking of the history of the arts in the Americas. To this day, that history remains a mirror image of the European evolution, and therefore begins with the colonial transplant of metropolitan art styles. Thus, the "only original creations of America"—to repeat the words of Octavio Paz—the arts that *originated in and of themselves,* and which epitomized, in the eyes of the "discoverers," all the newness of the New World, remain the achievements of alien races rather than the true point of departure of American art and, as such, the *common cultural heritage* of all peoples of the Americas.

The concept of pre-contact art and architecture as the common *cultural* heritage of all Americans is ever so simple to state, yet immensely difficult to comprehend and even more difficult to instill. It would have to be

instilled at a profoundly formative level, through a hemispheric educational reform, and not through such tactical or politically oriented appropriations as those reflected in certain exhibitions in the 1930s and 1940s, when the inter-American policy of the United States was designed to prevent fascist infiltration of Latin America.[9]

That the ancient Amerindian arts are one of the great artistic traditions of the world would be difficult to contest, though they are still regarded as a "poor relative" to the preeminent cultures of antiquity, say, the Egyptian or the Greco-Roman. Yet the acceptance in the Americas of a cultural and artistic heritage that is not sanctioned by educational systems institutionalized by the Europhile neocolonial statute, described above, becomes a matter perilously conflated with racial or modern nationalist politics. While I can understand the inarguable pride with which Mexico exhibited the "Splendors of Thirty Centuries" at the Metropolitan Museum in New York in 1990 (the show's title reiterates that of the exhibition *Twenty Centuries of Mexican Art* at the Museum of Modern Art in 1940), I think that the exclusive nationalist appropriation of the tradition implied by such display, no matter how natural it may appear on the grounds of racial continuity, is misguided.[10] It is just as misguided as the rejection of or self-declared alienation from the Amerindian traditions that I hear voiced by artists from the "whiter" Southern Cone: "I don't have Indian blood." These opposing views are symmetrical, and both are conflated with racial arguments, yet both are oblivious to the fact that, if we follow this reasoning—that is, the equation "culture-as-race"—then only the Greeks or the Italians would "own," or be entitled to, the Greek, Roman, or Renaissance traditions.

One of the exceptions that confirm the rule is Leopoldo Castedo's history of colonial arts and architecture, which begins with the pre-Columbian period. Much to the point, he writes that "the artistic American singularity reaches its high point in the epoch prior to the conquest; in the final analysis, the more related it is to the primordial roots of the pre-Columbian world, the more singular [art] becomes" (1970, 13). The observation is perfectly apt; however, the overwhelming historical evidence tells us that the connection with that "primordial root" was never intense enough to generate enduring models in the way classic Greek art did in the West. On the contrary, given the increasing homogenization of the art languages—all marching to the drum of the dominant cultures—the artists that did seek to root their work in a true American context now seem to be a "peculiar," distinctive band, almost an oddity—or, perhaps, the only dissenters.

Certainly, Kugler showed remarkable foresight when, in 1842, he perceived Mayan and Aztec monuments as art, but again, though foreign to the European canon, those artistic traditions also were iconographic. This basic assessment, though somewhat modified over the intervening century, has not changed. The discourse of pre-Columbian art is still suffused with the projection/reflection of the "fine art syndrome," with its intrinsic iconographic and hierarchic character. As I stated in the Introduction, the problem arises when, within the context of pre-Columbian art, we deal with an art that is widely believed to be an exclusive prerogative of the modern West and predicated on the long-held hegemonic misrepresentation of non-Western geometric designs of textiles and ceramics as

"ornamented crafts," rather than significant artistic elocutions of the cultures that produced them. In other words, it has been this successful relegation or ostracizing of the non-Western arts that made it possible to hail geometric abstraction as a Western patrimony, whereas, in all accounts, Western geometric abstraction is an adventitious flowering within an almost monolithically figural representational tradition: we have to go back to the Greek Geometric art of the eighth century B.C. to find some kind of Western precedent for it. As a further reduction of the Cubist grid, the abstraction of a geometric vocabulary of forms—heretical as this may sound to many readers—is only an analogue or simile of the tectonic grid (textiles or basketry, constructive techniques, body painting) that has informed the art of non-Western societies for millennia.

When they returned to Mexico after living in Europe, Diego Rivera and David Alfaro Siqueiros translated their awareness of the Parisian avant-garde's rage for the "ethnographic arts" into a call for an art of heightened social orientation that would also be deeply rooted in pre-Hispanic traditions. Thus, the Muralist movement grafted its art onto the revolutionary political changes operating in Mexico at that time, in a course of events that remains unique in the Americas and that exerted a powerful influence throughout the 1930s. A substantial part of the Muralists' message was the incorporation, as a principle of doctrine, of the Mesoamerican iconography. Yet, again, meaningful as this breakthrough was in dealing with the ancient art as such, it nevertheless represented a smooth transition from one eminently figural tradition to another.

Tamayo, who was of Zapotec ancestry, Carlos Mérida, who claimed the Mayan tradition as his own, and Wifredo Lam, who immersed himself deeply in syncretic Afro-Cuban religions, all chose to absorb native sources into a pictorial vocabulary that relied on figural allusions. Though they, too, intended to distance themselves from the received European value system, I think that the most crucial figure is Joaquín Torres García, who is usually considered an emissary of Modernism in Latin America, yet who was determined to transform—singlehandedly, if need be—the art of the Americas into a utopian model rooted in native traditions.

Torres García arrived in Paris in the mid-1920s to witness both the peaking interest in non-Western artifacts and, through his acquaintance with Van Doesburg and Mondrian, the baring of the Neo-Plastic grid. His story will occupy a substantial part of Chapter 10. I hope to demonstrate that the idiosyncrasies of Torres García's art, inseparable from his doctrinaire zeal, represent, perhaps better than the work of any other artist in the Americas, the deflection or, actually, the *mestizo*-ization of the modernist model on this side of the Atlantic. Furthermore, though he was hardly a pure abstractionist himself, on his return to South America his visionary discovery of a *geometric art* in humble Andean artifacts such as textiles, ceramics, and even stone walls and carved monuments involved a de facto overriding of the "fine art syndrome," which was certainly an aesthetic and theoretical quantum leap in his day—not to mention the implicit social and political significance of the vindication of the anonymous weaver or potter as *artist*. This is a pristine example of what José Carlos Mariátegui, the eminent Peruvian Marxist essayist, pointed out: "The authentic *indigenistas* [people working with or studying indigenous culture]—who shouldn't be confused with those who exploit indigenous

subject matter for its mere 'exoticism'—collaborate, consciously or not, in a political and economic work of revindication—and not of restoration or resurrection" (1976, 332). However, it shouldn't be construed from this that Torres García ever stated his point so clearly and irrevocably. On the contrary, in order to grasp his main line of thinking, the reader has to wade through a morass of rambling, often self-contradictory writing; like most visionaries, Torres García was unaware of his own prescience. However, he was the first to signal the validity of the *tectonic principle,* the structural paradigm for an abstraction that synthesizes the modernist grid and the pre-Columbian sources.

Synthesis is the key word here; yet centuries of institutionalized conceal-ment of the aboriginal cultures has so effectively derailed such a possibility that, even today, creative attempts at synthesis in art or poetry, for ex-ample, are often branded "appropriation" or "exploitation" in certain quarters. Such name-calling tends ultimately to perpetuate the status quo by reaffirming the dominant neocolonial culture that has relegated native arts to the realm of anthropology.

CONSTRUCTIVIST HISTORIES

The vast public works projects that accompanied the Inca territorial expansion brought stonework to a degree of proficiency unknown until then. This material context promoted the accelerated progress of sculptural forms and accentuated their "constructive" nature. In other words, the growing refinement of stone construction techniques helped define an idiom that, since it was dictated by tectonic law, was formulated in reductive geometric terms: flat cuts, cuboid volumes, and straight or curving edges. It was a more complete version of the vocabulary that had been suggested rustically in the rocks of Hanan Cuzco.

We know that the vast edifications, as well as the project of urbanization, were carefully planned by means of stone or clay maquettes. This fact, amply documented by archaeologists and chroniclers, evinces a developed sense of volumetric spatial configuration so coherent with sculptural conceptions that both suggest an interdependent evolution.[1]

The symbiotic relation between sculpture and construction technology gives rise to an almost inevitable comparison with a certain artistic movement of the twentieth century that was also the direct result of the application of constructive techniques and the use of the industrial materials of its time: Constructivism.

I am aware that this comparative proposal may seem, at first glance, surprising and perhaps even capricious. But I believe that *internal symmetries* of tectonic procedural principles exist between Andean sculptural production and that of the Constructivist movement during the first years of the Russian Revolution. Both of these sculptural modes were the result of the application of the constructive techniques of their respective eras. In any case, nothing could be as formally different—and, in that sense,

less susceptible to a critique based on "isomorphism"—as the weighty volumes of Inca sculpture and the Russian structures, which were fabricated out of rods and sheets of twisted metal and sometimes included glass or celluloid.[2]

I am not saying that there has been a cross-fertilization or any such interdependence between these sculptural modes: they are not only manifestly separated in time and space but belong to the extremely disparate cultural and ideological contexts of pre-capitalist Andean society and socialist revolution in Russia. It is, I reiterate, the recognizable *symmetry* of "constructivist" models in both societies that makes the comparison almost inescapable—a comparison, as we will see, from which other amazing parallels will emerge.

A close examination of the work of Josef Albers and Torres García will show what I think is the connecting thread that makes the comparison I am proposing viable. These two artists reenacted, to a degree, the European avant-garde's appropriation of the forms of primitive art. There was a temporal difference, however, in the contact that, say, Picasso, the German Expressionists, or the Surrealists had with non-Western arts. Albers and Torres García had assimilated the Cubist grid, acquiring a decisive vocation for a constructive order that preceded their encounter with pre-Columbian tectonics and, in turn, made the pre-Columbian influence possible. On the other hand, the Europeans, with the notable exception of Henry Moore and the young Giacometti, rarely opened themselves to what they saw as the "hieratic" character of pre-Columbian art, a "hieratism" that had a lot to do with the penetrating influence of the textile grid and its angular, orthogonal, and often plainly geometric imagery. This geometrism is most evident in the Andean arts, which were to be extremely influential in the development of the art and thinking of Torres García.

Russian Constructivism

The first beardless monument; the first object of October.

VLADIMIR MAYAKOVSKY, referring to the Tower of Tatlin

In 1920, Vladimir Tatlin, a central figure in the origins of the Constructivist movement, exhibited the maquette of the "Tower" (Plate 105), which he conceived as a monument to the Third International. As he explained it, this work represented the culmination of his pre-revolutionary experiments with industrial materials in real space, the counter-reliefs that were directly inspired by Picasso's collages and Cubist constructions, which Tatlin saw during his trip to Paris in 1913–1914.[3] Despite the utilitarian sense that Tatlin gave the monument—two concentric ramps in an ascending spiral that support spaces for the legislative assembly, the executive body, and the department in charge of radio and propaganda—he also recognized its symbolic nature, referring to the pyramid of the Assyrian King Sargon II, constructed in the city of Korsabad (c. 720 B.C.): "an ancient concept of form . . . was actually created in a new material for a new content. . . . Iron is strong like the will of the proletariat. Glass is clear like its conscience" (cited by Lodder 1983, 65).

The legendary Tower had an enormous impact: it not only stimulated a whole wave of new inventions, it was also, very probably, a source of programmatic definitions, as Constructivism assumed its definitive doctrinal shape between 1920 and 1922.

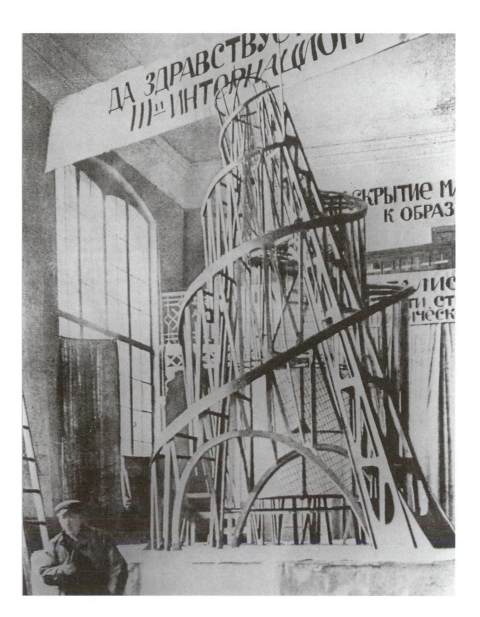

The Institute of Artistic Culture (INKhuK), created by the new Soviet
state in 1920, was the scene of heated debates over the changing role of art
and the artist in the new society. One of the most heated of these debates
was that over "composition vs. construction." The members of the First
Group of Constructivist Labor—the theoretician Aleksei Gan, Rodchenko
and his wife Varvara Stepanova, and the Sternberg brothers, Medunetsky
and Ioganson—held as a point of their dogma that "construction" was
related to real objects more than to a pictorial medium: "construction
contained a utilitarian imperative which limited its pure manifestation
to the construction of useful as opposed to aesthetic objects" (Lodder
1983, 83).

To synthesize the debates and the theoretical writings, it can be estab-
lished that a constructivist work must incorporate three basic principles:

1. *tectonics,* which arises from the confluence of the ideological prin-
ciples of communism on the one hand, and the *appropriate use of indus-
trial materials* on the other;

2. *construction,* which represents the process of structuration and organization of materials in *three-dimensional* space, and

3. *faktura,* which implies the use of materials in such a way that they do not clash with the tectonic and constructive aspects.

The principle of *faktura*—the use of industrial materials in accordance with mechanical and technological principles—gave rise to an aniconic, abstract form, just as in Inca sculpture. And, although somewhat obscure and even redundant ideological use is made of the tectonic principle, which involves everything related to construction, that does not diminish the procedural equivalencies: a deliberate, intentional tectonic in the case of the Constructivists and a more spontaneous result of specific cultural patterns in the case of Inca sculpture.

The symmetry does not end there. Very rapidly, the Constructivists came to deny that their work had any "artistic" meaning. Christina Lodder writes, "Under the pressure of the revolutionary conditions of contemporary life, they rejected 'pure' art forms. . . . In the[ir] place . . . they committed themselves to working in industry, espousing 'production art as an absolute value and Constructivism as its only form of expression'" (1983, 90). The industrial *faktura* of the works exhibited in the Third Show of the Society of Young Artists (OBMOKhU) exemplified this position: they were considered, retrospectively, mere laboratory work, the formal research necessary for the education of the artist-engineer or artist-constructor who, by joining with the productive forces of the society, would supersede the former division between art and industry.

To point out the most immediate parallel, this artist-constructor would have been the reincarnation of the ancient sculptor-constructor who worked to build Machu Picchu or Ollantaytambo. The same could be said of the artist-weaver or artist-potter who were *themselves* part of the society's forces of production, the goal to which both Constructivists and Productivists aspired. The legitimacy of this parallel is also evinced by the Constructivist rejection of "applied art" and all related ideas because, as Lodder observes, "it endangered the survival of their new concept. It is this fear that explains the extremism of their attack and the lengths to which they went to differentiate Constructivism from 'applied art'" (1983, 103). This repudiation of the cosmetic embellishment of the industrial product involved, without doubt, an aspiration to return to the meaning art had before the schism between "pure" and "applied" arts occurred—the meaning that existed in pre-Columbian societies.

Up to this point I have emphasized the analogies of procedural principles, but the philosophical divergences can no longer be avoided: there was no place within the socioeconomic reductivism of the Constructivist program—and even less within that of Productivism—for the spiritual meaning of art, the residual religiosity of antiquity. This painful dissociation, in which the social function of artistic activity excludes spiritual or symbolic content, was unthinkable in pre-Hispanic America, where useful objects produced by the artist were, in their vast majority, the bearers of iconic signifiers that articulated the society's fundamental religious or mythical symbolism, and were therefore of decisive importance as a force of social cohesion. Unlike the Western artist, the pre-Hispanic artist and his product were indispensable because they satisfied the cardinal needs of the social group.

But again, didn't the Constructivists want their work, intended as a homogenous intervention in industrial production, to have precisely this kind of fundamental social necessity? The *viability* of this hallucinatory, utopian project in an industrial society with extreme division of labor is another question, one that sheds light on the reasons for the decline of Constructivism in Russia and for the fragmentary, contradictory role art has come to play in twentieth-century civilization.

Malevich

The suprematist square and the forms proceeding out of it can be likened to the primitive marks (symbols) of aboriginal man which represented, in their combinations, not ornament but a feeling of rhythm.

KASIMIR MALEVICH,
The Non-Objective World

Malevich is one of the pivotal figures in the art of our time. Like Mondrian, he was one of the heirs of the Cubist revolution, which the two of them carried to its most radical extreme: the development of a pictorial language based on a vocabulary of rigorous geometric forms. Malevich came up with the name of "Suprematism" for this type of painting, in which he pursued the pure, *supreme* sensation.

Before that development, not only had Malevich worked under the influence of Cubism, but he had also assimilated—probably inspired by the refined "primitivism" of Natalia Goncharova—the geometrized forms of traditional Russian folk embroidery, a craft peripheral to mainstream Western art.[4] Undoubtedly, Goncharova must have predisposed him to see, in all clarity, the *non-ornamental* meaning of "primitive" art; he was the only one among the artists of the Russian avant-garde to describe it that way.

When Malevich proclaimed his Suprematism, on the occasion of the memorable *0.10: The Last Futurist Exhibit* that took place in Petrograd in 1915, he was already the undisputed leader of the other branch of the avant-garde in the years immediately prior to the Russian Revolution. Some of the most conspicuous members of the Constructivist movement, such as Rodchenko and Liubov Popova, had first worked under the influence of Malevich.

Within the Suprematist language (Fig. 36), the elemental geometric forms (the square, the rectangle, the circle, the triangle, the cross), as well as the infinite blank space in which they flowed, had a definite spiritual charge, impregnated with mysticism, which was irreconcilable with the social utilitarianism the Constructivists advocated.

For a long time, the spiritual (mystical, esoteric) motivations of the seminal figures of abstract art were obscured or ignored. Beyond the general secularization of art in our society, the causes of this concealment are various and difficult to simplify. What is certain is that geometric abstraction evolved toward a rationalism, or "scientificism," which was in many ways the opposite of the initial meaning abstraction had for its founders: Mondrian's early adhesion to Madame Blavatsky's "theosophy" is well known. Unlike Mondrian and Malevich, Frank Kupka and Wassily Kandinsky arrived at abstract art not through the perceptual changes introduced by Cubism, but by direct saturation in a climate of "spiritual vibrations" in which they actively participated and which led them away from objective representation. Kupka was a medium; Kandinsky was profoundly versed in Tantric Buddhism, Yoga, and Zen. His crucial question—"what was to replace the missing object?"—clearly reflects the metaphysical angst of the Western artist at the moment of the rupture with

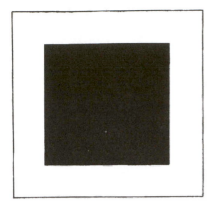

FIGURE 36
Kasimir Malevich, Suprematist
Square, *1920. From K. Malevich,*
Suprematism: 34 Drawings *(Vitebsk:
Unovis, 1920), n.p. Reprinted by
permission of Artist Bookworks,
East Sussex, England, 1990.*

PLATE 106
Kasimir Malevich, Zeta, *c. 1923.
Plaster model. Destroyed during
World War II.*

the ancient model, the phenomenal world of experience, "reality."[5]
Simplifying the whole, vast spiritual movement that permeated—secretly,
by definition—the European intellectual and artistic milieu toward the end
of the nineteenth century, one might say that the theosophists, by popular-
izing the dictum "God geometrizes" attributed to Plato, suggested the
response to Kandinsky's query.

Here we need to take a brief look at one of the lesser-known aspects of
Malevich's work. Amid the high-voltage theoretical and experimental

This was the atmosphere in which Malevich conceived his Suprematism:
thus the *supreme* sensation, induced by elemental geometric forms, was
equated with a mystic state beyond reason. "Suprematism is the way to
God," Michael Grobman goes so far as to say (1980, 26; for a better
understanding of the motivations involved, see Douglas 1986).

climate of those years, one of the most heatedly debated questions was that of architecture as a discipline unifying all the arts. According to Troels Andersen, it was Kandinsky who "had introduced Gropius's and Taut's ideas concerning utopian synthetic projects in which architecture, painting, and sculpture were united" (1970, 31) to Russia. These were none other than the ideas that had given rise to the foundation of the Bauhaus in 1919. At that point Tatlin was already working on a project of the same order: his famous Tower. Malevich's first volumetric pieces, which he called *Arkitectonics* (architectonic maquettes, Plate 106), also date from that year. However, Camilla Gray writes that "already in 1915 Malevich had begun experimenting in three-dimensional idealized architectural drawings" (1971, 167).

Of that first group of works no traces remain: those belonging to a second group he made in 1922–1923 were exhibited in a retrospective in Berlin in 1927, and some of them still exist in European and American collections.

Malevich thought that architecture should confront "the question as to the form of the building: the purely *architectonic,* devoid of purpose, and the specifically *architectural,* the material expression of a stated purpose" (cited by Andersen 1970, 32). But apart from his theoretical intentions, the absence of any concern with interior space—perhaps architecture's defining factor—allows for a reading of the maquettes as sculptural works. Built out of an accumulation of solid, independent unities—cubes and polyhedrons—they represent, as Andersen points out, a three-dimensional translation of the flat geometric elements of Suprematist painting (1970, 32). Thus, the cube (to which Malevich attributed a dense symbology) as the stereometric projection of the square (the central element of the Suprematist grammar) generates a series of tectonic forms whose similarity with the sculptarchitecture of the Incas is evident.[6] Mere isomorphism? Far from it: I believe that in this case, even more than in that of the Constructivist structures, the symmetry of principles generates similar configurations. Moreover, the cubical geometry of the maquettes, as a prolongation of the mystic language of Suprematism, supports the suggestion of a parallel with analogous volumetric signifiers in the art of ancient America, such as the aforementioned sculptarchitecture—a ceremonial, religious milieu—or with the sacred pyramids of ancient Mexico.

Albers's Synthesis

At this point, it may be illuminating to study how Josef Albers, an artist formed by the European tradition of the Bauhaus and Constructivism, was captivated by the forms of pre-Hispanic sacred architecture.

More than a "born painter," Albers, a product of the Bauhaus philosophy, was strongly oriented toward the architectonic synthesis of the arts and, more specifically, toward the abolition of the secular distinction between art and craft; his orientation was also strongly pedagogical. Only in the last years of his life did he concentrate all his energies on painting, especially on the systematic exploration of the way colors influence each other, a project whose result was the infinite series of *Homages to the Square.* This does not mean that he did not have an excellent gift for traditional figurative expression—he had an extensive education in that

Perhaps it was this timeless quality in pre-Columbian art which first spoke to us.

ANNI ALBERS,
Pre-Columbian Miniatures: The Josef and Anni Albers Collection

Monte Albán is one of the most beautiful sites. I would say that it competes with the Acropolis.

JOSEF ALBERS

tradition—but his entrance to the Bauhaus transformed him. Even before his incorporation into that institute, he had begun to work in stained glass; after his first year in the Bauhaus, Walter Gropius, founder of the Bauhaus, put him in charge of reorganizing the glass workshop. From the beginning, Albers showed an inclination for constructive tasks, but, beyond all else, he always maintained a cardinal interest in the form and meaning of architecture as a unifying discipline.[7]

Two little-known works, realized in architectural contexts and directly derived from the technique of bricklaying, will be the object of my analysis. Their design not only clearly illustrates the use of tectonic principles but also exemplifies a fruitful relation with the art of ancient America.

America (Plate 107) is, in fact, the title of a mural Albers completed in 1950, which was commissioned by Walter Gropius's studio for the Graduate Center of Harvard University. In this work, rather than applying paint on the wall, Albers decided to manipulate the bricks directly; by removing them according to ordered asymmetric patterns, he achieved a composition that suggests musical rhythms.[8]

Years later, in 1967, Albers was confronted with a similar project—a mural in the loggia of a laboratory at the Rochester Institute of Technol-

PLATE 108
Josef Albers, RIT Loggia Wall, *1967.*
Brick wall mural. 8 ft. x 70 ft.,
Science Building, Rochester Institute
of Technology. (Photo by
Robert Bagby; courtesy of the
Josef Albers Foundation.)

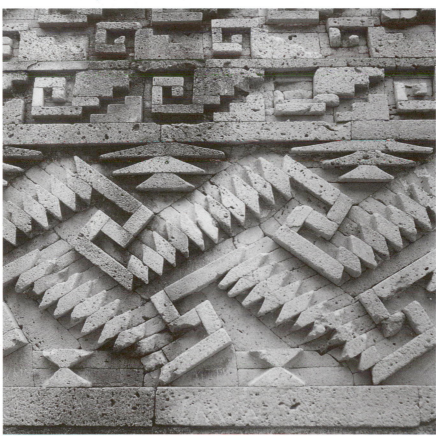

PLATE 109
Detail of a frieze, Palace of the
Columns, Mitla (Post-Classic
period),Oaxaca, Mexico.

ogy (Plate 108). This time he preferred to displace groups of bricks from their regular course in such a way that the salient unities create a play of lights and shadows; this play was organized in repetitive shapes in the form of an "hourglass" or double pyramid.

In my first analysis (Paternosto 1984 and 1984a), I compared these works with the Temple of the Sun (Plate 79), which crowns the ceremonial center of Ollantaytambo, since its six monoliths form, in reality, a colossal, hypertrophied wall constructed in the same way as the other walls of that architectural complex. The protuberances and the reliefs, organized in an orthogonal grid, not only affirm its nature as a frontal sculpture but also function as a counterpart to the brick patterns designed by Albers.[9] The formal differences that emerge from the materials used—bricks, as opposed to giant monoliths—do not obscure, in my view, the perfect symmetry of tectonic principles; just as Albers's murals are the result of bricklaying, the temple grows out of the typical constructive methods of the Incas.

More recently, however, I was able to locate the work that appears to be the indisputable source of Albers's brick murals: the friezes in relief at the palaces of Mitla in the valley of Oaxaca, constructed by the Zapotecs during the late Post-Classic period (Plate 109). This find, far from invalidating my previous interpretation, only reconfirms it by establishing the close relation of Albers's murals with a pre-Hispanic construction.

Neal Benezra's doctoral thesis on Albers's mural work has considerably broadened our knowledge of this aspect of Albers's work. It was also the first published work to point out that, after 1933—the year Albers and his wife Anni emigrated to the United States—the couple made no less than fifteen journeys to Latin America, most of them to Mexico. Benezra writes: "While these visits were often the result of lectureships in schools of architecture, in many cases they were simply long, working vacations. The Albers became impassioned admirers of Latin American artistic culture, collecting miniature sculpture and studying colonial, vernacular and pre-Columbian architecture in detail" (1985, 17).

Albers's interest in photography allows us to follow his tracks: he extensively documented the archaeological sites of Mexico: Mitla, Monte Albán, Tenayuca, Teotihuacán, El Tajín, Xochicalco, Chichén Itzá, Palenque, and Uxmal. During a visit to Peru in 1953, he also photographed Machu Picchu, Tampu Machay (Plate 47), Chan-Chan, Huaca del Sol, and—a final reconfirmation of my reading of his work—Ollantay-tambo. (For me, seeing Albers's photograph of the Temple of the Sun, with an inscription in Spanish—"El Monolito"—was the closure of a charmed circle: more than a decade before, the contemplation of that monument had been one of the experiences that led me to write this book.)

Apart from the murals, Albers's fascination with pre-Hispanic art bore numerous fruits: however, until recently, this period of his prolific career has been overshadowed by the brilliance of his *Homages to the Square*. We can only mention (a study of Albers's pictorial work is outside the limits of this analysis) the series of paintings he called *Tenayuca*, based on the photos of that pyramid that he took and painted between 1938 and 1943. Also dating from 1938 is the oil painting *Mexico*, and from 1940, *To Mitla*.

In 1942, Albers embarked on an ambitious printmaking project: a series of lithographs called *Graphic Tectonics*. The lithograph titles clearly

proclaim his bedazzlement with the architecture of the ancient ceremonial center of Monte Albán: a. *Ascension;* b. *Interim;* c. *Introitus;* d. *Prefatio;* e. *Sanctuary;* f. *Seclusion;* g. *Shrine;* and h. *To Monte Albán* (Fig. 37). Each of the works is, in effect, a variation on the theme of a pyramidal structure with stairs perceived two-dimensionally, executed with a crisp system of straight lines of differing widths. It is simply the translation of tectonic volumes to a two-dimensional schema. Two years later, Albers designed a wood engraving called *Tlaloc,* the god of rain or fertility in ancient Mexico; here the architectonic references are more ambiguous since the trapezoidal forms could be related either to the relief of the pyramid of Quetzalcóatl in Teotihuacán, or to an earlier oil painting, *Gate* (1936), to which it has a close formal similarity.

In any case, *America,* the brick mural, emerges as the culminating work of this period, and it, too, demonstrates Albers's architectonic interests. "I believe that any design organically connected with an architectural structure should be related to that structure," Albers said; he thought that paintings on walls were usually not murals at all but mere enlargements of easel paintings. In referring to *America,* he decided "to make a real mural

PLATE 110 (ABOVE, LEFT)
Josef Albers, Upward, *c. 1926.*
Sandblasted flashed glass.
17 in. x 11 3 /4 in. Collection of
the Josef Albers Foundation.
(Photo courtesy of the Foundation.)

PLATE 111 (ABOVE, RIGHT)
Anni Albers, untitled wall hanging,
1925. Collection of Die Neue
Sammlung, Munich. (Photo courtesy
of the Estate of Anni Albers.)

in which the *murus* [Latin for wall] was respected and preserved to the last degree possible" (cited by Benezra 1985, 35). From this perspective, the Mitla reliefs offered an organic solution; as Benezra observes, "The aesthetic underlying the work at Mitla—a concern for mural enhancement rather than sculptural effect—is one which Albers borrowed almost verbatim" (1985, 36).

The Mitla reliefs were composed in panels, and most of them were realized with small stones carved in cubic or prismatic forms similar to small bricks; other designs were carved on small plaques. All of them were set in clay, like mosaics. There are vestiges of ochre paint, as well; but today the designs come to life in the sunlight, heightened by the shadows of the interstitial spaces. This is one of the few totally abstract works of ancient Mexico; the spiraled and stepped or serrated grecques, the rhomboids, are all designs of plectogenic origin, and, precisely as in textiles and ceramics, they are systematically repeated within each panel. Like the flat stonework of Chavín and Tiwanaku, these forms must have responded to a regional textile tradition, of which almost no traces remain.[10]

The patterns of missing bricks that Albers conceived for *America* correspond very closely to the paintings on glass he made during his first years at the Bauhaus in the mid-1920s (Plate 110). But, in turn, those paintings are very similar to the tapestry work that his wife Anni had been developing in the Bauhaus studio beginning in, at the latest, 1922 (Plate 111). I will join the chorus of conjectures on who influenced whom by stating that, because of Josef's orientation toward crafts, the *structural*

geometry of textiles taught him the organizational rigor that was lacking in the amorphous accumulation of fragments of glass that immediately preceded his paintings on glass. This fact, if true, does not diminish the conception of the mural; on the contrary, it brings us full circle: not only did Josef use, much more openly, a textile structural image for the Rochester mural (Plate 108)—the "double pyramid" (Fig. 33) that I consider a kind of Andean yin/yang—but, if we return once more to the etymological root of the word "tectonic" (*teks*), it will refer us both to weaving (*texere*) and to fabrication. Thus, in complete agreement, Jorge Elliott observed that masonry leaves a "woven" surface and that in Mesopotamia, "where so much brick was used," walls were considered textile motifs (1976, 153).

A *"Constructive" Art: Mondrian and Torres García*

The orthogonality of building facades also had impressed the Dutch artist Piet Mondrian. And, though not motivated by the architecture of antiquity as Albers had been, Mondrian's 1914 *Facades*, inspired by the fronts of Parisian buildings, had a significant effect on the transition to his artistically mature work, Neoplasticism. In a letter that same year, he wrote: "I construct line and color combinations upon a flat plane with the aim of giving form [in Dutch, *beelden*] to *general* (principles of) *beauty* . . . I am of the opinion that, through the use of horizontal and vertical lines— constructed *consciously* though not by *calculation*, and directed by higher intuition—[I] can produce a work of art which is as strong as it is true" (italics mine; cited by Joosten 1971). This letter reveals the clarity with which Mondrian reflected on his work; it is also significant that, at the same time that he was working on his *Facades,* he twice used the metaphor of *construction* to characterize his use of line and color on the pictorial plane.

Clearly, Mondrian had found in the fabricated rectangularity of buildings, with their doors and windows (as in his 1914 *Composition, V;* see Plate 112), the structural principle for counteracting the vertical thrust of the tree that he had been developing in a group of works dating from 1912–1913. Thus began his preoccupation with the dynamics of verticals and horizontals. The encounter of these opposing forces—with vast implications rooted in esoteric-spiritualist doctrines—was to absorb Mondrian with an almost mystical zeal for the rest of his life.[11]

Here I return again to the etymology of the word "tectonic": we have seen that the Indo-European root *teks,* in suffix form *teks-nà,* means craft (weaving or fabricating), from which the Greek term *tekhné* derives (art, craft, skill). Guided by this etymological meaning, we return to the primal concept of art: not only is the original interdependence between art and the primordial human impulse to construct or weave illuminated, but we also find that every work of art can be thought of as a *construction.* Thus, when Mondrian described his works as *"constructions* in line and color," he was advancing a more extensive, metaphorical concept of "constructivism."

The work of Liubov Popova made it clear that, despite its two-dimensionality, painting could also be considered Constructivist. After having worked under the direct influence of Malevich's Suprematism until 1910,

Popova joined the Constructivists and became an ardent convert to the utilitarian ideology of artistic production. Until she abandoned painting entirely around 1921, she continued exploring the principles of Constructivism in a series of works called *Pictorial Architecture, Pictorial Constructions,* or *Spatial Force Construction* (Plate 113), which she began around 1917. Aleksandra Ekster also explored a virtual Constructivism on the pictorial plane; as she would affirm in the catalogue of the exhibit *5 x 5 = 25* held in Moscow in 1921, she aspired to realize "color construction based on the laws of color" (see Lodder 1983, 242).

Originally, in the heated theoretical atmosphere of post-revolutionary Russia, Constructivism and the "constructive" represented two defined factions: the latter term was deliberately used by Naum Gabo and Antoine Pevsner to distinguish their constructions with industrial materials, made with artistic goals in mind, from the Constructivist works whose intransigent social utilitarianism denied any artistic or spiritual connotation. As Lodder has rightly pointed out, the distinction "lost a lot of its *raison d'être,* especially as the creative impetus of Russian Constructivism declined towards the end of the 1920s and early 1930s and ceased to present an active alternative to the Western phenomenon" (1983, 40).[12]

Though in a rigorous historical sense this distinction should be maintained, in the artistic language we use today the terms "constructivism" and "constructive" have become interchangeable. One might attempt to establish a conceptual precision: taking into account that Mondrian called his combinations of lines and colors "constructions"—already anticipating, in 1914, the ideological definitions of the Russian Constructivists—it is possible to suggest that *constructive art* is a process involving the use of tectonic principles *as much on a flat surface as in space,* which therefore includes the historical notion of Constructivism as a strictly three-dimensional work, while allowing that the same principles can be developed on the plane.

We have seen that Albers made three-dimensional translations of volumetric tectonic entities. But perhaps the best way of illustrating this concept is to examine the work of Joaquín Torres García, particularly because the iconography of pre-Columbian art played a very important role in his heterodox assimilation of symbolic forms and constructive principles, which is still very difficult for many critics and historians of European and North American art to digest.

After having lived in Barcelona, where he grew up and received his artistic education, Torres García spent two years in New York (1920–1922) and later returned to Europe. After a stay in Italy, he finally settled in Paris in 1926. There he quickly developed links to the emerging avant-garde of abstract artists, and, together with Michel Seuphor, he founded the group Cercle et Carré (Circle and Square).[13]

In 1928, Torres García met Theo van Doesburg and was influenced considerably by Van Doesburg's working methods, which consisted in abstracting the orthogonal grid from natural forms (see Rowell 1985). Apparently, it was also through Van Doesburg that he learned the use of the golden section as a means of obtaining a proportioned structuring of the pictorial image. However, it is more possible that the Spanish painter Luis Fernández initiated Torres García into esoteric knowledge, both the golden section—an irrational measure full of mystical reverberations since

PLATE 112
Piet Mondrian, Composition, V,
1914. Oil on canvas.
21 5 /8 in. x 33 5 /8 in. The Sidney
and Harriet Janis Collection, The
Museum of Modern Art, New York.
(Photo courtesy of the Museum.)

PLATE 113
Liubov Popova, Spatial Force
Construction, c. 1921–1922.
Gouache and graphite on heavy
paper. 15 15/16 in. x 11 13/16 in.
Collection of Rachel E. Adler.

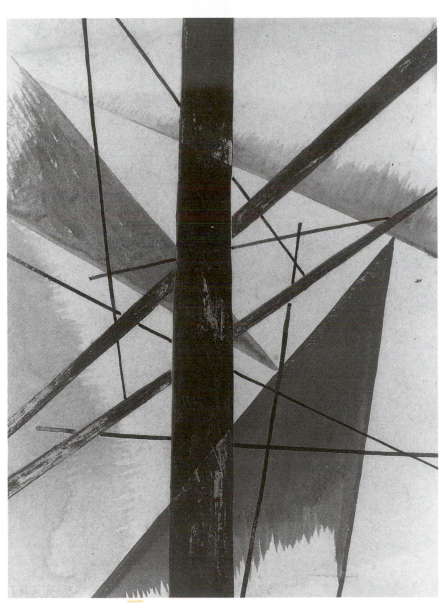

classical antiquity—and the magic of numbers or the occult medieval symbolism that intervened, as "hidden" ratios, in the building of cathedrals (see Rowell 1985, 12, for the memories of Augusto Torres, the artist's oldest son). Torres García was no stranger to the esoteric tendency, so widespread in European artistic and intellectual circles during those years.

With dogmatic fervor Torres García adopted the use of the golden section, as well as that of many symbols of the occult sciences. But his classicist past had also predisposed him toward proportion and order. In some drawings from his Barcelona days, in which fragmentary visions of objects or landscapes enclosed in rectangular subdivisions appear, the same vocation for a rigorous ordering of the plane is evident.

Mario Gradowczyk has perceptively suggested that the wood reliefs Torres García made in Paris between 1926 and 1928 had a decisive influence on the germination of his constructivism (1985, 34). (During childhood, Torres García had learned carpentry and at one point he tried to manufacture, on a commercial scale, the ingenious toys he designed, many of them composed of modular pieces.) The first reliefs were not yet

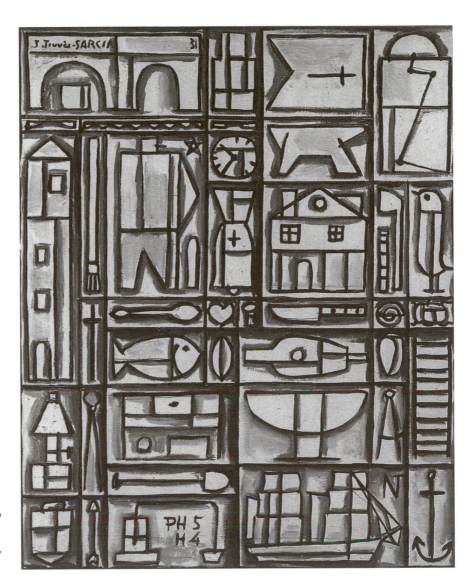

abstract; they were synthetic representations of objects, still lifes (Plate 114), "primitive" masks. At the same time, his painting, which was still figurative, fluctuated between forms of African tribal sculpture—in keeping with the widespread interest in "primitive" art at that time—and the acceptance of an overtly Cubist syntax. This moment of fluidity and indecision lasted until 1929.

In 1929–1930, Torres García appears to have put other principles to the test, making abstract sculptural pieces whose parts derive from the components of his toys or, in other cases, certain reliefs that demonstrate his assimilation of the principles of Mondrian's Neoplasticism. Thus, a relief dated 1929 (Plate 115) appears to be one of the first wooden versions of his "constructive universalism," as he would later call his idiosyncratic plastic language and entitle a book (1944) that summarizes his entire artistic thought. The images of a ruler, a man, a ladder, a fish, and a house can all be seen engraved in compartments created by wooden strips. While cutting and carving blocks of wood to fabricate plastic entities, Torres García must have developed a sense of "construction," as well as a clearer structural idea based on the use of geometric unities.

When Torres García became acquainted with Mondrian's work (the two artists were introduced to each other by Seuphor in 1929), he found himself more directly confronted with the "figure/abstraction" dilemma, an urgent theme in European art of the 1920s. In a significant passage from his autobiography, Torres García tells us, in the third person, how he finally resolved this disjunction, when his painting was at a "moment of transition": "But one day he thought: to the abstract must correspond the idea of a thing, something abstract as well. What could that be? It would have to be, in order to be graphically figured, either the written name of the thing, or the least apparently real schematic image possible: such as a sign. And he does this. He places, within *a subdivided construction like a stone wall* and within each compartment, the design of a thing. And that is it! It must be that" (1939, 268–270; italics mine).

Thus, at the beginning of the 1930s, Torres García's structuring of pictorial space became more rigorous; at the same time, the compartments or "niches" that resulted from the lineal scaffolding of verticals and horizontals became peopled with schematic images of objects and ancient or esoteric symbols, with the deliberate aim of creating a pluralist vision of the *universal* (Plate 116). In this way, Torres García established his rejection of Mondrian's geometric absolutism.

Other formal decisions also establish the philosophical differences between Mondrian and Torres García. After refining his neoplastic conception, Mondrian often employed the square pictorial format—"the true format of the twentieth century"—and the rhomboid, which is a square inclined on one of its vertices.[14] Given his theosophist convictions, the motives for this choice can be traced back to India. Theosophy adopted many of the religious ideas of Tantric Buddhism, principally those having to do with the mystical and symbolic powers of certain geometric forms. The square is a mandala form: it contains the structure of the *yantras,* symbols of cosmic unity, configured either by the archetypal images of lotuses or triangles pointing upward (the masculine) or downward (the feminine) or superposed, generating interior hexagons, and so on. Consequently, theosophy puts great doctrinal emphasis on the symbolism of the triangle. If we think of the rhomboid, too, as the sum of two triangles with their bases joined, Mondrian's adhesion to this format can be better understood.[15]

Torres García's esoteric knowledge did not affect his plastic practice to this extent; it was limited to the use of the golden section and to the mere notation of cabalistic and alchemical symbols. Moreover, Torres García remained faithful to the Western tradition, in which square or rhomboidal pictorial formats were unknown until the twentieth century. In his paintings, drawings, and constructions, he tended to prefer vertical formats, associated with portrait painting and the human figure, over horizontal or landscape formats.

As his artistic vocabulary was consolidated, Torres García began to call his paintings *Constructive Composition* or *Constructive Painting,* or simply *Constructive,* as well as calling his wood reliefs and his drawings *Constructions.* This practice, inseparable from his prolific theoretical writings, amounts to a declaration that an art based on tectonic principles can be developed both on the plane as well as in three-dimensional space. He manifested this clearly when he wrote:

What I mean by the term constructive art, extends to all art. All true art is constructive.

What I mean by the term abstract art, extends to all art. All true art is abstract.

The two terms amount to the same thing. That is why saying painter or constructor would have to be the same. (1947, 7)

This meaning of art is implicit in the semantic resonances of the word "tectonic," discussed above. Without going through the same specific etymology, Torres García arrived at the same definition.

Torres García returned to his native Uruguay in 1934, after more than forty years. Prior to his return, he spent a year in Madrid, where his visits to the Museo Arqueológico not only revived his interest in the ancient art of America (an interest that was sparked in Paris in 1928 when he visited the large exhibit of pre-Columbian art in the Musée des Arts Decoratifs), but also expanded his knowledge of the material culture of Egypt, the Paleolithic, and the Bronze Age. Once established in Montevideo, he continued his tireless activity as the doctrinary promoter of an art based on constructive principles: teaching, giving lectures, and so on. He founded the Asociación de Arte Constructivo (Association of Constructive Art), resumed publication of *Cercle et Carré,* this time in Spanish, and, in 1944, created his art school, the memorable Taller Torres García.

But most importantly, it was after Torres García's arrival in South America that his art began most openly to reflect the influence of the geometric symbolic forms of ancient South American art. His commitment is so intense that, at times, his pictorial symbolism becomes overtly didactic or borders on allegory (Plates 117 and 118). It also bears theoretical fruits: in 1939, at the culminating point of this period in his career, he publishes *Metafísica de la Prehistoria Indoamericana* (*Metaphysics of Amerindian Prehistory*). Elsewhere I have presented a detailed analysis of this work (Paternosto 1991), so here I will only point out certain essential aspects. To begin with, despite the title's wide scope, the work is almost exclusively dedicated to the Amerindian cultures of South America, principally to "the great, powerful, universal Andean [culture]" (1939a, 16).

As we have seen, Torres García's constructivist convictions acquire theological resonances. In his artistic conception there exists a doctrinary a priori: "*geometric order,*" within which he sees, in symbolic form, "the universal" (1939a, 15). In a tone that left no margin for doubt, he had already established this in an earlier work: "Geometric art is true art. . . . Geometric art is universal" (1938, 105). For that reason, when he perceives the predominantly geometric character of Inca art, he observes that its manifestations, though a "local episode," have a universal character. And he adds: "it is because of that, as well, that Constructive Art can and must be incorporated into the great Inca culture of South America, and especially into the primitive, the pre-Inca" (1939a, 35). When he discovers the geometric (*tectonic*) character of Andean art—a revelation for which his previous knowledge does not seem to have prepared him—he inscribes it into the universal tradition and at the same time tries to make his own "Constructive Art" belong to the Andean tradition.

Metafísica is the transcription of a series of lectures (it is divided into ten "lessons") that Torres García delivered to the Association of Constructive Art in the last months of 1938. During this period, in which his

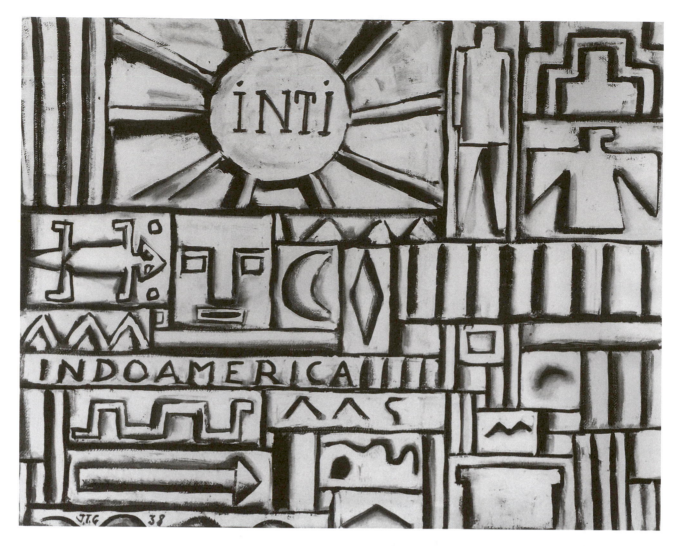

PLATE 117
Joaquín Torres García, Constructivo
en blanco y negro, *1938. Tempera on*
board. 32 in. x 40 in. (Courtesy of
the Galerie Gmurzynska, Germany.)

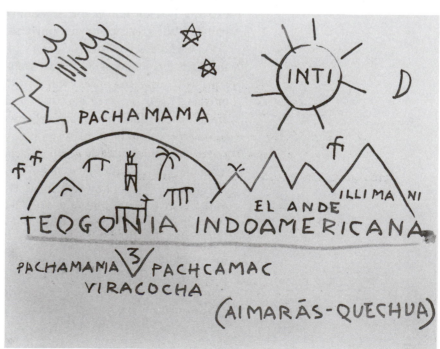

PLATE 118
Joaquín Torres García, Teogonía
Indoamericana, *c. 1937. Ink and red*
pencil on paper. 4 5 /8 in. x 5 3 /4 in.
Private collection, New York.
(Photo by D. James Dee; courtesy of
Cecilia de Torres, Ltd., New York.)

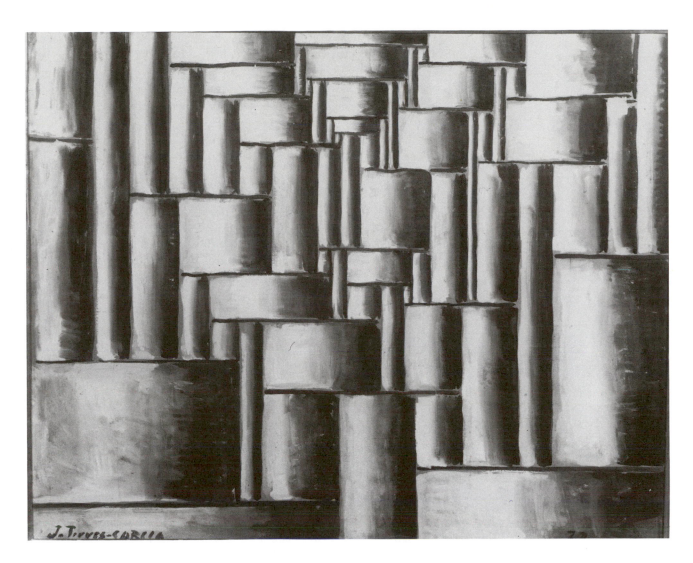

PLATE 119
Joaquín Torres García, Abstract
Composition, *1937. Tempera on
board. 32 in. x 39 3 /4 in.
Collection of Mr. Bernard Chappard.
(Photo by Eric Pollitzer.)*

theoretical formulation on Amerindian cultures was taking shape, the
work of the Peruvian ethnohistorian and intellectual Luis E. Valcárcel
influenced him greatly. In *Círculo y Cuadrado,* Torres García reproduced,
preceded and interspersed with his enthusiastic comments, several lengthy
passages of Valcárcel's article, "Apuntes para una Filsofía de la Cultura
Incaica" ("Notes for a Philosophy of Inca Culture"), in which Valcárcel,
with singular prescience, identifies the prevalently geometric character of
Inca art: "The straight line predominates in Inca forms. If the curve
appears it is to accentuate this characteristic by contrasting with it. This
supremacy determines the angular, essentially tectonic aspect of the artistic
works of the Tawantinsuyo" (1938, n.p.).[16] The aesthetic appreciation of
"geometric art" was by no means widespread in Latin America during the
1930s; nevertheless, Valcárcel points out lucidly that the textile matrix
("the nature of the warp") is the "mistress of stylization," the generator of
the geometrizing iconography of Inca—and, by extension, Andean—art.
Finally, Valcárcel sees in the Inca formal sobriety "the culmination of a
process of refinement very similar to that of Greek art" (1938, n.p.), a
statement that must have particularly attracted Torres García's attention,
since, "the Greek miracle," as Torres García called it, was supreme in his
own system of values.

Toward the conclusion of the *Metafísica,* when Torres García focuses on the "intimate structure of indigenous culture," he calls the Intiwatana its "true representative symbol" (though, in fact, we know those monuments to be inextricably associated with Inca architecture). He says of Inca architecture: "we remain astonished before something that overwhelms us by its force, its rhythm, its profound conception" (1939, 35). In this conception, a "*geometric thought*" reveals itself, similar to that which "was crystallized in Greece like a pure diamond" (here he agrees with Valcárcel). It was, I believe, this perception of Inca tectonic stonework that inspired Torres García to paint the most abstract of his works, in which, eliminating all symbolic notations and employing conventional shading, he achieved a striking similarity to the famous Inca walls (Plate 119). At that point, perhaps bolstered by the geometric thought he found in the indigenous cultures, Torres García finally felt free to bare the orthogonal grid, the very trait his painting shares with Mondrian's Neoplasticism. More than a formal similarity, the identity with the Inca walls symbolizes the cultural distance Torres García wanted to establish from Europe.[17]

In spite of its dated style, often repetitive contents, and total lack of bibliographical references, *Metafísica* is pervaded by evangelical zeal, an existential urge to convey a truth that makes its careless handling of some anthropological and historical data somehow understandable. In the end, the strengths of Torres García's text are his arresting insights and, above all, his perception—far ahead of his time though perhaps encouraged by Valcárcel's thinking—of the geometric designs (textiles, ceramics, or stonework) as the great art of the Andes. From today's vantage point, this perception may be recognized as the tectonic principle that emerges as a recurrent pattern underlying Andean forms and meanings.

David Alfaro Siqueiros (1921) proclaimed, for the first time, the need for an art distanced from the European tradition and nourished by the pre-Columbian cultures. Torres García arrived at the same conclusion and added that those cultures should be incorporated into what he called—in a language redolent of esoteric teachings—the "Great Human Tradition." He went Siqueiros one better, however: with utopian conviction, Torres García envisioned a telluric Constructive Art as *the* future art of the Americas. This prophecy, as such, obviously has yet to be fulfilled, but his call did not go unheeded. Recently, the exhibition devoted to "The School of the South" brought to the fore the range of Torres García's influence, not only among his students but among succeeding generations of Latin American abstractionists as well.[18] Though the phenomenon is far from a prevailing trend, the work of some younger artists who have come of age in the last two decades demonstrates what I pointed out as Torres García's deflection or *mestizaje* of the modernist model: though not ignoring Mondrian or Malevich, these artists are taking as their primary sources the tectonics of pre-Columbian art, either by itself or through the eyes of Torres García.

Finally, we can see that in the evolution of the works of Albers and Torres García, the pre-Columbian tectonic forms appear as the undoubted ancient ancestors of the constructivist vocabulary. This, beyond the contextual discrepancies, legitimates the symmetries I have suggested with the vanguard of the Constructivist movement in Russia.

THE NORTH/SOUTH AXIS: AN ABSTRACTION OF THE AMERICAS

While we transcend time and place to participate in the spiritual life of a forgotten people, their art by the same magic illuminates the work of our time.

BARNETT NEWMAN,
"Pre-Columbian Stone Sculpture"

By linking Joaquín Torres García's seminal work in South America to that of a transplanted European such as Josef Albers—and, more importantly, to the early work of the younger New York artists Adolph Gottlieb, Barnett Newman, and Mark Rothko—we have disclosed a previously unrecognized phenomenon: During the period from the mid-1930s to the late 1940s, these artists were laying the foundation for an abstract art of tectonic principles that was spawned by a cross-fertilization with native cultures of the Western hemisphere.

I am aware that such a reassessment of artistic developments in the Americas during that period flies in the face of the long-ossified historiography based on the segregation of "American" (United States) and "Latin American" art. The detection of an artistic phenomenon in the Americas occurring along the North/South axis is not even revisionist history: it is unwritten history. This void results from the rise of "American" art to world preeminence during the 1950s and the subsequent emergence of a self-centered, if not chauvinistic, art writing and scholarship that effectively kept the art of South and Central America in the shadows. Contrary to this established historical discourse, I will try to demonstrate the validity of the long-overlooked North/South connection, sustained above all by the posture of Torres García and Barnett Newman, both of whom extolled Native American arts, pre- or post-European contact, as the *common cultural heritage* of all peoples of the Western Hemisphere.

However, since Newman has primarily been associated with an interest in the "tribal" arts, I must insist that my focus here is on all native arts of the Americas, without making what is to me an untenable distinction between the "archaic" or "court" arts of the Aztec, Maya, and Inca

civilizations and the so-called "tribal" arts—those of the North American nomadic tribes, the Amazonian rain forest tribes, and so forth (see Chapter 1).[1] The fundamental unity of the metaphors that inform the arts of all these non-Western cultures—the "archaic" as well as the "tribal"—essentially manifests itself in the shaping of symbols, monuments, ritual paraphernalia, and semantic signs that were widely absorbed by the societies. In my view, this fundamental metaphoric unity ultimately overrides the quantitative societal differences between the great pre-Columbian civilizations and the tribal societies.

I have already pointed out how unpalatable Torres García's idiosyncratic aesthetic *mestizaje* still is to the prevailing Euro–North American perception; his use of symbols within a grid and his unevenly brushed surfaces remain, in all accounts, an unfathomable "bastardization" of languages.

I have also noted that not all of those symbols stem from a contact with the aboriginal cultures; the symbolic conglomerate Torres-García termed "Constructive Universalism" derived as well from a multiplicity of traditions such as those of Greco-Roman antiquity, alchemy and the occult sciences, the Cabala, and so on. It was perhaps this unorthodox approach, which would further deflect drastically the course of modernism on these shores, that attracted Barnett Newman to the Uruguayan master. In 1950, on the occasion of Torres García's posthumous show at the Sidney Janis Gallery in New York, Newman, according to Janis, went to the gallery daily and, drawing on his knowledge of mythology, philosophy, and archaeology, gave impromptu talks to other artists explaining Torres García's use of symbols (Duncan and Bradford 1974, 123). Janis also remarked that the work generated similar enthusiasm in other artists.

The one who immediately comes to mind is Adolph Gottlieb, whose *Pictographs* of the 1940s and 1950s (Plate 120) are, according to critics such as Irving Sandler (1962, 11–12; 1970, 195), and Robert Pincus-Witten (1969, 61–62), indebted to Torres García's much earlier use of the grid and symbols. Gottlieb, however, always cited different sources: Pacific Northwest Coast native paintings and textiles (Plate 121), as well as the Renaissance *predella* or fresco cycles.[2] Enclosed within the grid, Gottlieb's cipherlike forms—sometimes natural fragments—suggest the signs of a long-lost alphabet (Varnedoe 1984, 631). His friend Newman saw these fragments as "parts of symbols, placed in mosaic-like fashion one alongside the other" (1990, 76). This "mosaic-like" arrangement, the planar tectonics of the *Pictographs* as much as their philosophical roots in the primitive arts of the hemisphere, constitutes Gottlieb's sizable contribution to the genesis of an abstract art of the Americas.

Gottlieb's contribution precedes by several years the achievements of the artist who was, in many other respects, a central figure in the evolution toward a vernacular abstraction in North America: Barnett Newman. Newman started painting when he reached his forties, but before that he had been, and would continue to be, a prolific writer and polemicist. He was the most articulate spokesman for the new focus on the primitive and native arts of the Western Hemisphere.

In a little-known text of 1944, written as a foreword to the exhibition *Pre-Columbian Stone Sculpture* that he organized for the Wakefield Gallery in New York (the legendary Betty Parsons was then acting as

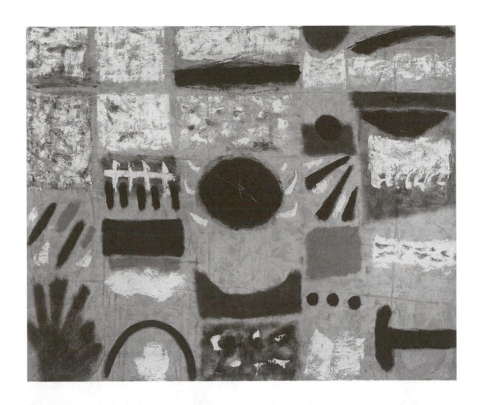

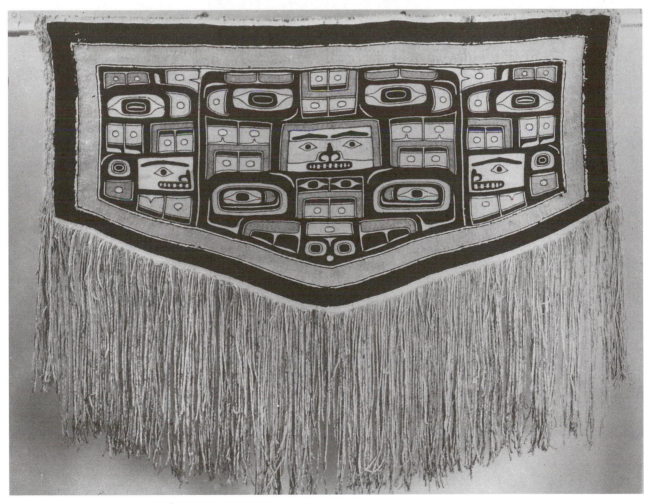

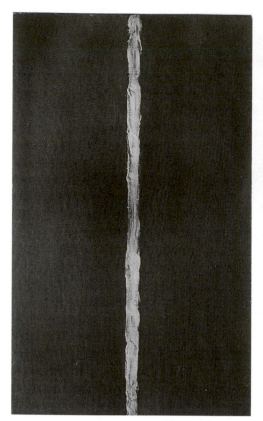

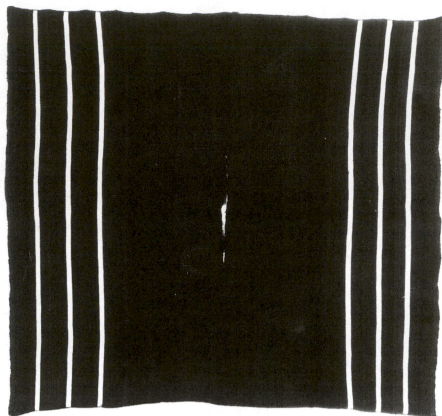

PLATE 122 (ABOVE, LEFT)
Barnett Newman, Onement I, *1948.*
Oil and masking tape on canvas.
27 in. x 16 in. Collection of the
Museum of Modern Art, New York.
Gift of Annalee Newman.
(Photo courtesy of the Museum.)

PLATE 123 (ABOVE, RIGHT)
Ponchito, Aymara weaving. Wool,
warp-faced plain weave.
Private collection;
courtesy of Andrés Moraga.

director of the gallery), Newman saw the ancient Amerindian cultures, our common heritage, as the unifying thread of the artistic culture of the Americas: "The growing aesthetic appreciation of pre-Columbian art," he stated, "is one of the satisfying results of our inter-American consciousness" (1990, 61). Later, at the request of *La Revista Belga* (a World War II propaganda publication destined for Latin America and disseminated by the Belgian Embassy in New York), he wrote an article on the same subject in which he further elaborated on the "inter-American understanding": "A friendship between peoples that is founded only on a common danger must be ephemeral. When the war is over, when the danger is overcome, will it mean a dividing of the road for North and South America? Shall we then look for a new friendship based on business?" Newman added that only through the comprehension of the art of the peoples and "the spiritual aspirations of human beings . . . [can] permanent bonds . . . be best built." While the phrase "inter-American consciousness" appears a bit politically naive, in the *Revista Belga* article Newman is aware of the U.S. policy of trying to enlist Latin American countries in support of the war effort, nor does he seem unaware—though he poses the issue rhetorically—of a "friendship based on business" (meaning economic imperialism), of which the worst was yet to come after the war (Newman 1990, 63).

Newman continued along these lines in an article written for *La Revista Belga* the following year, "The Painting of Tamayo and Gottlieb"—a comparison that would not be dreamed of today. In it, he stated that the two artists "are alike in that, working in the free atmosphere of the art tradition of the School of Paris, they have roots deep in the great art

tradition of our American aborigines," adding that "only by this kind of contribution is there any hope for the possible development of a *truly American art*" (italics mine; 1990, 72).[3]

Newman's keen awareness of the role aboriginal art traditions were to play in the gestation of an art of the Americas was articulated in various publications of the time, beginning with the well-known letter to the *New York Times* (June 7, 1943) that he signed, together with Adolph Gottlieb and Mark Rothko, in which they publicly professed "spiritual kinship with primitives and archaic art." (See also the chapter epigraph above, taken from Newman's foreword to the catalogue for the pre-Columbian stone sculpture exhibit [1990, 62].) Also important for full understanding of this position are his well-known 1948 article, "The Sublime is Now," and the lesser-known "Ohio, 1949," written on the occasion of a visit to the ancient Indian mounds in the Ohio Valley (1990, 170–174). If Newman was concerned with defining the position he shared with a group of New York artists (the group, including himself, that he put together for the exhibit *The Ideographic Picture,* held at the Betty Parsons Gallery in 1946), he was also seeking to clarify for himself something he believed to be a burning issue: the problem of subject matter in abstract art.

These writings all date from prior to or around 1948, the year in which Newman painted *Onement I* (Plate 122). Though the structure of this painting, the pictorial space parted in the middle by a vertical band, was not entirely unprecedented (see *Moment* of 1946), the stark, uninflected, deep red field of *Onement,* in high contrast to the light red of the central band, appears to have posed more definitive questions for Newman. After pondering the meaning of *Onement* for some eight months, he finally found that it was the appropriate solution to the problem of subject matter, and it ultimately became the prototype of his future works. In one of his characteristic quips, Newman would later call this painting "the dividing line" of his career. We therefore must regard it as thoroughly infused with the ideas and feelings he was espousing at the time: the heroic stance of the artist articulating metaphysical thoughts as a way to affirm his kinship with the primitive.

As we all know, Newman is generally considered the ultimate "reductivist," the forefather of minimalist aesthetics. Younger artistic generations and art critics widely assumed that his was an aesthetic of elimination, of exclusion, until, in the early 1970s, Lawrence Alloway made the first consistent attempt to redress that formalist reading of Newman's work, as well as of the work of Rothko and Clifford Still. Alloway stresses the complexity and cumulation of cultural layers implied in their art: "As the paintings of Newman, Rothko and Still became simpler in format they did not lose in complexity of content. Although various elements were dispensed with, what remained was a great deal more than nothing. The parts that they kept were, in fact, maximized and presented emphatically. The more art is simplified the more potent what is kept can become" (1973, 39; see also 1971, 31–39).

It is self-evident, on the other hand, that Newman's large expanses of unbroken color cleaved by vertical bands—or "zips," as he called them— declare the basic geometry of the rectangular canvas and the straight lines that divide it. With this extreme non-iconic pictorial signifier, so unprecedented that even his colleagues were turned off by the first show in 1950,

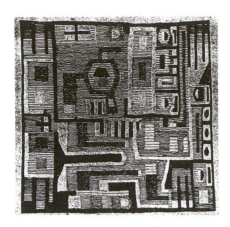

he tackled universal subjects, such as *Achylles, Joshua,* and the *Stations of the Cross.* He thereby established a radical departure for abstract painting, which was, despite its deceptive simplicity of means, pregnant with cultural allusions to themes previously treated by a vast iconography.

Who's Afraid of Red, Yellow, and Blue?

Newman's long-standing quarrels with "purist geometric painting," and especially with Mondrian's Neoplasticism, are better known than the inadequate notion he entertained of the geometric patterns occurring in weavings and ceramics.

In 1946, Newman organized the aforementioned exhibition of paintings by American Indians of the Pacific Northwest Coast for the inauguration of Betty Parsons's new gallery in New York. The exhibition grouped examples from private collections and from the American Museum of Natural History. (Edmund Carpenter acutely observed that, as the organizers of the exhibition transported the pieces across town, they "declassified them as scientific specimens and reclassified them as art" [1975, 9–49; cited by Clifford 1988, 239].)[4]

Newman states in the preface to the exhibition catalogue, "These paintings are ritualistic. They are an expression of the mythological beliefs of these peoples and take place on ceremonial objects only because these peoples did not practice a formal art of easel painting on canvas" (1990, 105–106). The significance of this enlightened assessment is unfortunately diminished by his reiterated misperception of the "geometric, objective patterns" generated by basketry and weaving. Later, in the foreword to the catalogue for the exhibition *The Ideographic Picture* (also held at the Betty Parsons Gallery), Newman belittled "the pleasant play" of those patterns that the (male) artists—seriously engaged in ritualistic painting—left "to the women basket weavers" (1990, 107–108). Furthermore, in Part 1 of "The Plasmic Image," Newman insisted "that strict geometry was the province of the women members of primitive tribes, who used these devices in their weaving, pottery, etc. No case of any primitive culture shows the use of geometric form for religious expression. The men, in most tribes the practicing artists, always employed a symbolic, even a realistic form of expression" (1990, 139).

Equipped with only spotty anthropological and archaeological knowledge, Torres García had, unlike Newman, a basically intuitive perception of the artifacts' designs as *art,* whether they were textiles or basketry, painting or ceramics—geometric or not. In Chapter 10, I emphasized Torres García's fascination with the "geometric thought" that, in his view, underlay the Andean cultures. Perhaps here it would be more to the point to return to his *The Tradition of Abstract Man* (1938). In the chapter entitled "Geometric Art," Torres García reproduced, among examples of rock art and ancient inscriptions, a pen drawing of a Wari-Tiwanaku tapestry tunic (Fig. 38)—a farsighted choice, for it was not until 1963 that Alan R. Sawyer singled out a sequence of these tunics, in which staff-bearing winged figures are subjected to gradual geometric reductions, as the means to articulate a sign system, a process worth examining in some detail.

The staff-bearing winged figures are the so-called "attendant angels"

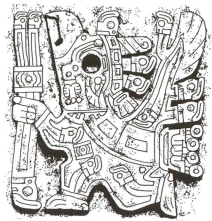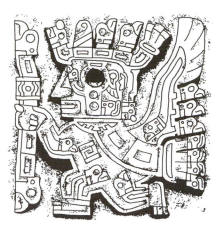

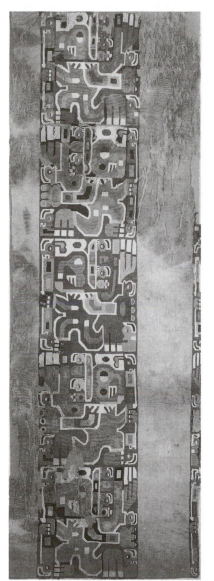

that surround the central deity on the Gate of the Sun frieze (see the concluding section of Chapter 1 above; see also Plate 5 and Fig. 39). Sawyer suggests (1967) that the earliest examples are those in which these "angels" appear with just the necessary distortion resulting from the transference of an image with natural traits to the textile coordinates of warp and weft (Plate 124). In examples that are conceivably of a later date, the geometrization becomes more accentuated and is ruled by conventions that impose lateral expansion or contraction of the design toward the edges of the tunic (Plate 125 and Fig. 38).

This process of abstraction appears to culminate in at least one astonishing example in the collection of the National Museum of Anthropology in Lima, the piece known as the "Lima tapestry," in which the icon appears to be reduced to a mere articulation of rectangular forms (Plate 125) and the references to the zoomorphic model have virtually disappeared, leaving only a syntactic relation to it.

In my view, the most fascinating aspect of this is that these sequences of geometric reductions, possibly realized between the eighth and ninth centuries, appear to anticipate a process at which Western art would only laboriously arrive in the twentieth century. I am referring to the transition from Cubism to geometric abstraction, perhaps best seen in the slow but coherent changes in Mondrian's work between the mid-teens and early 1920s. Though still very far from being recognized, these paradigmatic works by anonymous Aymara weavers represent a compelling "lesson in abstraction." And, though for the sake of argument I have emphasized the sequence of gradual geometric reductions, the other typical Wari-Tiwanaku tunic designs—the "paired" and "composite" motifs, to use Sawyer's terminology (Plate 126)—appear in already abstracted natural forms obsessively repeated throughout the garment. This repetition of motifs, as well as the conventions governing the totality of the Wari-Tiwanaku textile output—and the wide range of colors, whose use must have been codified—indicate, as Sawyer recognized, that we are confronting a system of signs, possibly of an emblematic character, emanating from the center of power. A system that presupposes, as I pointed out in reference to Chavín typology (see section entitled "Chavín de Huantar" in Chapter 1 above), the reductive methods inherent to the textile syntax, which are central to the symbol-making function of Andean arts.

Here, I am stressing Torres García's intuitive capacity, an often forgotten hallmark of artistic genius. Intuition is, in strictly philosophical terms,

PLATE 125
*Tunic (uncu), Wari-Tiwanaku
(Middle Horizon), Peru. Camelid
wool and cotton. 100 x 92.3 cm.
Collection of the Museo Nacional
de Antropología, Arqueología e
Historia del Perú (T.01650).
(Photo by Dirk Bakker.)*

the faculty of knowing without resorting to rational processes, an immedi-
ate cognition (from the Latin *intueri,* to look at, to contemplate): in other
words, knowing by seeing (Hessen, 1967), or, in Torres García's case,
seeing beyond a limited knowledge of the facts. On the other hand, the
extremely well-read and well-educated Newman falls prey to the "fine art
syndrome" that informs the anthropological literature: transfixed by the
paintings the Pacific Northwest Coast natives made on cloth, animal hide,
and bark or wood supports—objects the Western artist can associate
immediately with "art"—and obfuscated by his abhorrence of "geometric
design," Newman missed the point here entirely, namely, that "decora-
tion" was a concept alien to non-European art traditions.

 Besides the previous interpretation of archaeological textiles, there is
abundant ethnographic information on the symbolism attributed by
different tribal societies to the geometric, non-objective patterns of bas-
ketry and weaving that dispels the Western notion of the "merely decora-
tive." Franz Boas, whose *Primitive Art* (first published in 1927) appears
to have been Newman's source on Pacific Northwest Coast native art,
discusses the symbolic meanings of geometric ornaments such as the Aüeto
and Karayá in Brazil, the baskets of British Guyana, Cheyenne artifacts,
ceremonial woven objects of the Huichol in Mexico, as well as several
others in Africa and Polynesia (1927, 89ff.). However insightful, his
approach falls into the a priori "art/ornament" dichotomy and misses the
fundamental unity of metaphors underlying the manufacture of artifacts in
tribal societies, which more recent research has found. In this sense, the

study by David M. Guss, *To Weave and Sing* (1989, 181–182) becomes a contemporary interpretive model: "The Yekuana, like many tribal peoples, have no fixed categories corresponding to the Western concept of 'art', . . . therefore, in such a society there can be no object that is not [art]. Or, put another way, to become a true Yekuana is to become an artist." Guss was initiated by a (male) master weaver, so he learned to share in the mythological content symbolized by the crisp geometric designs of the bichromatic baskets (Plate 127), which are central to the culture. Guss further suggests that "the ultimate subject matter of the baskets is culture itself. For like 'all things made' (*Tidi 'uma*), they are intended as portraits of the society that inspired them" (1989, 69–70, 91). It appears, as well, that Newman overlooked what Boas says of the American Indians of California in whose culture basket weaving is also central: "[A]n occupation of women and thus it happens . . . that only women are creative artists. They are virtuoso in their technique. . . . The works of art made by men are, as compared to theirs, insignificant" (1955, 18).

It becomes quite contradictory, on the other hand, that Newman, who was to achieve the most radical abstraction of his time, still saw the abstract symbolism of Pacific Northwest Coast native art as embodied by "organic shapes"—natural forms that, though simplified or fragmentary, are still recognizable (Plate 121). Worse, he assumed that the tribal (male) artist might adopt, besides the symbolic, a "realistic mode of expression" (1990, 139). As we saw, this contradiction was resolved only in his painting.

PLATE 127
Yekuana basket: Woroto sakedi, similñasa. *Reprinted by permission of the author, from David M. Guss, To Weave and Sing: Art, Symbol and Narrative in the South American Rain Forest (Berkeley: University of California Press, 1989, Pl. 7, p. 178). (Photo by Philip Galgiani.)*

Though Newman was correct in attributing to women the role of weavers of the geometric patterns—though not correct in underestimating it, of course—he did not live long enough to witness the ever-increasing appreciation of, and studies devoted to, one of the most sophisticated weaving traditions ever known: ancient Andean textiles. As I observed above (see Chapter 7), the crucial significance weaving had within the society and, more specifically, the symbolism encoded in the stark geometry of those textiles is only now beginning to be understood. Essentially a women's art, weaving is so central to the culture that men, too, either practice it or are quite conversant with its techniques.

Irving Sandler observed that "the simplification of pictorial means practiced by the color field painters [for example, Newman, Rothko, and Still] . . . produced an elemental impact akin to that evoked by primitive art, which they greatly admired" (1970, 153). Elsewhere Sandler stated that Newman's "stark surfaces are primitivistic" (1970, 191). In point of fact, the "primitivistic" sense of Newman's broad expanses of color "joined" by vertical stripes (as Newman put it), would be better understood if we looked away from the mainstream discourse of Western art to perceive their amazing structural correspondence with the Andean textiles classified as "warp patterned" (Plates 122 and 123). Recent ethnographic work has demonstrated that even today the designs of those textiles—the colors chosen, as well as the vertically banded structures—encode specific cultural meanings referring to the social or physical environment, land distribution, crops, and so on (Bastien 1973; Adelson and Tracht 1983).

FIGURE 40
The allqa: *(a) positioning from the border; (b) the* allqa *alone. Reprinted by permission of the publisher, from Cereceda 1986, Fig. 10.5.*

At the cutting edge of this research, in her quest for the meaning of the spare geometry of the utilitarian bags woven by the women of the township of Isluga in the Chilean highlands, the anthropologist Verónica Cereceda began by posing the right questions:

Andean textiles, especially the archaeological ones, have been the subject of many studies. Questions have been asked about technique, use, chronology, style and spatial distribution. Still one can say that the specific language of the fabrics has been ignored, despite the valuable anthropological contributions made by these studies. From an iconographic point of view, attempts have been made to identify figurative motifs (flora, fauna, mythical scenes) or to interpret abstract forms that suggest the presence of more or less recognizable symbols. Efforts to isolate a possible lexicon, using a hierarchy exterior to the design, have started with the most immediately legible (head, sun, hut) but the syntax that would explain how such elements are articulated within the whole of the cloth remains unknown.

What, then, shall we do when confronted by a hermetical landscape of bands and stripes or, even worse, one made up of empty space? . . . Can a traditional Andean textile be viewed as a text—not as decoration or an illustration of realities outside the woven cloth but as a specific message behind which lies a system that explains the message? (1986, 149)

Cereceda ultimately isolated an operational visual syntax, some of whose basic units of meaning, such as the *allqa* (Fig. 40)—an alternation of a broad band and a thin stripe of dark color juxtaposed with lighter shades (1986, 161)—are, in my view, strikingly analogous to Newman's stripe/color plane. It appears, therefore, that the *viability* of Newman's pictorial syntax of extreme aniconic signifiers—the possibility that such syntax can conjure up meanings (whether or not they were the meanings his titles alluded to)—is more feasible in light of a semiological reading of Andean textiles than from the perspective of the discourse of European abstraction (that is, Neoplasticism); Newman's unsparing simplicity of means was decidedly alien, if not inimical, to this discourse, as he certainly intended. Here we have reached a paradox: The structural simplicity of Newman's painting is retrospectively "explained" by a women's art.

When Harold Rosemberg wrote about Newman's painting as the "living rectangle" (see Rosemberg 1964, 169; 1972, 96), he was taking Newman at his own words: in his foreword to the *Ideographic Picture* exhibition catalogue, Newman stated that, for the Kwakiutl artist painting on hide, "a shape was a living thing, a vehicle for an abstract thought-complex, a carrier of the awesome feelings he felt before the terror of the unknowable. The abstract shape was, therefore, real" (1990, 106).

Interestingly enough, the reference to Pacific Northwest Coast native art is common to both Newman and Cereceda. The latter resorts to examples of "split-representation" of animals in Tsimshian art collected by Franz Boas (1955, 225), who is also Newman's source, to reinforce her interpretation of the Isluga bag designs as analogously spreading out sideways from the central band or "heart" of the "being," since the bag is equated with an animal (Cereceda 1986, 161–162). Newman also referred to the meaning that representing living things "internally . . . by means of

bisection" had for American Indian painters of the Pacific Northwest Coast. He believed that the aboriginal artist was concerned not with the symmetrical pattern "but with the nature of the organism, the metaphysical pattern of life" (1990, 106). His first *Onement* painting (1948), with its monochromatic field bisected by the central band, certainly seems to be directly infused with such philosophical ruminations, as I already pointed out.[5]

Mark Rothko's paintings of stacked-up color rectangles could also be associated with some textile structures of simplified patterns, mainly with some interlocking warp-and-weft sleeveless shirts of the Nasca period or, even more reminiscent of Rothko's glowing hues, some featherwork tabards from the southern coast of Peru, attributed to the Wari period. However, I hasten to say that here we are on the slippery terrain of "isomorphism," for, while Torres García and Barnett Newman established willful connections with indigenous arts, in Rothko's case the link is tenuous at best. Sandler observed that, in the mid-1940s, Rothko's primal, biomorphic forms alluded "to observable phenomena—underwater organisms or the paraphernalia used in primitive rituals" (1970, 179). This observation applies to Rothko's work while he shared the ideas articulated by Newman, the group's spokesman. By the late 1940s, however, as Rothko achieved his signature style, he had gradually distanced himself from these ideas, prescribing a reading of his work that was more closely related to received Western ideas of the sublime, or classic and archetypal myths, than to Native American cultures. Yet one wonders whether Rothko's previous exposure to the frontality and symmetry of primitive artifacts had left an enduring imprint—no doubt unconscious—that led his work toward a basically similar format. But second-guessing an artist's creative process also presents perilous terrain.

Not a few members of the generation of early U.S. modernists that preceded Rothko and Newman were intensely connected to Native American arts: Max Weber, Marsden Hartley, George L. K. Morris, Arthur Dove, and the sculptor John Storrs. Only the latter is of interest here, however. The rest, taking their cue from the European avant-garde, relied on the icon as the significant focus of the "primitive" spirit: the totem, the idol, the mask, or else images of tepees or American Indians themselves. This applies to Hartley as well, though in his frontal arrangement of emblematic American Indian motifs we come as close as was possible during the first decade of the twentieth century to a reception of the grid as a structural prototype.

The sculptor John Storrs, on the other hand, is an intriguing figure. In his "Studies for Architectural Forms," a series of towerlike sculptures of modest scale in stone or metals that he developed in the 1920s, he appears to have fused his marked interest in architecture (he was born in Chicago and remained closely connected to the architectural community there) with the formal elements of Navaho blankets and other Native American objects he collected. His would certainly fit the bill of an art that responds to the structural principles of the tectonic. But the kinship these "architectural forms" have with the Art Deco style of the 1920s evinces a translation of the elements of the native arts into architectural ornaments rather than re-semanticized components. Moreover, his representations were

never more than semiabstract, and he even resorted to allegorical figurations when he had to comply with commissions for public sculpture. In the last years of his life, he finally turned to portraiture in stone reliefs. However, despite these inconsistencies, I think that Storrs is, in this context, not a negligible figure.

As a young artist living in the West, Jackson Pollock got to know Native American arts firsthand. Though he was aware of Picasso's seminal inclination toward the "primitive"—mainly through his reading of John Graham's article "Primitive Art and Picasso" and his book *System and Dialects of Art,* both published in 1937 (see Sandler 1970, 106; Varnedoe 1984, 639–645)—Pollock represents a more vernacular approach to the indigenous arts, devoid of the intellectual trappings of the Surrealists dabbling at ethnology. The "enshrinement of Jackson Pollock as the most telling representative of the New American esthetic"—proof of the widespread concern among New York artists of the 1940s with the primal notion of the "artist as myth-giver or shaman"—is "richly problematic" (Varnedoe 1984, 640). I do not intend to dwell on this here; I only want to emphasize that Pollock, in his archetypal imagery, mythical figures, or formal borrowings from artifacts, also relies heavily on the iconicity of the aboriginal arts, until the poured or dripped "all-over" abstractions of 1947–1951, though he returned to a figurative mode in his late work, in which he still uses the dripping technique. The dripped abstractions, however, can hardly be said to represent a tectonic order: net over net of paint skeins, a veritable "palimpsest" of space with unmistakable indications of a feverish execution. On the other hand, I think a case could be made that Pollock's poured abstractions, perhaps the epitome of the much sought-after rupture during the 1940s with the European tradition, are a result of his previous intense search for the primal energy of a tribal artist. In other words, the originality of this paragon of the art of the Americas came from his reliance on indigenous traditions, even if he was not directly or formally indebted to them. Varnedoe writes, "There we find [in the abstractions] a less evident, more deeply seated assimilation of tribal art, on broader formal and spiritual terms" (1984, 641).

Palimpsest, from 1944 (illustrated in Rushing 1986, 278), is in fact the title of an oil by Richard Pousette-Dart, another artist active in New York in the 1940s, who referred to his work of that time as "having an inner vibration comparable to American Indian art . . . something that has never been perceived. I felt close," he alleged, "to the spirit of Indian art. My work came from some spirit or force in America" (Rushing 1986, 277). Rushing adds: "Pousette-Dart, as the word *palimpsest* suggests, obscured or partially erased earlier versions by 'rewriting,' inscribing new visual information on top of the old," just as "Native American rock art are composite creations consisting of countless layers built up on the surface, sometimes over millennia" (1986, 278). Pousette-Dart is indeed an important figure in this context; he pointedly alluded to his spiritual connection with rock artists in another comment: "Many times I felt as if I were painting in a cave—perhaps we all felt that way, painting then in New York" (Rushing 1986, 277), a statement that also echoes the then widespread representation of the artist as myth-maker or shaman. It should be obvious by now that I have de-emphasized speculations on myth and archaic symbolism as the way to connect with the unconscious mind or the

Jungian collective unconscious, speculations that were an intellectual vogue in those days, spearheaded by John Graham's writings of the late 1930s. My decisive criterion here is the presence of a more verifiable factor, namely, a tectonic order that invokes, implicitly, the textile grid, so "full of language" (see Chapter 7, above). Pousette-Dart's paintings of the 1940s are undeniably infused with archaic symbolism. However, more often than not the structural ordering of the grid is missing, and in some instances—as in the above-mentioned *Palimpsest*, in *Fugue, No. 4* of 1947 (illustrated in Rushing 1986, 272), in *Figure* of 1944–1945, or in *Forestness* of 1946 (illustrated in Hunter 1986, 72–73)—the heavy overpainting can be construed as the intentional obscuring of the grid which nevertheless can be glimpsed underneath. I therefore find Pousette-Dart's early work closer to Pollock's (something also observed by Rushing 1986, 277) than to Torres García's or Gottlieb's, whose works epitomize the use of an emphatic grid coupled with symbols.

However, it is of the utmost importance to note that even artwork that would not entirely conform to my definition of an abstraction grounded in structural principles—either emanating from a synthesis of the modernist grid and hemispheric sources or found directly in the latter—can embody in a far more fundamental sense (as in the case of Pollock's work, for many the cornerstone of the new U.S. art) a seminal redirection of attention toward the arts of the Americas. This new view would incite, from other perspectives, a revision of the art historical discourse apart from European traditions.

In discussing "abstraction of the Americas," we lack well-rounded, ready-to-use historical constructs such as "Neoplasticism" or "Suprematism." We have only intimations, loose elements found in the work of artists who, despite visionary claims that they were the cultural heirs of the Amerindian arts, did not work them out to the fullest extent in the end. I am referring again to the two cardinal figures in my quest for an "abstraction of the Americas": Torres García and Barnett Newman. For both of them, the period of cross-fertilization with hemispheric sources was short-lived. While, after his return to South America, Torres García went so far as to transform his brainchild, the Association of Constructive Art in Montevideo, into a center for the study of the Amerindian cultures, in the last years of his life he dismissed that intense involvement as a strategy in the service of Constructivist indoctrination; he even came to repudiate Inca culture as decadent. For his part, Newman rarely returned after the 1940s to the ideas on the primitive and indigenous artistic mind that he had so ardently sustained. Looking back in 1969, however, thus demonstrating that he had internalized once and for all the philosophy of "primitive man," Newman put his previous concerns into historical perspective: "Twenty years ago we felt the moral crisis of a world in shambles, a world devastated by a great depression and a fierce world war" (1990, 287). Newman engaged instead in a tense exchange with mainstream art topics as a way of sustaining his artistic claims. Best remembered as a fierce polemicist with an often acerbic wit, his portentous language and the large claims he staked for his abstraction have fallen of late into much disfavor, mainly among those for whom art seems to be ruled by a law of diminishing expectations.

As if to typify a polarity along the North/South axis of the Americas, the pictorial languages Torres García and Newman chose seem to diverge in opposite directions: the grid enclosing a profusion of symbols versus an unprecedented, pared down to the bones, abstraction. A divergence that appears to derive from the contrast between the "Mediterranean anthropomorphism" that Torres García translated into a modern pictography and Newman's pictorial stance, which could be interpreted as ultimately—and subliminally—validated by the aniconic Jewish religiosity. Newman, an intellectual who fashioned himself as an artist when he found a radically abstract mode of stating pictorial subjects, is worlds apart from a *pintor de raza,* a born painter like Torres García, who had such deep, persistent roots in classicism that he did not fully come to grips with the artistic issues of the twentieth century until he was in his fifties—not a mean feat if we consider that, by that age, most artists are well set in their ways.

Yet there is an underlying *tectonic order* common to both artists that, as I have repeatedly pointed out, can ultimately be traced back to the symbolic geometry of the ancient textiles, and that tectonic order is what I now see as the cardinal term defining an abstract art of the Americas.

We know all too well that neither Torres García's utopian vision of a telluric Constructivism as *the* art of the Americas nor Newman's view of an inter-American consciousness based on a common cultural heritage have prevailed. Nonetheless, in what appears now as a fleeting, nearly forgotten moment, Torres García and Newman can be seen as having effectively laid the groundwork for an abstract art of the Americas that today is still only haltingly being assimilated by succeeding generations. It remains, as a whole, a potentiality, a task yet to be completed.[6]

It is therefore important to reformulate the message that can be drawn from the example of these two artists, a message that, in my view, remains entirely relevant. In 1944 Newman wrote: "The art of the future will, it seems, be an art that is abstract yet full of feeling, capable of expressing the most abstruse philosophic thought" (1990, 69). Half a century later, that statement has not lost any of its intrinsic validity: within the contextual terms of a true culture of the Americas, one that encompasses its own roots—as Torres García and Newman so headily propounded in their writings—abstraction can become a vehicle for metaphorical thought, a method akin to philosophy, where things cannot be said in other than apparently hermetic terms.

To put it another way, while the practices that a hegemonic Western culture has ostracized or second-rated as "crafts" (weaving, pottery, construction in general) provide the structuring principles for an art that we call "abstract," this abstraction becomes, in its operative terms, a nonverbal tool of knowledge, which dissects or, more precisely, deconstructs that hegemonic grip, as the ancient "crafts" re-emerge in the Western artistic consciousness as *art sources.*

NOTES

Introduction

1. This contention appears in the 1975 edition of Kubler's book and remains unchanged in the third edition published in 1983. Despite the head found in Cuzco, which is believed to represent the Inca Wiracocha, I do not think this was the prevailing expressive mode: excavations have not produced other examples, and it isn't easy to understand how monumental sculptures can "vanish."

2. In a later text (1976), Kendall meticulously documented Inca architectural forms; though extremely concise, it is an excellent contribution to the study of that aspect of Inca culture. Lamentably, the sculpture we are concerned with continues, in Kendall's book, to be mere "carvings" or "geometric sculptings."

3. Paul Westheim glimpsed this line of reasoning. In discussing the stepped grecque sign, he observes that it appears in the context of a religious art: he therefore affirms that "it wasn't simply a question of filling surfaces. What is created always 'means' something, reveals something of myth and of the gods." Thus Westheim finds himself compelled to call the stepped grecque sign "one of the substantive ornaments of the Mexican ancient world" (1985, 156).

4. Barbara Braun's *Pre-Columbian Art and the Post-Columbian World* (1993) is a highly effective and sorely needed assessment of ancient American artistic sources of twentieth-century art, focusing mainly on leading modernist figures who drew most conspicuously from those sources (Paul Gauguin, Henry Moore, Frank Lloyd Wright, Diego Rivera, and Joaquín Torres García) and exploring, as well, the ramifications of their influence. Braun points out that "it was only in the second half of the nineteenth century that the aesthetic interest in Pre-Columbian forms moved from the margins to the center of consciousness in the West, after the decorative arts were elevated to the status of fine arts as a result of the crusades of John Ruskin and William Morris" (36). As ideologically sound as Ruskin's and Morris's revalorization of the decorative arts was (an early and prescient warning

against the first cultural ravages of industrial capitalism), it is striking that aesthetic appreciation of pre-Columbian art had to reach the Western mind through the lower ranks of the hierarchical "sundering of the arts," that is, through the "crafts" movement.

5. In 1973, Junius B. Bird organized a show called *Peruvian Paintings by Unknown Artists, 800 B.C. to 1700 A.D.*, at the Center for Interamerican Relations (now called The Americas Society) in New York. The text he wrote for the catalogue was the first specific treatment of the subject.

6. Nevertheless, the canvas was not totally impregnated with paint. In fact, as William J. Conklin points out (1978, 2), the technique (instruments and paints that were used) is still not understood very clearly: "The paint must be sufficiently liquid to flow smoothly and cover evenly, but not so liquid as to penetrate by absorption to the other side of the cloth." It thus acted in exactly the same way as the acrylic emulsion paints of today: both can be folded or rolled up without damaging the painted surface.

1. Monumental Stone Sculpture in the Andes

1. William J. Conklin (1978, 8) has suggested that the cotton fabric was manufactured in the coastal towns and then taken to the mountains to be painted (see also Bonavía 1985).

2. The identification of represented fauna is a legitimate archaeological method but is inadequate as a criterion of artistic interpretation. In the archaeological sense, see Lathrap 1968, 73, who suggests that the jungle of the eastern slopes of the Andes is where Chavín cultural archetypes originated.

3. In any case, a verbatim transcription of the complex metaphors in the sculpture of the temple at Huantar never occurs either in ceramics or in other, lesser media; even on a larger scale, as in the friezes of Cerro Blanco in the Nepeña valley, the reception of Chavín iconography is ciphered. Only the painted fabrics found in Karwa, on the southern coast, are comparable to the temple's sculpture in their profusion and iconic complexity.

4. Today, too, there is some questioning of the concept of Chavín de Huantar having been the ceremonial center of a dominant cult—a kind of "Vatican" of pan-Andean religion—and, therefore, a questioning of the theological cohesion of the Early Horizon. The greater or lesser iconic discrepancies within the Chavín model would then indicate a selective acceptance of the cult (indicating, moreover, a reading of the iconography or style in the sense that is proposed here). Thus, the Early Horizon would come to be characterized by a federative modality of regional cults that apparently accept a Chavín preeminence without completely adhering to it (see Burger 1988, 114–128). But this revaluation of the characteristics of the Early Horizon does not preclude the idea that the painted fabrics had a catechistic function; the greater or lesser success of this attempt at indoctrination does not affect the intention with which it appears to have been conceived.

5. *Taypicala* (the stone in the center) is the Aymara name of this ceremonial site.

6. The art of Wari-Tiwanaku is a pristine example of this, but I plan to demonstrate in a future study that the patterns of the textile medium had a much more general influence on Andean art.

2. Inca Stonework

1. *Mit'a* was coercive tribute given to the state in the form of personal labor; it was rotating, never permanent.

2. Luis Llanos told Rowe that in Ollantaytambo a treasure hunter (*huaquero*) uncovered the remains of wooden rollers beneath a block of stone. See Rowe 1963, 226.

3. Oddly enough, the niches in the cave of Choqequilla, not far from Ollantaytambo, show the same traits of this fusion of architectonic elements; they are the sole examples known outside of the Titicaca region.

4. The most recent archaeological research provides radiocarbon dates that seem to more than amply corroborate my point. On the basis of a cluster of dates associated with Inca-style stone structures from north of Cuzco, Brian Bauer points out (1992, 47) that "these findings suggest that Inca-style stone architecture in the region of Cuzco may have appeared for the first time between A.D. 1260 and 1390, a range of dates much earlier than previously predicted." These findings coincide with the assumed mythical foundation of Cuzco in c. A.D. 1200, while radiocarbon dates associated with Killke, or early Inca, pottery indicate a settlement in the region datable to A.D. 1000. Other radiocarbon dates provided by Bauer (1992, 48, though he warns that more evidence is needed) seem to support many of the chroniclers by indicating that the "Inca state expanded beyond the Cuzco region, and established control of an enormous Andean territory, within the span of a few generations," in "the latter half of the fifteenth century and the early sixteenth century."

5. The architects and master masons were professionals employed by the state; they were exempt from the ordinary impositions and were employed full time in the public works (Rowe 1963, 224).

6. Conklin made this comment during a seminar, "The Warp and Weft of Andean Time," sponsored by the Society for Art, Religion and Contemporary Culture, New York, November 7, 1987.

7. In Cuzco's Plaza de Armas, blocks of considerable size and polygonal form—apparently never used in the walls for which they were destined—have been placed in the green patches. They constitute a clear example of the concept of "sculptural masonry." Something similar happens with the blocks left in the plaza of Ollantaytambo. Ann Kendall intuited this concept; in *Everyday Life of the Incas* (1973, 161) she wrote that "aesthetically, the ingredients of sculpture were included in the finest Inca masonry."

8. See references to the work of Josef Albers in Part 2, Chap. 10.

9. An intriguing photograph exists by Martín Chambi, "Muro Inca," taken in 1925 (published in the Lima magazine *Taxi* in February 1985, a copy of which was given to me by Wendy Weeks in Ollantaytambo), in which a wall of refined polygonal execution appears partially covered by a wall of inferior quality (the wall appears to be the spectacular Hatun Rumiyoc in Cuzco, of which the famous "twelve-angled stone" forms a part). I do not know what meaning this covering had (was it added after the Spanish Conquest?), but in any case chroniclers consistently agree in their descriptions of the fascinating quality of the stonemasonry. It is thus possible to conjecture that, if concealment of these works of constructive art had been observed, it would have been recorded. According to Cecilia Vicuña, the occasional concealment of these walls by other inferior walls or by stucco would be analogous to the sacrificial burning of valuable textiles.

10. On a recent visit to the Koati Island ruins in Lake Titicaca, where Inca and Tiwanaku influences are fused, I could see (because of the lamentable deterioration of the buildings) that the exterior plastering was reinforced with the regional *ichu* straw, as is common in the fabrication of adobe bricks. This is even more evident in the stepped forms framing the large niches, where special care appears to have been taken: the *ichu* had been braided, forming spiral threads that function like the iron wires used in reinforced concrete.

11. Garcilaso de la Vega makes a specific reference to Cuzco as the "navel" of the world, because the city is almost exactly in the center of the territory of Peru "which is long and narrow like the human body" ([1604] 1991, Book 2, Chap. 11, p. 95).

12. After Yupanki (Pachakuti) had named "the whole city together" body of a

lion, the lords of Cuzco went to find him to "place on him the tassel of the state and insignia of king"; they find him "painting and drawing certain bridges . . . and thus he drew certain roads which left from a town and went to these bridges and rivers" (Betanzos [1551] 1987, Chap. 17, p. 81). This clearly appears to be an action separate from and later than the remodeling and naming of the city "body of a lion"—and, here again, the city is referred to as the territory between the rivers. Nevertheless, Zuidema wants to see in this a single action, which would mean that "body of a lion" was a metaphor referring to the whole valley of Cuzco, assuming that "certain roads" implied the system of the *ceq'e*. I do not think the text permits such an interpretation: the reference to a system as specific as the *ceq'e*, which were central in the life of the Inca empire, in a form as vague as "certain roads" that united towns and bridges does not fit in with the minute attention to detail that characterizes Betanzos's narration of cultural events— sacrificial rites, public ceremonies, and so on. Moreover, in the final analysis, I believe that there is no obstacle to conceiving, as in Nasca, the coexistence of a geoglyph (Cuzco/puma) and radial lines (the *ceq'e*).

13. See also Tedeschi 1955, 20, as well as Scully 1960.

14. With the benefit of a historical perspective, we can also see now that these sculptural works had long anticipated the Minimal works of the 1960s. Jack Burnham observed that in "The Echo," the experimental museum that Goeritz created in Mexico (1953), there is a volumetric construction by Goeritz, "a truly prophetic, space-filling object with all the earmarks of works produced over a decade later in England and the United States" (1968, 122). Burnham also cites Goeritz's work as an antecedent of David Smith's *Cubi*. While Barbara Rose (1969) coincides with Burnham, Gregory Battcock, with a chauvinism characteristic of New York critics in those days, refuses to admit Goeritz's work as an antecedent of the 1960s Minimalism (1968).

On Barragan's architecture, see Emilio Ambasz (1976) and Juan Acha (1980). In relation to the *Espacio Escultórico*, see also Acha (1979a) and Jorge Manrique (1984).

3. *Nature as the Grand Scale*

(The expression "nature was the grand scale" was used by Lucy R. Lippard in a letter to C. P. dated May 12, 1978.)

1. *Qoyllur rit'i*, the yearly procession to the peak of Mount Ausangate is, to this day, the most poignant testimony of the vestigial Andean cult, now syncretically mixed with Catholic beliefs and symbology.

2. The painted designs in the cup of the *paqcha* illustrated in Plate 24 indicate that it belongs to a post-contact, transitional period (see Chapter 7); yet, it also attests to the persistence of the symbolism implied by fluids circulating through zigzagging or rhomboidal grooves—a symbolism that, one might infer, was increasingly residual in the new cultural milieu implanted by the colonial rulers.

3. See McMann 1980; Plates 47, 48, and 49 illustrate zigzagged and diamond-shaped incisions.

4. Though the symbolic content of Old Europe is not transferable to the Andean context, the fact that the artifacts lack direct written references is a determinating factor in establishing the analogy. Furthermore, just as in the Andes, Gimbutas has had to use "comparative mythology, early historical sources, and linguistics, as well as . . . folklore and historical ethnography" (1989, xv). See also Gimbutas, *The Goddesses and Gods of Old Europe, 6500–3500 B.C., Myths and Cult Images* (1982).

5. Valcárcel (1963, 180) states that "Kenko is known to be an empty and violated tomb that probably contained the remains of the Inca Pachacuti," but he does not elaborate further. Kubler takes up this surmise (1975, 334).

6. Measurements that I took in 1988 enabled me to verify that the seats have a wider base than what today is their top point, which suggests the trapezoidal form of a niche that has been destroyed. Inojosa (1935) had already made the same determination.

7. In 1980, Zuidema and Van der Guchte identified the throne as the sixth *wak'a* in the fifth *ceq'e* of the Chinchaysuyo, Sabacurinca (Randall, personal communication).

8. Ubbelohde-Doering mistakenly calls it Kenko Grande (1967, 249).

9. Ann Kendall (1973, 46, 75) points out that the niches with a stepped pattern can also be found in Tambo Colorado, Yucay, and Urco.

10. Robert Randall's "Del tiempo y del río . . ." (1987) is a penetrating essay on the meaning of water in the Andean cosmology.

4. *Machu Picchu*

1. Ann Kendall suggests that the Inca Tupac Yupanki may have completed the construction of Machu Picchu (1973, 79).

2. "In a message sent to Matienzo in 1565," writes Wachtel (1976, 276), "Tito Cusi himself enumerates his empire's 'provinces': Rupa Rupa, Pilcocuni, Guaranpay, Peaty, Chiranaua, Chiponaua; as well as Vitcos, Manari, Sicuane, Chacunanchay, Niguas, Opatary and Paucarmayo. All the inhabitants of these 'provinces' paid him tribute, and Tito Cusi adds, not without a certain exaggeration, 'There are so many of them that they can't be counted, and you would need twice as much land as there is from Quito to Chile for them to populate.'"

3. "The Spanish victory may have been facilitated by an epidemic which hit the region of Vilcabamba in 1572," observes Wachtel (1976, 290). "The bridges—even the one over the Urubamba—and the roads were not watched or protected."

4. However, Paul Fejos (1944) was much less impressed by the "fortifications" and observed that the satellite centers he explored lacked any defensive constructions.

5. González Corrales brought to my attention the remains of this small cylindrical pillar, which is in many ways analogous to the Intiwatana of P'isaq.

6. Morris and Thompson point out the care with which the *usnu*, the inner gates, and certain buildings of the ceremonial complex of Huánuco Pampa were constructed; this "set the area apart in terms of the special nature of its construction and its imitation of, and *symbolic link* with, the capital of Cuzco" (italics mine; 1985, 89).

7. In fact, the window facing southeast frames the appearance of the tail of Scorpio, just before the December solstice. The Incas must have considered the Pleiades and Scorpio to be the constellations that announced the solstices. They also called Scorpio "Qollqa," for its links with the agricultural cycle.

8. The sequence of ceremonial fonts at Choquesuysuy was first published by Paul Fejos (1944) and then reproduced by Luis E. Valcárcel (1973). There is a sequence of ceremonial fonts in Chachabamba as well, but they are constructed horizontally.

5. *Saywite*

1. See Rostworowski's detailed study of the war with the Chankas (1988, 43 ff.).

2. This is Cecilia Vicuña's interpretation, based on an analogy with the ceremonial meaning of the *kiva* among the Pueblo Indians of the North American Southwest. These spaces, generally constructed below ground, facilitated an intimate relation with the earth mother (personal communication).

6. Ollantaytambo, the Other Paradigm

1. The love story of the legendary army commander Ollantay and an Inca princess gave rise to a play versified by Ricardo Rojas in 1939 and staged in Buenos Aires the same year. Rojas rejected a version of the tale dating from the seventeenth century and based his tragedy on a "forgotten Cuzco folk version, reconfirmed by another one that the archaeologist Wiener heard in Ollantaytambo" whose pre-Hispanic origin is more probable (Rojas 1939, 11).

2. Kubler thinks that these are probably the most ancient continually occupied residences in South America (1975, 329).

3. Ubbelohde-Doering (1967, 252) mentions the existence of the drawing. During my stay in Cuzco in 1979, I showed my copy of it to Chávez Ballón, who, accompanied by his students a few days later, verified the existence of the fallen capital. It lies at the foot of the monument and can be clearly discerned.

4. J. Lee Hollowell argues that the Fortaleza (the ceremonial complex in what I consider Hanan Ollantaytambo) is "a highly complex intertangle of constructions from different periods that can well stretch back in time a lot further than the accepted 'late Inca'" (1989, 3). The lack of photographs or drawings to illustrate his points, compounded by the lack of standardized denomination of the areas to which he is referring, makes it difficult to understand some aspects of Hollowell's analysis, which contains some otherwise interesting, though not inarguable, suggestions. I would not argue, however, with Hollowell's point about the different building campaigns and the rearrangement of the site. In fact, if the Temple of the Sun does not belong in its present location, and it actually "has been expediently assembled from parts of a previous building and relocated to its present site" (Hollowell 1989, 4), the hasty rearrangement would seem to coincide with the historical circumstances pointed out by Rowe (1961, 321, quoted above; the present site of the temple suggests a more defensible spot in wartime), making it very "late Inca" indeed. At any rate, the haste does not seem to have affected the precise orientation of the temple, indicating, in my analysis, an unmistakably symbolic intention.

5. Garcilaso writes that "they embalmed the dead body. . . . All its innards they buried in the temple that they had in the town they called Tampu, which is in the river below Yucay, less than five leagues from the city of Cozco, where there were very large buildings and of superb stonework" ([1604] 1991, Book 6, Chap. 5, p. 337).

6. Jean-Pierre Protzen (1986, 101, 105) analyzes the morphology of the protuberances by their function; according to him they are only present on blocks at the site of construction and do not appear on blocks abandoned during transport. Gasparini and Margolies (1980, 325), however, come up with the right question: if the protuberances had practical functions, why were some eliminated while others were not? Hemming approaches the meaning of these tactile signs: he perceptively notes that the masons could easily have eliminated them if they were no more than the traces of the work process, and he concludes, "They serve no purpose. We can only conclude that they were left for aesthetic reasons. One of the most famous Zen Buddhist gardens in Kyoto in Japan is decorated only by a pair of low cones of gravel. The Inca projections are just as satisfying" (Hemming and Ranney 1982, 33). Ubbelohde-Doering does not discuss the subject clearly. While on more than one occasion he accepts the utilitarian function of the protuberances, in describing the tower in Machu Picchu he appropriately evaluates their symbolic meaning. In 1944 Rowe believed that these protuberances were one of the typical features of Inca architecture: "The Incas often left knobs of undressed stone protruding from the blocks in a wall, apparently for pure decoration, as they are always distributed at random, serving no obvious purpose and forming no pattern" (1944, 26). Later, in 1946, Rowe partially changed his criterion, pointing out that

the protuberances provided support for levers, and that since they were not eliminated "they were probably considered decorative, as similar ones were in Greece in the fourth century B.C." (1963, 226). I have already discussed the inappropriateness of the "decorative" criterion. Moreover, one of the most striking characteristics of the enigmatic protuberances is that, contrary to what Rowe wrote in 1944, they are carefully polished. Thus, the term "breasts" used by González Corrales in his 1971 doctoral thesis on Inca stonework is appropriate, because it makes manifest the organic sensuality of these forms.

7. I have already discussed the few examples of cubical reliefs and projections whose composition is rigorously symmetrical: the sculpture at the entrance to the cave of Choqequilla and the bath of the ñusta in Ollantaytambo (see Chapter 3 above).

8. John H. Rowe (1963, 325), referring to motifs in ceramics, weavings, and stone which have been seen as glyphic symbols, writes that they "are all too few and too symmetrically placed to be conceivable as linguistic symbols." This implies, conversely, that an asymmetrical organization is the essence of such symbols.

9. The drums of some African tribes that produce only two notes, the Morse alphabet, and the codes of alternating digits used by computers are some of the binary systems developed by different societies to communicate information.

10. Hollowell's work (1989) is a sizable contribution to the study of Ollantaytambo. It was unknown to me before the publication of the Spanish edition of this book.

11. Hollowell (1989, 5) makes a good case for the former existence of an Inca temple in the Manyaraki plaza, on top of which the present Catholic church was built. In fact, an ancient temple in that location would support my contention that the Inkamisana area, as well as the Manyaraki plaza, would be the *hurin* sector of Ollantaytambo.

12. This textile belongs to the Textile Museum in Washington, D.C., and is catalogued as TM 1965, 40, 23.

13. The chroniclers agree that during the Inca empire, which was the latest manifestation of Andean cultural history, agriculture continued to have this central role in society, and its tasks were ritualized: the Sapa Inca himself began the tasks of plowing and sowing. Similar rites accompanied the beginning of the harvest.

7. *Threading Signs: An Andean Geometry*

1. This was suggested to me by Cecilia Vicuña.

2. The decipherment of the writing called "Linear B" demonstrated that Greek was spoken in Mycenae, which led to further investigations of cultural continuity across the so-called Dark Age between the collapse of Mycenae and the appearance of the geometric ceramics. Roland Hampe and Erika Simon's *The Birth of Greek Art* (Oxford University Press, 1981) is based on this premise. Nevertheless, there is still no evidence of the full use of writing after the fall of Mycenae, the period during which the signs on the vases appear to substitute for writing.

3. One of the textiles belongs to the collection of the Munich Ethnographic Museum and dates from the Middle Horizon, Wari-Tiwanaku culture; the other is of the Inca period and is reproduced in a book by Paul Kosok (1965, Fig. 34).

4. Ferdinand Anton (1987, 190) refers to Barthel's research: largely thanks to the survey carried out by Victoria de la Jara, about four hundred geometric, multicolored signs have been identified, of which Barthel believes he can read twenty-four and conjecture with some accuracy about the meaning of fifty more. "In his view," writes Anton, "the Inca script was akin to early First Dynasty hieroglyphics in Egypt; ideograms strung together in a sort of telegraphese." De la Jara had previously advanced her belief that the geometric designs functioned as

logograms, like the Chinese calligraphic signs (1964, 1975). But Anton observes that no progress has been made following the work by Barthel and de la Jara.

5. Referring to studies on nonverbal forms of communication such as that of the marked beans (see Chapter 6 above) or that of the *qipu,* Luis Millones states that "another line, apparently more promising in these studies, has focused on the motifs that are reproduced in the textiles, particularly in the horizontal bands or *tocapus* that adorned the wearing apparel of the noble class. Various keys have been suggested for deciphering this supposed writing" (1987, 74). More recently, in her analysis of the Andean Late Horizon pieces exhibited in the *Circa 1492* exhibit (National Gallery of Art, Washington, D.C., 1991–1992), Elizabeth P. Benson acknowledges the Barthel and de la Jara interpretation of the *t'oqapu* (in relation to the Dumbarton Oaks example) as a form of syllabic writing to be read as an incantation. She cautions, however, that most scholars believe that "the motifs are part of a symbolic language but not true writing" (1991, 594, item 451).

6. The earliest Quechua lexicons are: Fray Domingo de Santo Tomás, *Lexicón o vocabulario de la lengua general del Perú* (1560); Anonymous, *Vocabulario y phrasis de la lengua general de los indios del Perú, llamada Quichua* (published by Antonio Ricardo, 1586); and Diego González Holguín, *Vocabulario de la lengua general de todo el Perú, llamada Quichua o del Inca* (1608).

7. Rostworowski writes that the boards (or pieces of fabric, or "tapestries"; there is no agreement on the medium used) were located in the Royal Palace in Madrid in 1586 and used as evidence in a suit brought by a grandson of the conquistador Hernando de Soto: "That document informs us that one of the boards represented the Spanish conquest, meaning that they did not only illustrate Inca history but also the events connected with the Spaniards" (1989, 278). She also points out in a note that the document is being examined by Dr. Enrique M. Dorta of Madrid's Universidad Complutense in an attempt to locate the paintings. This seems to indicate that the paintings were basically figurative, of a historical nature, and, if they were indeed painted on fabric, they were in all probability colonial works and not the "boards" or "planks" that both Sarmiento and Molina describe as having been commissioned by the Inca Pachakuti, a description that better fits the pictorial techniques used prior to the conquest. No painted fabrics of exclusively Inca provenance are known to exist; the pictorial representation of biblical or historical scenes was something taught to native artists after the conquest. One possibility remains: that, as Rostworowski suggests, the "fabrics" may have been painted by coastal artists, from a region where the technique was widespread. But, here again, the "narrative," historical genre does not fit in with the norms of pre-European art. In short, these new facts demonstrate the possibility that the works sent by the Viceroy Toledo to Spain were colonial and not the "boards" mentioned by the chroniclers.

8. Late in 1987, an additional spectacular example of a tunic with asymmetric *t'oqapu* and even more reductively conceived signs was exhibited in a New York gallery. The piece is now in the collection of the Museum of Fine Arts in Boston, and it has been reproduced on the cover of the catalogue of the exhibit, *To Weave for the Sun, Andean Textiles in the Museum of Fine Arts, Boston,* held at the museum in 1992. See Plates 67a and 67b, pp. 179–182 for an explanation of its attribution to the early colonial or transitional period.

8. Stoniness

1. The expressions are Rowe's who, in reference to the art of the Incas, states nevertheless that "the impression of simple strength" given by Inca objects "can be very appealing to the modern inquirer" (1963, 287). Kubler believes that "the intrinsic meaning of Inca art reinforces the general impression of an oppressive

state. It is as if, with the military expansion of the empire, all expressive faculties, both individual and collective, had been depressed by utilitarian aims to lower and lower levels of achievement" (1975, 335). Both authors forget that the "creative liberty" of the artist in bourgeois society is a very recent Western acquisition and a dubious interpretative category for pre-Hispanic art.

2. In a photograph by writer and photographer Samivel, the *omphalos* of Delphi appears, nonetheless, as a hive-shaped stone. See his *Grecia, Treinta Siglos de Cultura* (Mexico: Editorial Herrero, 1962), first published in French as *Le soleil se lève en Grèce* (Arthaud, 1959). I thank Jorge Vicuña Lagarrigue for having shown me this book.

3. This myth, recorded by Fray Martín de Morúa in his *Historia del origen y genealogía general de los reyes del Peru,* is cited by Harold Osborne (1968, 55). It seems to allude to the gleam of metal as an abstract way of representing the sun, as with the golden plates that covered some of the enclosures of the Qorincancha.

4. In the Christian tradition, Jesus renamed Simon Peter (*pietra,* rock) at the founding of the Christian church, the spiritual orb.

5. Cassirer (1975, 22) discusses linguistic ambiguity at length as "the source of all mythology"; he also cites the myth of Deucalion and Pyrrha as an example of this, because of the similarity of the words *laos* and *laas*. He adds that, although the linguistic explanation of mythic motifs no longer takes such an elemental form, it is nevertheless tempting to seek the origin of myth in language.

6. Cuniraya Wiracocha "just by speaking could have beautifully finished terraces made, held up by walls" (Osborne 1968, 96), which suggests the fundamental importance of the agricultural terraces, another Inca work of great magnitude that increased substantially the area available for cultivation in the narrow Andean valleys.

7. Curátola's references to the "interior of the mountains" and the "subterranean world" (1977, 62) make one think he means "chthonic divinities." Nevertheless, I think that this highly suggestive definition of the tectonic divinities can be considered to be within the geology of the earth's crust.

9. Beyond Europe: Rereading the Artifacts

1. Much less well known, however, is Gauguin's Peruvian ancestry: his maternal grandmother was Flora Tristán, a flamboyant French-Peruvian agitator on behalf of workers' and women's rights. Gauguin spent a good part of his childhood in Lima, and in his later correspondence he would insistently refer to his "Peruvian," "savage," "Indian," or "Inca" identity. His involvement with the ancient Andean ceramics that inspired his pottery making had been neglected by art historians until Barbara Braun brought it to the fore (1986, 36–37; 1993, 52–91).

2. Here I follow the balanced account George Kubler (1991) gives of the different points of view from which ancient Amerindian arts were granted aesthetic recognition, beginning with the first European contact.

3. Nelson Rockefeller started collecting pre-Columbian art at the prompting of Diego Rivera and Miguel Covarrubias; Rockefeller was already a modern art collector, advised by Alfred Barr, Jr., founder of the Museum of Modern Art (MoMA), which was largely funded by the Rockefeller family fortune. Rockefeller began offering his pre-Columbian collection to the Metropolitan during the 1930s; because the Metropolitan refused to accept it, he founded the Museum of Primitive Art in 1954 to house it. He was closely advised by René d'Harnoncourt, one of the most remarkable personalities of the "pre-chauvinist" era of the U.S. art world. Exceedingly knowledgeable about primitive art, d'Harnoncourt, who was born in Austria, acquired his expertise on pre-Columbian art in Mexico where he lived between 1926 and 1933. He joined the staff of the MoMA in New York in 1944

and became its vice president in 1949. Before joining the MoMA, he had been involved in several exhibitions of native art, and he became the éminence grise behind similar shows at the MoMA (see Kubler 1991, 143–146).

4. The recent overhaul of the National Museum of the American Indian, now housed in a splendid turn-of-the-century Beaux Arts building that used to be the Customs House in downtown Manhattan, reflects the cultural politics of the last decades. It has been turned over to the Native Americans themselves, who now run it and act as "curators" interpreting the *art*/ifacts on display. Their views are invaluable as the bellwether for understanding the sense that art had in their cultures; I am afraid, however, that the museum's insistence on the concept of "Indian"—an arch-Eurocentric denomination that I try to avoid as much as possible—reinforces the sense of separateness.

5. The collection belonged to Guido Di Tella, whose family fortune endowed the Di Tella Foundation, parent institution of the Instituto Di Tella in Buenos Aires. The Instituto's center for the visual arts became a hotbed of avant-garde exhibitions during the 1960s. Guido Di Tella started collecting pre-Columbian art on the advice of the foremost specialist in the field, Dr. Alberto Rex González, author of *Arte Precolombino de la Argentina* (1977) and advisor to two exhibitions of Argentinian pre-Columbian art held at the Di Tella Institute in 1963 and 1966. In the mid-1980s, under the directorship of Daniel Martínez, the Museo Nacional de Bellas Artes accepted the donation of Di Tella's collection. Martínez also actively, though unsuccessfully, sought funds to build a wing in which the collection could be permanently exhibited. In taking these steps, Martínez acknowledged the influence of two artists who had been urging governmental authorities to acquire pre-Columbian art long before his tenure at the museum: the painter Antonio Berni (see Cockcroft 1988) and the sculptor Líbero Badii. Less well-known than Berni outside of Argentina, Badii was unable to travel to war-devastated Europe in 1945 for the customary journey to further his artistic education, so he decided to travel through the Andean region instead (see his drawing of the Intiwatana in Machu Picchu, Plate 56). This pioneering move was later reflected in his art. Berni also traveled to Peru and Bolivia in 1941 after staying in Europe in the 1930s. It is interesting to note that in 1971 an exhibition of ancient indigenous arts was held at the Museo Nacional de Bellas Artes; later, in 1987, I was instrumental in bringing together all the parties for an extended exhibition of a private collection of Andean textiles curated by Ruth Corcuera and Isabel Iriarte. As a result, a substantial part of these holdings were acquired for the museum's collection.

6. Herbert Spinden's *A Study of Maya Art* had a groundbreaking effect in academic circles; in the 1920s, the heyday of exploration in the Mesoamerican region, a yearning for the artistic style of that exotic civilization reached the general population. Mainly in Southern California, a "Maya fever" seemed to grip the imagination of architects, designers, and decorators. The most noticeable outcome of this was the "Maya Revival" style in architecture. Spinden and other academics served as consultants on the "authenticity" of certain projects. See Barbara Braun's analysis of the enduring effect Maya architecture had on Frank Lloyd Wright (1993, 137–179); see also Marjorie Ingle (1984).

7. Scully seems to be the connecting voice here, for he also contributed a perceptive essay, called "Mankind and the Earth in America and Europe," to *The Ancient Americas, Art from Sacred Landscapes* (1992, 71) that sums up his thought on the matter. I was introduced to his work by Lucy R. Lippard. (The Spanish edition of the present book [1989] reflects this symbolic connection between art and nature.)

8. The gigantic exhibit *Circa 1492,* held at the National Gallery of Art in Washington, D.C., in 1991–1992, which surveyed the art and culture of Europe and the Mediterranean world, Asia, and America in the age of exploration, was

accompanied by an even more voluminous catalogue in which all the essays dealing with American cultures at the moment of European contact were commissioned from writers with an ethnographic or anthropological background.

9. The Good Neighbor policy was devised by President Roosevelt in 1933 to promote unity in the Western hemisphere in light of the rise of expansionist fascist ideologies in Europe and the concomitant threat to U.S. investment in Latin America. Nelson Rockefeller, representing a substantial part of such vested interests, was clearly the most appropriate choice for the post of Coordinator of the Office of Inter-American Affairs, to which he was appointed by Roosevelt in 1939. The Museum of Modern Art in New York was perhaps the most visible face of the "Rockefeller establishment"—Rockefeller left the presidency of its board of directors to accept his government appointment. It was no coincidence that between 1940 and 1945, under the guidance of Rockefeller's close advisor René d'Harnoncourt, the museum held eight exhibitions devoted to ancient and modern Latin American art. One of the most notable of those exhibitions was *Twenty Centuries of Mexican Art* (1940), which was cosponsored by Mexico and curated by the leading Mexican archaeologist, Alfonso Caso; that extensive undertaking prefigured the Mexican show at the Metropolitan Museum in 1990 (see n. 10 below). Other institutions that presented coordinated events during the same period were the Golden Gate International Exposition in San Francisco (1939–1940), the Brooklyn Museum, the Fogg and Peabody Museums at Harvard University, the American Museum of Natural History (in connection with the New York World's Fair), and the National Gallery of Art. Braun, who is my source here, states that "all these exhibitions interpreted pre-Columbian objects as belonging to a common American heritage" (1993, 43; see also Cockcroft 1988). I am not writing a social history here; however, I would like to point out that, though in ideological discourses "inter-American" has become a code word connoting United States imperialism in the Americas, we should nevertheless be able to deconstruct the expression in order to emphasize the genuine and spontaneous cultural exchanges that—"above and beyond the corporations" (in the words of the Argentinian writer Julio Cortázar who, though hardly an admirer of U.S. governmental policies, was a fan of prize fighting, jazz music, and, obviously, U.S. literature)—have taken place between North and South America in modern times, mainly in literature and music. Though, since the 1950s, the worldwide imperial influence of the United States in the visual arts has been suffocating, we should not forget the tremendous influence the Mexican Muralist movement had in the U.S. during the 1930s and 1940s. In the 1930s, Diego Rivera ranked next to Picasso as the most popular and influential artist in the U.S. (see Braun 1993, 185–249; see also Cockcroft 1988).

10. That show, as Braun observes, was the centerpiece of a "staggering array of highly coordinated and slickly marketed exhibitions of ancient and modern Mexican art" (trumpeted in the New York media as "Mexico: A Work of Art"). She adds that it "served as cultural harbinger of another U.S. government hemispheric policy: free trade with Latin America, only this time Mexican corporations interested in hastening the policy's implementation picked up the tab" (1993, 43).

10. Constructivist Histories

1. Sarmiento de Gamboa ([1572] 1907, Chap. 37), Betanzos ([1551] 1987, Chap. 10), and Garcilaso de la Vega ([1604] 1991, Vol. 1, Book 2, chap. 37) refer specifically to this practice. Rostworowski writes of it, "These things would seem fantastical if not for the references contained in a document of 1558–1567 concerning a land dispute between two indigenous chieftains in the Chillon river valley on the central coast. Both parties appeared before the Royal Audience of the Kings with clay models representing the part of the valley in dispute, and with

these models they demonstrated their respective claims before the judges" (1988, 73).

2. The exhibit *"Primitivism" in 20th-Century Art,* curated by William Rubin for New York's Museum of Modern Art in 1984, was celebrated for the magnificent examples of tribal art it presented, but also harshly criticized as an exercise in ethnocentric decontextualization. The exhibit included one of the most flagrant cases of isomorphism. Its curator compared a wooden silhouette from New Guinea, which had concentric circles in color alluding to the head and the stomach, with the concentric circles of a Kenneth Noland tondo. Unbelievably, the curator described the New Guinea painting as an "autonomous" abstraction, something that is only possible in the West, while indeed the concentric circles of the Noland work were a formal exploration without extrapictorial references—*autonomous.*

3. Tatlin went so far as to offer to work as Picasso's servant in order to be close to him and stay longer in Paris, since he was traveling on a very meager budget. Christina Lodder, whose *Russian Constructivism* is a fundamental work for understanding the history of the movement, has assembled several fascinating stories about Tatlin's trip to Paris and suggests that, during his visits to Picasso's studio, Tatlin must have seen the famous tin guitar (today in the collection of the Museum of Modern Art in New York), the three-dimensional counterpart of the aesthetic revolt of our time: constructed and assembled sculpture, radically distinct from the solid, carved, or modeled volume of the sculpture that preceded it.

4. Natalia Goncharova was one of the most noteworthy artists of the flowering of the Russian avant-garde, before the Russian Revolution. Together with Mikhail Larionov, she developed her most well-known production: a semiabstract kind of painting they called "Rayonnism," a synthesis of Cubism, Futurism, and Orphism. Prior to that, she had worked in a "primitivist" mode inspired by Russian traditions, work that inspired the young Malevich, when he arrived in Moscow, to create his Cubo-Futurist paintings of 1910–1913. See Camilla Gray's *The Russian Experiment in Art: 1863–1922* (1962, Chaps. 4 and 5). On page 153 of that work is a reproduction of a piece of folk embroidery from the province of North Dvinsk that is considered a direct influence on Malevich's Cubo-Futurism, "or more indirectly through the work of Goncharova from 1909–1911" (Gray 1962, 153).

5. The question "what was to replace the missing object?" from Kandinsky's 1913 "Reminiscences" (reprinted in *Kandinsky: Complete Writings on Art* [London: Faber & Faber, 1982]) is cited by Sixten Ringbom (1986) in his essay "Transcending the Visible: The Generation of the Abstract Pioneers," published in the catalogue of an exhibit that was a landmark in the revaluation of the history of abstract art: *The Spritual in Art: Abstract Painting, 1890–1985* at the Los Angeles County Museum. This catalogue is an excellent guide to the extensive literature available today on the subject.

6. One example of the symbology Malevich attributed to the cube is that, when Lenin died, Malevich compared him to Christ and suggested that his body be placed "in a cube, as in eternity" (cited by Hilton Kramer, 1980).

7. When the Bauhaus moved to Dessau, Albers also worked on designing furniture and glass, as well as typography.

8. Neal Benezra (1985, 31) also refers to a musical tempo and cites Albers who, referring to this mural and the way the absent bricks are organized, compared it to an "instrumentation" in the musical sense.

9. There is a more direct analogy with another mural by Albers, the *Stanford Wall* (Lomita Mall, Stanford University), finished posthumously in 1980, which is a freestanding wall, independent of the architecture, constituting a relief sculpture. The work is two-sided, with brick on one side and highly polished black granite on the other, and, though the relief pattern on the brick face maintains a close relationship with the *America* mural, the patterning on both sides has been

achieved by the insertion of a highly "modernist" material—rods or bars of stainless steel. (See Benezra 1988 for analysis and illustrations.)

10. Mary Elizabeth King analyzes examples of textiles from the Oaxaca area. About one of the textiles, a double weave dating from the Post-Classic period, she writes that "the geometric edge is similar to Mixtec architectural ornament" (1979, 271).

11. Already in 1909 Mondrian had become a member of the Dutch branch of the Theosophical Society.

12. Following Europe's first exposure to Russian avant-garde art—the 1922 exhibit in the Van Diemen Gallery in Berlin—the spatial constructions of Tatlin, Rodchenko, and their acolytes were appreciated as a new artistic manifestation, stripped of the strong utilitarian intention and the ideological meaning that inspired them. The decline of the movement itself occurred even before Stalin inaugurated the era of Social Realism; Russia's isolation during the Second World War and the Cold War perpetuated this Western misunderstanding. In this historical void, the aesthetic proselytism that Pevsner and, in particular, Gabo developed after their emigration, transformed them, erroneously, into synonyms for Constructivism. Recently, since the process of de-Stalinization, Soviet historians themselves have begun to delve into a past that was officially condemned to oblivion. This opening made possible the fundamental works by Camilla Gray and, more recently, Christina Lodder, which are indispensable for an understanding of the historic meaning of Constructivism.

13. The association was established in 1930, formed by about eighty artists. Three issues of a magazine of the same name were published; in the first of these, Torres García published "Vouloir Construire." In April of that same year, the group's First International Exhibit was held in the Galerie 23. Among others, the participants were Jean Arp, Willi Baumeister, Germán Cueto, Pierre Daura, Kandinsky, Le Corbusier, Fernand Léger, Mondrian, Amédée Ozenfant, Kurt Schwitters, Friedrich Vordemberge-Gildewart, Sophie Taeuber-Arp, Torres García, and Georges Vantongerloo.

14. That the square is the authentic format of the twentieth century was observed to me by Jesús R. Soto in a conversation in 1971. A few years later I realized why it was foreign to our tradition.

15. In evaluating the symbolic meaning of the triangle for theosophy, Erik Saxon (1979, 41) writes that "while it does not refer to the diamond specifically, it is easy to see how the symbolically consistent fusion of the two triangles should be possible." He also cites other vernacular references that may have influenced the choice of the rhomboidal form: first, the fact that Dutch painters had used this format for portraits (apparently it was a local practice) and, more important, that heraldic crests hung at the tops of columns inside churches in the seventeenth century were diamond-shaped. He also perceptively observes that in the rhomboid the structure of a cross is implicit, as well as the blades of a windmill, a typically Dutch pictorial subject that Mondrian had worked with before his evolution toward Neoplasticism.

16. Valcárcel's article originally appeared in the Buenos Aires newspaper *La Prensa,* whose literary and artistic Sunday supplement published Valcárcel's work regularly. During the 1930s and 1940s, *La Prensa* carried continuous coverage of the archaeological discoveries taking place throughout the Americas, as well as related theoretical articles (*La Prensa*'s morning rival, *La Nación,* did the same). These publications were a constant source of information for Torres García, who collected them avidly. (I thank Cecilia de Torres for allowing me access to the artist's archives.)

17. This interpretation is supported by the passage from Torres García's autobiography quoted above, which was written at a time when the artist was permeated with pre-Columbian art. In an article published in *Artinf* (1981), I dealt

for the first time with the Inca walls as a sculptural and symbolic manifestation. (Lucy R. Lippard read an early version of this article, written in 1978, and gave a critical response to it by letter in May 1978.) Later, in another article in *Artinf* (1984), I established the relation between the Andean walls and Torres García's painting. Margit Rowell (1985) agrees with my interpretation.

18. The exhibition, *El Taller Torres García, The School of the South and its Legacy,* was co-curated by Mari Carmen Ramírez (1992) and Cecilia de Torres and opened in 1991 at the Centro de Arte Reina Sofía in Madrid, traveling later to the Archer M. Huntington Art Gallery at the University of Texas at Austin, where the exhibit had originated. Then it was shown at the Monterrey Museum, Mexico, the Bronx Art Museum, New York, and the Tamayo Museum in Mexico City. It featured the work of the original members of the Association of Constructive Art, such as Amalia Nieto and Rosa Acle, and of the Taller Torres García, among them the two sons of Torres García, Augusto and Horacio (also former members of the A.C.A.), as well as Gonzalo Fonseca, Francisco Matto, and Julio Alpuy. The continuity of the Taller legacy was emphasized in the section of the exhibit devoted to the contemporary legacy, which presented the more recent work of these artists, together with historical pieces by Carmelo Arden Quin, who forms the link between the Taller Torres García and the "Río de la Plata avant-garde." This avant-garde movement was a group of geometric abstractionists that flourished in Buenos Aires in the mid-1940s, gathering artists from Uruguay and Argentina (such as Alfredo Hlito, who was represented in the exhibit). The Taller legacy was also reinforced by the work of succeeding generations that was exhibited, such as works by Alejandro Puente and Marcelo Bonevardi and the much younger Elizabeth Aro and Alejandro Corujeira. Two paintings of mine were included in the exhibit. In total, the work of thirty artists in different media—painting, sculpture, drawing, stained glass windows, murals, furniture—was presented, demonstrating the range of the Taller's educational activity, which was conceived in the spirit of a medieval guild, yet possessed links to the modern Bauhaus. Unfortunately, the work of the Colombian artists Eduardo Ramírez Villamizar and Edgar Negret was not included. Both artists were early practitioners of a constructive sculpture indebted to the doctrine of Torres García's *Universalismo constructivo,* widely read in Latin American artistic circles in the decade following its publication (1944).

11. The North/South Axis: An Abstraction of the Americas

1. Based on this discredited notion, the curators of the exhibition *"Primitivism" in 20th-Century Art,* held at New York's Museum of Modern Art in 1984, omitted pre-Columbian Amerindian arts, yet included *some* manifestations that were deemed "tribal artifacts" (that is, the Nasca lines), apparently with the aim of establishing a connection to the work of some contemporary artists. The very fact that the peoples of Nasca were able to command a large contingent of workers devoted to the construction of the lines demonstrates a complexity of socioeconomic organization that belies a straitjacketing into the "tribal society" concept.

2. W. Jackson Rushing has pointed out that "the influence of Southwest Indian art was apparent even before that of Northwest Coast art in Gottlieb's Pictographs" and that the colors he employed during his stay in Arizona in 1937–38 and which "continued in many of the Pictographs, are reminiscent of the buffs, browns, tans and rust colors of the Pueblo pottery on display at the Arizona State Museum" (1986, 279).

3. See also Newman's review of a large show of modern art held at the Museum of Modern Art in the summer of 1944 on the occasion of its fifteenth anniversary (1990, 66–71), in which Newman deals with the work of Tamayo and Matta, who were included in the show on equal footing with the rest of the modern masters.

4. Carpenter has identified Newman, Max Ernst, "and several others" as organizers of the show—thus his affirmation that "the Surrealists" declassified the specimens, and so on. However, according to the exhibition catalogue, the main curating responsibility appears to have been Newman's, though the assistance of Max Ernst, John Graham, some private collectors, and the scientists at the Museum of Natural History is acknowledged.

5. In his *Painting as Model,* Yve-Alain Bois gives a compelling though irretrievably mainstream analysis of Newman's painting—the type of writing made possible to a large degree, by Newman's silence on the matter of archaic aboriginal symbolism after the 1940s. Bois relies decisively on Maurice Merleau-Ponty's *Phenomenology of Perception* and on Lacan to elucidate the matter of symmetry. Around 1961, in my formative years, I read the Spanish translation of Merleau-Ponty's book (1957), and over the years I have returned to his elegant, seductive exposition of Husserl's thought. Therefore, I am not arguing with Bois's interpretation. However, I chose to emphasize Newman's advocacy of an art in the Americas that would absorb hemispheric sources in opposition to the traditional artistic subservience to European art. This stance, unequivocally articulated in Newman's writings as well as in his organization of related exhibitions, is so central to Newman's thought and feeling in the years preceding *Onement I* that it cannot be disregarded, as Bois does. That "forgotten Newman" of the 1940s—so well represented by the seminal painting whose frontality and symmetry exhibit a deep kinship with archaic art—is, in my view, of far more importance in the development of an abstract art with roots outside neocolonial culture than is the mainstream historical figure who fostered Minimalism.

6. I have not dealt here with the work of other artists who have worked in this vein in more recent years, simply because they fall outside the time frame I set at the beginning of my search for the foundational traits of this abstraction. The first ramifications of these basic strains occurred during the 1950s in the work of the Guatemalan Carlos Mérida and that of U.S. artists Louise Nevelson, Alfred Jensen (also born in Guatemala), and Tony Smith, as well as in the work of the Argentinian sculptor Líbero Badii (born in Italy) and the Mexican Gunther Gerszo. In all of these artists a total or partial recognition of ancient Amerindian tectonics can be observed.

WORKS CITED

Acha, Juan. 1979. *Arte y sociedad: Latinoamérica. El producto artístico y su estructura*. Mexico City: Fondo de Cultura Económica.

———. 1979a. Otra escultura transitable en México. *El Universal* (Mexico), July 8.

———. 1980. Los espacios transitables de Luis Barragán. *La semana de bellas artes* (Mexico City) 137 (July 16).

de Acosta, Joseph. [1590] 1940. *Historia natural y moral de las indias*. Reprint, Mexico City: N.p.

Adelson, Laurie, and Arthur Tracht. 1983. *Aymara Weavings, Ceremonial Textiles of Colonial and 19th-Century Bolivia*. Washington, D.C.: Smithsonian Institute.

Agurto Calvo, Santiago. 1987. *Estudios acerca de la construcción, arquitectura y planeamiento incas*. Lima: Cámara Peruana de la Construcción.

Alcina Franch, José. 1983. *Pre-Columbian Art*. Translated from the French by I. Mark. Paris. New York: Harry N. Abrams.

Alloway, Lawrence. 1971. Color, Culture, the Stations. Notes on the Barnett Newman Memorial Exhibition. *Artforum* 10, no. 4 (December): 31–39.

———. 1973. Residual Sign Systems in Abstract Expressionism. *Artforum* 12, no. 3 (November): 36–42.

Ambasz, Emilio. 1976. *The Architecture of Luis Barragán*. New York: Museum of Modern Art.

Andersen, Troels. 1970. *Malevich, Catalogue Raisonné*. Amsterdam: Stedelijk Museum.

Anton, Ferdinand. 1987. *Ancient Peruvian Textiles*. London: Thames and Hudson.

Arguedas, José María. 1964. Puquio, una cultura en proceso de cambio. *Revista del Museo Nacional de Historia* (Lima), 1956. Reprint, in *Estudios sobre la cultura actual del Perú*. Lima: Universidad de San Marcos.

———. 1972. *Los ríos profundos*. Buenos Aires: Editorial Losada.

Arriaga, Fray Pablo José. [1621] 1968. *Extirpación de la idolatría en el Perú.* Madrid: Atlas Biblioteca de Autores Españoles.

Ascher, Marcia, and Robert Ascher. 1981. *Code of the* Quipu: *A Study in Media, Mathematics and Culture.* Ann Arbor: University of Michigan Press.

Ashton, Dore. 1983. *Noguchi.* New York: Pace Gallery.

———. 1992. *Noguchi East and West.* Berkeley: University of California Press.

Aveni, Anthony. 1986. The Nazca Lines: Patterns in the Desert. *Archaeology Magazine* 39, no. 4 (July–August): 33, 39.

Barthel, Thomas S. 1971. Viraco chas Prunkgewand (Tocapu Studien 1). In *Tribus,* no. 20:63–124. Stuttgart: Linden Museum für Völkerkunde. (No English translation.)

Barthes, Roland. 1977. *Elements of Semiology.* New York: Hill and Wang.

Bastien, Joseph W. 1973. Qollahuaya Rituals: An Ethnographic Account of Man and Land in an Andean Village. Ph.D. diss., Cornell University.

Battcock, Gregory. 1968. *Minimal Art: A Critical Anthology.* New York: Dutton.

Baudin, Louis. 1972. *El imperio socialista de los incas.* Santiago de Chile: Ediciones Zig-Zag.

Bauer, Brian. 1992. *The Development of the Inca State.* Austin: University of Texas Press.

Benezra, Neal David. 1985. *The Murals and Sculpture of Josef Albers.* New York: Garland Publishing.

———. 1988. New Challenges Beyond the Studio: The Murals and Sculpture of Josef Albers. In *Josef Albers, A Retrospective.* New York: Guggenheim Museum.

Bennett, Wendell C. 1934. Excavations at Tiahuanaco. *Anthropological Papers of the American Museum of Natural History,* vol. 34, part 3:359–494. New York.

———. 1963. The Archaeology of the Central Andes. In *Handbook of South American Indians,* vol. 2. Washington, D.C.: Bureau of American Ethnology, 1946. Reprint, New York: Cooper Square Publishers.

Benson, Elizabeth P. 1991. Entry for Item 451. In *Circa 1492: Art in the Age of Exploration,* edited by Jay A. Levenson. Washington, D.C.: National Gallery of Art and Yale University Press.

Betanzos, Juan de. [1551] 1987. *Suma y narración de los incas.* Edited by María del Carmen Martín Rubio. Reprint, Madrid: Atlas.

Bingham, Hiram. 1975. *Lost City of the Incas.* N.p., 1948. Reprint, New York: Atheneum.

Bird, Junius B. 1967. Pre-Ceramic Art from Huaca Prieta, Chicama Valley. In *Peruvian Archaeology.* Palo Alto, Calif.: Peek Publications.

Boardman, John. 1978. *The Pre-Classical: From Crete to Archaic Greece.* London: Penguin.

Boas, Franz. 1955. *Primitive Art.* Oslo: N.p., 1927. Reprint, New York: Dover Publications.

Boero Rojo, Hugo, and Oswaldo Rivera Sundt. 1979. *El fuerte preincaico de Samaipata.* La Paz, Bolivia: Editorial Los Amigos del Libro.

Bois, Yve-Alain. 1990. *Painting as Model.* Cambridge, Mass.: MIT Press.

Bonavía, Duccio. 1985. *Mural Painting in Ancient Peru.* Translated by Patricia Lyon. Bloomington: Indiana University Press.

Braun, Barbara. 1986. Paul Gauguin's Indian Identity: How Ancient Peruvian Pottery Inspired His Art. *Art History* 9, no. 1:36–54.

———. 1989. Henry Moore and Pre-Columbian Art. *RES* 17/18 (Spring–Autumn): 158–197.

———. 1993. *Pre-Columbian Art and the Post-Columbian World: Ancient American Sources of Modern Art.* New York: Harry N. Abrams.

Burger, Richard L. 1988. Unity and Heterogeneity within Chavín Horizon. In *Peruvian Prehistory*, edited by Richard W. Keatinge. Cambridge: Cambridge University Press.

———. 1992. *Chavín and the Origins of Andean Civilization*. New York: Thames and Hudson.

Burnham, Jack. 1968. *Beyond Modern Sculpture*. New York: George Braziller.

Bushnell, Geoffrey H. S. 1967. *Ancient Art of the Americas*. New York: Praeger.

Cabello de Balboa, Miguel. [1586] 1840. *Miscelánea Antártica, Part 3: Historia del Perú*. Paris: N.p.

Cahill, Holger, curator. 1969. *American Sources of Modern Art*. New York: Museum of Modern Art, 1933. Reprint, New York: MoMA.

de la Calancha, Fray Antonio. 1638. *Crónica moralizada de la orden de San Agustín*. Barcelona: N.p.

Carpenter, Edmund. 1975. Collecting Northwest Coast Art. In *Indian Art of the Northwest Coast*, edited by Bill Holm and Bill Reid. Seattle: University of Washington Press.

Carrión Cachot, Rebeca. 1955. *El culto al agua en el antiguo Perú*. Lima: N.p.

Cassirer, Ernst. 1975. *The Philosophy of Symbolic Forms*, vol. 2. New Haven: Yale University Press.

Castedo, Leopoldo. 1970. *Historia del arte y de la arquitectura colonial*. Desde la época precolombina hasta hoy. Barcelona: Editorial Pomaire.

Cereceda, Verónica. 1986. The Semiology of Andean Textiles: The Talegas of Isluga. In *The Anthropological History of Andean Polities*. Cambridge: Cambridge University Press and Maison des Sciences de l'Homme.

Chávez, Sergio Jorge. 1975. The Arapa and Thunderbolt Stelae: A Case of Stylistic Identity with Implications for Pucara Influence in the Area of Tiahuanaco. In *Nahwa Pacha*, vol. 13.

Chuang-Tzu. 1962. *Writings*. In *The Texts of Taoism*, Part 1. Translated by James Legge. New York: Dover.

Cieza de León, Pedro. [1553] n.d. *La crónica del Perú*. Reprint, Mexico: Editorial Nueva España.

———. [1554] 1973. *El Señorío de los Incas*. Reprint, Lima: Editorial Universo.

Cirlot, J. E. 1971. *Dictionary of Symbols*. New York: Philosophical Library.

Clifford, James. 1988. *The Predicament of Culture: Twentieth-Century Ethnography, Literature, and Art*. Cambridge, Mass.: Harvard University Press.

Cobo, Father Bernabé. [1653] 1956. *Historia del Nuevo Mundo*. Reprint, Madrid: Colección Biblioteca de Autores Españoles.

———. [1653] 1979. *History of the Inca Empire*. Translated and edited by Roland Hamilton. Austin: University of Texas Press.

Cockcroft, Eva. 1988. The United States and Socially Concerned Latin American Art. In *The Latin American Spirit: Art and Artists in the United States, 1920–1970*. New York: Bronx Museum.

Conklin, William J. 1972. Chavín Textiles and the Origins of Peruvian Weavings. *Textile Museum Journal* 3, no. 2:13–19.

———. 1978. The Revolutionary Weaving Inventions of the Early Horizon. *Ñawpa Pacha* 16:1–19.

———. 1981. *Museum of the Andes*. Tokyo: Newsweek and Kodansha.

Cordy-Collins, Alana. 1982. Chavín Art: Its Shamanic/Hallucinogenic Origins. In *Pre-Columbian Art History*, edited by Alana Cordy-Collins and Jean Stern. Palo Alto, Calif.: Peek Publications.

Curátola, Marco. 1977. Mito y milenarismo en los Andes: del Taki Onqoy a Inkarri. La visión de un pueblo invicto. In *Allpanchis Phuturinqa*, 10:65–92. Cuzco: Instituto de Pastoral Andina.

Dockstader, Frederick J. 1967. *Indian Art in South America*. Photography by Carmelo Guadagno. Greenwich: New York Graphic Society.

Douglas, Charlotte. 1986. Beyond Reason: Malevich, Matushin and Their Circles. In *The Spiritual in Art: Abstract Painting 1890–1985*. New York: Abbeville Press.

Duncan, Barbara, and Susan Bradford. 1974. *Joaquín Torres García: Chronology and Catalogue of the Family Collection*. Austin: University of Texas Press and the Archer M. Huntington Art Gallery.

Duviols, Pierre. 1973. Huari y Llacuaz. Agricultores y pastores. Un dualismo prehispánico de oposición y complementariedad. *Revista del Museo Nactional* (Lima) 39.

———. 1977. Los nombres quechua de Viracocha, supuesto "Dios Creador" de los evangelizadores. In *Allpanchis Phuturinqa*, 10:53–63. Cuzco: Instituto de Pastoral Andina.

Dwyer, Edward B. 1979. Early Horizon Tapestry from South Coastal Peru. In *The Junius B. Bird Pre-Columbian Textile Conference*, edited by Ann Pollard Rowe, Elizabeth P. Benson, and Anne-Louise Schaffer. Washington, D.C.: Textile Museum and Dumbarton Oaks.

Eliade, Mircea. 1959. *The Sacred and the Profane: The Nature of Religion*. New York: Harcourt Brace Jovanovich.

Elliott, Jorge. 1976. *Entre el ver y el pensar. La pintura y la escritura pictográfica*. Mexico City: Fondo de Cultura Económica.

Fejos, Paul. 1944. *Archaeological Explorations in the Cordillera Vilcabamba in Southeastern Peru*. New York: Viking Fund Publications in Anthropology.

Flores Ochoa, Jorge A. 1977. Enqa, enqaychu, illa y khuya rumi. In *Pastores de Puna*, edited by Jorge A. Flores Ochoa. Lima: Instituto de Estudios Peruanos.

Frame, Mary. 1984. Visual Images of Fabric Structures. In *The Junius B. Bird Conference on Andean Textiles*. Washington, D.C.: Textile Museum.

———. 1990. *Andean Four-Cornered Hats, Ancient Volumes*. New York: Metropolitan Museum of Art.

Franquemont, Edward. 1987. Meaning in Ethnographic Textiles. Talk delivered at conference, The Warp and Weft of Andean Time, at the Society for Art, Religion, and Contemporary Culture, New York, November 7, 1987.

Garcilaso de la Vega, "El Inca." [1604] 1991. *Comentarios reales de los incas*. 2 vols. Reprint, Lima: Fondo de Cultura Económica.

Gasparini, Graziano, and Louise Margolies. 1980. *Inca Architecture*. Translated by Patricia Lyon. Bloomington: Indiana University Press.

Gebhart-Sayer, Angelika. 1985. The Geometric Design of the Shipibo-Conibo. *Journal of Latin American Lore* (Los Angeles).

Gimbutas, Marija. 1982. *The Goddesses and Gods of Old Europe, 6500–3500 B.C.: Myths and Cult Images*. Berkeley: University of California Press.

———. 1989. *The Language of the Goddess*. San Francisco: Harper.

Gisbert, Teresa. 1992. The Indigenous Element in Colonial Art. In *America, Bride of the Sun*, exhibition catalog. Antwerp, Belgium: Royal Museum.

Goldwater, Robert. 1986. *Primitivism in Modern Art*. Cambridge, Mass.: Harvard University Press.

Gombrich, E. H. 1979. *The Sense of Order: A Study in the Psychology of Decorative Art*. Ithaca, N.Y.: Cornell University Press.

González, Alberto Rex. 1977. *Arte Precolombino de la Argentina*. Buenos Aires: Filmediciones Valero.

González Corrales, José A. 1971. Lítica inca en la zona del Cusco. Ph.D. diss., Universidad de San Antonio Abad del Cusco.

González Holguín, Diego. [1608] 1952. *Vocabulario de la lengua general de todo el Peru llamada lengua qquichua o del Inca*. Lima: Impr. Santa Maria.

Gordon, Robert B. Laboratory Evidence of the Use of Metal Tools at Machu Picchu (Peru) and Environs. *Journal of Archaeological Science* 12 (1985).

Gow, David, and Rosalind Gow. 1975. La alpaca en el mito y el ritual. In *Allpanchis Phuturinqa*, 8. Cuzco: Instituto de Pastoral Andina.

Gradowczyk, Mario H. 1985. *Joaquín Torres García*. Buenos Aires: Ediciones de Arte Gaglianone.

Graves, Robert. 1978. *The Greek Myths*. 2 vols. London: Penguin.

Gray, Camilla. 1971. *The Russian Experiment in Art: 1863–1922*. New York: Abrams.

Greenberg, Clement. 1965. *Art and Culture*. Boston: Beacon Press.

Grieder, Terence. 1982. *Origins of Pre-Columbian Art*. Austin: University of Texas Press.

Grieder, Terence, and Alberto Bueno Mendoza. 1985. Ceremonial Architecture at La Galgada. In *Early Ceremonial Architecture in the Andes,* edited by Christopher B. Donnan. Washington, D.C.: Dumbarton Oaks.

Grobman, Michael. 1980. About Malevich. In *The Avant-Garde in Russia 1910–1930, New Perspectives*. Los Angeles: Los Angeles County Museum.

Guaman Poma de Ayala, Felipe. [1615] 1988. *El primer nueva crónica y buen gobierno*. Edited by John V. Murra and Rolena Adorno. Translations from Quechua by Jorge L. Urioste. 2 vols. Mexico City: Siglo Veintiuno.

Harrison, Regina. 1989. *Signs, Songs and Memory in the Andes. Translating Quechua Language and Culture*. Austin: University of Texas Press.

Guss, David M. 1989. *To Weave and Sing. Art, Symbol and Narrative in the South American Rain Forest*. Berkeley: University of California Press.

Hauser, Arnold. 1951. *The Social History of Art*. 4 vols. New York: Vintage Books.

Hébert-Stevens, François. 1972. *L'art ancien de l'Amérique du Sud*. Paris: B. Arthaud.

Hemming, John, and Edward Ranney. 1982. *Monuments of the Incas*. Boston: Little, Brown and Co.

Hessen, Johan. 1967. *Teoría del Conocimiento*. Buenos Aires: Editorial Losada.

Hollowell, J. Lee. 1989. Re-assessment of the Fortaleza, Ollantaytambo, Peru. *Willay,* no. 32–33 (Fall-Winter): 3–7.

Hunter, Sam. 1980. *Isamu Noguchi 75th Birthday Exhibition*. New York: Andre Emmerich and Pace Galleries.

———., ed. 1986. *Transcending Abstraction: Richard Pousette-Dart, Paintings, 1939–1985,* catalog. Fort Lauderdale: Museum of Art.

Hyslop, John. 1990. *Inca Settlement Planning*. Austin: University of Texas Press.

Ingle, Marjorie. 1984. *The Mayan Revival Style*. Salt Lake City: University of Utah Press.

Inojosa, Franco. 1935. Janan Kosko. *Revista del Museo Nacional* (Lima) 4, no. 2.

———. 1937. Janan Kosko II. *Revista del Museo Nacional* (Lima) 6, no. 2.

Isbell, William H. 1988. City and State in Middle Horizon Huari. In *Peruvian Prehistory,* edited by Richard W. Keatinge. Cambridge: Cambridge University Press.

de la Jara, Victoria. 1964. *La escritura peruana y los vocabularios quechuas antiguos*. Lima: N.p.

———. 1967. Vers le déchiffrement des écritures anciennes du Pérou. In *Science Progrès* (Paris), no. 3387 (July): 241–247.

———. 1975. *Introducción al estudio de la escritura de los Inkas*. Lima: INIDE, Ediciones Previas.

Jiménez Borja, Arturo. 1984. Introducción a la cultura Huari. In *Arte y tesoros del Perú, Huari*. Lima: Banco de Crédito de Perú.

Joosten, Joop. 1971. Mondrian: Between Cubism and Abstraction. In *Piet Mondrian, Centennial Exhibition*. New York: Guggenheim Museum.

Kano, Chiaki. 1979. *The Origins of Chavín Culture*. Washington, D.C.: Dumbarton Oaks.

Kauffmann Doig, Federico. 1976. *El Perú Arqueológico*. Lima: Kompaktos.

Kendall, Ann. 1973. *Everyday Life of the Incas*. London: Batsford.

———. 1976. Descripción e inventario de las formas arquitectónicas incas. Patrones de distribución e inferencias cronológicas. *Revista del Museo Nacional* (Lima) 42:13–96.

King, Mary Elizabeth. 1979. The Prehistoric Textile Industry of Mesoamerica. In *The Junius B. Bird Pre-Columbian Textile Conference*. Washington, D.C.: Dumbarton Oaks Textile Museum.

Kosok, Paul. 1965. *Life, Land and Water in Ancient Peru*. New York: Long Island University Press.

Kramer, Hilton. 1980. Art View. *The New York Times*. July 20.

Kubler, George. 1962. *The Shape of Time*. New Haven: Yale University Press.

———. 1975. *The Art and Architecture of Ancient America*. New York: Penguin.

———. 1991. *Esthetic Recognition of Ancient Amerindian Art*. New Haven: Yale University Press.

Larco Hoyle, Rafael. 1944. La escritura pre-incana. *El México antiguo* 6, no. 7-8:218–238.

Lathrap, Donald W. 1968. The Tropical Forest and the Cultural Context of Chavín. In *Conference on Chavín*. Washington, D.C.: Dumbarton Oaks.

Lavalle, José A., and Werner Lang, eds. 1981. *Arte y Tesoros del Perú. Culturas Precolombinas, Chavín*. Lima: Banco Crédito del Perú.

Levenson, Jay A., ed. 1991. *Circa 1492: Art in the Age of Exploration*. Washington, D.C.: National Gallery of Art and Yale University Press.

Lippard, Lucy R. 1983. *Overlay: Contemporary Art and the Art of Prehistory*. New York: Pantheon Books.

Llanos, Luis. 1936. Trabajos archeológicos en el departamento del Cuzco. Informe sobre Ollantaytambo. *Revista del Museo Nacional* (Lima) 5, no. 2:123–156.

Locke, Leland R. 1923. *The Ancient Quipu or Peruvian Knot Record*. New York: Museum of Natural History.

Lodder, Christina. 1983. *Russian Constructivism*. New Haven: Yale University Press.

Lumbreras, Luis G. 1971. Towards a Re-evaluation of Chavín. In *Conference on Chavín*. Washington, D.C.: Dumbarton Oaks.

———. 1979. Introducción a la pintura precolombina. In *Arte y tesoros del Perú, Tercera Parte, Pintura*, edited by José A. de Lavalle and Werner Lang. Lima: Banco de Crédito del Perú.

Manrique, Jorge. 1984. Espacio Escultórico. Obra abierta. *México en el Arte* 4:2–11. Mexico City: Instituto Nacional de Bellas Artes.

Mariátegui, José Carlos. 1976. *7 ensayos de interpretación de la realidad peruana*. Lima: Amauta, 1928. Reprint, Lima: Amauta.

McMann, Jean. 1980. *Riddles of the Stone Age: Rock Carvings of Ancient Europe*. London: Thames and Hudson.

Menzel, Dorothy. 1978. Style and Time in the Middle Horizon. In *Peruvian Archeology*, edited by John H. Rowe and Dorothy Menzel. Palo Alto, Calif.: Peek Publications.

Menzel, Dorothy, John H. Rowe, and Lawrence Dawson. 1964. *The Paracas Pottery of the Inca: A Study in Style and Time*. University of California Publications in American Archaeology and Ethnology, vol. 50. Berkeley: University of California Press.

Millones, Luis. 1987. *Historia y poder en los Andes Centrales desde los orígenes al siglo XVII*. Madrid: Alianza América.

Molina, Cristóbal de, "El Cusqueño." [1573] 1943. *Fábulas y ritos de los incas*. Reprint, Lima: Miranda.

Morris, Craig. 1988. A City for an Inca. *Archaeology Magazine* 41, no. 5 (September–October): 43–49.

Morris, Craig, and Donald Thompson. 1985. *Huánuco Pampa: An Inca City and Its Hinterland*. London: Thames and Hudson.

Murra, John V. 1978. *La organización económica del estado inca*. Mexico City: Siglo Veintiuno.

Newman, Barnett. 1990. *Barnett Newman: Selected Writings and Interviews*. edited by John P. O'Neill. New York: Alfred A. Knopf.

Nodelman, Sheldon. 1970. Structural Analysis in Art and Anthropology. In *Structuralism,* edited by Jacques Ehrmann. New York: Anchor Books.

Osborne, Harold. 1968. *South American Mythology.* London: Paul Hamlyn.

Paternosto, César. 1981. Escultura lítica inca. *Artinf* (Buenos Aires) May: 15–17.

———. 1984. Escultura incaica y arte constructivo. *Artinf* (Buenos Aires) June-July: 21–25.

———. 1984a. Escultura abstracta de los incas. *Boletín del Centro de Investigaciones Históricas y Estéticas* 26:33–58 Caracas: Facultad de Arquitectura y Urbanismo, Universidad Central de Venezuela.

———. 1991. Re-Imagining Torres García's Vision: A Reading of *Metaphysics of Amerindian Prehistory.* Paper delivered at symposium, The Inverted Map: The School of the South, held at The University of Texas at Austin's College of Fine Arts.

Paz, Octavio. 1979. El arte de México: materia y sentido *and* El uso y la contemplación. In *In/Mediaciones.* Barcelona: Seix Barral.

———. 1983. *El laberinto de la soledad.* Mexico: Fondo de Cultura Económica.

Pease G. Y., Franklin. 1973. *El dios creador andino.* Lima: Mosca Azul Editores.

Pincus-Witten, Robert. 1969. New York. *Artforum* 8, no. 10 (Summer): 61–62.

Polo de Ondegardo, Juan. [1571] 1916. *Informaciones acerca de la religión y gobierno de los incas.* Reprint, Lima: n.p.

Ponce Sanginés, Carlos. 1972. *Tiwanaku: Espacio, Tiempo y Cultura; Ensayo de Síntesis Arqueológica.* Academia Nacional de Ciencas de Bolivia, Publicación No. 30. La Paz, Bolivia.

Posnansky, Arthur. 1945. *Tihuanacu: La Cuna del Hombre Americano [Tihuanaco: The Cradle of American Man],* vols. 1 and 2. New York: J. J. Augustin.

———. 1958. *Tihuanacu: La Cuna del Hombre Americano [Tihuanaco: The Cradle of American Man],* vols. 3 and 4. La Paz: Ministerio de Educación.

Protzen, Jean-Pierre. 1986. Inca Stonemasonry. *Scientific American* 254, no. 2 (February): 94–103.

Ramírez, Mari Carmen. 1992. Re-Positioning the South: The Legacy of the Taller Torres García in Contemporary Latin American Art. In *El Taller Torres García: The School of the South and Its Legacy,* edited by Mari Carmen Ramírez. Austin: University of Texas Press.

Ramos Gavilán, Alonso. 1976. *Historia de Nuestra Señora de Copacabana.* La Paz: Academia Boliviana de la Historia.

Randall, Robert. 1982. Qoyllur Rit'i, an Inca Fiesta of the Pleiades; Reflections on Time and Space in the Andean World. *Bulletin de l'Institut Français d'Etudes Andines* (Lima) 11, nos. 1–2:37–81.

———. 1987. Del tiempo y del río: el ciclo de la historia y la energía en la cosmología incaica. *Boletín de Lima* 54 (November): 69–95.

Rawson, Philip. 1978. *The Art of Tantra.* London: Oxford University Press.

Read, Herbert. 1957. *Imagen e Idea. La función del arte en el desarrollo de la conciencia humana.* Translated by Horacio Flores Sánchez. Mexico City: Fondo de Cultura Económica.

Ringbom, Sixten. 1986. Transcending the Visible: The Generation of the Abstract Pioneers. In *The Spiritual in Art: Abstract Painting, 1890–1985.* New York: Abbeville Press.

Rojas, Ricardo. 1939. *Ollantay, Tragedia de los Andes.* Buenos Aires: Losada.

Rose, Barbara. 1969. The Politics of Art: Part III. *Artforum* 8, no. 9 (May): 36–41.

Rosemberg, Harold. 1964. *The Anxious Object: Art Today and Its Audience.* New York: Collier Books.

———. 1972. *The De-Definition of Art*. New York: Collier Books.

Rostworowski de Díez Canseco, María. 1953. *Pachacutec Inca Yu panqui*. Lima.

———. 1986. *Estructuras andinas del poder. Ideología religiosa y política*. 2nd ed. Lima: Instituto de Estudios Peruanos.

———. 1988. *Historia del Tahuantinsuyo*. Lima: Instituto de Estudios Peruanos.

———. 1989. *Costa Peruana Prehispánica*. Lima: Instituto de Estudios Peruanos.

Rowe, John Howland. 1944. An Introduction to the Archaeology of Cuzco. *Papers of the Peabody Museum of American Archaeology and Ethnology* 27, no. 2:3–59.

———. 1961. The Chronology of Inca Wooden Cups. In *Essays in Pre-Columbian Art and Archaeology*, edited by Samuel K. Lothrop et al. Cambridge, Mass.: Harvard University Press.

———. 1962. *Chavín Art: An Inquiry into Its Form and Meaning*. New York: Museum of Primitive Art.

———. 1963. Inca Culture at the Time of the Spanish Conquest. In *Handbook of South American Indians,* vol. 2. Washington, D.C.: Bureau of American Ethnology, 1946. Reprint, New York: Cooper Square Publishers.

———. 1967. Stages and Periods in Archaeological Interpretation [reprinted from *Southwestern Journal of Anthropology* 18, no. 1 (1962): 40–54] *and* Form and Meaning in Chavín Art. In *Peruvian Archaeology.* Palo Alto, Calif.: Peek Publications.

———. 1968. The Influence of Chavín in Later Styles. In *Conference on Chavín.* Washington, D.C.: Dumbarton Oaks.

———. 1976. Religión e imperio en el Perú antiguo. *Antropología andina* (Cuzco) 1, no. 2.

———. 1978. The Adventures of Two Pucara Statues. In *Peruvian Archaeology,* edited by John Rowe and Dorothy Menzel. Palo Alto, Calif.: Peek Publications.

———. 1979. Standardization in Inca Tapestry Tunics. In *The Junius B. Bird Pre-Columbian Textile Conference.* Washington, D.C.: Textile Museum and Dumbarton Oaks.

Rowell, Margit. 1985. Order and Symbol: The European and American Sources of Torres García's Constructivism. In *Torres García: Grid-Pattern-Sign, Paris-Montevideo, 1924–1944.* London: Hayward Gallery.

Rubin, William. 1984. Modernist Primitivism, An Introduction. In *Primitivism in 20th-Century Art,* vol. 1. New York: Museum of Modern Art.

Rushing, W. Jackson. 1986. Ritual and Myth: Native American Culture and Abstract Expressionism. In *The Spiritual in Art: Abstract Painting 1890–1985.* New York: Abbeville Press.

Samaniego, L. E., E. Vergara, and H. Bischof. 1985. New Evidence on Cerro Sechín, Casma Valley, Peru. In *Early Ceremonial Architecture in the Andes,* edited by C. Donnan. Washington, D.C.: Dumbarton Oaks.

Sandler, Irving. 1962. Reviews. *Art News* (New York).

———. 1970. *The Triumph of American Painting.* New York: F. Praeger.

Sarmiento de Gamboa, Pedro. [1572] 1907. *History of the Incas.* Reprint, London: Hakluyt Society.

Sawyer, Alan R. 1967. *Tiahuanaco Tapestry Design.* New York: Museum of Primitive Art, 1963. Reprint, in *Peruvian Archaeology.* Palo Alto, Calif.: Peek Publications.

Saxon, Erik. 1979. On Mondrian's Diamonds. *Artforum* 18, no. 4 (December): 40–45.

Schweitzer, Bernhard. 1971. *Greek Geometric Art.* London: Phaidon.

Scully, Vincent. 1960. *Frank Lloyd Wright.* New York: George Braziller.

———. 1969. *The Earth, the Temple, and the Gods.* New York: Praeger.

———. 1992. Mankind and the Earth in America and Europe. In *The Ancient Americas, Art from Sacred Landscapes,* edited by Richard F. Townsend. Chicago: Art Institute of Chicago and Prestel Verlag, Munich.

Sherbondy, Jeanette. 1982. El regadío, los lagos y los mitos de origen. *Allpanchis Phuturinqa* 17, no. 20:3–32. Cuzco: Instituto de Pastoral Andina1.

Siqueiros, David Alfaro. 1921. Manifiesto a los plásticos de América. *Vida americana* (Barcelona) 1 (May). [Only one issue of this magazine was published.]

Skinner, Milica Dimitrijevic. 1984. Three Textiles from Huaca Prieta, Chicama Valley, Peru. In *The Junius B. Bird Conference on Andean Textiles*. Washington, D.C.: The Textile Museum.

Squier, Ephraim George. 1877. *Peru: Incidents of Travel and Exploration in the Land of the Incas.* New York: Harper and Bros.

Stone-Miller, Rebecca. 1986. Color Patterning and the Huari Artist: The "Lima Tapestry" Revisited. In *The Junius B. Bird Conference on Andean Textiles*. Washington, D.C.: The Textile Museum.

———. 1992. Camelids and Chaos in Huari and Tiwanaku Textiles. In *The Ancient Americas: Art from Sacred Landscapes,* edited by Richard F. Townsend. Chicago: Art Institute of Chicago and Prestel Verlag, Munich.

———. 1992a. To Weave for the Sun: An Introduction to the Fiber Arts of the Ancient Andes *and* Creative Abstractions: Middle Horizon Textiles in the Museum of Fine Arts, Boston. In *To Weave for the Sun, Andean Textiles in the Museum of Fine Arts, Boston.* Boston: Museum of Fine Arts.

Stübel, A., and Max Uhle. 1892. Die Ruinstätte von Tiahuanaco. Leipzig.

Tedeschi, Enrico. 1955. *Frank Lloyd Wright.* Buenos Aires: Editorial Nueva Visión.

Tello, Julio C. 1960. *Chavín: Cultura Matriz de la Civilización Andina.* Lima: Universidad Nacional Mayor de San Marcos.

Torres García, Joaquín. 1938. *La Tradición del Hombre Abstracto.* Hand-lettered text with drawings by the author, facsimilar reprint, Montevideo, 1974. (English trans. by Cecilia Torres appears in Margit Rowell, *Torres García: Grid-Pattern-Sign, Paris-Montevideo, 1924–1944.* London: Hayward Gallery, 1985.)

———. 1939. *Historia de mi vida.* Montevideo: Asociación de Arte Constructivo.

———. 1939a. *Metafísica de la prehistoria indoamericana.* Montevideo: Asociación de Arte Constructivo.

———. 1944. *Universalismo constructivo.* Buenos Aires: Editorial Poseidón.

———. 1947. *Mística de la pintura.* Montevideo: Asociación de Arte Constructivo.

Townsend, Richard F. 1985. Deciphering the Nazca World: Ceramic Images from Ancient Peru. *The Art Institute of Chicago Museum Studies* 2, no. 2:117–139.

———. 1992. Landscape and Symbol. In *The Ancient Americas, Art from Sacred Landscapes.* Chicago: Art Institute of Chicago and Prestel Verlag, Munich.

Ubbelohde-Doering, Heinrich. 1967. *On the Royal Highway of the Inca.* Reprint, New York: Praeger. [Originally published in German in 1941.]

Urton, Gary. 1981. *At the Crossroads of the Earth and the Sky: An Andean Cosmology.* Austin: University of Texas Press.

Uslar Pietri, Arturo. 1980. *Veinticinco Ensayos.* Caracas: Monte Ávila Editores.

Valcárcel, Luis E. 1938. Apuntes para una Filsofía de la Cultura Incaica. *Círculo y Cuadrado* (Montevideo) 7 (September).

———. 1963. Cuzco Archaeology. In *Handbook of South American Indians,* vol. 2. Washington, D.C.: Bureau of American Ethnology, 1946. Reprint, New York: Cooper Square Publishers.

———. 1964. *Etnohistoria del Perú antiguo.* Lima: Universidad de San Marcos.

———. 1973. *Machu Picchu, el más famoso monumento arqueológico del Perú.* Buenos Aires: EUDEBA.

Varnedoe, Kirk. 1984. Abstract Expressionism. In *Primitivism in 20th-Century Art,* vol. 2. New York: Museum of Modern Art.

Vasari, Georgio. [1568] 1965. *Lives of the Artists.* A selection translated by George Bull. London: Penguin.

Wachtel, Nathan. 1976. *Los vencidos. Los indios del Perú frente a la conquista española (1530–1570).* Madrid: Alianza Editorial.

Westheim, Paul. 1985. *Arte antiguo de México.* Mexico City: Biblioteca ERA.

———. 1986. *Ideas fundamentales del arte prehispánico en México.* Mexico City: Biblioteca ERA.

Wiener, Charles. 1880. *Pérou et Bolivie. Récit de voyage suivi d'études archéologiques et ethnographiques et des notes sur l'écriture et les langues des populations indiennes.* Paris: Librarie Hachette.

Zuidema, R. T. 1964. *The Ceque System of Cuzco: The Social Organization of the Capital of the Inca.* Leiden: E. J. Brill.

———. 1977. Mito e historia en el antiguo Peru. *Allpanchis Phuturinqa* 10:15–52. Cuzco: Instituto de Pastoral Andina.

———. 1979. The Inca Calendar. In *Native American Astronomy,* edited by Anthony Aveni. Austin: University of Texas Press.

———. 1985. The Lion in the City: Royal Symbols of Transition in Cuzco. In *Animal Myths and Metaphors in South America,* edited by Gary Urton. Salt Lake City: University of Utah Press.

———. 1990. *Inca Civilization in Cuzco.* Translated from French by Jean-Jacques Decoster. Austin: University of Texas Press.

INDEX

22, **66**, 69, **120**, **122**; public art, 4–
5; reductive geometry in, 27, **199**;
and religious symbolism, 4;
Rumihuasi, 130–132; stone as stone,
19; of stone to sun diety, 178;
symmetry in, 91; tectonic forms in,
xv; votive objects, **176**, 176–177.
See also architecture; art; monumen-
tal works; sculptarchitecture
Sculpture to be Seen from Mars
(Noguchi), 67–68
Seat of the Inca. *See usnu*
Sebastián, 60
semiotics: beans as signifiers, 157–158;
color as signifier, 156, 194; and
geometric vocabulary, 169, 243n4,
244n5; ideograms, 157, **157**, 169–
170; linguistic structure, 170–171,
222; protuberances as signifiers,
156, 158; of the *qipu,* 155–157,
156; rhythms as, 206; use of
repetition, 174
The Shape of Time (Kubler), 191, 192
Shipibo-Conibo culture, 172
shirts with *t'oqapu. See t'oqapu*
Silva, Federico, 60
Siqueiros, David Alfaro, 197
Smith, David: *Cubi,* 240n14
social sciences and art, 193
social utilitarianism, 202–203
solar observatories, 107–108
Spatial Force Construction (Popova),
212, 213
Spinden, Herbert, 246n6
Staff God, 24, **25**, 34
steps: alternating, **74**, **80**, **110**, 111–113,
112, **133**; Chinkana, 85; Lacco, 85–
87, **86**; as part of sculptarchitecture,
63; as symbols, 71
stirrup bottle, **27**
stone: and *guanca,* 183; and Inkarri
myth, 184–185; meanings of, 179–
180; as medium, 181–182; nature
of, 179–180, 185–186; sacred, 180–
184
stone carvings. *See* sculpture
Stone of the Twelve Angels (Cuzco), **36**
stonework: as bas-relief, 49; evolution,
42–47; and geometric thought, 220;
jointure, 42; precision of, 35, 47;
sculptural level, 117; symbolic
heirarchy of, 42, 47–49; and textile
techniques, 91; as weaving, 211. *See
also* architecture; sculptarchitecture;
sculpture; walls

Storrs, John, 232–233
"Studies for Architectural Forms"
(Storrs), 232
A Study of Maya Art ,246n6
"The Sublime is Now, "225
Suchuna: Lizard Rock, 81, 81–82;
sculpted rock, 80; as term, 77; *usnu,*
78, 79, **79**
sun cult, 23–24; and ceq'e system, 9;
Intiwatana as observatory, 107–108;
procession of, 75–76; symbol for,
177–178. *See also* Qoricancha
Temple
Sunken Temple (Tiwanaku), **33**
Suprematism, 203–204
Suprematist Square (Malevich), **204**
symbolic forms. *See* symbols
symbolism: and aesthetics, 6–7, 193; in
basketry, 172–173, **230**; Construc-
tive Universalism, 222; in Cuzco
sculpture, 94; in European art, 193;
in geometric abstraction, 13, 130,
217, 228, 231; in *Monument to the
Third International* (Tatlin), 200;
and myth, 233–234; of repetition,
241n4.6; in Saywite Monolith, 127–
130; steps and, 111, 113; of stone,
180; in Torres García, 214–216; use
of metaphors, 222, 228. *See also*
symbols
symbols: of Chavín, 20, 25; chevron,
163; condor, **162**, 163; corn, 179;
Cosmic Egg, 127–128; dark as, 64;
as designation of rank, 171–172;
diamond (rhomboid), 163, 249n15;
felines, 57–58, **87**, 97, 163; heraldic,
91; hourglass, 64, **171**; human
figure, 163; metal, 177–178, 245n3;
monkey, **87**, 88; reptiles, 81, 81–82,
163; Staff Gods, 178; stepped relief,
138; steps, 71, 111, 113; in stone-
work, 42; trapeziod, 54, 138, 148;
triangle, 249n15; water manipula-
tion, 89, 94, 113–114, 154–155. *See
also* symbolism
symmetry: in architecture, 59; in
sculpture, 91, 92; of textile struc-
tures, 164; in *t'oqapu,* 171
System and Dialects of Art, 233

tabernacles, 39, **148**
Taller Torres García, 217
Tamayo, Rufino, 192, 197
Tampu Machay, **88, 89**